Egyptian Art Jaromir Malek

ART&IDEAS

Φ

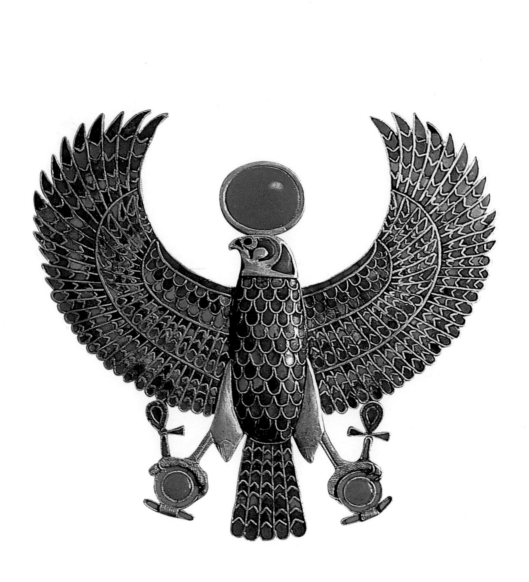

Egyptian Art

Opposite
Horus hawk
pendant from
the tomb of
Tutankhamun,
Valley of the
Kings, Western
Thebes,
c.1330 BC.
Gold,
semiprecious
stones, glass;
h.6·5cm, 2½in.
Egyptian
Museum,
Cairo

Ancient Egypt holds a special place in the popular imagination, but this is not a new phenomenon. Outsiders have regarded this civilization with fascination since the time when it was still in full flourish. Sometimes the reaction was more like bewilderment. No one conveyed this better than the Greek historian Herodotus, who wrote with amazement in the fifth century BC:

In Egypt the women go to the market and sell the produce, while the men remain at home weaving; and their weaving technique involves pushing down the weft, which in other countries is pushed upwards. Egyptian men carry loads on their heads, the women on their shoulders. The women urinate in a standing position, the men sitting down … Elsewhere priests grow their hair long: in Egypt they shave themselves. The common custom of mankind in mourning is for the bereaved to cut their hair short: Egyptians in the event of bereavement let both their hair and beards (which they normally shave) grow long … For writing and for counting with pebbles the Greeks move their hands from left to right, the Egyptians from right to left.

1
The Rosetta
Stone,
196 BC.
Basalt;
118×77 cm,
46½×30⅜ in.
British
Museum,
London

Strange land indeed! First-hand accounts of visitors such as Herodotus are invaluable sources for studying ancient Egypt and its art. Since the decipherment of the hieroglyphic script by Jean-François Champollion in 1822 – with the help of the Rosetta Stone (1) – it has also been possible to read texts written by the Egyptians themselves. The Rosetta Stone was invaluable in the decipherment as it bears a decree from the reign of Ptolemy V Epiphanes (204–180 BC) repeated in three scripts: hieroglyphs, demotic (a late phase of Egyptian with its own script) and Greek.

Still our image of ancient Egypt depends heavily on the evidence of visual arts and architectural remains. As historical data these need to be handled carefully because depictions in art are not always the realistic accounts they seem to be. The study of

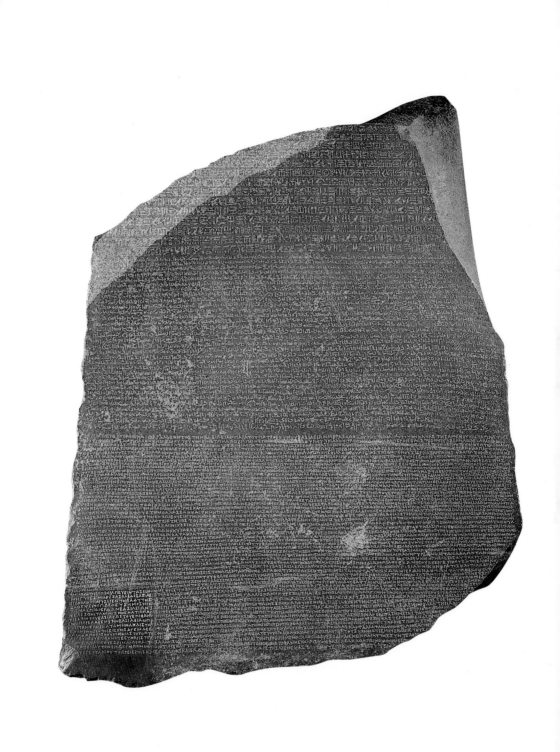

Egyptian art can be a source of great joy, but demands both open-mindedness and a questioning spirit. Often works are incompletely preserved and those which have survived may not be entirely representative. The situation is changing constantly with new excavations and research; what may seem clear and uncontroversial today may be thrown into confusion by a new discovery tomorrow, while present uncertainties may be removed by a brilliant new study or a fortuitous find.

This book draws on the latest Egyptological research and excavations to provide a 'state of the art' account. It aims to offer a concise but comprehensive and accurate introduction to ancient Egyptian art and architecture – from their beginnings deep in prehistoric times to their final decline at the beginning of the Christian era. Ancient Egyptian art was manifest in many varied forms: monumental architecture such as pyramids, temples, tombs and palaces; sculpture, wall-reliefs and paintings; jewellery, furniture, papyri, pottery and a large variety of objects of daily life, and all these are described in this book. The real masterpieces were usually associated with the ruling élite and its ideology. But there were also the modest artefacts of the ordinary, mostly peasant, population, such as personal ornaments and amulets. Works from all levels of society are discussed in the following pages to give a comprehensive picture of artistic achievement.

It is a particular feature of this book that it places great emphasis on context and ideas. Much Egyptian art served specific usages which were precisely defined in religious and funerary beliefs. To uncover those purposes and so to explain why a particular work of art was created, to elucidate its connections with other artistic achievements and to throw light on their mutual dependence, are among my main concerns.

No special knowledge is needed in order to delight in aesthetic qualities. But understanding adds enormously to this pleasure, and it is hoped that this book will help readers to appreciate ancient Egyptian art more by knowing something of what it meant to those who made it.

1

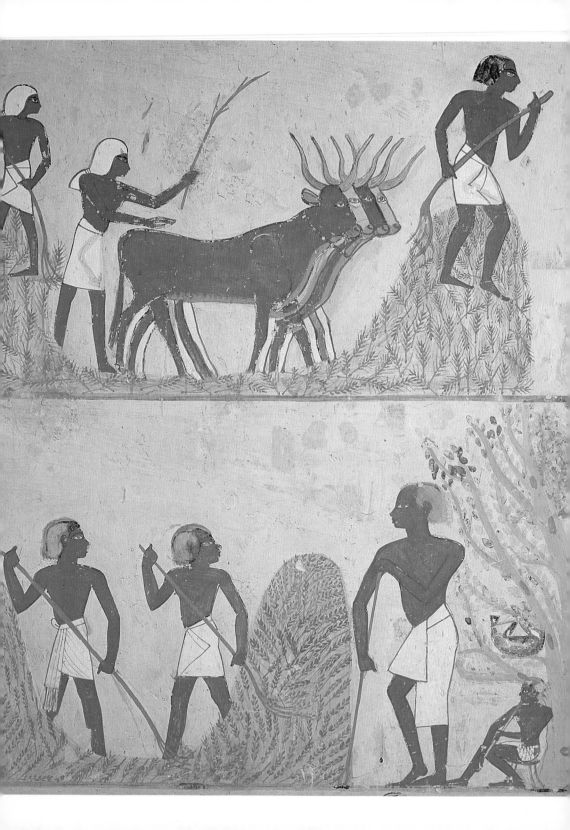

Ancient Egyptian civilization owed its existence to the favourable ecology that prevailed in the northeastern corner of Africa for several thousand years before the emergence of the kingdom of Upper and Lower Egypt around 3000 BC. Ancient Egypt was created by the Nile: the river was the most important contributor to economic life, and the country's very survival depended on the agricultural production which the Nile made possible. This benign environment attracted a varied population, including a substantial and important influx of people from other regions of Africa and from Western Asia, who formed an enormously able and gifted amalgam, a complex society which made astonishingly rapid progress in all spheres of human endeavour during the three-thousand-year period before the beginning of the Christian era. Among its greatest achievements are its art and architecture. Combining superb aesthetic qualities, breathtaking perfection and often enormous scale, these masterpieces are firmly rooted in the civilization's belief system, and both art and the spiritual beliefs it expressed were inextricably part of the physical world to which they belonged. Moreover, the country's fortunate environmental conditions (which significantly altered in subsequent centuries) meant that Egyptian civilization had no parallel elsewhere in the ancient world.

A key aspect of the ecology of ancient Egypt was the annual inundation of the Nile. Every year, between July and November, the waters of the river rose and flooded much of the land in the Nile Valley and the Delta for some three or four months. This annual occurrence was caused by regular torrential rains in the mountains of Ethiopia and in the southern Sudan. When the flood-tide receded, it left behind a rich and fertile silt deposit and pools of stagnant water. This, coupled with a warm and sunny climate that was not as rainless as it is today, provided ideal conditions for

2
Agricultural scene, tomb of Mena at Sheikh Abd el-Qurna, Western Thebes, c.1375 BC. Painting on plaster

simple but highly productive farming, of which there are lively depictions in many ancient Egyptian reliefs and wall-paintings (2). Egypt's dependence on the inundation was absolute and the balance of the relationship between man and nature was delicate and easily disturbed. A low Nile brought food shortages and suffering; a series of failed inundations resulted in famine. An unusually high flood caused widespread damage and destruction of settlements in the Nile Valley.

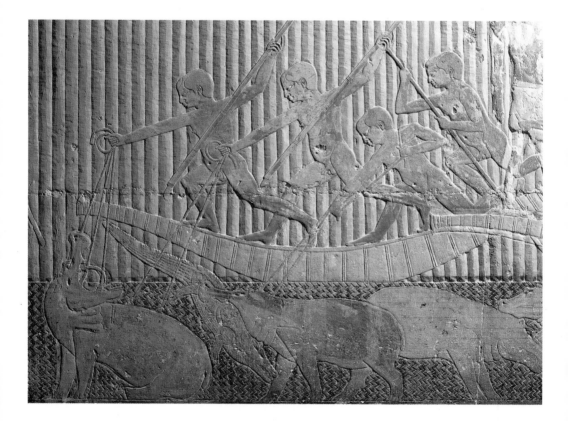

Benevolent climatic conditions persisted, with brief but devastating fluctuations, throughout the tremendously successful three-thousand-year period under the Egyptian kings or pharaohs (the word is derived from the Egyptian per-aa, 'the great house'). Not until Alexander the Great wrested the country from the short-lived Persian occupation in 332 BC, and power passed first to the Macedonian kings and then to the Ptolemaic dynasty, did Egypt's long-lived pharaonic civilization go into decline. Its death knell

was the defeat of the navy of Mark Antony and Cleopatra (51–30 BC) by Octavian at Actium in 31 BC, which took the supreme authority of government away to Rome.

As the name *Kemet*, 'Black Land', suggests, the Egyptians regarded only the cultivated area within the reach of the Nile inundation, recognizable by its dark rich soil, as their country proper. This was Egypt; 'abroad' began as soon as one left the Nile Valley or the Delta, although Egyptian administration claimed jurisdiction over the immediately adjoining deserts because of their economic (hunting, quarrying, commerce) and strategic importance. Ancient Egypt was geographically well defined by natural boundaries. The northern limit was marked by the marshy shores of the Mediterranean, the southern frontier by the granite barrier of the first Nile cataract which made river navigation hazardous some 850 km (530 miles) further south. The daunting, barren and inhospitable wilderness (*Desheret*, 'Red Land') of the rocky Eastern and the sandy Western (Libyan) Deserts hemmed in the life-giving Nile on either side.

3
Hippopotamus hunt, tomb of Ty, Saqqara, c.2400 BC. Limestone, painted raised relief

The Nile Delta (*Ta-mehu*, Lower Egypt) starts at a point some 20 km (13 miles) downstream from modern Cairo, where the Nile river divides into several branches which course northwards towards the Mediterranean. A wide expanse of extremely fertile land and rich pasture, this was a farming paradise that produced not only grain, dairy products and meat but also abundant wine and honey. While large areas of the Delta were marshy, teeming with wildlife (3), the region was also the location of cities which were important centres of trade with the Aegean and eastern Mediterranean. However, the northern approaches to Egypt, along the Mediterranean coast or through the Sinai peninsula, were the routes taken by foreign invaders as well as traders. This potential threat was transformed into real danger when Egypt came into direct contact with foreign powers in the Syro-Palestinian region and farther afield during the second and first millennia BC.

Egypt's southern part (*Ta-shema*, Upper Egypt), stretching 650 km (400 miles) between the first Nile cataract and the vertex of the Nile Delta, was little more than a narrow strip of land, sometimes only a

few kilometres wide. Nevertheless, parts of the valley were renowned for their grain harvests. Other economic advantages of Upper Egypt over the Delta lay in the access to mineral deposits in the desert hills to the east, and the gold, wood and human resources of Nubia ('the land of gold') beyond the first Nile cataract. Upper Egyptian cities also controlled the caravan routes linking the valley with the oases of the Western Desert and the African countries further south. Luxury materials such as gold, ivory, ebony, incense and exotic animals and their pelts, not to mention ostrich eggs and feathers, reached Egypt along these routes. The sheer distance between Upper Egypt and the northern frontiers and power centres provided a degree of strategic safety which also contributed to the area's success.

The country's abundant natural resources greatly influenced its arts and architecture. There was a deficiency in one respect, however: with the possible exception of its border areas, Egypt had no trees capable of providing timber for large-scale construction. Instead, Egyptian technology mostly had to make do with local wood from the acacia, the date and dom palms, the persea and tamarisk trees, and the sycamore fig, all of which provided only short pieces of timber. Elaborate joinery, using a range of joints including mortise-and-tenon, was employed in furniture-making, while the hulls of boats were constructed from planks that were dovetailed end-to-end to achieve the necessary length. This method, together with the absence of a keel, made them unsuitable either for sea voyages or for carrying heavy loads. For large ships, better quality timber had to be imported from Nubia and the Syro-Palestinian region. It was also used in tomb construction, including the making of massive coffins and the large stelae known as 'false doors' (4). Imported hardwoods, such as ebony, were used especially for prestige items.

4
False door from the tomb of the estate manager Iyka at Saqqara, c.2450 BC. Wood; h.200cm, 78¾ in. Egyptian Museum, Cairo

On the other hand, Egypt possessed extraordinary mineral wealth. Stone suitable for building purposes occurs along the whole length of the Nile Valley – mainly limestone of varying quality, but also sandstone in the southernmost part of the country. Expeditions were dispatched to Wadi Hammamat in the Eastern

Desert to procure greywacke (schist), a hard stone used by sculptors. Granite, which was employed as a building material (5) and for sculpture, came from the region of the first Nile cataract, near Aswan. Diorite, another hard stone, and one which occurred in a wide range of colours used for statuary, was brought from the Eastern Desert or from Nubia in the south. Egypt's rich variety of the natural materials of art also included red quartzite, alabaster and basalt. These provided the monumental elements of Egyptian statuary and architecture. Semiprecious stones such as turquoise, amethyst, carnelian, jasper and others, used in the manufacture of jewellery, also came from the desert surrounding the fertile

5
The valley (lower) temple of Khephren at Giza, c.2500 BC. Granite

6
Nubians bringing tribute, tomb of Amenhotep Huy, the Nubian viceroy under Tutankhamun, Qurnet Murai, Western Thebes, c.1330 BC. Painting on plaster

territories. Gold was mined in the Eastern Desert, and much came from Nubia. In the complicated relations of the Ancient Near East, Egypt's gold often spoke more loudly than its arms: it was eagerly sought and demanded by vassals and potential foes alike. Supplies of Egyptian grain and gold were a frequent topic in diplomatic correspondence. Copper was by far the most important material for the manufacture of tools and weapons throughout much of Egyptian history. Supplies of this metal came from Sinai, although Egypt also had to rely heavily on imports from Western Asia and Nubia.

Ancient Egypt's northern and southern geographical limits were reached, and the national identity forged, early in the third

millennium BC, and although vast neighbouring areas of
Palestine and Syria to the northeast, Libya to the west and Nubia
to the south were administered or at least controlled on many
later occasions, the concept of what constituted the land of ancient
Egypt changed little. Egypt's population is estimated to have risen
from about half a million in 3000 BC to four and a half million at the
beginning of the Christian era. Nubia was almost completely
Egyptianized during the second millennium BC, although its terri-
tory was never governed in the same way as Egypt proper. This
situation is depicted in scenes of Nubians bringing tribute on the
walls of contemporary tombs and temples (6), especially those

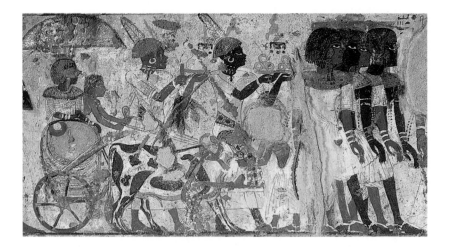

connected to officials responsible for the administration of Nubia.
These occasions were probably fictitious, but the images never-
theless convey correctly the relationship between Nubia and
Egypt. None of the major developments in ancient Egyptian art
were attributable to an ethnic change, resulting from either inva-
sion or migration, although various stylistic stimuli were brought
from abroad – from Persia, Mesopotamia, the Syro-Palestinian
region, the Aegean and the Roman empire – possibly introduced
by imported craftsmen and artists. Conversely, particularly in the
first millennium BC, Egyptian art, which must have compelled
admiration and respect, influenced the artistic production of
the other, younger civilizations of the Mediterranean world.

The same language, Egyptian, which belongs to the Afro-Asiatic language group (also known as the Hamito-Semitic languages) was spoken in the whole of Egypt. There must have been dialectical or pronunciation differences because ancient Egyptian sources inform us that communication between an inhabitant of the Delta and a person from the Nile Valley was not easy. Other languages were spoken by immigrants who settled in Egypt, or were written for administrative purposes during periods of foreign domination. Aramaic was introduced by the Persians, and Greek was the language of the ruling élite under the Ptolemies and the Romans.

The hieroglyphic script was used for monumental inscriptions throughout the whole of Egyptian history. Although Egyptian hieroglyphs (from the Greek *hieros*, 'sacred' and *gluphe*, 'carving') represent recognizable images of people, animals, birds and various objects (7), they are not real picture writing. Each hieroglyph has a phonetic value (fixed pronunciation) or plays a specific role in the script (eg indicates that a word belongs to a particular category of meaning). In theory, it would have been possible to use no more than a small number of signs, in the same way that we use our alphabet. But the script was seen as a gift from the gods, and to interfere with it in a radical way was not possible. The close connection between hieroglyphs and images was never lost, and the transition from one to the other was effected effortlessly and smoothly on monuments. Egyptian artists were very adept at exploiting it. For example, in the name which identified the person represented by a statue, the sculpture itself was regarded as the concluding hieroglyph, so there was no need to supply the actual hieroglyph in writing. Hieroglyphic inscriptions respected the orientation and other characteristics of the objects on which they were written; hieroglyphs inscribed on statues usually faced the same way as the sculpture itself.

Egyptian religion comprised a diverse system of beliefs about the gods, and the king's links to them. It offered an explanation of the cosmos and a concept of life after death. Both religion and society were highly stratified, and the religious practices of the privileged classes differed markedly from those of the mass of ordinary

people. Moreover, religious beliefs did not remain constant over the three millennia but were continually reinterpreted. Egyptian temples were intended not for popular worship but to provide a place where the king could commune with the gods; they were closed to everyone else, regardless of social standing. Temple duties, however, were usually delegated to priests, most of whom were not professionals and were recruited from privileged social groups – in this way there was some general participation in temple rituals. The abstract religious concepts associated with large temples would have been incomprehensible to the majority of ordinary people, who worshipped their gods in simple local shrines which grew up spontaneously. The forms of deities that were popular among the illiterate mass of Egyptian peasants differed markedly from those worshipped in temples.

One of the most striking features of Egyptian religion was the multiplicity of its deities, each of which could manifest itself in a variety of forms – as a living animal or bird, or as a man-made image which could be anthropomorphic (in human form), zoomorphic (in animal form), a combination of the two, or in some inanimate or vegetal form. The pharaoh, who was not regarded as a fully-fledged god, was not an ordinary mortal either. As *netjer nefer* ('junior god'), he shared the gods' designation *netjer* and was seen as a personification of the god Horus and the son of the sun god Re.

7 Overleaf
Stela of
Princess
Nefertiabet
from her tomb
at Giza,
c.2500 BC.
Limestone,
raised relief;
h.38cm, 15in.
Musée du
Louvre, Paris

The origins of many of the gods can be traced to so-called local deities that go back to times when communities were relatively isolated, probably even before the appearance of permanent farming settlements. Local conditions produced gods who reflected the character of the area. So, for example, the deity of the marshy region around Lake Faiyum was the god Sobek who manifested himself in the form of a crocodile, while the cults of gods whose zoomorphic form was the bull were particularly frequent in the pastoral setting of the Delta. The multiplicity of different local gods never decreased; there were attempts to systematize the Egyptian pantheon but never to suppress any of the deities. In this sense, Egyptian religion was remarkably tolerant. A dramatic rise

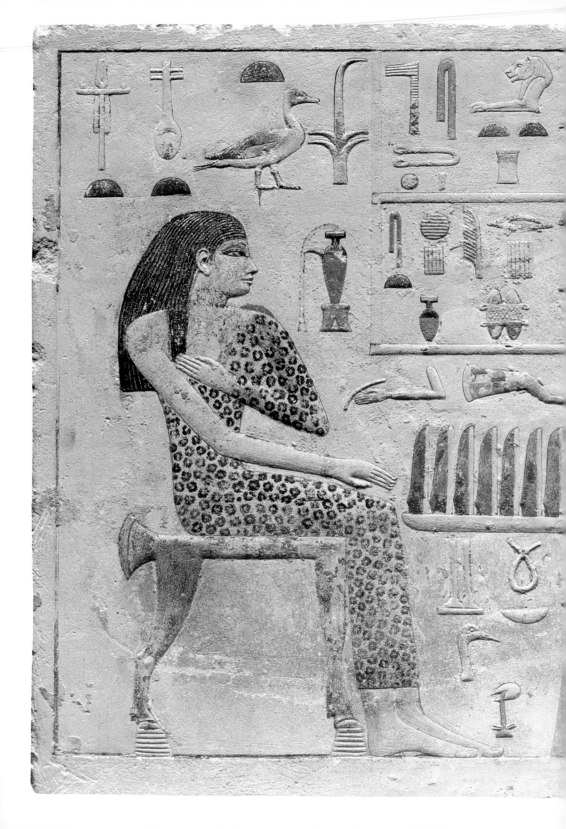

in the status of a particular deity was often due to the rise in importance of the god's home town. Some deities associated with places that became centres of power rose in status to the point where they might be described as state divinities: Amun (or Amun-Re) of Thebes (modern Luxor, in the southern part of Egypt), Ptah of Memphis (south of modern Cairo), and Re (or Atum) of Heliopolis (the northeastern suburb of Cairo).

Astronomical ideas played an important role in the early concepts of the afterlife. According to these beliefs, at his death, the pharaoh retired to the northern region of the sky where he became one of the circumpolar stars which never set. Later, ideas about the god Osiris and his kingdom of the dead in the west replaced such concepts, and solar ideas, according to which the king accompanied the sun god Re during his nocturnal journey through the underworld, subsequently became prevalent. Eventually, even ordinary people were able to participate in the beliefs centred on Osiris, who became by far the most popular Egyptian deity.

Egyptian art's close links to religious, funerary and other beliefs lent it a stamp of remarkable continuity and homogeneity. By ensuring the perpetual validity and efficacy of religious ideas, it had a direct bearing on this world and the afterlife. The fact that most surviving ancient Egyptian art was created to express ideas about the afterlife, and that many works come from tombs, appears to suggest that the Egyptians were preoccupied with death. But this is a misleading picture. Continued existence after death was the wish of all Egyptians and the most important of all personal religious beliefs. Yet people did not desire to enter paradise when they died, but rather hoped that they would be able to continue an existence similar to that which they led in their lifetime. Egyptian tomb art reflected this wish and was concerned with providing the necessary conditions for such an afterlife. It contains much information about Egyptian everyday reality, although – as will become clear – these depictions should not be accepted uncritically. Great effort and expense were devoted to expressing ideas about the afterlife, and proportionately more works of art were therefore

concerned with this area than with everyday life. Clearly, however, the artistic record should not be taken as a comprehensive statement about the mentality or daily preoccupations of the Egyptians.

A few examples may help to illustrate the relationship between Egyptian art and the society that produced it, beginning with the royal role. For much of Egyptian history, only the king was able to approach and plead with the gods on the people's behalf. He was responsible for the smooth running of the world and the maintenance of the established order, the tasks with which he was entrusted at his coronation. The success of the king in protecting the established order against internal and external enemies, safeguarding its smooth functioning, and maintaining good relations with deities was essential for everybody's wellbeing. A statue of a divine being was an essential feature of all temples; it served as the god's manifestation, or physical presence. Through the statue communication with the deity was made possible. A statue of a pharaoh set up in the same temple ensured his eternal presence at the side of the god and so guaranteed his perpetual access to the divinity. Such statues as well as reliefs carved on the walls of temples conveyed ideas about the relationship between the king and the deity worshipped there, capturing the ideal state of affairs, so ensuring its existence in perpetuity. While much emphasis was placed on ritual, the temple was in other respects able to function independently, without further interference.

Public display and accessibility were also secondary considerations for much of the art made for tombs. Here, a statue placed in a closed statue room provided the required physical abode for the deceased's *ka* (soul or spirit) which continued to exist even after death. Artistic requirements would be difficult to grasp without understanding the statue's purpose: for example, the representation had to be sufficiently lifelike and identifiable so that the *ka* would recognize its own statue. Such ideas were also related to the conditions in which the dead were buried. The dry desert sand acted as a natural dehydrating agent and allowed the preservation of bodies. This would have encouraged ideas about the

continuation of the body as a physical abode in order to accommodate the spiritual aspects of the human personality. Such beliefs not only provided a stimulus for the making of statues for the *ka* to inhabit, but also encouraged the artificial mummification for which ancient Egypt is so famous. Reliefs or wall-paintings in the tomb guaranteed that the material needs of the deceased would continue to be satisfied in the afterlife. While the representations on the walls fulfilled this role by their mere existence, offerings of real food and drink were also brought to the tomb's altar. Thus, most of the great Egyptian masterpieces that we now see in museums were never on public display in their original context. Some would be seen by a limited number of people, especially priests, but many others were rendered completely inaccessible, shut away in tombs which were intended to remain sealed forever.

A key characteristic of ancient Egyptian art was thus its functionality – its creation to serve a particular, invariably metaphysical, purpose. The pyramids, the popular symbol for ancient Egypt and all it represents, are best understood in terms of their functionality (8). For example, the height and size of the pyramids and the perfection of their design far exceeded what we would describe as 'practical'. But for the Egyptians these qualities were precious, and the effort required in the pyramid construction was not regarded as wasteful because the structures served a clear purpose in enhancing the status of the king entombed within. This was important not only for the king's afterlife, but also for the afterlife of all his contemporaries buried in tombs around the pyramid.

As far as is known, no statues were made for purely aesthetic purposes. There are also no known portraits made for their own sake. Inside royal palaces and houses there were wall-paintings, and possibly some relief carvings, which had no open religious character, although even these are sometimes interpreted as being spiritual in meaning. The only artworks that seem likely to have been wholly secular were such items of daily use as decorative cosmetic utensils, jewellery, stone vases, games (9) and textiles, of which exquisite examples survive.

8
The pyramids
of Menkaure,
Khephren and
Khufu (l to r),
Giza,
c.2530–2460 BC

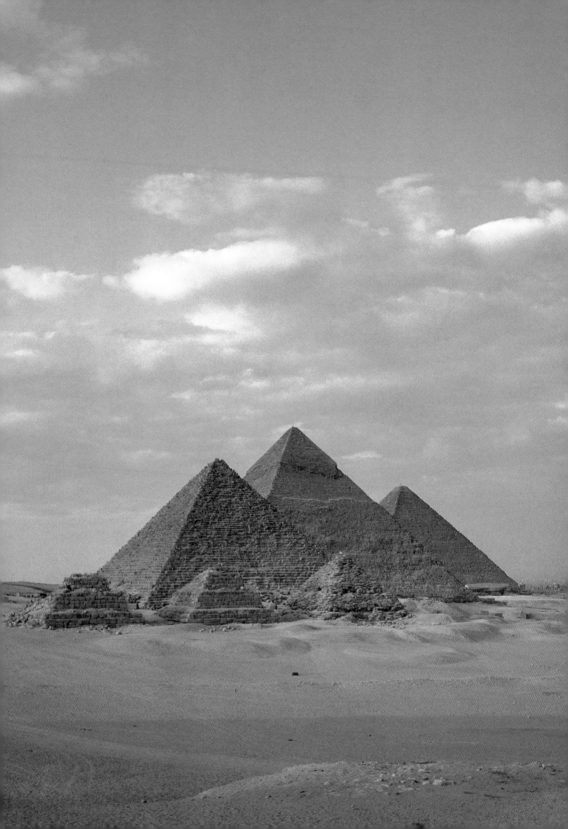

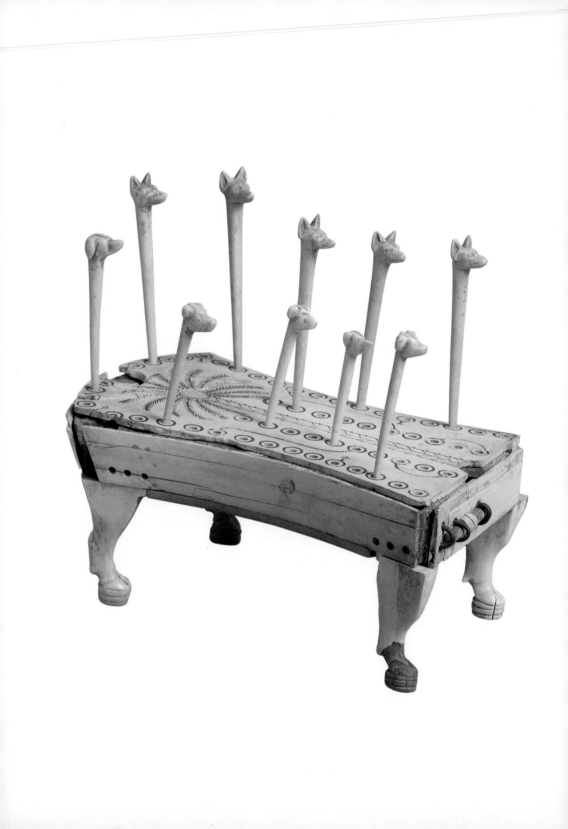

Although most Egyptian artworks were functional in conception, this does not detract from their aesthetic value. Egyptian artists were not simply turning out endless copies. Moreover, the ideas that the arts expressed changed throughout the three millennia during which ancient Egypt flourished, and this meant that their subject matter was reinterpreted and modified to suit new requirements and changed circumstances. This took place, nevertheless, against a background of extreme reluctance to abandon earlier concepts and forms that had been thought to be effectual in the past. This is why, despite the fact that Egyptian artists received important stimuli from abroad at various stages of their development, the reception of such influences was not easy. The undisguised functionalism of almost all Egyptian arts was extremely restrictive and made it difficult to accept artistic ideas from abroad.

9
Game of
'hounds and
jackals' from
the tomb of
the official
Rensoneb
in Western
Thebes,
c.1810 BC.
Wood, ivory
and ebony;
h. of board
6·5cm, 2½in.
Metropolitan
Museum of
Art, New York

In the hierarchical structure of ancient Egypt, the king was the theoretical owner of all the land and the ruler of all the people. This meant that there was no distinction between royal and state property. In theory the pharaoh held complete power in political, economic and other state affairs. In practice, it was unavoidable that complex arrangements soon evolved which imposed restraints on royal authority, executive as well as economic. This also carried dangers, however, since the erosion of the pharaoh's power gradually undermined the credibility of the whole system. The periods of political disintegration and economic anarchy into which Egypt was plunged from time to time were largely due to such inherent weaknesses.

Egypt was fortunate in possessing able and energetic administrators at all levels. At first, these 'officials' were royal relatives; later, they were talented men recruited from almost any social group, although there were soon pressures for positions to become hereditary. One person might hold a variety of administrative posts, and such a spread of interests often made it possible to bypass the cumbersome bureaucratic system and improve its efficiency. The connection between administrative offices and priestly functions was always close and many distinguished people bore titles linking them to both spheres of Egyptian life.

Cultivators were not free to leave the land they farmed and offer their labour elsewhere. Their link to the land was a powerful mechanism through which the ruling élite exercised its control over the people (there was little in the way of a coercive apparatus such as police). A free unattached labour force did not exist. However, because the king was the theoretical owner of all the land, he was able, when needed, to summon anybody he wished to take part in construction works, military service or expeditions to quarries. Only those settled on land specifically exempted from such obligations were able to avoid these duties. But the ancient Egyptian system of production was not based on the enslavement of workers as in classical antiquity, and comparisons with the medieval feudal system are equally inaccurate.

Temples were the largest landholders in Egypt after the pharaoh. Pyramids and cult temples of dead kings and tombs of the élite were also endowed with land. Their task was to maintain the posthumous cult of the deceased kings and private individuals. The produce from such estates was used not only for offerings required in the temple or tomb chapel, but also to maintain the priesthood, peasants working on the estate's fields, and craftsmen and artists in its workshops, as well as for the upkeep of officials in various administrative capacities. Officials in the state administration had their own large estates which they received from the king; in the absence of money, this was the most efficient way of providing for their needs. In later periods of Egyptian history, landholding was extended to private individuals of modest standing.

Temples, palaces, necropolises and large estates had their own workshops and studios in which craftsmen and artists manufactured both the elaborate works commissioned by the privileged and the humble goods required by the farming population. The social standing of craftsmen and artists was only slightly better than that of peasants. They were entirely dependent on the establishment to which their workshop belonged and were not free to leave, although they were able to use some of their time to make and sell goods as a form of private enterprise. There were no independent artists who

made their living solely by selling their works. Judging from the complete absence of written references linking women to the production of monumental works of art, we must assume that this was a closed male domain. The few instances where women appear to be described as scribes or painters have been shown to refer to the application of body paint. However, women were involved in the manufacture of everyday objects such as textiles and pottery, which form some of the most attractive products of ancient art.

As will be clear by now, all works of ancient Egyptian art contain a multi-layered web of ideas, allusions and symbols which our modern eyes disentangle only with extreme difficulty. Two more concepts, both linked to the Nile river where we began this discussion, are central to understanding Egyptian art. The first is the all-pervading notion of the duality of two elements held in harmonious opposition. Philosophically, it was a remarkable premise: everything has its counterpart which contradicts and negates it, but by doing so completes it and makes its existence possible. In the naturally occurring phenomena of Egyptian reality, two contrasting elements were ever present. There was the river with its strip of fertile land, and there was the barren and inhospitable desert. The narrow Nile Valley in the south (Upper Egypt) was contrasted by the wide expanse of the Delta in the north (Lower Egypt). The abundance of the Nile inundation which turned large areas of Egypt into huge lakes was the opposite of the low Nile during the rest of the year. The neatly cultivated fields could hardly be more different from the chaotic marshy areas teeming with wildlife which still existed in parts of Egypt early in its history. The orderly functioning of the Egyptian state was, at least in Egyptian eyes, in complete distinction to the conditions outside Egypt's borders.

Such a way of understanding the world found its reflection in countless examples in royal and everyday life. The title which the Egyptian pharaoh adopted at his coronation was dual: he was 'one who belonged to the sedge and the bee' or, as we translate it, 'the king of Upper and Lower Egypt'. There were the two main royal crowns: white (later associated with southern Egypt) and red

(for northern Egypt). The two main deities protecting the king were
the vulture goddess Nekhbet of Nekheb in southern Egypt, and the
cobra goddess Wadjit of Buto in the Delta. In Egyptian religion and
mythology, the positively good deity (eg Osiris or Horus) is paral-
leled by a wicked and dangerous counterpart (eg Seth). Some of the
gods underwent a 'character split' during which the benevolent
features of their character were subsumed in one manifestation
(eg in the cat goddess Bastet, the patroness of family happiness)
while the bellicose and wild characteristics were concentrated
in another (eg in the lioness goddess Sakhmet, the raging image
of inclemency and war). Or, the goddess Bastet could manifest
herself in two different animal forms, as a lioness or as a cat.

This presented enormous opportunities for artists whose task was
to express such abstract notions in visual forms. The king was
shown wearing the white crown on the southern wall of the temple,
but the red crown on the northern wall. The two heraldic plants of
southern and northern Egypt (the sedge and papyrus) entwined
into one, symbolizing the 'union of the Two Lands' at the beginning
of each new reign, was a frequently repeated motif (see 54). The
orderly conditions in Egypt were portrayed on the interior of temple
walls, but they were contrasted by the depiction of the chaotic situa-
tion abroad on the other side of the same wall. The statues of the
goddess Bastet could show her as a lion-headed goddess, but with
small figures of cats sitting at her feet (10): the two aspects of her
character were shown separately but were meant to be understood
as one whole. The examples are endless, and careful observation of
almost any Egyptian work of art will reveal them. Such a retention
and repetition of iconographic features contributes to the popular,
if misleading, perception of ancient Egyptian art as unchangeable,
but it added greatly to its cohesion by providing elements which
were relatively stable and regularly occurring. That the concept of
duality encouraged balance and equivalence, especially in archi-
tecture, is immediately obvious to the viewer. Egyptian symmetry
always emphasizes the contrasting character of the two elements
rather than that of two identical components, so that the balance
is never absolute and can be more aptly described as opposition.

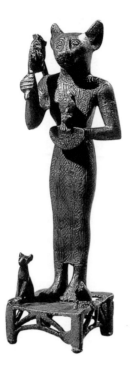

10
The goddess
Bastet,
c.600 BC.
Bronze;
h.16cm, 6¼in.
British
Museum,
London

The second important concept derived from the Nile was the cyclical nature of events. The river's regular inundation was calculated in advance and eagerly awaited. This encouraged astronomical observation and the calculable appearance of constellations on the horizon, and their predictable disappearance further strengthened the understanding of events as an ever-repeated cycle.

The cyclical approach to events is closely related to ideas concerning life after death. The annual inundation brought the Egyptian countryside back to life in an almost miraculous way. Correspondingly, the onset of the dry season heralded the approach of harvest and the demise of much of the vegetation. The concept of death and rebirth, which came to play such an important part in the lives of all Egyptians and provided the inspiration as well as the subject for much of Egyptian art, thus reflected the events in nature. The death and resurrection of Osiris, originally a chthonic (earth) deity, became one of the most potent symbols in Egyptian religion.

This cyclical concept was also applied to history, which was seen as a process returning continually to its starting point. According

to the Egyptians, the first king 'joined the Two Lands' (the Nile Valley and the Delta) and so formed Egypt. This act of creation was negated at the death of each pharaoh but was re-enacted at the beginning of each new reign. Then, it was thought, a period of chaos was replaced by an orderly state of affairs. History was thus but a series of beginnings and ends as the country experienced a ritual unification of the Two Lands at the coronation of each new king. The consequences of such an approach to events is the absence of any era of continuous dating.

This has caused difficulties for historians, but problems of dating are not as acute as for other countries in the Ancient Near East. It must be admitted that absolute dates (those given in years BC), particularly for the first half of Egyptian history, may give the impression of spurious accuracy. A useful guide to the reigns of the pharaohs has been provided on page 430. However, corrections may be plus or minus 200 years for the beginning of the Egyptian historic era. This margin of error decreases with time, until accuracy is achieved from the seventh century BC onward. Strictly

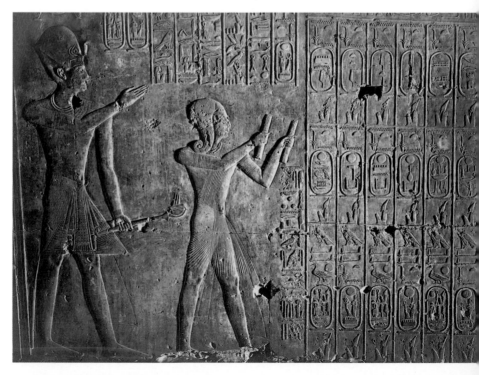

11
King Sety I and Prince Ramses (later King Ramses II) before the list of kings in the memorial temple of Sety I at Abydos, c.1280 BC. Limestone, painted raised relief. Photographs by J P Sebah, c.1890

speaking, all the dates before the seventh century BC should be indicated as approximate (*eg* c.2972 BC rather than just 2972 BC).

The standard division of Egyptian history used by Egyptologists represents one of the most serious obstacles to the understanding of Egyptian chronology by non-specialists. In order to avoid ambiguity, Egyptologists prefer to use relative dates, based on a system of dynasties (royal houses) introduced by the Ptolemaic historian Manetho in the third century BC. There is no general consensus about the lengths of individual reigns and the overall duration of the dynasties. The Egyptians did not use a dating system which was independent of the individual rulers. Each king numbered his own regnal years, and we have to know the names of all the kings and the precise length of each reign in order to establish an overall chronology. Fortunately, we have a few astronomical dates and there are several surviving lists of kings compiled by the Egyptians themselves. Those recorded on the walls of temples and tombs (11), however, were not intended as accurate historical records and were selective, so that their evidence must be treated with caution.

Sometimes Manetho's dynastic system works reasonably well, but we now know that it contains serious flaws and must be used with circumspection. Manetho's tables of kingship only partly reflect blood relationship within the ruling family; 'dynasties' in this sense are not what we understand by the term nowadays. Rather than being based purely on family descent, Manetho's divisions are often derived from the location of the capital of the country. Some dynasties are not clearly defined, others overlap or are contemporary. Furthermore, the modern arrangement of Egyptian history into larger sections (kingdoms and 'intermediate periods') is unreliable and the premises on which it is based are sometimes uncertain. But until a better system is devised and is generally accepted, the traditional division into dynasties and larger historical periods cannot be avoided completely.

All this shows the huge complexity of ancient Egyptian civilization and the difficulties involved in trying to understand its art. Much of its context is now irretrievably lost and even scholars can claim only partial knowledge of the beliefs which were the main reason for its creation. We can never hope to comprehend it fully. But, although simply looking at Egyptian art can be a hugely rewarding and enjoyable exercise, understanding the world in which it was created can greatly increase its interpretation, partial though even an informed appreciation must necessarily be.

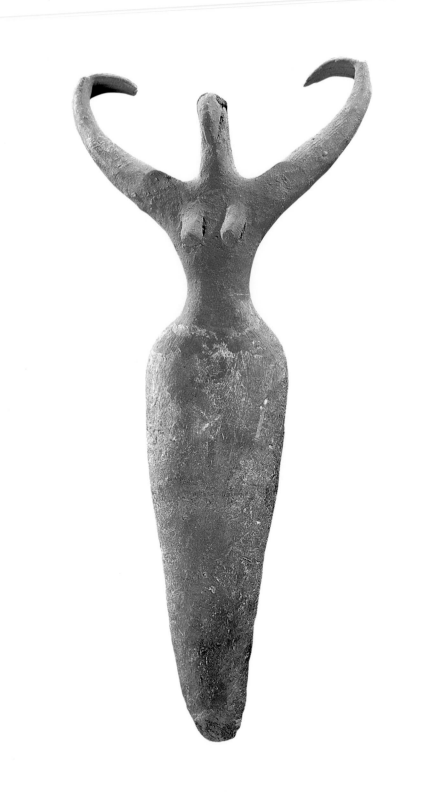

Books on Egyptian art used to start at the beginning of the First Dynasty, around 3000 BC, when it was thought many of the characteristics of ancient Egyptian culture appeared suddenly and almost from nowhere. Some scholars believed that links with the Predynastic Period (5500–2972 BC) were so tenuous that to include predynastic works of art in their discussion was unnecessary. Now most books make at least a token nod in the direction of the Predynastic Period. But is this enough? How far back into prehistory can we legitimately delve in our search for the earliest signs of artistic creativity? Stone implements found in Upper Egypt attest to occasional human occupation, especially on the hill plateaux overlooking the Nile, from about 700,000 BC. Few things are more directly and brutally functional than these flint tools (13), designed to tear the skin, flesh and sinews of hunted animals, yet they hold a degree of grim fascination. Their makers had to shape the stone into a form envisaged first in their imagination, and in doing so they applied concepts such as symmetry, which were to play a prominent role in Egyptian art. Even though the primary intention was pragmatic, the tools display a high level of finish, which must have been the outcome of aesthetic preferences. It could be argued, therefore, that these early hunters were the most distant predecessors of the pharaonic artists who carved wall-reliefs and fashioned stone statues.

The Palaeolithic Period in Egypt, during which men for the first time began to make primitive stone implements, extends down to 8000 BC, but flat stones showing signs of intensive wear may have been used for the grinding of grain as early as 15,000 BC. It was at that earlier time that occasional visitors to the Nile Valley learnt how to exploit the annual rhythm of the river and began to harvest wild cereals on a regular basis. This sporadic exploitation continued for some ten millennia, until the first settled farmers and

12
Female figure from el-Mamariya, c.3500 BC. Terracotta; h.29·3cm, 11½ in. Brooklyn Museum of Art, New York

cattle-herders appeared in the Nile Valley around 5500 BC, at the beginning of the Neolithic Period. They were forced to seek a new way of life by climatic changes and the progressively deteriorating situation in the Saharan grasslands, and were attracted by the fertile conditions created by the Nile inundations. On their arrival they encountered other peoples who had already been grain-gathering, fishing and hunting along the river for many thousands of years. The Egyptian Neolithic cultures represent the coexistence and gradual mixture of these ethnic elements, together with immigrants who arrived from Western Asia.

The term Neolithic, as used by Egyptologists, refers to the way of life in an area where farming communities shared common characteristics reflected in archaeological material. Neolithic cultures are usually named after localities where they were first identified or where they are most extensively represented in the archaeological record. They are attested from all over Egypt, although in the Nile Delta their remains are buried deep under the silt deposited by inundations and so are inaccessible. The cultures named after the locations of Merimda in the western Delta, the Faiyum in Middle Egypt (the northern part of Upper Egypt), and Badari in Upper Egypt are the earliest (5500–4000 BC). Later the Nagada culture (4000–2972 BC) dominated at first Upper Egypt and then the whole country.

13
Stone implements from the Theban area, c.100,000 BC. Flint; max. h.15cm, 5⅞in. Egyptian Museum, Cairo

In Egyptian chronology, the Neolithic cultures constitute the Predynastic Period, which preceded the earliest historical dynasty of kings known from written records (2972–2793 BC), and therefore pharaonic (dynastic) Egypt (2972–332 BC). During the second half of the Predynastic Period, especially after 3500 BC, the surviving archaeological material from different parts of the country is remarkably homogenous, an unmistakable sign of close contacts even before the whole of Egypt was formally united under the rule of one king.

Neolithic agriculturalists lived in permanent settlements on the margins of the Nile Valley or the levees of the Delta, where their simple houses were safe from the waters of the inundation. They grew emmer wheat, barley and flax, reared cattle, sheep, goats

and pigs, fished intensively and, to a lesser degree, hunted. The climate was more humid and so more benign than in pharaonic Egypt or today. The annual cycle of the Nile provided a naturally occurring agricultural clock, but there was no need for large-scale artificial irrigation. The Predynastic Egyptians made pottery and basketry, mastered the art of weaving, and used faience (made by heating powdered quartz) and, on a small scale and mostly for luxury ornaments, copper.

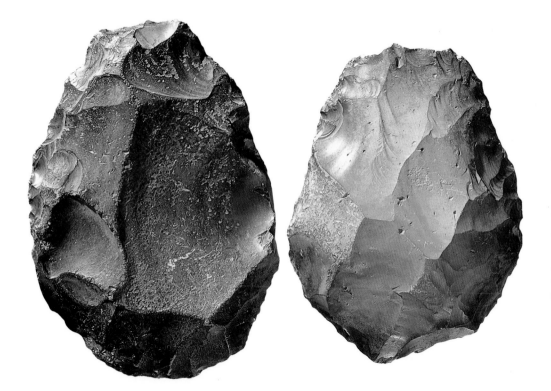

Personal ornaments and other articles found on the bodies buried in Predynastic cemeteries, especially the early ones, are very modest. Nevertheless, they deserve to be considered in this discussion of Egyptian art. If nothing else, they attest to some aesthetic awareness and artistic competence of Predynastic Egyptians within the limited technology at their disposal. There seems little doubt that these decorative items gave pleasure to their owners and were not manufactured merely for funerary purposes. They included combs, hairpins and earrings, beads

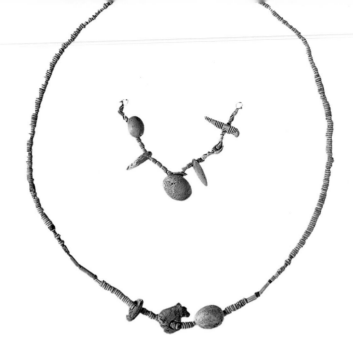

Egyptian Art

14
Necklaces
with amulets
in the form of a
hippopotamus
and a hawk,
from Badari,
c.4500 BC.
Shell and
faience;
h.2 cm, ¾ in.
British
Museum,
London

and pierced shells which formed necklaces, bracelets and rings,
and cosmetic palettes for the preparation of green and black eye-
paint. There were also small amulets (14), often in the form of an
animal such as a hippopotamus, bull or jackal, or a bird such as
a crouching hawk. These were not necessarily images of zoomor-
phic deities. They may have been meant to afford protection from
these often feared creatures, or to endow their owner with desired
animal characteristics (strength of the lion, speed of the gazelle,
etc.). These small objects were made of a variety of materials,
such as stone (including semiprecious turquoise, carnelian and
jasper, and also lapis lazuli, perhaps from the Western Desert
and also brought by long-distance trade from as far afield as
Badakhshan in Afghanistan), ivory, shell, bone, pottery, faience
and copper, and later gold and silver. They continued to be used
by the poorest Egyptians throughout the whole of pharaonic
history. They are familiar to all archaeologists working in the
field, but standard accounts of Egyptian art hardly ever mention
them. This is not surprising. They reflected the aesthetic feelings
and artistic ability of ordinary people, but paled into insignifi-
cance once the arts of the Egyptian élite emerged at the
beginning of the historic period.

The often repeated, yet misleading statement that there was a huge gap between Predynastic (Neolithic) and later Egyptian art assumes that the great and complex achievements of the pharaonic period arose quite suddenly from nowhere. Since even historians use works of art as a means of assessing the level of sophistication and prosperity of ancient Egyptian society, this sometimes leads to erroneous and racially biased views about the Egyptians of the dynastic period and about the emergence of the Egyptian state. The reasons for the most important developments of this period are even today sometimes sought outside Egypt, in the form of direct foreign influence.

In reality, Predynastic and pharaonic art form a continuum; the change that occurred would be more accurately compared to a steep step or sudden acceleration of pace. More than almost any other aspect of Egyptian society, the arts benefited from the new favourable circumstances which arose towards the end of the Predynastic Period and at the beginning of the historic period. The hieroglyphic script was an as-yet imperfect tool of communication, and so the visual arts were the main means of expressing and recording beliefs and ideas. They were patronized by the wealthiest and most influential members of society, especially the royal court, and developed rapidly. Their representational conventions and basic iconography were established in a very short space of time, perhaps not more than one or two generations. To modern eyes, this gives the superficial impression of the sudden appearance of art forms and ideas without any antecedents – a view further strengthened by the ancient artists' reluctance to change the main aesthetic characteristics once they had been established. Some iconographic motifs may have been brought from abroad at that time, for example from Susa in Iran and Sumer in Mesopotamia (now Iraq). These include representations of a man subduing two wild animals (the 'master of the beasts' motif), animals with long entwined necks, a rosette motif, men wearing long non-Egyptian garments, and possibly also scenes of boats with a high prow and stern. At most, however, this proves the existence of early extensive contacts with the other

parts of the Ancient Near East and shows that Egypt was ready to receive such stimuli.

The indisputable link between the humble artistic productions of the Predynastic Period and the perfection of pharaonic art can be traced, for example, in images drawn from the natural world, which were the most common motifs of Predynastic art. Among items of daily use, combs (15) and cosmetic palettes (16) provide the clearest links with later art. Combs, most commonly made of ivory or bone but also of wood, often had handles in the form of an acutely observed beast, such as a gazelle, shown as a two-dimensional silhouette. It is attractive to think that its presence was due to sheer aesthetic pleasure and admiration of the animal's grace and elegance, but modern perception of these ordinary items may be deceptive. The underlying ideas may have been broadly religious or linked to a superstition.

These images are reminiscent of collections of drawings of boats, people, birds and animals that were incised or hammered (pecked) onto rock surfaces along the Nile. Often they form large picture galleries in Upper Egypt and Nubia, along desert wadis (dry riverbeds) and caravan tracks. The art of rock carving was never lost, and the dating of these rock pictures is notoriously difficult: the earliest are probably Predynastic, others later, and they continued to be made right down to modern times. The earliest record animal species which disappeared from Egypt and Lower (northern) Nubia before the beginning of the pharaonic period, such as the elephant (17) and giraffe. They belong to the vast number of comparable rock drawings at various Saharan sites in the Western Desert. Hunting magic is usually offered as an explanation for their creation, but this is far from certain.

Some of the boats and human figures encountered in rock drawings are directly comparable to those depicted on late Nagada pottery (after 3500 BC) and in the Painted Tomb (c.3100 BC) in the desert cemetery near Hierakonpolis (ancient Nekhen, modern Kom el-Ahmar in Upper Egypt), which belonged to one of the early Upper Egyptian rulers (see 25). To find clear representational

15
Animal combs from Nagada, c.3200 BC. Bone; h.17, 10·7 and 12·8cm, 6⅝, 4¼ and 5in. Ashmolean Museum, Oxford

16
Cosmetic palette in the shape of a ram, from Nagada, c.3500 BC. Schist; 18·3×8·9cm, 7¼×3½in. Ashmolean Museum, Oxford

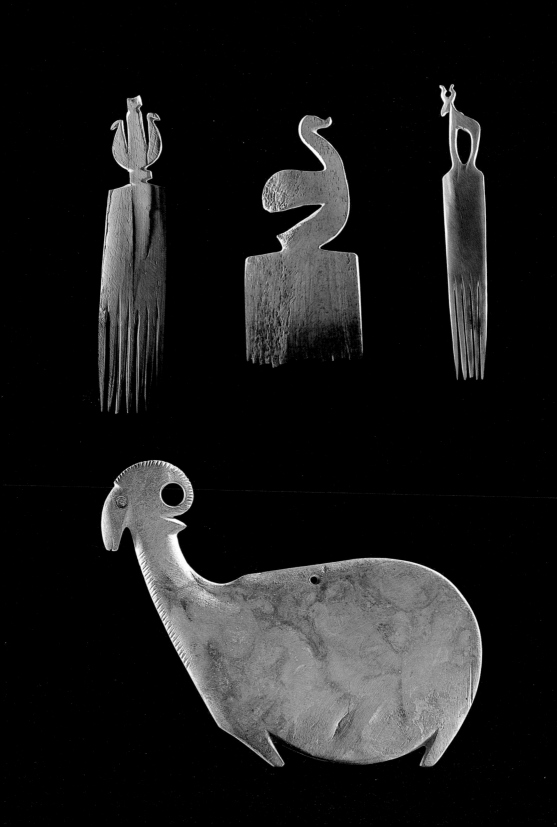

similarities in such diverse works is quite remarkable; it may indicate that not all rock pictures were made by humble hunters.

Flat stone palettes of simple geometric forms were used for the grinding of malachite (copper ore) or galena (lead ore) in order to obtain paint used in make-up, a custom which may have been functionally protective (against the glare of the sun) as well as decorative or ritualistic. Soon their shape was made to resemble the silhouette of an animal, perhaps a horned creature (16), an elephant, bird, fish or turtle. More unusual forms included boats with human figures. Additional details were sometimes incised, and the resemblance was further enhanced by slight modelling

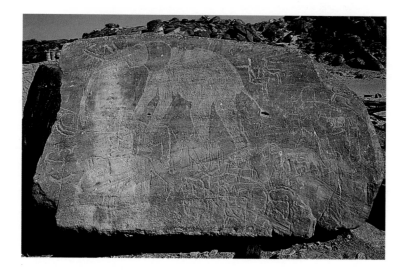

17
Rock drawings, Wadi el-Sebua, Nubia, c.5000 BC

and even an inlay for such features as an animal's eyes. In this way, the palette-makers were gradually acquiring the ability to carve in stone and becoming aware of the potential of relief, a technique whose use they developed to great effect by the end of the Predynastic Period and which eventually led to spectacular wall decoration in pharaonic temples and tombs.

Pottery is commonly found in Predynastic graves, although the potter's wheel was not known during this period. Predynastic pots show that a simple turning device was occasionally employed in their manufacture but wheel-thrown pottery only appeared

around 2400 BC. Many of these pots have never been used; they were specially manufactured as grave goods, and show that workshops providing tomb furnishings, which were such a typical feature of the ancient Egyptian funerary scene, were not an invention of the pharaonic period. The aesthetic qualities of Predynastic pottery sometimes resulted from the method used during its manufacture. Black-topped ware of the Badari and early Nagada cultures had deep red bodies with wide black rims, an attractive colour pattern which may have been produced by placing the vessels upside down in hot ashes during their firing. The potter was almost certainly aware of this aesthetic effect and deliberately tried to achieve it.

During the early Nagada culture (4000–3500 BC), pottery was often decorated with painted scenes which included people as well as animals (18). Cross-hatching was used to indicate animal fur, and this probably led to the white-on-red painted geometric designs in which even the outline of the beast was made up of straight or nearly straight lines meeting at angles. It is not surprising that the origin of this linear style has been sought abroad, since it seems out of keeping with the usual representational conventions of Egyptian art. But it is more likely that the style is entirely indigenous and imitates basketry and reed matting. In the later stage of the Nagada culture, red-on-buff pottery decorated with boats (19) may provide early representations of real or imaginary journeys which the deceased had to undertake. Such ideas are known from later times and may at first have recorded transport of the corpse by boat to the nearest cemetery. Representations of people, sometimes with hunted animals, and rows of flamingos were also common.

These were the beginnings of Egyptian painting, which was to flourish in such a spectacular fashion on later tomb walls. Hints (but as yet no more than that) of some of the representational conventions of later Egyptian two-dimensional art can already be detected. Scenes and motifs (eg rows of birds) are arranged into horizontal strips (registers), the rudiments of pharaonic portrayal of the human body (a combination of a front view and a profile) are

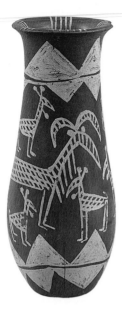

18
Vessel with
Barbary
sheep, from
Nagada,
c.4000 BC.
Painted
pottery;
h.25·5cm, 10in.
Ashmolean
Museum,
Oxford

present, and there is an intentional disregard for realistic relative
sizes. An interesting solution to the problem of representing
people inside the boat's cabin – by showing them above it, as
if outside the boat – also has direct parallels in later art. This
became a standard pharaonic method for showing the contents
of a closed shrine, box or a similar item.

Some pottery vases were modelled in the shape of an animal
(eg hedgehog, bird or fish) and were probably used for special
purposes, although their precise function is not known. Such
pottery should be seen as an important step in the development
of animal sculpture. The painted spirals and zigzags used to deco-
rate some Predynastic pottery imitated the much sought-after
veined stones from which elegantly designed vessels were made.
Stones of varying colours, ranging in hardness from easily worked
alabaster to the unyielding and recalcitrant basalt and porphyry,
were used. Occasionally, these vessels also took the form of an
animal or a bird, even when the material to be worked was obdu-
rately difficult. The quality of these stone vessels progressively
improved in the course of the Predynastic Period as the confidence
of their makers at working in stone increased. The earliest repre-
sentations of craftsmen manufacturing such stone vases are

several hundred years later, but the techniques of Predynastic craftsmen probably were not much different from those of their Old Kingdom successors. The form and surface texture of the vessels were obtained by pounding, rubbing and smoothing with stone blocks. A bow drill with flint blades was used to hollow out the vessels. Copper tools, especially the tubular drill, may have already been used at the end of the Predynastic Period.

Excavations of Predynastic graves and settlements have produced the earliest fully three-dimensional statuettes of people and animals known from Egypt. Easily manageable materials such as clay, ivory and wood were most frequently chosen by the early sculptors, although stone was increasingly used towards the end of the Predynastic Period. Such sculptures can be categorized, but there are too few of them, and the relationship between their different categories is too unclear, for them to be confidently related to the archaeological divisions of the Predynastic Period.

Probably the earliest Egyptian sculptures in the round come from the Merimda culture in the western Delta and date to about 4500 BC. They were clumsily made in baked clay and betray no previous experience or special skills on the part of their makers. A female

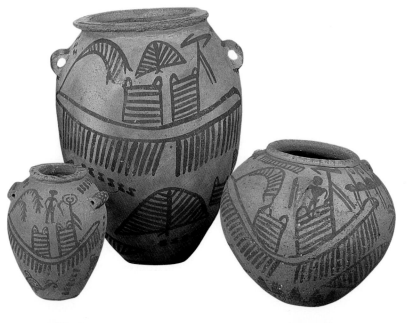

19
Vessels with boats and human figures, from Nagada and Abadiya, c.3500 BC. Painted pottery; h.8·9, 18·8 and 10·2cm, 3½, 7⅜ and 4 in. Ashmolean Museum, Oxford

statuette with a crudely indicated nose, eyes and breasts is the first attempt at a representation of a human figure known from Egypt. A sculpted mask-like head has been found which is more detailed, with hollow eyes and nostrils and a gaping mouth (20). This may be part of a broken figure of which the body is now lost. There are also small figurines of cattle.

Sculptures of the Badari and early Nagada cultures were considerably more sophisticated. The statuettes of women (21) were usually made of hippopotamus or elephant ivory, sometimes inlaid, and much of their appearance was due to the shape of the tusk from which the figure was carved. This form was also imitated in clay. These women have conspicuously large heads and huge haunting eyes. Their hair sometimes appears to be cropped or they are close-shaven; at other times their hair or a wig falls in long lappets onto their chest. Their arms are held close to the body, with the hands on the stomach or the hips. The emphasis on their sexual characteristics is noticeable and probably explains their inclusion in male graves – to guarantee the deceased man's continued ability to procreate in the afterlife. The custom of including the so-called concubine figures (this is a trivializing modern term) in tombs occurred sporadically during the pharaonic period, although they always remained confined to simple burials and have never been rated highly as works of art.

Female statuettes of a different type (see 12) are known mostly from the late Nagada period (3500–2972 BC). They are made of baked or unbaked clay; as so often in later pharaonic art, the material exercised powerful influence over the form and determined some of its characteristics. These statuettes have a schematically rendered beak-like head (hence the term 'bird deities' coined by modern archaeologists) and often gracefully raised wing-like arms with their hands above their head. They have no feet; instead, their lower legs form a peg-like extension – perhaps in order to set them upright in the sandy ground of the grave or symbolically to prevent them from escaping. The latter concept occurs in the later Pyramid Texts, where hieroglyphic

20
Sculpture from Merimda, c.4500 BC. Painted terracotta; 10.3×6.7cm, 4×2⅝in. Egyptian Museum, Cairo

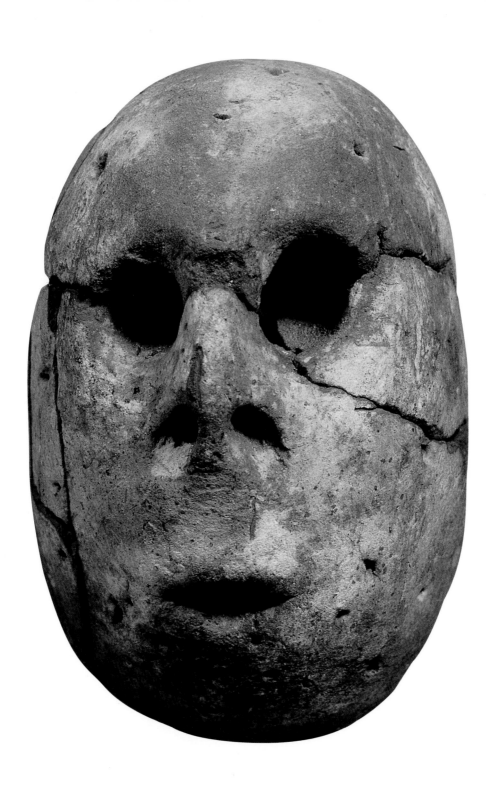

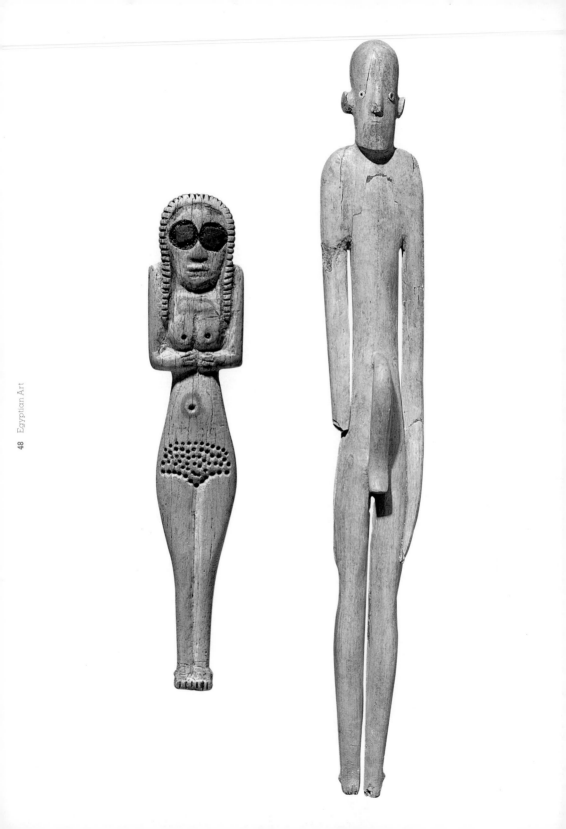

signs showing living creatures were mutilated in order to render them immobile and so unable to run away or cause damage. These schematic images are very different from the earlier, rather painstakingly detailed representations, and it seems unlikely that they were meant to portray female deities. While little is known about the religion of Predynastic Egyptians, it is improbable that ordinary people would have been buried accompanied by images of their gods; in pharaonic Egypt deities were not represented in private tombs before the second millennium BC. These statuettes may have been linked to continued male fertility, but the women's raised arms suggest rather that they represented mourners lamenting the death of the buried person. In order to indicate the background against which some of these female figures should be seen, an interesting artistic solution was adopted: the animals and plants surrounding them were painted on their bodies. Some 1500 years later, during the late Middle Kingdom (after c.1800 BC), the same method was used on faience statuettes of hippopotami in order to indicate the beast's habitat (see 115). And a related idea, involving carving such scenes on the surface of statues, gained widespread popularity from the end of the second millennium BC.

The stick-like ivory male statuettes (22) that were made during the early Nagada period also betray the dependence of form on material. An impressive penis-sheath is the only discernible item of clothing worn by these men. Their arms are held close to the body and the legs are shown together because the figure could not depart from the limits imposed by the shape of the ivory tusk without being made in several sections joined together, a technique that was not favoured by Predynastic sculptors. Interestingly, similarly accoutred men painted on contemporary pottery sometimes have their arms raised above their heads, again possibly as a sign of mourning. Male statuettes of a different type, made of stone, were produced throughout the Nagada period, but especially in its late stages. These are little more than heads on schematically rendered bodies lacking any details except, sometimes, the nipples (23). Some of these figures may be quite large (c.30 cm, 12 in. or more). They have staring eyes indicated by drilled holes (originally

21
Female figure, Nagada I, c.4000–3500 BC. Ivory; h.11·4cm, 4½in. British Museum, London

22
Male figure with penis sheath, from el-Mahasna, c.4000–3500 BC. Ivory; h.34cm, 13⅜in. Egyptian Museum, Cairo

perhaps inlaid) and, occasionally, a conspicuous nose and ears. Their main characteristic is, however, a long pointed beard. This can also be seen on a much more realistically conceived statuette, the famous MacGregor Man (24) in the Ashmolean Museum in Oxford (named after the Reverend William MacGregor – one of the most prominent British antiquaries and collectors of Egyptian artefacts at the end of the nineteenth and the start of the twentieth century – to whom it originally belonged). The purpose of these male sculptures is hard to ascertain. For the reasons already mentioned, it is unlikely that they represented deities, and so they were probably the earliest funerary statuettes of private individuals and predecessors of the sculptures so typical of later Egyptian tombs.

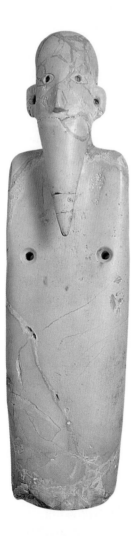
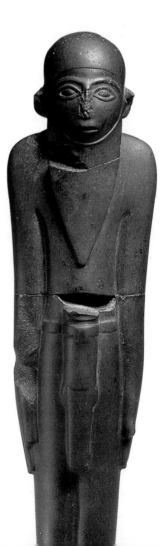

Egyptian texts tell us that one of the modes of everybody's existence, the immaterial *ka* (translatable as 'spirit', although not in the usual Christian sense) required the person's body on which to focus, not only during their lifetime but also in the afterlife (the 'spirit' was, in fact, the personality itself and the body was its visual form). The need to meet this requirement after death was probably at the root of two different aspects of tomb practices, one mortuary (attempts at primitive mummification), the other artistic (the introduction of tomb statues). Every effort was made to protect the body of the deceased person from destruction, but the statue was intended as a replacement for the body of the deceased should this perish. It is usually thought that the 'statue for the body' solution came about only when Egyptian graves became tombs, the bodies began to be placed in coffins, and the contact with the natural mummifying (dehydrating) agent – the hot, dry desert sand – was lost and the preservation of the body imperilled. But if rudimentary tomb sculptures existed as early as 4000 BC, some of the typically pharaonic ideas about life after death must have appeared much earlier than is generally thought, suggesting a continuity, in purpose if not in form, between Predynastic and pharaonic tomb sculptures.

Funerary ideas provided stimuli for the creation of tomb statuettes and sustained the production of specialized grave goods, especially pottery. They also led to the appearance of the earliest tomb paintings and encouraged new architectural ideas. The Painted Tomb at Hierakonpolis (25), in southern Upper Egypt, probably belonged to a local ruler who died around 3100 BC. The burial chamber was sunk into the surface of the desert and lined with mud brick, and its walls were mud plastered and covered with whitewash and yellow ochre. They were decorated with scenes painted in white, black, reddish brown, yellow and green, showing large boats in the Nile landscape with people and animals. The subjects can be compared to those found on pottery and in some rock drawings. As on Nagada pottery, early suggestions can be discerned of later representational conventions (arrangement in registers) and iconography (a man subduing two animals and another slaying captives).

23
Bearded man from Gebelein, c.3500 BC. Breccia; h.50cm, 19⅝in. Musée d'Histoire Naturelle, Lyon

24
Bearded man ('MacGregor Man'), from Nagada, c.3200 BC. Basalt; h.39cm, 15⅜in. Ashmolean Museum, Oxford

Some of these features are also present on the highly decorative handles of flint knives known from the late Predynastic Period (26). These objects must have belonged to people of exceptional standing in society. The knife handles were made of ivory and their decoration includes rows of animals and birds, boats and battle scenes, and also themes which were probably foreign iconographic imports from what are now Iraq and Iran. These include intertwined snakes, the 'master of the beasts' motif and representations of men wearing distinctly non-Egyptian garments.

It is on these decorated knife handles that the earliest clear examples occur of the technique known as raised relief (more precisely low relief or bas-relief), in which the sculptor removes the material around the representations, leaving the scenes standing out above the surrounding plane. Strictly speaking, relief is three-dimensional, but its characteristics are broadly the same as those of two-dimensional representations, such as paintings. The occurrence of motifs adopted from outside Egypt has prompted suggestions that even relief carving was an import. This cannot be determined

25
Scene with boats,
Painted
Tomb at
Hierakonpolis,
c.3100 BC.
Painting
on plaster;
c.110 × 498 cm,
43⅜ × 196 in.
Reconstruction

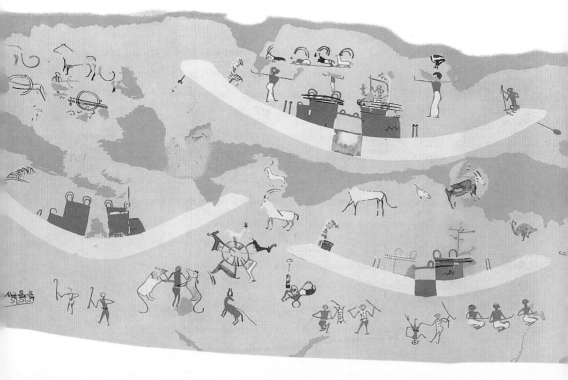

with certainty; if this was indeed the case, the seeds brought from abroad found well-prepared ground in Predynastic Egypt.

During the Predynastic Period primitive places of worship of various deities sprang up at most population centres. Small statuettes of animals made of ivory, baked clay, stone or faience come from these shrines, but the exact form of worship which took place there and the religious ideas associated with them are not known. Small animal figures (*eg* hippopotami) made of hard flint seem to be similar in form to combs and cosmetic palettes. They also depict animals as nearly two-dimensional silhouettes, figures not completely rounded out. These 'silhouette sculptures' were not primarily functional; it is more likely that they were produced in order to show off the skills acquired in the making of stone implements. Comparable statuettes made of other kinds of stone, such as schist, are also known. These sculptures probably date from the end of the Predynastic Period, after about 3100 BC.

Already during the Predynastic Period, some of these shrines evolved into temples of local gods and probably contained large

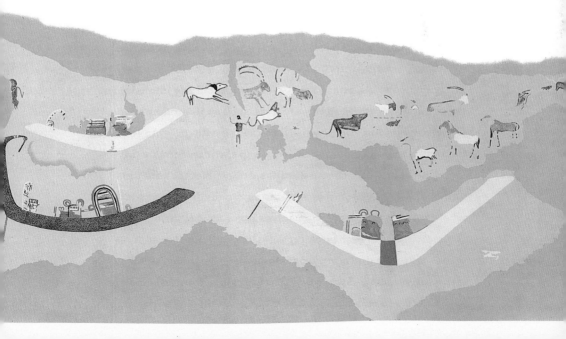

sculptures of anthropomorphic deities. Excavations at Hierakonpolis have shown that these temples were built mostly of wood and mud-covered rushes. At Koptos in Upper Egypt, three colossal (originally about 3 m or 10 ft high), but unfortunately incomplete, late Predynastic standing statues were found (27). They represent the ithyphallic god Min who originally grasped a detachable erect penis in his left hand. Their bodies depart only very little from the columnar shape of the initial block of stone, a principle which applied to Predynastic statuettes and is also well known from pharaonic sculptures. The ideas behind the creation of such statues were not entirely dissimilar, though not identical, to those which stimulated the making of tomb statues: they served as manifestations of the deities and so made communication with them possible.

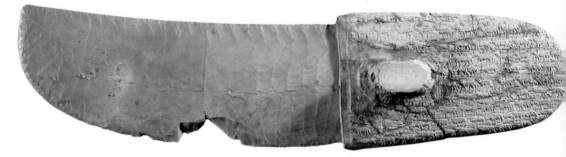

The process of uniting Neolithic farming settlements into larger and more powerful units gathered pace during the late phase of the Predynastic Period, after 3500 BC. It was particularly intensive in the population centres of Upper Egypt, such as Hierakonpolis, Gebelein, Nagada and Abydos. It coincided with growing social inequality and the emergence of a group of conspicuously privi-leged members of local communities, either chiefs or shamans (although it is questionable whether such a distinction existed), who were able to procure themselves luxury goods through commerce or by commissioning them locally. Access to sources of raw materials and control over long-distance trade routes (especially from the Syro-Palestinian region in the northeast and from Nubia and sub-tropical Africa in the south) played a part in

26
Knife from
Abu Zeidan,
Nagada II,
c.3200 BC.
Flint and
ivory;
l.23·2cm, 9⅛in.
Brooklyn
Museum of
Art, New York

27
Colossal
statue of the
god Min from
Koptos,
c.3150 BC.
Limestone;
h.177cm,
69⅝in.
Ashmolean
Museum,
Oxford

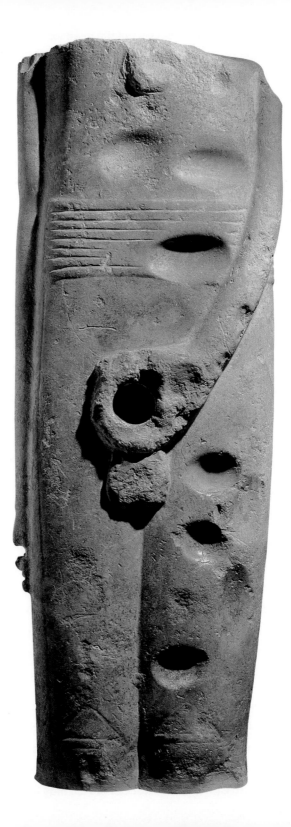

this development (though not the need for a central authority in order to organize artificial irrigation; this was practically non-existent). The power ambitions of the local chiefs were, it seems, of paramount importance. River-borne communication between villages strewn along the banks of the Nile was so easy that the position of the local rulers had to be made secure from outside interference by gaining control over the neighbouring areas.

The increasing social stratification of the late Predynastic Period was reflected in burials conspicuously larger in size and richer in funerary goods. At first, this may have been no more than an expression of different material circumstances – a local chief would have been able to assemble a more impressive collection of grave goods and been accorded a more lavish burial than an ordinary member of his community. The beliefs underlying the need to be buried with funerary goods and in a clearly marked grave need not have differed from the highest to the lowest in society.

The first large region to come under the control of a single ruler was Upper Egypt. Some of the tombs at Abydos certainly belonged to these late Predynastic kings, sometimes collectively described as Dynasty 0 (c.3100–2972 BC). Their conspicuous burials reflected the pre-eminent social status of these rulers, which must now have begun to be mirrored in the beliefs surrounding such a privileged position. The territorial ambitions of these Upper Egyptian kings were ultimately fulfilled when they incorporated chiefdoms of northern Egypt into their realm. The geographical distribution of objects found throughout Egypt which can be linked to a particular ruler, as well as contemporary royal iconography, suggest that this was fully accomplished by King Narmer (3000–2972 BC), but it is possible that some of his predecessors may already have claimed control over the whole of Egypt.

It was during Narmer's reign, or that of his successor King Aha (2972–2939 BC), that a new royal residence and administrative centre of Egypt, later known as Memphis, was established at the vertex of the Nile Delta, on the west bank of the Nile (southwest of modern Cairo). Either Narmer or Aha may have been the

legendary Meni, the first Egyptian ruler listed in later king-lists. Written records now started to be kept for administrative and religious purposes, and this ushered in the historic, or dynastic (pharaonic), period. The first 325 years (2972–2647 BC) correspond to the first two royal dynasties identified by Manetho (see Chapter 1) and are called the Early Dynastic Period by Egyptologists.

These political changes may have been fundamental, but they had little effect on farming techniques or the organization of Egyptian agriculture. The lives of ordinary peasants and their religious beliefs and superstitions remained largely unchanged. While the early administration of the country was simple and focused on the person of the king, his immediate family and the royal residence, the new super-privileged ruling social group had incomparably greater power and wealth. Combined with their need to maintain their status, this now created conditions for the production of works of art the like of which Egypt had not known before. This was court art and patronage at its most extreme, and the dependence of the artist on his patron was absolute. The arts of ancient Egypt from this period onwards became the main vehicle for expressing the ideology on which the Egyptian kingdom was based, especially the definition of the role of the king in Egyptian society and his relationship to the gods and to ordinary Egyptians. The complex and varied religious beliefs of the élite and their ideas concerning life after death were also of paramount importance.

The rapidity with which the final formation of a unified Egypt took place meant that the arts that mirrored this process also developed very quickly as new opportunities were eagerly seized and exploited. The artistic legacy of the Predynastic Period was an essential precondition for this astonishing progress. The speed with which Egyptian art codified its basic parameters, such as the method of representing the human body and the canonical proportions, which were from then on regarded as incapable of further improvement, was remarkable. The contrast between the speed of artistic development in the early pharaonic period and the resistance to change during the following three thousand years could

not be greater. While gradual changes continued to take place, the world order which had been established by the gods and entrusted to the king for safe keeping was, by definition, perfect. Moreover, the arts were thought to have been handed down by the gods – an important reason why Egyptian artists continued to uphold the old divine prototypes and only rarely searched for completely new solutions.

At the beginning of the dynastic period, it seems that few of the shrines of local deities benefited from royal patronage. Egyptian religion was now clearly stratified, with the beliefs of the mass of the population and those of the ruling élite going in different directions. Nevertheless, figurines of animals and now even people, in stone, faience, wood or ivory (28, 29), continued to be deposited in local shrines. Paradoxically, it is these figurines which provide clues concerning Egyptian sculpture at the beginning of the pharaonic period. Larger animal statues also existed but were relatively rare.

Some temples of local deities did enjoy royal patronage at this time, and these required images of gods to serve as their manifestations, and of the king to ensure his permanent presence at their side. Of the statues that must have been made to satisfy this demand, none has survived, leaving a large gap in the artistic record. However, the making of such statues is recorded in the fragmentary annals (yearly records) known as the Palermo Stone, after the present-day location of the largest of the fragments. One of the Egyptian words for the making of a statue was the same as for giving birth, so that statues were 'born'. They were made of various materials, including copper, which was so valuable that it was eventually recycled; consequently very few examples have survived.

The rapidly increasing power of the pharaohs towards the end of the Predynastic Period and during the Early Dynastic Period had a dramatic effect on sanctuaries directly linked to the royal cult, such as the temple of Horus at Hierakonpolis (whose living image the king was thought to be) and the temple of the jackal god Khentiamentiu who presided over the royal necropolis at Abydos.

28–29
Female figure from Hierakonpolis, c.3000 BC. Ivory; h.20cm, 7⅞in. Petrie Museum of Egyptian Archaeology, University College London

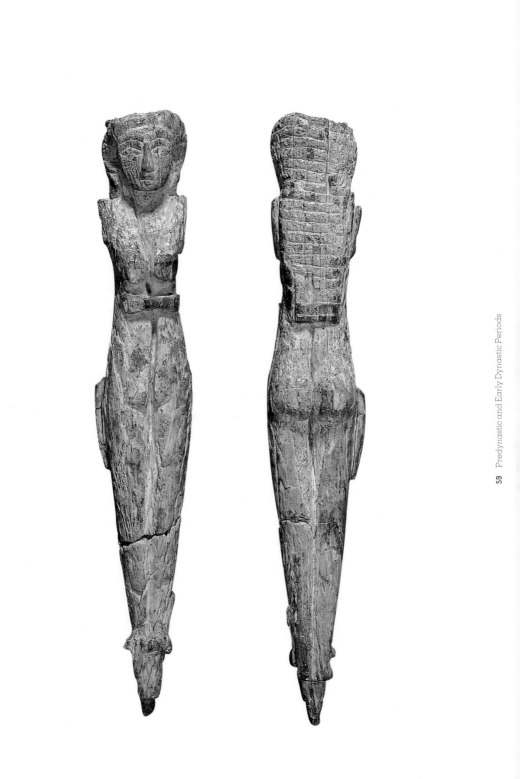

Little is known about the architecture of Early Dynastic temples. They were, no doubt, built of sun-dried mud bricks, with the use of stone confined to their most vulnerable elements, especially door-ways and thresholds. The opportunities for relief decoration carved in stone, so characteristic of pharaonic Egypt, remained very limited throughout the Early Dynastic Period. It does not look as though modelling in clay was used, perhaps because of its limited durability. Relief decoration was quite possibly carved in wood, although no evidence of it has survived.

The developments that were to lead to the magnificent wall-reliefs of later temples were now well under way and continued via smaller objects connected with royal temples, such as palettes and maceheads. Palettes, which had been practical objects used for grinding eye paint, now became votive objects. It seems certain that eye or body paint was used during temple ceremonies, either by the officiant (probably the pharaoh himself) or, more likely, to adorn the temple's statues. It would have been quite appropriate for the pharaoh to present the temple with a highly decorative image of the palette normally employed for such a purpose. It was not used in the ordinary life of the temple, but the structure was there for eternity and such a votive object ensured that it was able to function for ever. At the same time, because the decoration associated the palette with a specific king, it ensured his personal connection with the temple's deity and his infinite ability to perform the temple ritual.

Almost all such votive palettes date to the end of the Predynastic Period. The Narmer Palette from the temple at Hierakonpolis may not be the earliest, but is the most important for the discussion of Egyptian art (30, 31). It is large (c.64 cm or 25¼ in. high) and is made of black schist. In the centre of one of its sides (recto) there is a circular depression, almost a shallow bowl, which indicates the object's original purpose. The name of the king is written as two hieroglyphs (one showing a catfish = *nar*, the other a chisel = *mer*) in a *serekh*, an imitation of the façade and ground plan of the royal palace, at the top of each side. The overall meaning of the images

on the palette is clear: the triumph of royal authority over its enemies. The main scene, on the palette's other side (verso), was to become the standard artistic expression of this concept: the king, brandishing a mace, is about to shatter the head of a kneeling foe whom he grasps by the hair. This takes place in front of the god Horus, shown as a hawk, who with a human hand holds a rope attached to a symbolic representation of a subjugated land. Other scenes on the palette are variations on this theme, with the king appearing as a bull in one of them. It would be tempting to see this as a historical record of events that took place during Narmer's reign and an expression of thanks for their successful outcome. Indeed, these palettes are sometimes described as commemorative, although their purpose was probably more general.

The main task of the Egyptian king was to safeguard the smooth functioning of the world and the continued existence of the established order, *maet*. For these he was responsible to the gods on the one hand and to the people on the other. He maintained the order of the world by force, by merciless suppression of any internal opposition in Egypt and by ruthless subjugation of external enemies. It was this concept which the Narmer Palette conveyed and which its presence in the temple of Horus ensured. The king was regarded as a manifestation of Horus, and his Horus-name, one of several, equated him with the god. The Narmer Palette demonstrates very clearly the main function of Egyptian official art, as a carrier of ideas.

While the Narmer Palette shows how early the ideas concerning the role of the Egyptian pharaoh were formulated, it is also one of the first examples of some of the representational conventions which were to characterize Egyptian two-dimensional art for the rest of its history. The scenes are executed in low relief which is fairly flat, with only some suggestions of additional internal modelling (in this respect, some of the other palettes display a much bolder relief and appear to be more advanced). They are arranged in registers, horizontal strips separated by lines which serve as baselines for the scene above. All figures are placed on

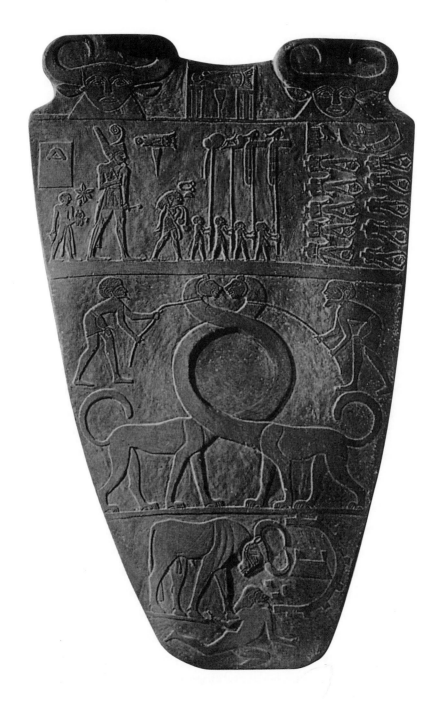

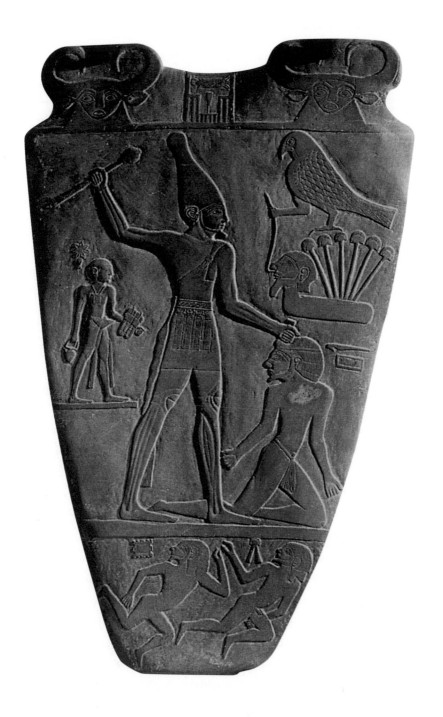

such a baseline; the only exceptions are prostrate bodies of slain men and, curiously, the two lion-tamers. Smaller scenes, for example the sandal-bearer behind the king in the main scene, can be shown in sub-registers with their own baselines.

The concept of perspective as known in Western art did not exist; representations precede or follow in a horizontally arranged sequence (ie are placed to the right or left of each other but on the same baseline). This way of expressing spatial relationships in two-dimensional art is called aspective. At the same time, some interplay and overlap between individual figures are allowed, so the legs of the hapless foe on the verso of the Narmer Palette are partly obscured by the king's feet and by each other. In this system, the relative sizes of human figures vary according to their importance or the requirements of composition. This directs the viewer's attention towards the main elements of the scene: in the procession on the recto of the palette the king is twice as large as the vizier and the sandal-bearer; the standard-bearers are smaller still.

In general in Egyptian art, the preferred direction in which the figures face is to the right, although symmetry and orientation often demanded the opposite and overruled it (this was especially common in architectural decoration). The same formula was prevalent in hieroglyphs and the preferred direction of Egyptian writing was, consequently, from right to left (thus beginning with the main element, the face of a human figure or the head of an animal). Human figures are shown in what was deemed to be the most characteristic views of their individual parts, a method which would be retained for the rest of Egyptian history: the face, arms and legs are seen in profile with the left foot advanced, but the eye and the shoulders are in front view. The mouth, navel and knees are exceptions and are represented as if in three-quarter view. All the important elements must be present and complete, ie unobscured. The image is a composite, but integrated, representation of various aspects of the figure which could not have been seen together at any one time, a view which is faithful and complete, yet not naturalistic. Such an approach also made it easier to depict

entirely artificial compositions. In order to achieve a convincing image of captivity, one of the talons of the hawk on the Narmer Palette was replaced by a human arm with a hand grasping the rope restraining the captive, the symbol of the subjugated land. In spite of the incongruity of the combination, the result is not disturbing and does not seem to be out of place.

Such an approach to the complexity of an image, with its emphasis on individual elements, characterized not only Egyptian visual arts, but also, in different ways, other aspects of Egyptian culture and thinking in general. For example, religious compositions known as hymns to deities can invariably be broken down into a series of constituent phrases, while in Egyptian mathematics, complex fractions were expressed as a series of fractions with one as the numerator (eg $^7_{12} = {}^1_3 + {}^1_4$). As will become clear, this complexity profoundly affected the design of both representational scenes and architecture. The representation of the royal palace behind the king on the recto of the Narmer Palette shows that similar rules also applied to inanimate objects. A straight view from above (ie plan) or front or side elevations were the only acceptable possibilities, but they were sometimes combined in one image which contained both.

The palette makes clear the emphasis placed on symmetrical design. The head of the goddess Hathor in the guise of a woman with a cow's horns is repeated at the top of each side of the palette, and symmetry can also be seen in the figures of lion-tamers restraining the two lionesses whose long necks form the rim of the small bowl on the palette's recto. A similar symmetrical approach is obvious when one considers the two sides of the palette together: Narmer wears a conical white crown on the verso and a red crown (more squat) on the recto. At the same time, the reluctance to repeat the same subject unchanged can be discerned in the differences in the details of the two men restraining the lionesses.

The scenes are complemented by rudimentary hieroglyphic inscriptions which convey the name of the king and the titles of the anonymous vizier (highest official of royal administration) and the

royal sandal-bearer. They also record the name or ethnicity of the foreigner being slain by the king, identify the rectangle behind the king on the recto as the royal palace, indicate 6,000 as the number of prisoners held captive by the god Horus, and provide some unclear information concerning the royal barque. These are among the earliest known hieroglyphic inscriptions and such labelling remained the chief use of the hieroglyphic script throughout the Early Dynastic Period and the early Old Kingdom. It was not until some 450 years later, around 2500 BC, that longer texts and proper narratives appeared.

Another votive palette, also from Hierakonpolis, is the Two Dogs Palette (32, 33), named after the two animals whose bodies frame its upper part. It contains no prominent human figures and no evident connection with any particular ruler, although such a link may once have been obvious from the object's context. The artistic conventions of Egyptian art which can be so instructively demonstrated on the Narmer Palette are less clear. The mêlée of animals on both sides of the Two Dogs Palette may seem unusual but is nevertheless very Egyptian in character – the difference between the real and the fictitious (*eg* the winged griffin and the bizarre flute-playing jackal on the verso) is a purely modern distinction. On the verso of the palette, the wild animals of the desert (oryx, various gazelles, giraffe, wild bull) are attacked by two symmetrically placed lions (almost certainly references to the king – such symbolism is known from all periods of Egyptian history) and a leopard. However, the beasts are not arranged in registers. It has been suggested that because of this the Two Dogs Palette must predate the introduction of registers in Egyptian representations. But this is a very simplistic assumption, and the artist responsible for the design may well have been more sophisticated than this explanation implies.

The apparently haphazard distribution of the animals on the palette vividly conveys the feeling of disorder and anarchy. This contrasts forcibly with the frozen-in-time, static scenes on the Narmer Palette. It has already been explained that one of

32–33
Two Dogs Palette from Hierakonpolis, c.3000 BC. Schist; h.43cm, 17in. Ashmolean Museum, Oxford
Left
Recto
Right
Verso

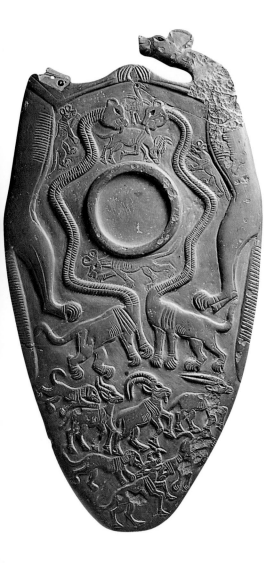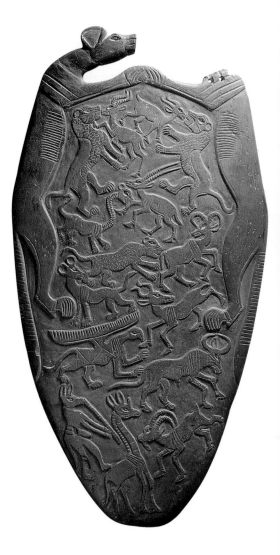

the duties of the Egyptian king was to maintain order among human beings inside as well as outside Egypt, but he was also held responsible for stability in nature, which was constantly threatened by the forces of chaos, represented by the wild and untamed animal world. On the Two Dogs Palette the king, alluded to by the lions, is shown subduing the forces of nature. The object complements the Narmer Palette and was probably made at the same time.

A number of palettes or their fragments have been found at Abydos, the site of the late Predynastic and Early Dynastic royal cemetery, where they had probably been presented to the temple of the god Khentiamentiu. One of them, the so-called Battlefield Palette (34), is, despite its fragmentary state, the most expressive palette of all in its portrayal of a lion attacking a man whose body is lying on the ground twisted in its death throes, while vultures feast on corpses below.

Another group of Early Dynastic objects on which the early stages of ancient Egyptian relief carving technique can be observed comprises large votive maceheads – originally maces that have now lost their hafts made of wood or precious metal. Many examples of these weapons have been found in excavations of Predynastic cemeteries. The mace was the main striking weapon of Predynastic Egypt and the scene on the Narmer Palette shows its deadly effectiveness. We cannot rule out the possibility that such maces were used violently during certain temple rituals, especially those linked to the king and his reign, but it is extremely unlikely that human sacrifices took place in historic times. When the symbolism of the standard scene in which the pharaoh strikes down a foe with a mace became established, the weapon itself became a fitting gift from the pharaoh to a temple, especially if it witnessed ceremonies associated with kingship. For an artist, a macehead provided a surface on which to express kingship ideas in scenes carved in low relief. We can only specu-late whether the subject of this relief was also painted; it seems likely that it was.

Several votive maceheads, variously complete, were found at Hierakonpolis. They date to the end of the Predynastic Period. One fragment (35), measuring some 25 cm (10 in.), carries a scene in which a king is shown with a wooden hoe, perhaps taking part in a foundation ceremony marking the limits of a planned shrine. The king's name may be recorded by two signs written next to his face, a rosette motif and a scorpion, and the owner is usually identified as King Scorpion, regarded as a close, probably immediate, predecessor of Narmer. It is, however, more likely that the scorpion figure should not be interpreted as a hieroglyphic sign and so the owner of the macehead was probably also Narmer. The Scorpion Macehead shows many features which we can see on the Narmer Palette, such as registers and sub-registers, the conventions for the portrayal of the human body, and the disregard for realistic relative sizes of representations. As a small fragment of another rosette suggests, there was a symmetrically arranged scene on the now-lost half of the object.

Arts connected with ideas about life after death also benefited from the emergence of a central authority represented by the king. Differences in the quality of funerary equipment were apparent in the Predynastic Period, but the much sharper distinction in status and wealth between the members of the royal family, who monopolized the country's administration, and the rest of the population now accentuated them even more. The lack of more precise knowledge of early funerary beliefs is severely limiting; it is only when funerary inscriptions become more common and explicit after 2500 BC that such beliefs can be followed in some detail. For the earlier period it is necessary to extrapolate contemporary religious thinking from its material manifestations or from its reflection in works of art. All the same, there can be little doubt that the ideas concerning life after death held by the Egyptians of the historic period developed from those of the Predynastic Period.

It seems that the early rulers of Upper Egypt resided originally in the neighbourhood of Abydos. Large tombs for the élite, including early kings and members of their family, had already been built

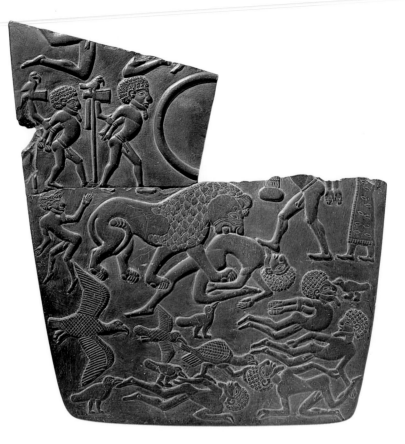

34
Battlefield
Palette from
Abydos,
c.3000 BC.
Schist;
h.32·8cm,
12⅞in.
British
Museum,
London
(lower part)
and
Ashmolean
Museum,
Oxford
(upper part)

there well before the end of the Predynastic Period. The royal resi-
dence was moved to Hierakonpolis at the end of the Predynastic
Period and to Memphis at the beginning of the First Dynasty, but
the kings continued to be buried at Abydos. During the First
Dynasty such large tombs also appeared at Saqqara (the cemetery
of Memphis) and several other sites. These were made for the local
administrators; there are no grounds for regarding any of them as
royal tombs or cenotaphs. Saqqara took over as the royal necropo-
lis from Abydos at the beginning of the Second Dynasty, although
the last two kings of the dynasty were still buried at Abydos.

These large tombs were quite distinct from the graves of the rest
of the population. They are known as mastabas, from the Arabic
word for the mud-brick benches outside houses in modern
Egyptian villages which they resemble. For the first time in

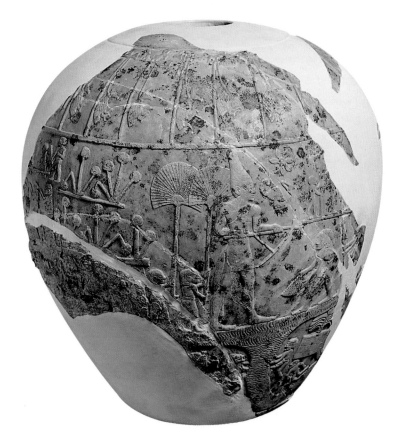

Egyptian history it is possible to talk about funerary architecture.
It is, however, worth noting that throughout the First Dynasty the
royal tombs at Abydos were not markedly different in size from
those of the pharaoh's relatives, and that their superstructures (the
part showing above ground) are mostly destroyed, a feature which
has caused a good deal of confusion in the minds of historians and
archaeologists (the situation, however, changes if ancillary struc-
tures, built at some distance from the tombs proper, are also taken
into account). For example, the superstructure of the Saqqara
tomb made for Hemaka, a local administrator under King Dewen
(2879–2832 BC), measured 37.9 × 15.9 m (124 × 53 ft), and was over
5 m (16 ft) high. Such tombs were rectangular in plan, with the
longer sides facing east and west and having a clear batter
(slope). They were built of mud brick and only occasionally were
some of their elements, such as floors, made of limestone or granite.

At first, the burial chamber was dug into the rocky surface of the desert and was surrounded by storerooms containing funerary goods, but later these were incorporated into the superstructure above ground. The burial chamber was protected by a separate mound which was then covered by the mastaba itself. The maze of the rock-cut underground rooms in the tombs of the Second Dynasty kings Raneb (2765–2750 BC) and Ninutjer (2750–2707 BC) at Saqqara is an important pointer to the growing ability to work in stone on a large scale.

There is some support for the idea that in their external appearance these early mastabas resembled the royal palace and that the tomb was intended to be the dwelling of the *ka* (spirit) of the deceased. The exterior of mastabas of the First Dynasty (36) displayed a series of niches of a complex pattern which is known as 'palace façade' because, it seems, it imitated the recessed enclosure wall of the royal palace (as in the *serekh* used for writing the pharaoh's Horus-name). Similarly niched frontages existed in Mesopotamia, from where the Egyptian 'palace façade' may derive. The outside walls of the mastabas were coated with gypsum plaster and painted, probably mostly white but with geometric designs in black, red, yellow, blue and green inside the niches. These may have copied the patterns of mats hung on the walls of Egyptian dwellings and give us some idea of the taste and ornament of domestic life (similar interiors are also known from the scenes of family life represented in later tomb reliefs). The almost complete absence of stone surfaces offered no scope for relief carving.

36
The mastaba of Queen Merytneit at Saqqara, c.2870 BC. Mud brick and other materials

Royal tombs contained a pair of stelae in the form of stone round-topped slabs, with the name of the king in the *serekh* carved in low relief (37). The *serekh* probably represented the royal palace in a composite view: the lower part showed the recessed external façade, the upper part was the structure seen from above. The Horus-hawk was often perched on top of the *serekh* while the name was written inside – the king was at home in his palace. These stelae were the focus of the funerary cult, consisting mainly of a

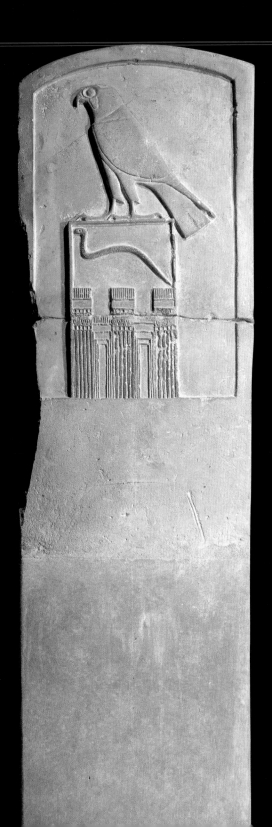

ceremonial renewal of offerings of food, drink and other necessities which the *ka* of the deceased person was thought to require in the afterlife. The stelae identified the recipient of the funerary offerings in a clear and unequivocal way. The design of these stelae is simple and avoids any figures except for the Horus-hawk perched on top of the *serekh*, but they display an astonishingly accomplished standard of iconography and relief carving only one or two generations after the small-scale reliefs on the palettes and maceheads of King Narmer.

The royal tombs at Abydos were provided with structures that may have imitated royal palaces, and small brick-built models of estates were found near tombs at Saqqara. These must have been intended to provide for the material needs in the king's (or the official's) afterlife. Several hundred years later, this function was taken over by reliefs in the temples attached to pyramids or in the chapels of tombs. Some of the royal mastabas were surrounded by burials of retainers, priests, dwarfs and even dogs, who may have been killed so that they could accompany their master. These burials are marked by crudely carved stelae, which look like a travesty of the accomplished royal stelae. The difference in artistic and technical quality between them could not be greater. It suggests that the number of artists responsible for the first-rate works of the Early Dynastic period was probably very small and that only very few members of Egyptian society were able to benefit from their work. A Saqqara mastaba of an official of the First Dynasty King Qaa (2818–2793 BC) had special architectural arrangements for the maintenance of the funerary cult constructed against its north side. This is the earliest recorded funerary cult chapel and its position was, no doubt, dictated by religious beliefs in which astronomical orientation towards the north played an important part.

The funerary cult chapel of this official also contained the remains of two badly decayed large wooden statues. These are among the earliest tomb statues of the pharaonic period, predated only by even less well preserved wooden statues, possibly female, from the tomb of the First Dynasty King Djer (2939–2892 BC) at Abydos.

37
Stela of Wadji
from his tomb
at Abydos,
c.2879 BC.
Limestone;
h. of whole
stela
143 cm, 56⅜ in.
w. 65 cm, 25½ in.
Musée du
Louvre, Paris

They showed the owner standing with his left foot advanced, the usual pose for male statues of the pharaonic period. This harks back to the aspective concept of two-dimensional representations with which three-dimensional statues were closely linked. There, such a position of the feet is essential if both are placed fairly close on the same baseline, with neither fully obscured and the toes – the most important element of the foot – visible, while the figure faces to the right. The sculptor would have started with a preliminary sketch, a procedure that automatically ensured the close link between statues and drawings. Because of this, even in three-dimensional sculpture the characteristic features of Egyptian statues were probably well established early in the First Dynasty.

The differences between predynastic statues and pharaonic sculptures were profound – much more so than in the field of two-dimensional representations. While the development of pharaonic reliefs can be traced from predynastic times without any significant interruptions, the same cannot be said about statues. The rules concerning two-dimensional representations (reliefs and paintings), which were established around the beginning of the pharaonic period, had a profound influence on three-dimensional sculptures. By bringing the two categories closer, they changed the formal language of three-dimensional art beyond recognition.

38
Statue of
Khasekhem
from
Hierakonpolis,
c.2650 BC.
Limestone;
h.62cm, 24½in.
Ashmolean
Museum,
Oxford

Although statues representing kings were made both for temples and for royal tombs during the Early Dynastic Period, and probably already towards the end of the Predynastic Period, such early works have not survived. The earliest royal statues found in a controlled excavation represent the Second Dynasty King Khasekhem (2674–2647 BC; 38) and are thus some 350 years later. Khasekhem's statues come from the temple of Horus at Hierakonpolis, which, as has been seen, was particularly closely linked to the royal cult. The king is shown seated wrapped in a cloak worn during the jubilee festival (*heb-sed*, the 'festival of the tail', after an element of the king's ceremonial dress), and there are representations of the contorted bodies of slain foes incised on

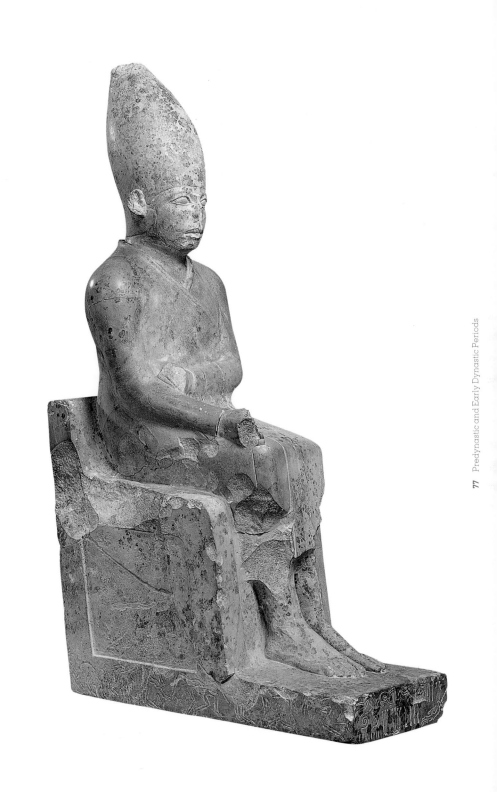

the base of the statue. The jubilee ceremonies represented the renewal of the king's physical powers and his authority to rule over Egypt after his first thirty years on the throne. It was as if the king once again underwent the coronation ceremony. The statue showing him wearing a jubilee festival garment would have ensured that the king was able to repeat this ceremony at regular intervals forever. This was the main reason for the statue's creation: to express an idea in stone and so to secure its permanent validity.

The remains of the funerary equipment with which the storerooms of the mastabas once overflowed show that the impression of austerity which might be suggested by the lack of tomb decoration would be very much mistaken. It is almost certain that, while many of the items found in tombs were specially manufactured for funerary purposes, they would have reflected conditions in the royal palace and the houses of Egyptian nobility. It was the different range of opportunities rather than a lack of ability which separated the Early Dynastic artists from their successors. The standard of craftsmanship evident in the fragments of furniture, jewellery, stone vessels and various small items is quite extraordinary and paints the picture of a leisurely life, sophisticated luxury and a taste for beautiful things enjoyed by the ruling group in Egyptian society. The wooden furniture was carved with intricate decoration (eg in imitation of reed matting) and incorporated elements of other materials, especially faience and ivory. Unlike much of the wood, these have often survived and include human figures (among them dwarfs who were employed as house servants, and figures of foreign captives) and carved animals echoing the small sculptures of the Predynastic Period.

39
Bracelet from the tomb of Djer at Abydos, c.2892 BC. Gold and turquoise; 1.15-6 cm, 6⅛ in. Egyptian Museum, Cairo

Gold, faience and various semiprecious stones were employed in the manufacture of finger-rings, bracelets, collars and necklaces. Some of those found in royal tombs were probably made specially for the burial and incorporate motifs associated with divinity and royalty, for example a bracelet of King Djer formed of alternating turquoise and gold plaques in the shape of a *serekh*

with a Horus-hawk perched on top of it (39). In practice, it is often difficult to distinguish between items which were used in the deceased's lifetime and those manufactured as funerary goods.

Vessels made of a variety of hard stones (eg granite, greywacke, basalt, alabaster, porphyry, etc.) had been known in the Predynastic Period, but now they reached the peak of their variety and accomplishment; their makers achieved complete mastery of material and form. Plain forms were supplemented by others imitating basketry (40) and using various remarkably imaginative and apparently experimental designs, some never to be tried again. These vessels were merely containers for precious oils, unguents and so on, and it was the contents that had religious significance not the containers. Consequently, a degree of experimentation with the shape of the vessel was possible.

Gaming pieces, usually in the form of recumbent lions, were used in a popular board game. Circular *mehen* (snake-game) boards are known, including an example made of alabaster with obsidian and jasper inlays. These were forms of entertainment, but such games were also associated with ideas concerning the afterlife. The mastaba of Hemaka, a high official of King Dewen, at Saqqara, contained a series of round plaques which were used for a similar purpose (41). They were made of such materials as stone, horn, ivory, wood and copper, and several are decorated with inlaid figures of animals and birds. Small wooden or ivory labels were attached to some items of funerary equipment for identification or, in the case of food and beverages, for dating purposes. They were rather crudely incised with scenes that show the king slaying a captive, harpooning a hippopotamus or spearing fish. At least some of these are depictions of ceremonies which took place during religious festivals. Such subjects were to appear later in the relief decoration of pyramid temples.

After 2800 BC, during the Second Dynasty, the ownership of mastabas extended to a wider circle of privileged persons, some of them relatively minor officials and priests. They were smaller in comparison with First Dynasty mastabas, but it was here that a major advance in the use of relief decoration in private tombs was made. A stone rectangular stela (42) was set up in a niche near the south end of the otherwise plain eastern exterior face in front of which the ceremonies of the funerary cult took place. Unlike stelae in royal tombs, these were not freestanding but a stone element of the brick-built mastaba. The stela showed the tomb-owner seated at a table surrounded by various items of food and drink, or at least by their names (and since Egyptian hieroglyphic

script recording them often contained images of such offerings the effect was the same), as well as other requirements such as linen. This ensured the continued existence of this desirable state of affairs but did not stop such commodities being brought to the tomb as offerings for the *ka* of the deceased person.

The representations on these Second Dynasty tomb stelae were carved in low relief, which was then painted. They are still fairly crude and technically rather simple, and the composition of the scene lacks sophistication, although nearly all the colours used in later pharaonic reliefs are already present: black, white, red, yellow, blue and green. It was here, however, that the relief was at last

40
Vessel
imitating
basketry
from north
Saqqara,
c.2800 BC.
Schist;
1.22·7 cm, 9 in.
Egyptian
Museum,
Cairo

41
Hemaka's
gaming disc
showing
hounds
hunting
gazelle,
from his tomb
at Saqqara,
c.2850 BC.
Steatite and
alabaster;
diam. 8·7cm,
3½in.
Egyptian
Museum,
Cairo

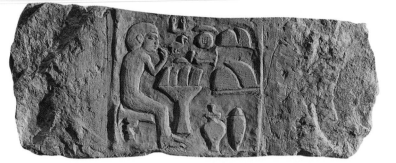

42
Stela of the
woman Sitka
from her tomb,
c.2700 BC.
Limestone;
h.14·5cm, 5¾in.
Staatliche
Sammlung
Ägyptischer
Kunst, Munich

given an opportunity which was eventually to result in the magnif-
icent painted relief decoration of private tombs of later periods.

During the Predynastic Period, Egyptian arts were slowly realiz-
ing their potential, as if their makers were wondering which
possibilities were going to open up for them and in which direc-
tion they should proceed. By the end of the Early Dynastic Period
most of the basic conventions in two- as well as three-dimensional
representations had been established. Egyptian architecture was
ready for the huge leap forward to be made at the beginning of the
Old Kingdom. In the minor arts, there was an astonishingly large
variety of forms. The compass was set.

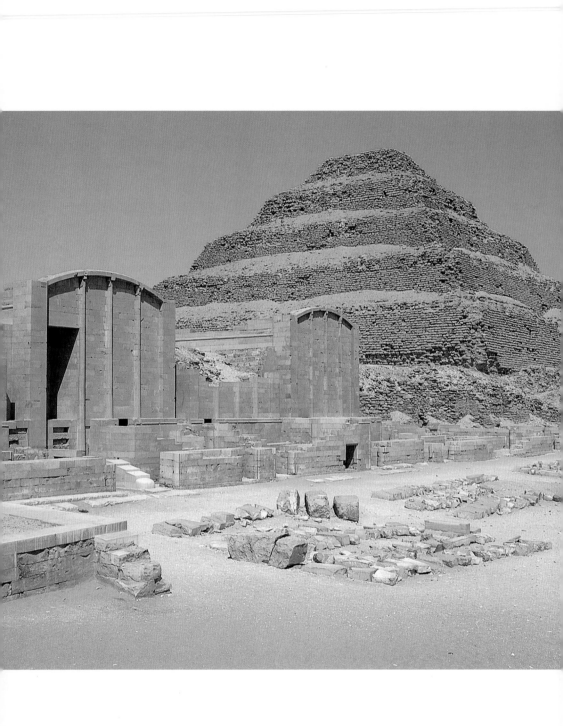

The Old Kingdom (2647–2124 BC) was the longest unbroken
period of sustained achievement of ancient Egyptian culture.
Its outstanding art and architecture were looked back on with
nostalgia in later times, and in the visual arts – as well as in liter-
ature, medicine and other fields – characteristics arrived at in
the Old Kingdom were retained or imitated. Egyptians were still
visiting the Step Pyramid of Djoser at Saqqara (43), one of the
most famous monuments of the Old Kingdom, a thousand years
after it was built. They were so impressed that they wrote in
their graffiti that it seemed 'as though heaven were within it',
as though 'the sun rose in it', and 'heaven rained myrrh and
dripped incense upon it'.

The achievements of the Old Kingdom can be attributed to a vari-
ety of factors. By about 2650 BC, pharaonic Egypt was 350 years old
and its main characteristics were well established. Agriculture
and crafts prospered, and the country's superiority over its less
advanced neighbours ensured its complete security from foreign
interference. Centralized government was in the hands of a
succession of inspired rulers who were able to direct the country's
resources towards some of the most remarkable achievements
of the ancient world. In this, they relied on able administrators
recruited from all levels of Egyptian society; a man of talent could
make his way upwards more easily at this time than at any other
period of Egyptian history. Concepts concerning kingship, religion
and the afterlife informed ambitious building projects and the
production of works of art. These, especially monumental archi-
tecture, in their turn profoundly influenced the Egyptian economy,
administration and society in general. Huge building projects
involved large labour forces. Some of these people were directly
involved in the construction, but many more provided the neces-
sary organizational and logistic support. They were seconded

43
Step Pyramid
and festival
chapels
of Djoser
at Saqqara,
c.2610 BC.
Limestone;
h. of pyramid
60m, 197ft

from agricultural production and this reduction of food-producing workers required new and more efficient ways of organizing the Egyptian economy and state administration, especially the collection of taxes and the management of royal estates. Funerary cult establishments, such as pyramid complexes, were assigned their own land and other economic resources as well as their own personnel, and the result of this was a substantial restructuring of Egyptian society.

The fame of being Egypt's (and the world's) first monumental builder in stone goes to King Djoser (2628–2609 BC) and his chief adviser Imhotep. Some two thousand years later, the latter's reputation as architect and physician resulted in his elevation to a semi-deified status. Imhotep was one of the few private individuals in ancient Egypt whose posthumous local prominence (comparable to Christian 'local saints') surpassed their immediate geographical and chronological limits and made them semi-deified figures revered throughout the whole of Egypt.

Djoser's was not the first attempt at monumental architecture, however. A large building project was begun late in the reign of a king identifiable either as Khasekhem (2674–2647 BC) of the Second Dynasty or Nebka (2647–2628 BC) of the Third. This is almost certainly the structure known as Qisr el-Mudir, to the west of the tombs of kings Raneb (2765–2750 BC) and Ninutjer (2750–2707 BC) at Saqqara. It seems that it was planned as a large stone mastaba, the first of its kind in Egypt, but the king's death did not allow the builders time to achieve more than an initial delineation of the area. At present, the site is little more than a windswept undulating plain largely covered with fine sand, and signs of building activities are more easily discernible on aerial photographs than on the ground.

Djoser's tomb, also at Saqqara, to the northeast of Qisr el-Mudir, likewise began as a stone mastaba of square plan, but the outcome of the six distinct stages of construction was a pyramid of six steps. The base of the Step Pyramid of Djoser measures 140 m (460 ft) east to west by 118 m (388 ft) north to south, and is 60 m (197 ft)

high. This unusual and strikingly beautiful monument benefits from its position on high ground which makes its modest height much more impressive (comparable, in effect, with the 92 m or 302 ft of the Statue of Liberty in New York, and the 111 m or 364 ft of St Paul's Cathedral in London). Such a stone structure was a major advance in Egyptian architecture, and no subsequent development could match the importance of this achievement. It is astonishing that only one generation separated the birth of the idea that a large structure could be built entirely of stone from its triumphant realization. From its earliest large-scale use, stone was regarded as the material in which to build for eternity and so was ideally suited for tombs and temples. In civil architecture, unbaked mud brick (baked bricks were not known) remained the main construction material for palaces, houses and administrative buildings.

The unusual shape of the stepped superstructure of the new royal tomb invites theories about its significance, but changes in the plan of the original mastaba leave little doubt that the development was driven primarily by practical rather than symbolic or aesthetic considerations. The desire to raise a building of considerable height which would dominate the area was probably foremost in the architect's mind. This forced him to choose a structure resembling at first four, then six, stone mastabas of diminishing size stacked on top of each other. The steep slope of the building's sides (74 degrees for the lowest step), the small size of the limestone building blocks and the limited experience of stonemasons would have made it difficult to create a building of this size employing a single mastaba design. Because of the function of the structure which, as a brick-built mastaba, had been tested by time, an even more radical departure in form was not an available option.

Djoser's pyramid contains no interior rooms or cavities above ground level. The pharaoh's body was deposited in a subterranean burial chamber below the pyramid. A temple for his funerary cult stands next to the pyramid's northern side, and so

maintains the tradition of the north–south orientation of the Early Dynastic mastabas. To the east of Djoser's Step Pyramid there are buildings that imitate in stone the form of shrines constructed in perishable materials (the designs of stone walls in front of the shrines, for example, imitate wooden stake fencing); to the south, there is a huge court open to the sky. These would have been at the dead king's disposal had he desired to renew his physical powers and his authority to rule by holding a royal jubilee festival in the afterlife. They are, therefore, replicas of the arrangements for such a festival in the king's lifetime, either in a temple suitable for that purpose or in the capital city. This provision was clearly thought to be of utmost importance because it is the second most conspicuous feature in the enclosure, after the pyramidal tomb itself. Both the Step Pyramid and the adjoining buildings are surrounded by a high stone wall of 'palace façade' appearance which forms a huge enclosure measuring 544 × 277 m (about 1800 × 900 ft). In the entrance corridor and on the façades of some of the jubilee festival buildings are the earliest stone columns known from Egypt. They

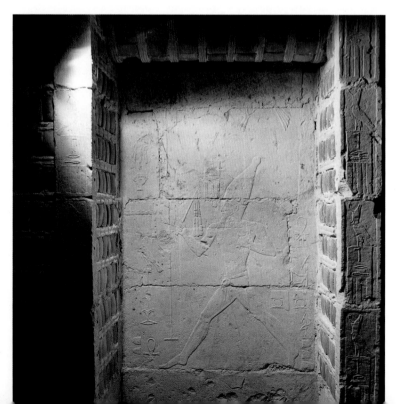

44
Relief showing
Djoser
performing
the jubilee
run, beneath
the South
Tomb in his
Step Pyramid
enclosure at
Saqqara,
c.2610 BC.
Limestone;
c.110×59cm,
43⅜×23in

are engaged (*ie* partly attached to the wall behind them) and not monolithic but made up of segments.

The form of the step pyramid corresponds to the earlier mastaba's burial chamber surmounted by its mound, and the enclosure wall is the equivalent of the mastaba's walls. The principal ideas concerning the royal tomb did not change substantially, therefore, but found a new formal interpretation in monumental stone architecture. From then on, however, the tomb of the king was quite different from those of other members of the royal family and his contemporaries. This separation was further strengthened by the absence of other, non-pyramidal élite tombs in the immediate vicinity of Djoser's Step Pyramid.

In the faience-tiled rooms below the Step Pyramid and the building in the southern part of the enclosure ('South Tomb'), there are scenes in which Djoser celebrates his jubilee festival and performs the jubilee run (44). We have already seen that concerns about the king's continued ability to celebrate his jubilee festival were the reasons behind the making of the earliest known royal statues set up at Hierakonpolis (see 38) at the end of the Early Dynastic Period. The jubilee run formed an essential part of the ceremonies and was perhaps originally required as a proof of the king's continued physical prowess and thus his ability to rule. Its main purpose was probably a symbolic demarcation of the territory over which the king reigned. The representations are situated close to the two extreme turns of the jubilee course marked by small crescent-shaped structures in the open court at ground level in front of the pyramid. The form and setting of these scenes are reminiscent of Early Dynastic tomb stelae. Djoser is shown in six episodes of the jubilee festival, either running towards or standing in front of shrines of deities erected for the occasion. The hawk representing the god Horus, with whom the king was identified, spreads his protective wings above the king, while a standard with the image of the jackal god Wepwawet ('Opener of the Ways') precedes him. The crescent-shaped markers can be seen beside the king's feet. In reality, there would have been priests and

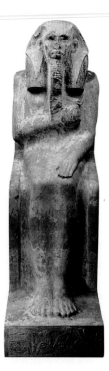

45
Seated statue
of Djoser from
his Step
Pyramid
enclosure at
Saqqara,
c.2610 BC.
Painted
limestone;
h.142cm,
55⅞in.
Egyptian
Museum,
Cairo

attendants involved, but the representation makes it quite clear
that the jubilee festival was performed solely for the king's benefit
and so all other human beings have been excluded. Even the
sunshade bearers behind the king are replaced here by hiero-
glyphic signs for 'life' and 'dominion', provided with human arms
and hands which hold large sunshades.

These reliefs not only depicted the event but their presence ensured
a successful outcome, should the king be required to perform it in
the afterlife. The scenes are in very low ⸱elief, with variations in the
depth of carving to suggest the modelling of the face, leg muscles
and other areas of the body. These are the earliest significant
reliefs found in a royal funerary monument; there are no compara-
ble scenes in Djoser's cult temple or any of the adjoining buildings.

The jubilee festivals that King Djoser hoped to celebrate in his
afterlife also provided the inspiration for the oldest surviving
large royal statue (45). Carved in limestone, it is slightly over
life-size and shows the seated king draped in the jubilee festival
cloak. Though the inlaid eyes have been gouged out, it is possible

to detect some resemblance in the statue's full face, fleshy nose and heavy lips to Djoser's image in the reliefs. Such a similarity in the appearance of the king's face in statues and reliefs exists in all good pharaonic works. The statue was placed in a statue room (called *serdab* by Egyptologists, from the Arabic word for cellar) close to the southern wall of the cult temple. There were other royal sculptures in the Step Pyramid enclosure, some larger than life-size, but all are badly damaged. In one Djoser was, apparently, accompanied by three female members of his family. Another showed him seated with his feet resting on nine bows and three lapwings, the standard Egyptian symbols for the subjugated external enemies and the Egyptian populace. (The Egyptian notion of plurality was expressed by threes and multiples of threes.) Stone statues of deities may also have been placed in the jubilee festival imitation shrines, but they have not been found.

During the next three quarters of a century several of Djoser's successors attempted to build a royal tomb in the form of a step pyramid. None of them, however, succeeded in completing such a structure. The next major change in the architecture of royal tombs occurred during the reign of King Snofru (2573–2549 BC), when the step pyramid was transformed into a true pyramid. The builders' initial inexperience can be seen in the way the design of the first of these pyramids had to be modified when faults appeared during construction and the slope of its sides was reduced. The result was the 'Rhomboidal' or 'Bent' pyramid at Dahshur (46).

46
The 'Bent Pyramid' of Snofru, Dahshur, c. 2560 BC

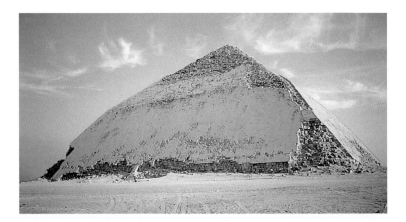

Snofru's second pyramid, the 'Red' pyramid (after the pinkish colour of its limestone blocks) at the same site, was the earliest true pyramid.

Yet again, various theories have been put forward to explain the change in form from stepped to smooth-sided pyramid, but none can be accepted unreservedly. The possibility that it was intended to resemble the summit of the obelisk of the sun god Re in the temple at Heliopolis (northeast of Memphis) cannot be discounted. The sun god's universal character, the proximity of his temple to the country's capital, and the fact that Re's influence was in ascendancy at this time, seem to support this theory, but it remains unproven. It may equally be that the superstructure of the pyramidal royal tomb arrived at its ultimate logical shape, tempered by practical considerations. From its very beginning, ancient Egyptian monumental architecture in stone was based on the geometry of straight lines, right angles and flat planes, and the true pyramid was the simplest practical solution available within this definition. The angle of incline of Snofru's 'Red' pyramid was exceptionally small, only 43 degrees, but as the

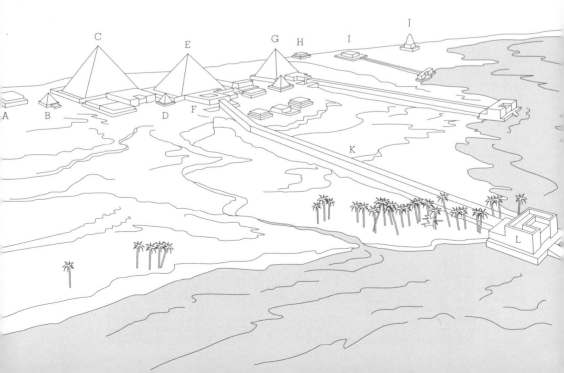

builders' confidence grew, that of the later structures varied between about 50 and 57 degrees. The exact procedures employed in the building of pyramids are still imperfectly known and details are disputed: there are no texts that describe pyramid building and hardly any working notes. But this is due to the character of such documentation, probably kept on papyri (used at least as early as the First Dynasty), and the long period of time that separates us from the age of the pyramid builders. The pyramids themselves have survived and occasionally we also have indications of the building techniques, such as remains of brick-built construction ramps used to bring building material to the pyramid. Some technical problems intrigue, for example how the builders ensured that the four sloping sides met exactly at the summit. But while it is possible to suggest various solutions to this and other problems, it is difficult to demonstrate which of them was actually used by the ancient builders.

The new pyramid was an austere geometric structure with no decoration or inscriptions on its smooth outer casing. The change to the true pyramid was accompanied by a complete reorientation of the associated buildings; the main axis now ran from east to west. The small size and limited decoration of the ancillary buildings connected with Snofru's pyramids show that they were the earliest of their kind; it refutes unscientific theories suggesting that the pyramid of Snofru's son Khufu (also known by his Hellenized name Kheops, 2549–2526 BC) arrived at its perfection outside the pyramids' sequential development. In spite of their simplicity, however, Snofru's structures unmistakably constitute what Egyptologists call a pyramid complex (47). When its basic elements were fully established under Snofru's successors, it consisted of the lower (valley) temple at the edge of the cultivated area in the east, a long ascending causeway leading to the upper temple against the east face of the pyramid on the desert plateau above, a miniature satellite pyramid near the pyramid's southeastern corner, small pyramidal tombs for the burials of queens, and boat-pits containing dismantled barques for the sky journeys which the king would undertake in the afterlife. The change from a

47
The pyramid complexes at Abusir, c.2425 BC. Reconstruction drawing. (A) Unfinished pyramid of Raneferef, (B) Pyramid of Queen Khentkaues, (C) Pyramid of Neferirkare, (D) Subsidiary pyramid, (E) Pyramid of Neuserre, (F) Pyramid temple, (G) Pyramid of Sahure, (H) Unfinished pyramid of Shepseskare, (I) Sun temple of Userkaf, (J) Sun temple of Neuserre at Abu Ghurab, (K) Causeway, (L) Valley temple

step pyramid enclosure to a pyramid complex hugely expanded the opportunities for the carving of wall-reliefs and was of immense artistic importance. Statues and reliefs were created in both the lower and the upper temples of pyramids, and reliefs were also carved on the walls of the roofed causeway.

Such a radical restructuring clearly resulted from a profound rethinking of the beliefs concerning the king's afterlife. It is almost certain that ancient astronomical ideas focusing on the circumpolar stars, which the king was believed to join at his death, were now overtaken, though not suppressed, by others. In these the god Osiris presided over the kingdom of the dead in the west, and the orientation of the pyramid complexes where the approach axis was westward reflected this. The Pyramid Texts, a corpus of religious spells inscribed in the interior of the pyramids from the reign of King Unas (also known as Wenis, 2341–2311 BC), show that the deceased king identified himself with Osiris; his close relationship to the sun god Re was also affirmed. He was described as the god's son, and the name Re became an almost obligatory element of royal names.

The architecture, reliefs and statues of the pyramid complexes served one common purpose: to maintain the king's posthumous royal status and so to safeguard his existence after death. The funerary cult mainly consisted of the presentation of food and drink offerings in the chapel in the western part of the upper temple. Only priests attached to the pyramid were allowed inside the complex (the pyramid itself was sealed and the tomb chamber inaccessible). Statues and reliefs in royal pyramid complexes were not intended for general admiration; their purpose was fulfilled by their mere existence. The same applied to inscriptions: they identified the monument as belonging to a specific king and expressed ideas which representations alone were unable to convey. It was not necessary for them to be read or recited aloud (and the same is almost certainly true of the Pyramid Texts).

In the entire complex of buildings, only the pyramid constituted a topographical marker, visible from afar as it rose above its

enclosure walls. This may have been a powerful motive in the striving for massive height. It was only from around 2350 BC that a 'standardized' pyramid (some 52·5 m or 172 ft high and with a base of 78·5 m or 258 ft square) became common. The reasons for this change was a shift in the religious background rather than economic considerations.

Architecturally, pyramid building climaxed early, in the pyramid of King Khufu at Giza (see 8), northwest of Memphis. This is the largest pyramid in Egypt, 146 m (479 ft) high on a ground-plan of 230 m (755 ft) square, and was considered one of the Seven Wonders of the Ancient World. Few man-made structures equal it in size: it would accommodate such other famous buildings as the Taj Mahal, St Peter's basilica in Rome, or St Paul's Cathedral in London without difficulty. It is estimated that some 2,300,000 stone blocks weighing on average 2·5 tons were used during its construction, although this depends on the unknown size of the knoll of natural rock which was probably incorporated into its design. The restricted space meant that the number of skilled workers employed in the pyramid construction was probably not very large, hardly exceeding 10,000 men, but these must have been greatly outnumbered by others who were involved in the quarrying and transport of building material and supporting activities. The astronomical and mathematical properties inherent in its design and the perfection of its construction have always intrigued casual observers, scholars, mystics and writers of popular books alike. The pyramid's astonishingly precise orientation on the cardinal points, the relationship between its various measurements, which involves the use of the mathematical value π, and the possible alignment of the small interior shafts that run from the two large chambers to the outside on certain stars, such as Alnitak, in the constellation of Orion, and Sirius, the brightest star in the sky, have prompted countless theories concerning its date, origin and purpose. These range from the pyramid being one of the granaries of Joseph, a huge astronomical clock, a record in stone of the past, present and future of mankind, or a state-organized project to keep the Egyptian labour force busy, to a monument

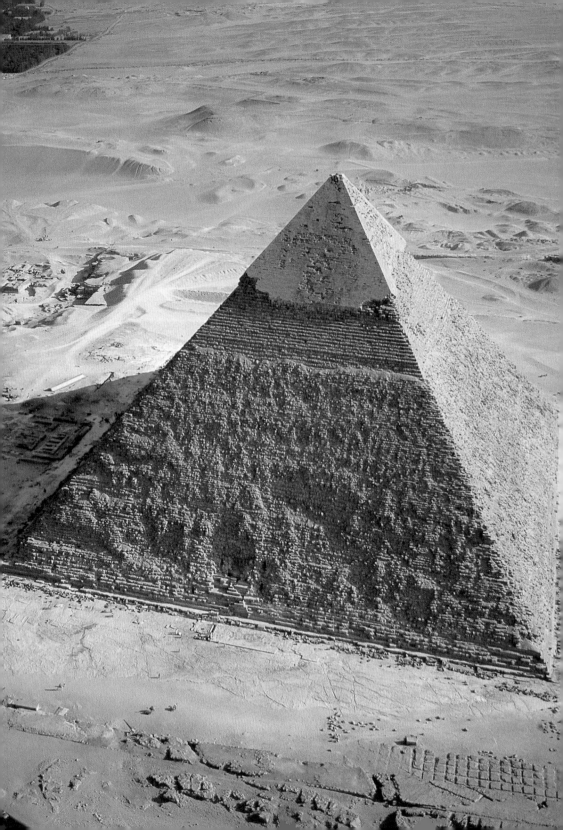

which embodies the wisdom of a now extinct people. But there is no reason to regard Khufu's pyramid as anything other than a perfect example of the royal tomb designed at the time when resources permitted its full and uncompromised realization. Only the centrally controlled thriving economy of the Egyptian state could embark on an enterprise of such magnitude. It is as much a comment on the excellence and durability of the ancient builders' work as on the enormous mass of material used in its construction, that Khufu's pyramid even now inspires admiration and awe.

There is an indisputable relationship on the ground between the three pyramids at Giza (see 8), those of Khufu, Khephren (Rakhaef or Khaefre, 2518–2493 BC; 48) and Menkaure (2488–2460 BC), all kings of the Fourth Dynasty. It is, however, improbable that this was due to any overall architectural design of the whole area, based on aesthetic or religious reasons. The suggestion that the positions of the Giza pyramids reflect the relationship between the stars of Orion's belt is unconvincing and unproven. Nor is there evidence that existing man-made structures or natural features of the landscape were taken into account by Egyptian architects of the Old Kingdom for reasons other than purely practical ones. The relationship was probably the result of procedures adopted during the surveying of the building site. When the second and third pyramids were being built at Giza, the existing structures would have provided the fixed points that the surveyors needed to mark out their site. These would have been much easier to use than any astronomical phenomena or temporary arrangements, and so the mutual relationships would have been introduced quite unwittingly and almost accidentally.

Just to the northwest of the lower (valley) temple of Khufu's son Khephren at Giza is a huge statue (73·5 m or 241 ft long, 20 m or 66 ft high) of a human-headed lion carved in a natural limestone knoll, known as the Great Sphinx (49, 50). Its head is that of a king wearing the royal headcloth. There is some disagreement about the date of this sculpture. It has been suggested that geological evidence of the weathering of the stone indicates that the Great

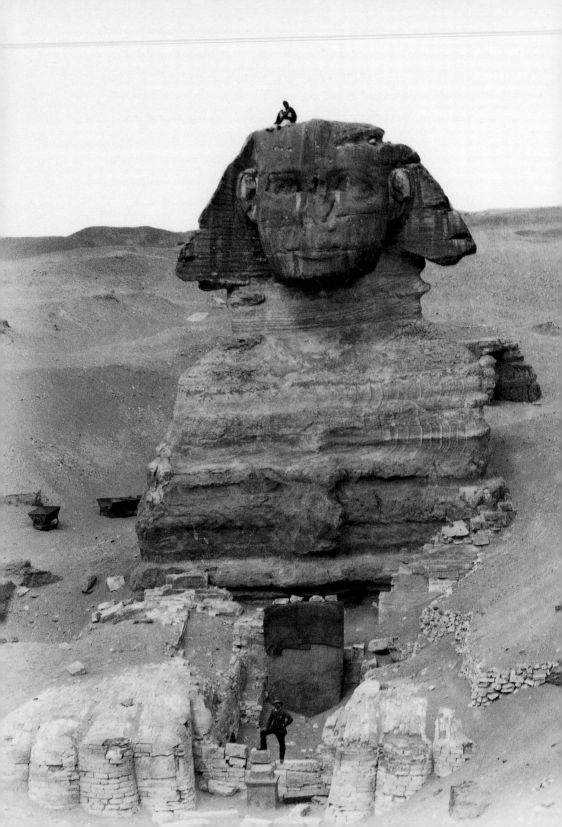

Sphinx is several thousand years older than the reign of Khephren, but this disregards the monument's context and all we know about the development of Egyptian art and society. Such a radical change of the Sphinx's date is impossible. Some Egyptologists think that the Sphinx may have been made under Khufu but most place it in the reign of Khephren. Whatever its date, the Great Sphinx is one of the earliest examples in art of this mythical creature (the etymology of the word may be ancient Egyptian, from *shesep-ankh*, 'living image', but this is far from certain). Moreover, it is both formally perfect when compared with

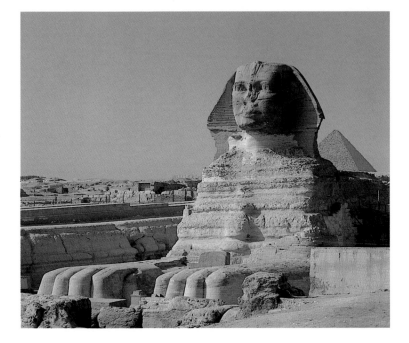

49–50
The Great
Sphinx, Giza,
c.2500 BC,
Limestone
rock;
h.20m, 66ft
Left
Photograph
taken c.1886
Right
View

the sphinxes made over the next three thousand years, and is the largest statue ever made in Egypt, and indeed in the whole of the ancient world.

The lion was linked to royalty and its guardian role made it an ideal image to place at gates and doorways, so its position at the entrance to Khephren's pyramid complex was appropriate. By this time, the Egyptian artists had developed methods for the portrayal of deities which were to remain standard for the rest of

51
The goddess
Isis as a
woman with
cow horns in
the tomb of
Haremhab,
Valley of the
Kings, Western
Thebes,
c.1300 BC.
Painted raised
relief

Egyptian history. A god or a goddess could be shown in their anthropomorphic form, as a man or a woman with divine attributes, such as a special headdress – *eg* the goddesses Isis and Hathor as women with the sun-disc and cow horns (51), Amun with a pair of tall plumes (see 101), or Ptah wearing a close-fitting skullcap – or the *ankh* symbol held in one hand. The *ankh* symbol, a looped or key-like cross, was a hieroglyphic sign used for writing the word 'life'. The still-disputed object which it represents, perhaps the thongs of a sandal, probably bears no relationship to this meaning; the similarity was purely phonetic. The gods were often shown holding the *ankh* to the mouth of the king, thus giving him life.

The other extreme was the zoomorphic manifestation, as an animal (*eg* Hathor as a cow; see 239) or bird. For some deities this was the expected form of appearance, but artistically it created considerable difficulties, as when it was necessary to combine anthropomorphic and zoomorphic images in a single sculpture

or scene. An ingenious third, composite, solution was therefore found in which a human body was combined with the head of an animal or bird, for example Hathor as a cow-headed woman, Sakhmet with the head of a lioness, Thoth as a man with the head of an ibis, or Seth (52) with a donkey-like head, possibly a mythical animal. This was a purely iconographic device which had no independent religious significance but became very popular in Egyptian visual arts.

The Great Sphinx is unusual because the principle of the composite representation is reversed: it has a human head and an animal's body. Perhaps the explanation is simple – this was the only solution which maintained the identity of the king (his face) while endowing him with divine attributes (a leonine body). A similar approach can be seen in much later sculptures showing the king in the guise of an anthropomorphic god; there, the face is that of the king so that the sculpture is instantly recognizable but various attributes are divine. The Great Sphinx at Giza probably

52
Relief including a composite image of a deity with human body and animal head, from Sahure's temple at Abusir, c.2440 BC. Limestone; h.140cm, 55⅛in. Ägyptisches Museum, Berlin

shows King Khephren as the lion god Ruty, protecting the approach to his funerary complex, and as such would be a perfect example of the integration of architecture and sculpture. In later periods, avenues of sphinxes lining the approaches to Egyptian temples continued and developed this theme (see 189).

From about 2450 BC, the main elements of the upper temple of a pyramid complex became standardized. The temple consisted of an entrance hall, a large pillared or columned court open to the sky, a room with five niches for royal statues, a chapel for the presentation of offerings, and a large number of storerooms. The upper temple of King Sahure (2447–2435 BC) at Abusir contains granite monolithic columns which replaced, though not entirely superseded, the earlier rectangular pillars (see 5). The capitals of some of these columns imitate tightly bound date-palm fronds, others are in the shape of a cluster of papyrus-stems. The nearby mastaba of Ptahshepses, a vizier of King Neuserre (2408–2377 BC), contains columns with lotus capitals. The lotus capitals suggest that these were not just faithful imitations in stone of columns made of vegetal materials. That may have been true of the origin of columns, deep in Egyptian prehistory, but by the middle of the third millennium BC the date-palm, papyrus and lotus had probably acquired a symbolic value that played a part in the ideas associated with a particular temple or tomb. The lotus was linked to resurrection, and it was believed that the creation of the world had occurred in the primeval papyrus marshes.

While the development of royal sculpture went hand in hand with the progress of royal tomb architecture, nearly a century separates the statue of Djoser (see 45) from the next freestanding royal sculpture identified with certainty. No statues have been found in the unfinished step pyramids of Djoser's successors; figures of Snofru have survived, but these were not freestanding, but rather attached to the rear walls of the niches in his lower temple. Statues of Snofru's son Khufu were probably fully freestanding sculptures but are almost completely lost; this is particularly unfortunate as it must have been during his reign that sculptors

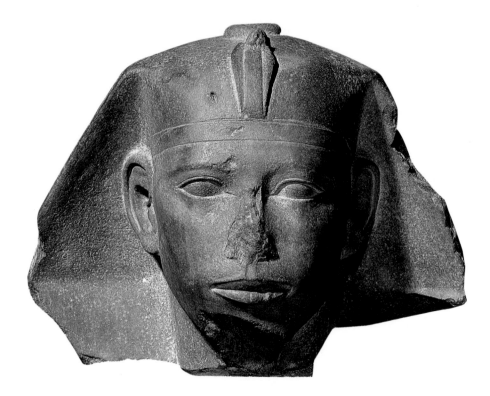

made significant progress. This is suggested by the statues of
Khufu's younger son Radjedef (2526–2518 BC), from his pyramid
complex at Abu Rawash, north of Giza. Although fragmentary,
they include the earliest sphinxes (predating the Great Sphinx at
Giza by one or two decades). A remarkably fine head of Radjedef
wearing the royal headcloth (53) almost certainly comes from one
such sphinx. There are also several new statue types, such as the
seated king with a small figure of his queen kneeling at his feet.
This subject was not, as far as we know, repeated in royal sculp-
ture, although it became popular in private statues (see 76).
Royal statues were always at the forefront of the development
of Egyptian sculpture and, within limits imposed by religious
beliefs, set the trend for private sculptures.

None of these statues, however, prepares us for the stunning qual-
ity of the sculptures made for Khephren, another of Khufu's sons.
As at the beginning of the pharaonic period, highly accomplished
masterpieces appeared as if from nowhere, although once again it
is important to remember that this impression is dependent on the

chance survival of some works and the loss of others. In 1860, when the French archaeologist Auguste Mariette was excavating the lower temple of Khephren at Giza (see 5), workmen discovered a pit with the remains of at least ten royal statues. Some were just fragments, and three were headless but otherwise complete seated figures. The best and most interesting was, fortunately, reasonably well preserved, with only the left arm and left leg damaged (54). It shows the king seated impassively, yet with supremely serene confidence, on a high-backed lion-seat, wearing only the royal headcloth and a short kilt. The king's hands rest on his thighs – the left hand palm down, the right clenched in a fist, and the bare feet of his conspicuously strong and solid legs are firmly planted on the pedestal in front of the seat. This is the ultimate accomplishment in the search for the ideal royal statue which can be traced from the self-conscious jubilee images of King Khasekhem (see 38) at Hierakonpolis through the similar statue of Djoser (see 45) in his Step Pyramid at Saqqara.

54
Seated statue of Khephren from his valley temple at Giza, c.2500 BC. Diorite; h.168cm, 66in. Egyptian Museum, Cairo

A remarkable feature of this statue is the hawk perching on the back of the royal throne. Its outstretched wings are placed on either side of the king's headcloth, as if cradling his head in a gesture which in Egyptian art came to be associated with the protection of the weak by the strong. Two seemingly contradictory notions – impersonal cold dignity bordering on haughtiness, and loving protection – were blended in the perfectly finished hard diorite sculpture to produce a powerful effect. A work of undisputed artistic quality, the sculpture conveys a precise ideological concept. The hawk is the manifestation of Horus with whom the Egyptian king was identified. As the wild bird combines fluently with the man, the divinity of the hawk becomes one with the humanity, albeit exceptional, of the king.

This conceptually complex sculpture should not be regarded as a unique work of art: it was almost certainly just one in a craftsmanlike series of such statues placed in Khephren's otherwise undecorated lower temple (fragments of similar sculptures have been found at Giza). Egyptian artists, meanwhile, as if unaware

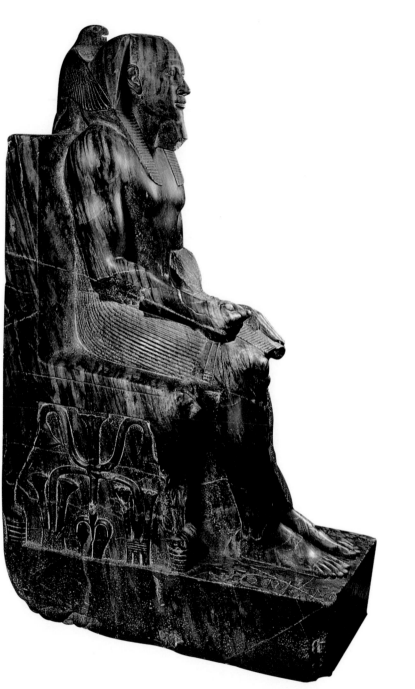

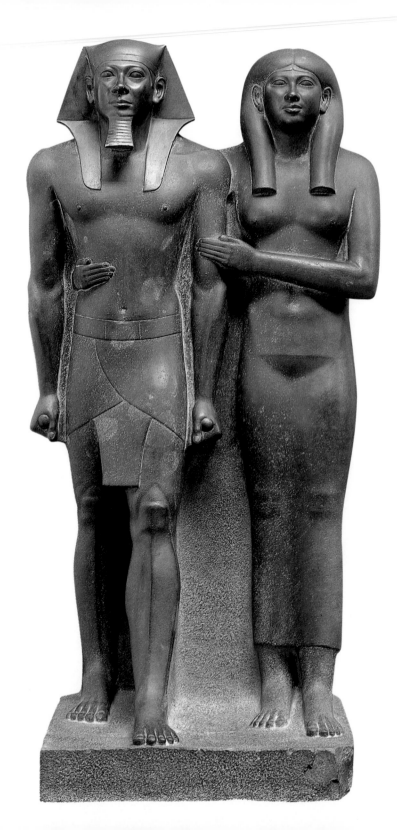

that they had arrived at a masterpiece, continued to experiment with other forms expressing the same concepts. Later attempts known from the Old Kingdom are at best indifferent; a small statuette of King Raneferef (2418–2408 BC) from Abusir exudes great charm but little authority, and a similar sculpture of Pepy I (2280–2243 BC) fares even worse in comparison. Yet, aesthetics apart, when the intended function of these works of art is taken into account, it cannot be said that one sculpture fulfilled its role better or worse than another. The superior aesthetic quality of some works is an 'added option', which shows that their makers were accomplished artists rather than routine craftsmen, and that those who commissioned them probably appreciated their beauty and perfection as much as we do today.

Statues from the temples of pyramid complexes tend to show the king seated, less often standing, sometimes with his queen (55) or in the company of gods. There was a recognized hierarchy in the postures displayed in Egyptian works of art, and being seated invariably indicated a person ranked above those merely

55
Statue of
Menkaure with a
queen, probably
Khamerernebty
II, from his valley
temple at Giza,
c.2460 BC.
Schist;
h.139·5cm,
54⅞in.
Museum of Fine
Arts, Boston

56
Triad of
Menkaure with
the goddess
Hathor and the
personification
of the 7th Upper
Egyptian nome,
from his valley
temple at Giza,
c.2460 BC.
Schist;
h.93cm, 36⅝in.
Egyptian
Museum, Cairo

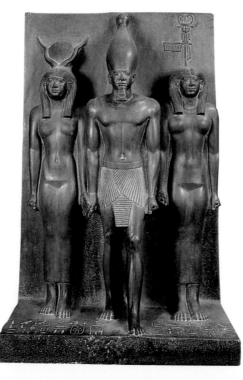

standing. Statues were three-dimensional counterparts of wall-reliefs and were integral parts of the temple's decorative programme. On the walls, the king appeared in a variety of scenes as different concepts were conveyed, and the reason for the large number of royal statues set up in the same building may be explained by similar considerations.

The pyramid complex of King Menkaure, owner of the third of the pyramids at Giza, contained a number of triads (groups of three figures) showing the king in the company of the goddess Hathor and a personification of one of the nomes, Egypt's administrative districts (56). This was not unusual in ancient Egyptian art: a locality could be represented by its local god or goddess or, when preferred, shown personified, as a human being. Since toponyms (place names) were grammatically of the feminine gender, the typically rigid Egyptian logic demanded that such personifications were female. This ability to convey almost any concept visually, often using ingenious symbolism and visual punning, was one of the most remarkable characteristics of ancient Egyptian art.

Most Egyptian stone statues were monolithic (ie carved out of one piece of stone). This restricted their forms quite severely. Sculptures consisting of several separate elements were made in the later periods of Egyptian history, for example during the reign of Amenhotep IV (Akhenaten, 1353–1337 BC), but this was in order to combine different materials and so achieve a pleasing colour effect rather than to avoid technical difficulties. The representation of a sceptre, mace or staff held in the person's hand always posed a problem which Menkaure's sculptors solved by reducing them to short sections grasped in the king's hands, barely protruding beyond his fists. This ingenious artistic solution abandoned the shapes of the original items and allowed practical consideration to override representational rules. Another solution to the same problem had earlier been tried in private sculpture. The official Sepa, of the early Third Dynasty, was shown as if holding the staff and sceptre vertically and pressed close to his body (57), but this was clearly not felt to be a satisfactory image, so the method was discarded.

Menkaure's triads show him standing with his back rigidly upright, leaning against a large back panel. His left foot is advanced, but he is not walking – the soles of both feet are firmly planted on the ground. This meant that the sculptor had to make the left leg slightly longer, a feature which is common, although hardly ever noticeable, in Egyptian three- as well as two-dimensional representations.

The large corpus of statues produced under the kings whose pyramids are at Giza makes it possible for the first time to distinguish between different artistic styles of the same period. There are two distinct naturalistic styles, differing only in such details as the treatment of the musculature and the bone structure showing beneath the skin. In the earlier style the modelling is more severe and simplified, reducing shapes to their main planes, while in the later style it is softer and more fussy, displaying an interest in detail. It is not clear whether these differences were due to the artistic idiosyncrasies or abilities of individual sculptors, teams of sculptors or different royal workshops.

It remained the king's face that made his statues (and his two-dimensional representations) recognizable. The official likeness of a king, however, might change several times during his reign. This suggests that while Egyptian royal sculpture aimed beyond portraiture, aspiring to an ideal of kingship that transcended individual appearances, it did not completely disregard the ruler's actual facial features. Thus, while it is possible to identify many royal sculptures with some certainty, there is no way of ascertaining how accurate a likeness may be and how much it derives from contemporary convention. In theory, however, all Egyptian royal statues can be assigned to a particular ruler by their resemblance, although our knowledge is not yet sufficient to make this kind of identification as safe as that based on inscriptional evidence. For much of Egyptian history the body of a royal statue simply showed the contemporary ideal type with no individual characteristics. In order to identify an uninscribed headless royal statue, therefore, it is often necessary to look for general stylistic and

formal characteristics (eg the treatment of the body common during a particular period, or the type of garment or jewellery worn). The chances of assigning it unambiguously to a specific ruler are limited. However, at a much later date the body was also sometimes modified in order to record such characteristics as age or corpulence (see 125), or to convey religious ideas, such as the assimilation of the royal person to particular deities.

The majority of royal statues found in pyramid complexes were less than life-size and were placed on pedestals or in niches or shrines. Some were placed in the five niches that formed such a characteristic feature of the upper temple, others were set up elsewhere in the upper temple or in the lower (valley) temple. The remains of the original emplacements and the orientation of inscriptions show that Egyptian statues were meant to be viewed from the front. This is in complete contrast to the profile view preferred in two-dimensional art, but is inevitable if the statue stands centrally and symmetrically in a shrine open only at the front. Before carving it, the sculptor would have sketched out the front and side views of the planned statue on the block of stone. These sketches defined the two main axes of the statue emerging from the stone. Examples where the equilibrium created by these two directions is disturbed (figures turning or leaning) are very rare.

By about 2400 BC the large panel against which some Old Kingdom sculptures stand (for example, Menkaure's triad; see 56) had developed into a narrow back pillar; its presence identifies a sculpture as being of Egyptian manufacture, since no other sculptural traditions are known to have adopted this convention. The size of temple statues was linked to their architectural context and, perhaps with the exception of some much later sculptures, was not an important concern in its own right. However, some colossal (larger than life) statues were created – Menkaure had a large seated statue made of alabaster in his upper temple, while a huge red granite head is all that remains of a colossal statue of Userkaf (2454–2447 BC) in his upper temple at Saqqara.

57
Statue of Sepa, probably from Saqqara, c.2600 BC. Painted limestone; h.169cm, 66½in. Musée du Louvre, Paris

58
Statue of Pepy II on the lap of his mother, Ankhnesmeryre II, probably from Saqqara, c.2230 BC. Alabaster; h.39cm, 15⅜in. Brooklyn Museum of Art, New York

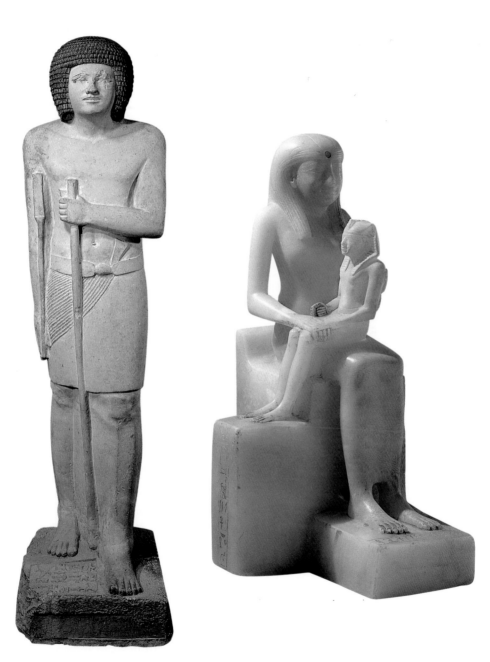

The preferred material for royal sculptures during the third millennium BC was hard stone, such as pink/red or black granite, orange/red quartzite, yellow/white alabaster, brown/black diorite or dark green greywacke, although many statues were also made of limestone, wood and copper (see 81). Since it is likely that all these statues were originally painted in rather gaudy colours, the natural colouring of the stone or its veining was of little importance; however, this approach to sculpture was to change later. In marked contrast, the veining in stone vessels was always appreciated. Hardness (and therefore durability) and exclusivity were the main considerations in the selection of material. As only a fraction of the statues made for pyramid complexes have survived, the sequence of royal sculptures of the Old Kingdom contains a number of serious gaps. However, it is clear that by the middle of the third millennium BC the Egyptians had developed a variety of types of royal statues, the conventions governing their making were firmly established, and their carving was carried out with a high level of technical skill. These qualities would continue to apply to royal statues for the rest of Egyptian history.

Pepy II (2236–2143 BC) is the last ruler of the Old Kingdom now known by his statues. They display several unusual types: one depicts him as a small squatting child wearing the royal head-cloth (we know that Pepy II came to the throne in extreme youth); in another (of unknown provenance) he is sitting on the lap of his mother, Ankhnesmeryre II (58). The pose demands the figure of a child, but Pepy II is shown as a scaled-down adult seated in the dignified posture associated with Egyptian kings. Such an artificial composition was not unusual in the Egyptian visual arts; the correct way of portraying the king required by the sculpture's function was more important.

Apart from royal figures, two other types of sculpture are known from pyramid complexes after about 2450 BC. Statues of kneeling, bound captives sometimes flanked the lower section of the causeway, close to the lower temple. These were the earliest examples

of an arrangement in which rows of identical statues lined the approaches to a building, forming an architectural feature. This concept was to be used on many subsequent occasions, especially in alleys of sphinxes flanking the approaches to Egyptian temples (see 189). The second type involved temple waterspouts, installed to protect against a sudden downpour which would have flooded the large paved areas. These spouts were sometimes carved in the shape of a lion's head; they are among the few animal sculptures known from pyramid complexes (gods shown in purely animal form were a rare sight in royal buildings of the Old Kingdom).

Royal funerary monuments of this period were also decorated with two-dimensional reliefs. The lower temple of the southern pyramid of King Snofru at Dahshur was the first in which substantial wall areas were given over to relief decoration. The processions of personifications of estates and nomes which supplied provisions for Snofru's pyramid and its personnel are the best preserved sections. This was the pictorial equivalent of a formal royal decree setting out which estates would supply the king's cult, and its inclusion in Snofru's pyramid complex secured its survival better than a copy made on a sheet of papyrus ever could. There were other scenes directly or indirectly concerned with provisioning, for instance those showing Snofru inspecting stalls of oryxes, and processions of fecundity figures, personifications of the richness and fertility of the land. In the world in which Snofru was presumed to live after his death these representations would have made certain of material necessities. The second major theme in Snofru's reliefs is the celebration of the jubilee festival. This is closely related to other scenes concerned with the king's status and his relationship to the gods. There is also a scene where the king is hunting wildfowl in the Nile marshes, but it would be a mistake to take it as a record of a real event. The wild birds in the marshes are a symbol of the untamed forces of nature; by hunting them, the king maintains order in the world by suppressing the forces of chaos and so symbolically fulfils his obligation to the gods.

The reliefs in the pyramid complexes of Snofru's immediate successors were concentrated in their upper temples but are now almost completely destroyed. The fragments which have survived show that the quality of the carving in very low relief, with minute differences in height conveying the subtle modelling of the figures, was superb. A century or so later, relief decoration was fully developed in the pyramid complex of King Sahure at Abusir and in those of his successors. A substantially enlarged repertory of scenes is distributed over the lower temple, causeway and upper temple. The original colouring of the reliefs

is sometimes still quite well preserved, for example on the body of Autib, the female personification of joy (59). There are some subjects in Sahure's lower temple not previously known, such as the royal barque and the portrayal of the king as a griffin (a lion with the head, wings and claws of an eagle) trampling on fallen enemies.

Recently discovered images from Sahure's causeway include scenes of military training (60), entertainment (61), archery and the

transport of funerary goods to the pyramid. These depart from the repertory of scenes directly linked to the provisioning activities for the king's funerary cult, but they can be indirectly connected with the king's role in the maintenance of world order. There is also a scene showing the transport of Sahure's pyramidion (the capstone that crowned the summit of his pyramid), which was made of hard stone and had to be brought from a distant quarry. This may show a real event rather than the imaginary world created by these reliefs, but this is conjectural. In his upper temple Sahure was shown slaying a Libyan chief and hunting desert animals. There are also ships

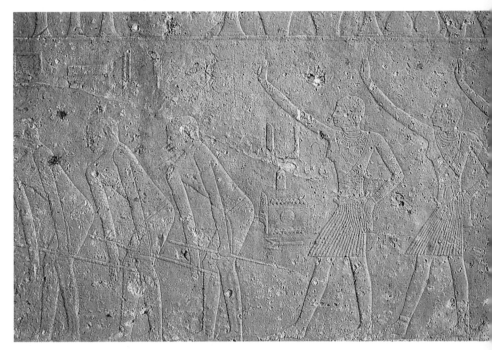

taking part in an expedition (probably to the Lebanon) and scenes of Libyan and Asiatic booty, including live bears.

The modern viewer should not be deceived by the apparent realism of these scenes and their convincing details (eg the fact that the Libyan chief and members of his family are named). It is likely that by the reign of Sahure this type of scene had already become a genre. There is no way to know when it was first introduced, as it may well have occurred in temples where the decoration has been

lost. The same scene, with exactly the same names, was included some two hundred years later in the temples of Pepy I and Pepy II at Saqqara, and was still depicted nearly two thousand years later in the temple of the god Amun built by Taharqa (690–664 BC) at Kawa in the Sudan. The purpose of these reliefs was not to provide a record of historical events but rather to depict a situation appropriate for the reign of an ideal king. While this does not exclude the possibility that some of these happenings may have taken place under Sahure, the value of these depictions as historical sources is severely restricted.

Somewhat later, in the upper temple of King Neuserre, the relief decoration was noticeably bolder, and relief became higher still shortly afterwards. Moreover, the carving technique was now modified wherever this was feasible: only small areas of the surface immediately adjoining the representations were cut away by the sculptor, and these lower planes were then imperceptibly brought sloping upwards to the original surface level. The overall effect of this method was not much different from 'true' low relief, and this was a substantial labour-saving device. The reliefs were painted in black, white, blue, red, yellow, brown and green, usually on a blue-grey background (nowadays the paint is often lost). Each colour covered an area delineated by the relief carving, but the painter who followed the sculptor did not mechanically confine his work to the carved relief and may have added further details, indicated texture or patterning, or gradation of colour. Raised relief, irrespective of its height, was used on interior surfaces illuminated only by diffused light. For inscriptions and scenes on doorways, pillars and other areas exposed to direct sunlight, sculptors used sunk relief, which relies on the contrast between the brightly lit surface and the shadow cast by the sharp edges of the deep carving. In sunk relief the sculptor removes the material within the outlines of the representations, leaving the surrounding surface intact. As the surface of the carved image actually lies below the surrounding surface, this is the opposite of raised relief. Sunk relief was painted in the same way as raised relief.

A century after Sahure, the lower (valley) and upper temples of King Unas at Saqqara were linked by a long causeway extensively decorated with remarkable reliefs. The various subjects include events in the natural world, market and workshop scenes, and episodes of warfare. There are also scenes of granite palm-capital columns and other building elements for Unas's pyramid complex being brought by ships from the quarries at Aswan. River transport was the obvious option in Egypt where the Nile and canals linked practically all places. Wheeled conveyances were not known until the introduction of the chariot sometime in the first half of the second millennium BC, but chariots were not strong enough for heavy goods. Away from the Nile or canals, building material was laboriously dragged on sleds. For some of these subjects, Unas's artists may have followed the example of their predecessors who worked for Sahure. Some of these themes may have been included in order to provide background and depth to the main subjects, as if to give personal details in the decoration of the pyramid complex. In a way, this went beyond the original purpose of these reliefs and provided the artists with greater scope for displaying their individual artistic ability. Unas's upper temple contained a number of scenes which expressed the king's close ties to various gods and thus his elevated status, a ubiquitous theme in such temples. This was one of the preconditions that enabled him successfully to communicate and plead with the gods on the people's behalf, one of the main tasks assigned to him in the Egyptian religious system. Almost any goddess could be described as the king's mother and their relationship was often conveyed in a visual form by showing the king suckling at her breast (62).

For nearly a century, between 2454 and 2369 BC, each Egyptian king constructed yet another large monument, a sun temple at the edge of the desert, not far from the royal pyramid complex. (An apparently undecorated temple with a court open to the sky built in front of the Great Sphinx at Giza during the reign of Khephren may have been a predecessor of the sun temples constructed some fifty years later.) Its purpose was to ensure the king's continued close relationship to the sun god Re in his afterlife, and in this

respect the sun temple was a funerary monument rather than simply a temple. Its plan had much in common with that of the pyramid complex, but its focal point was a large open court with a massive masonry-built obelisk and a large altar. The offerings to the sun god were, therefore, presented in an open space and in the full glare of the sun. Altogether, the names of six sun temples from this period are known, built by kings ranging from Userkaf to Menkauhor (2377–2369 BC), but only two, those of Userkaf and Neuserre, have so far been located (63). The relief decoration of

62
Unas being suckled by a goddess, from his pyramid temple at Saqqara, c.2320 BC. Limestone, painted raised relief; 83 × 78 cm, 32⅝ × 30¾ in. Egyptian Museum, Cairo

63
View of the sun temple of Neuserre, Abu Ghurab, c.2380 BC

the sun temple of Neuserre concentrates on two subjects, the king's jubilee festival and scenes showing the beneficial influence of the sun god on life in the Egyptian countryside. The main episodes in the annual life cycle of animals, birds and fish are shown with acutely observed detail, although the three annual seasons are here reduced to two, inundation and harvest. Large figures which personify the seasons and others that represent localities and abstract concepts of richness and fertility of the land accompany the subjects drawn from nature. Humans also

appear, but play a minor part. It was from this source that subjects drawn from the natural world may have been imitated in some later pyramid complexes and also in several private mastabas.

In Egyptian art, representations of animals, birds, fish and other living creatures are remarkable for the accuracy of the artist's observation and ability to convey their main characteristics with maximum economy. For most animals there was a generally recognized method of depiction and the main representational conventions were similar to those of human figures (head in profile, all the essential parts of the body had to be shown, etc.). But the artist enjoyed much more creative freedom because the subject was less rigidly linked to the conceptual purpose of the work of art and less was therefore at stake.

When the first step pyramid was built by King Djoser (see 43), royal and private tomb architecture had finally parted company and began to develop as two different forms, although points of contact continued in relief decoration. While the kings built themselves step pyramids in stone, their wealthier subjects continued to be buried in brick-built mastabas. One of these, at Saqqara, belonged to the official and physician Hesyre, a contemporary of Djoser. The mastaba contained a series of eleven wooden stelae with carved representations of the tomb-owner (64). These were placed in niches in the mastaba's interior corridor chapel, as if a protective wall had been added in front of a niched façade. The quality of the relief is excellent, enhanced further by the more sensitive modelling possible in wood.

It was part of the king's contract with the gods that he would look after the needs of his subjects. In practice, much of this task was delegated, for example to officials, who were given land as a form of state salary and became responsible for the provisioning of their subordinates as well as peasants settled on their land. The king's obligation towards his people extended into their afterlife. At first, an official's tomb was frequently constructed, decorated and equipped with funerary goods by the king (ie made by royal craftsmen and artists and provided with produce from royal

estates). It is likely that Hesyre's stelae were made by the same artists who carved Djoser's reliefs (see 44). But the proportion of tombs provided by the king gradually declined, and the number of those which were built by private initiative increased enormously in the second half of the third millennium BC. This signalled a changing economic situation in the country and greater democratization of the market in funerary goods.

Early in the Old Kingdom, the pyramid complex had provided new opportunities for royal sculpture and relief. Something similar started happening in private brick-built mastabas towards the end of the Third Dynasty, after 2600 BC. In order to afford better protection to the tomb's most important decorated and inscribed element, its stela, it was moved into the body of the mastaba and approached by a narrow corridor. The result was a small interior T-shaped chapel, often described as cruciform because the niche with the stela in the centre of the crossbar of the T can be seen as completing the form into a cross. The recessed brick-built niche with a stone stela began to be completely lined with stone. Its rear wall carried a representation of the deceased seated at a table laden with offerings, as on stelae in private mastabas of the Second Dynasty, and he was also shown standing on the niche's side walls. The niche with the stela, as the focus of the funerary cult, would have been seen as an imaginary doorway linking this world and the afterlife. Eventually, the niche evolved into a monolithic stela which bears some resemblance to a real door with a complex system of jambs. On such a 'false door', the dead person is shown seated at a table on a panel above the lintel, and he is also depicted standing on the jambs.

This 'false door' form was typical of tomb stelae during the Old Kingdom and was regarded as an interface between the worlds of the living and the dead. The vast majority of false doors are made of limestone, although hard red granite was the more desirable material, and some of these monuments made of the cheaper limestone were painted red to imitate it. Wooden false doors are rare (see 4). In Hesyre's brick-built chapel, dating to the reign of Djoser,

some plastered mud-brick walls already carried painted representations, mostly of his funerary equipment, but also of herdsmen and their cattle crossing a crocodile-infested canal and other scenes. The walls of the corridor leading to the cruciform chapel also carried a variety of painted scenes. When these chapels began to be lined with stone, they were carved with scenes which were regarded as important for the tomb-owner's afterlife, especially those connected with the provisioning of the tomb, such as bearers of offerings approaching the false door. They were mainly in bold (high) relief. The burial chamber itself was at the bottom of a deep shaft, inaccessible and undecorated. Although this basic arrangement varied, a chapel with a stela above ground, and an underground burial chamber, always comprised the two main elements of Egyptian private tombs.

The new ideas concerning the king's afterlife which brought about the change from the step pyramid to the true pyramid complex had a remarkable effect on the whole concept of Egyptian cemeteries. The royal pyramid became the focus of the necropolis, with the tombs of the king's contemporaries clustering around it. Snofru and particularly his successor Khufu had rows of uniform stone-built mastabas built around their pyramids for their relatives, officials and priests of their funerary cult. In this way, these kings hoped to preserve the fabric of their contemporary society even after death.

These mastabas were designed by the same architects and built by the same crews of stonemasons who worked on the construction of the pyramid. In their size and standard of workmanship they were vastly superior to any private tomb previously built in Egypt. In their plan and relief-decoration, however, they did not follow the contemporary brick-built mastabas which had developed more spontaneously and individually. It was as if the king tried to decree the correct form of private tomb. The mastabas around the pyramid of Khufu had solid stone-built superstructures, with no interior rooms. The relief decoration was limited to a stela fixed in the eastern face of the structure (see 7). These mastabas were also provided with a special type of tomb sculpture in the form of

'reserve' heads (so called because they were intended as substitutes in case of damage to the head of the tomb-owner's corpse). These limestone heads of men and women, probably made in royal workshops, display a remarkable variety of facial types and may be realistic portraits (see 77). The effort to provide large numbers of state-constructed tombs could not be sustained and was abandoned after the reign of Khufu. Neither the reserve head, nor this type of stela, became standard features of Old Kingdom tombs.

Mastabas continued to be constructed with ever more and larger internal rooms, until by c.2300 BC these sometimes filled the whole of the superstructure. The mastaba was, in effect, transformed into a regular building. Parts of it may have been set aside for a specific

65
Frieze of geese
from the tomb
of Prince
Nefermaet
and his wife
Itet at Maidum,
c.2570 BC.
Paint on
plaster;
27 × 172cm,
10⅝ × 67¾in.
Egyptian
Museum,
Cairo

purpose, such as the funerary cult of other members of the family, and some of the rooms were used for a specialized purpose, such as the storage of particular items of equipment. From around 2500 BC rock-cut tombs, which were hollowed into rock-faces left after the quarrying of stone for pyramid building, began to be made at Giza. Such tombs at Giza are dated to the reign of Khephren, but there are rock-cut tombs at Saqqara which exploit natural rather than man-made rock-faces and these may be earlier. The focus of the funerary cult was again a false door; the walls of the rooms in these rock-cut tombs were decorated with carved reliefs.

The repertoire of scenes on the walls of private tombs developed along similar lines to those in the temples associated with

pyramids. Provisioning scenes were the first to appear, especially offering-bearers and subjects directly connected with the preparation of offerings, such as fishing and the slaughtering of oxen. Processions of personified estates, such as were introduced in the lower temple of Snofru's pyramid at Dahshur, were common and represented a pictorial version of the tomb's endowment document. However, there were no representations of the king or gods in private tombs during the Old Kingdom. The scenes shown in tombs soon went beyond straightforward provisioning, as if to create a more detailed setting for the more important scenes. In the tomb of Nefermaet and his wife Itet at Maidum, dating to the reign of Snofru, men were shown netting fowl, a stage which

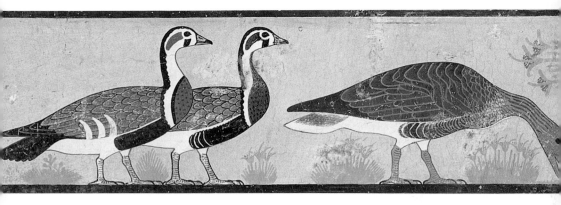

preceded bringing these birds as tomb offerings. Some of the details, such as the faithful depiction of the geese (65), are astonishingly accurate and seem to have been of considerable aesthetic interest for the artist.

Depictions of the Egyptian countryside included agricultural activities, such as ploughing, sowing, harvesting, threshing, winnowing and storing grain, as well as milking and other episodes to do with cattle-breeding, flax-harvesting, viticulture and horticulture. Marsh scenes included papyrus gathering, canoe and mat making, netting fowl, and men jousting with punting poles (66). Hunting scenes were relatively infrequent (67). There are scenes showing various craftsmen, such as metalworkers (68, 69),

66
Boatmen jousting,
probably from a
tomb at Saqqara,
c.2400 BC.
Limestone,
raised relief;
w.145 cm, 57 in.
Egyptian
Museum, Cairo

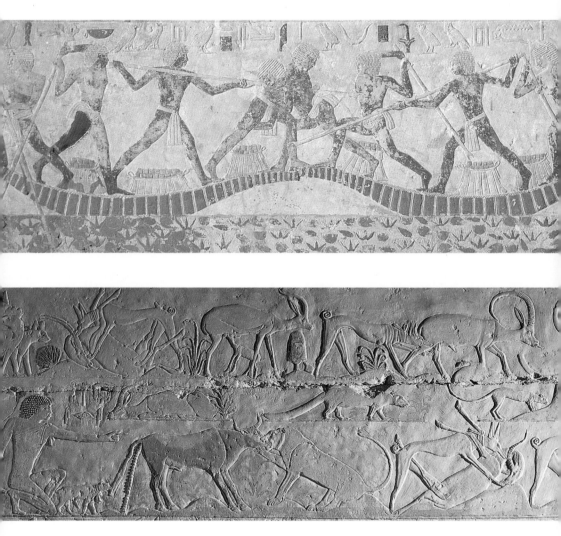

67
A hunting scene
in the tomb of
Ptahhotep
at Saqqara,
c.2350 BC.
Limestone,
raised relief

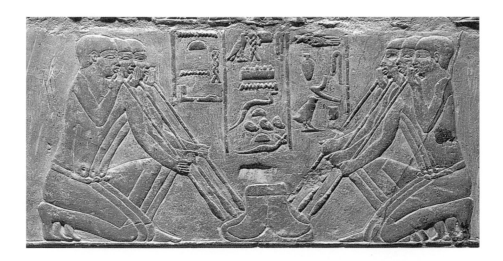

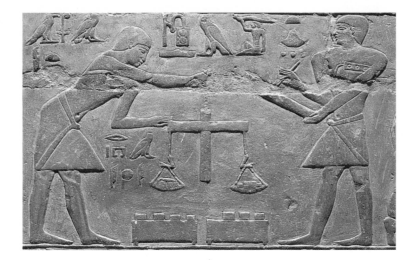

68–69
Metalworkers
in the tomb of
Mereruka at
Saqqara,
c.2300 BC.
Limestone,
raised relief

jewellers, carpenters, boat-builders, leather-workers, makers
of stone vessels and sculptors. On the walls of the tomb chapels
the deceased was depicted, sometimes accompanied by his wife,
children, attendants and pet animals. Many everyday activities
are shown as if unfolding in registers before them. The deceased
is shown on a much larger scale than the minor figures; his height
usually corresponds to that of several registers, if not the whole
of the wall (70). The design of the scenes thus appears to contrast
the dignified tomb-owner and members of his family who were

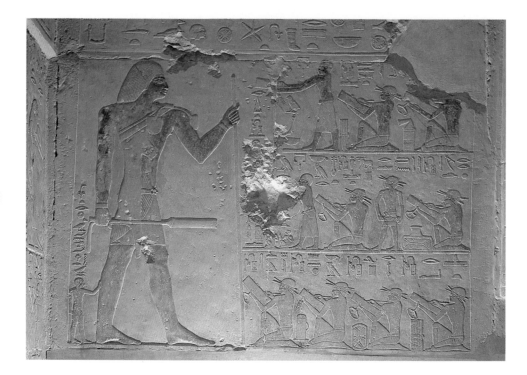

smartly, often ceremoniously attired, with the ordinary and
mostly anonymous peasants, craftsmen and servants. We read
this as social comment but there is no evidence that this was the
intention and the reliefs were not meant to be a record of contem-
porary Egyptian society. They show the deceased and his family
whose afterlife they ensured, while the other figures are little
more than elements of the background helping to attain the
desired goal of the tomb decoration, which was the deceased's
luxurious existence in the afterlife.

The deceased is almost always shown in a passive role, watching rather than doing, but there are two notable exceptions: in scenes where he is fowling with a throw-stick or harpooning fish. Both of these activities are shown taking place in the marshes, and such representations are often placed above or close to doorways. Everything suggests that these scenes are fictional rather than a true reflection of reality. The hunting techniques, with the deceased standing in a small papyrus skiff, were too inefficient and had been replaced by other methods, such as netting, by this date. However, they could pass as a quaint sport rather than as a serious occupation. The presence of the deceased's retinue, sometimes with the family crowding the skiff, is quite unrealistic, and his attire is hardly suitable for an arduous pursuit.

70
Prince
Kanenesut I
and scribes,
in his tomb
from Giza,
c.2450 BC.
Limestone,
painted raised
relief;
w.143cm,
56¼in.
Kunst-
historisches
Museum,
Vienna

Fowling and fishing may originally have been ancient provisioning themes, the significance of which had perhaps been transmitted through an oral tradition that was much older than the Egyptian visual arts. We have seen that such themes were reinterpreted to suit royal ideology in the reliefs of the pyramid complexes, but they were also retained as an element of the repertory of private tomb decoration. As if recognizing the fact that non-material pursuits were also important to the tomb-owner, many of the reliefs show musicians, especially flautists and harpists, singers, dancers and people clapping to keep rhythm, and also men playing various games.

These reliefs convey the impression that the deceased took his whole world with him into the chapel of his tomb. But it was not that simple. Tomb reliefs must not be taken uncritically, as straightforward illustrations of Egyptian daily life, nor as images of wished-for Egyptian paradise. Their purpose was not a faithful record of reality and the selection of subjects need not have been representative. Some motifs may have been included, modified or omitted for reasons that are not immediately obvious. This was contemporary Egypt seen in a distorting mirror of artistic conventions and religious content, further complicated by a symbolism which is now impossible to decode fully.

Short hieroglyphic inscriptions accompanied the representations and provided further information that would have been difficult or impossible to convey visually, such as the names of the protagonists, their conversations and explanations of their activities. In the mastaba of Ty at Saqqara an overseer for a group of harvesters exclaims: 'What is it, then, men? Hurry up, our emmer is ripe.' 'It is coming and it is bringing a good catch of fish', comments an excited fisherman in the same tomb. In the mastaba of Ptahhotep, also at Saqqara, a herdsmen says to an ox in his charge: 'Hey! my darling, eat the bread.' Egyptian artists seem to have felt that leaving large blank spaces was a shortcoming, and the texts helped to overcome this. They also personalized representations that were otherwise drawn from the standard repertory of tomb scenes.

While the Egyptian way of representing a human figure was to view it as a composite image in which all the important elements were visible, even large static figures of the deceased sometimes demanded solutions which on close examination appear unorthodox. For instance, a standing official typically grasped a sceptre in his right hand, with the right arm hanging down along the body and the sceptre held horizontally, while in his left hand was a long staff held nearly vertically in front of him. This caused problems, however, when the figure was shown facing left, because the left arm would have obscured the body, a solution which was either unacceptable or was thought to be infelicitous. Egyptian artists had no hesitation in attaching the left arm to the right shoulder and vice versa; this avoided any obscuration and was clearly not felt to be out of place.

Even more serious were problems encountered in the representations of minor figures engaged in various active pursuits, in which the artist was required to produce the variety of postures demanded by the composition of the scene. There is no evidence to show that there were pattern books, for example on papyri, in which standard postures were recorded and from which they could be copied. It is equally difficult to imagine that artists would have learnt all the various permutations during their

apprenticeships and retained them in their memory. It is much more likely that they were trained in drawing various elements from which the human figure could be built up, and that they combined them as each situation required.

This illustrates the typically Egyptian approach to creativity. Hundreds of mastabas and rock-cut tombs decorated in relief are known, yet it is practically impossible to find two tombs, or even two tomb walls, that are identical. Because Egyptian art was functional and served a specific purpose, it would have been unthinkable for the artists to create freely, producing completely new solutions by methods previously unknown. This might have endangered the main purpose of their work by depriving it of its efficacy. So how can we explain the variety of forms? The creativity of Egyptian artists lay in producing a new and pleasing combination using known elements. It is here that the notion of creativity and originality, so important in modern perceptions of art, applies. The corpus of elements available to each individual artist did not remain the same because changes in beliefs as well as in the world around them had to be accommodated, but any additions would almost certainly have been made by the master artists and sanctioned by the priests. All the same, the reluctance to abandon concepts deemed to have worked well in the past was noticeable, and they were often retained in spite of completely changed circumstances.

The question of whether the anonymous men who created Egyptian statues and reliefs were 'artists' or 'craftsmen' seems irrelevant and would have been incomprehensible to the Egyptians. When such statements as 'it was the painter Semerka, one rewarded by him [ie by the tomb-owner], who painted this tomb of his [ie of the deceased]' or 'it was Inkaf, one rewarded by him [again, by the deceased], who executed the work on this tomb of his [ie the dead person's tomb]' are occasionally found, they can be explained by a wish to record that the tomb was paid for and no claim against its owner was outstanding, and perhaps also by an attempt on the part of its makers to participate in the dead person's afterlife.

Unfinished tombs allow us to reconstruct the sequence of procedures used by tomb artists. The design of the decoration of the tomb chapel of an Old Kingdom mastaba started with the selection of subjects (eg agriculture, cattle-breeding, crafts, etc.) available to the artists and their distribution in different rooms of the chapel. It is not certain whether the customer had any say, but similarities in the tombs of relatives may suggest that this was the case. There is some internal logic to the distribution of the scenes and their orientation. For example, the large figures of the deceased are usually shown as if facing out of the tomb, while offering-bearers are invariably shown proceeding towards the interior of the tomb or its false door. As a rule, scenes did not extend over corners, so each wall represented a self-contained tableau.

The next step was the overall design of each wall. It was necessary to decide on the basic composition, for example whether there was going to be a large figure, how the subjects were going to be divided into registers, and which of the number of episodes available for each type of subject matter were going to be included (eg the choice for agriculture was ploughing, sowing, reaping, etc.). If it was felt desirable to indicate a sequence of activities, then the lowest register on the wall was regarded as chronologically the latest; within the register, the episode closest to the large figure of the deceased was the most recent. The scenes in registers were oriented towards the large figure. Each scene was then designed by deciding on details such as the number of people to be shown and how. Finally, each figure was created by building it up from its individual elements.

The stone wall on which the scenes were going to appear was first smoothed and, if necessary, its surface repaired with plaster. Draughtsmen outlined the register lines and sketched the figures in red paint. A set of rules which defined the standardized proportions of the human figure (also called the Egyptian canon of proportions) was strictly adhered to in large-scale figures. It was naturalistic and derived from accurately observed proportions of living Egyptians. In order to maintain the correct proportions of

the figures the draughtsmen used three or four guiding-lines intersecting the figures at vital points such as the knees, shoulders or forehead; the rest was sketched in. (During the Old Kingdom such guidelines sufficed for establishing proportions, but by the Middle Kingdom the full grid was in use; see 97.) The draughtsmen's supervisor then made any corrections in black ink. The sketches sometimes show details, for example on the birds' feathers, which improved or enriched the representation but which the draughtsman must have known would later be removed in the sculpting – this was not a mechanical action lacking in foresight, but rather the spontaneous creation of an artist. Then it was the turn of the sculptors who chiselled out the representations using copper tools. The reliefs were subsequently painted, during which the remains of the guidelines that assisted the draughtsmen were covered up.

The procedure shows why the relationship between three-dimensional reliefs and truly two-dimensional drawings was so close as to make them practically identical: one evolved from the other. As a general rule, relief was preferred to mere painting because of its durability. Painting on a plaster-covered surface was the only option in brick-built mastabas when the walls were not lined with stone slabs, but tombs are known where painting was used on a stone surface. In most cases it is possible to identify special reasons for it, for example bad quality surface in rock-cut tombs, or the lack of time, resources or skills to create relief. Painting was also used when mastabas' burial chambers began to be decorated, after c.2300 BC, but the reasons need not have been purely practical. The decoration of these burial chambers imitated the painting on wooden coffins and this may have influenced the choice of the technique.

It was around 2650 BC, at the beginning of the Third Dynasty, that stone statues were first placed in private tombs of the pharaonic period. Some of the sculptures found in Predynastic graves may have had the same function as these later tomb statues, and some Early Dynastic mastabas contained wooden statues, but the three

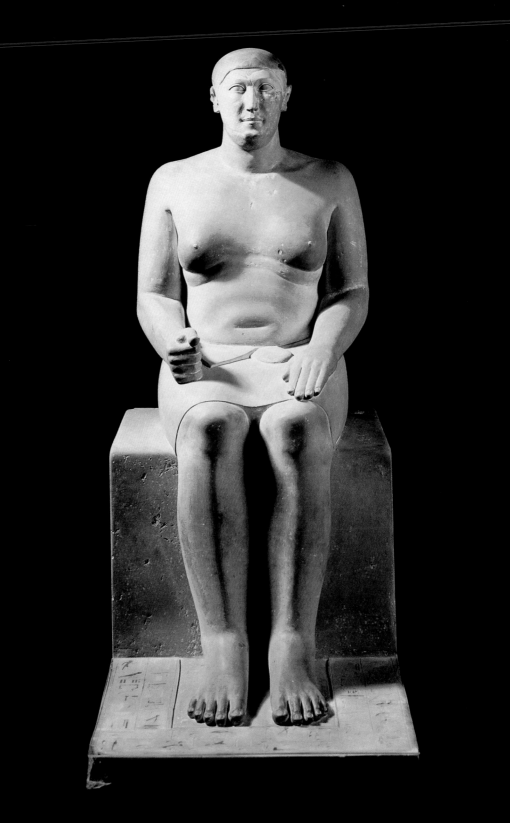

main types of individual male statues that evolved during the Old Kingdom continued to be used for the rest of Egyptian history. The majority show a seated figure (71), and this type remained most frequent for the next two thousand years. One of the hands usually rests flat on the knee, while the other is clenched in a fist. The second main type, the standing figure, also appeared early. The man is usually standing upright, with his gaze fixed into the distance, his left foot advanced (sometimes these are described as striding statues although this is a misnomer), his hands held alongside the body with the fists clenched (72). The third type, the

71
Statue of
the vizier
Hemyunu,
from his tomb
at Giza,
c.2530 BC.
Painted
limestone;
h.156cm,
61½in.
Roemer-und
Pelizaeus-
Museum,
Hildesheim

72
Statue of Ty,
from his tomb
at Saqqara,
c.2400 BC.
Painted
limestone;
h.200cm,
78¾in.
Egyptian
Museum,
Cairo

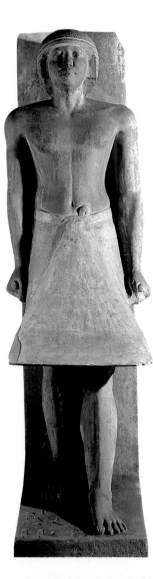

scribe statue (73), was introduced during the Fourth Dynasty, around 2540 BC, and continued to be used until the beginning of the Twenty-Sixth Dynasty, at the end of the seventh century BC. It shows the deceased seated on the ground with his legs crossed in the typical posture of an Egyptian scribe. Literacy was an achievement essential for holding office and so worth recording for posterity. Other types of statue, for example kneeling figures, were very rare.

The clearly defined function of tomb statues restricted their variety. Nevertheless, there was scope for different ways of handling each type. Variants of the standing statue and the scribe statue can be seen in rock-cut tombs, where they were carved out of the rock itself (74). The impression produced was that of a statue in a niche, with its back still attached to the niche's rear wall. Some tomb statues are known to have been placed in wooden shrines, and this may have contributed to the popularity of such statues. Statues in rock-cut tombs often show groups of people, either whole families or the same person several times, as in the tomb of Meryre-nufer Kar at Giza, which dates from about 2250 BC. Young men were sometimes represented nude, which was a convention in the depiction of youth. There were only two types of Old Kingdom female statues, seated and standing. In contrast to men, the feet of the standing statues of women were kept together, not shown with the left foot advanced, but this did not necessarily apply to goddesses.

From around 2570 BC pair statues showing a husband accompanied by his wife became popular and were made in a number of variations on seated, standing and kneeling postures. Statues of the husband and wife (the Egyptians of the Old Kingdom were mostly monogamous; cases where a man had several wives were exceptional) may have been carved separately although they were intended to be placed side by side, but this seems to have been an early approach to pair statues that was later abandoned. The statues of Prince Rahotep and his wife Nofret, from the reign of Snofru, were found in Maidum and are good examples of this

73
Scribe statue of the boundary official Kai, from his tomb at Saqqara, c.2450 BC. Painted limestone; h.53cm, 20⅞in. Musée du Louvre, Paris

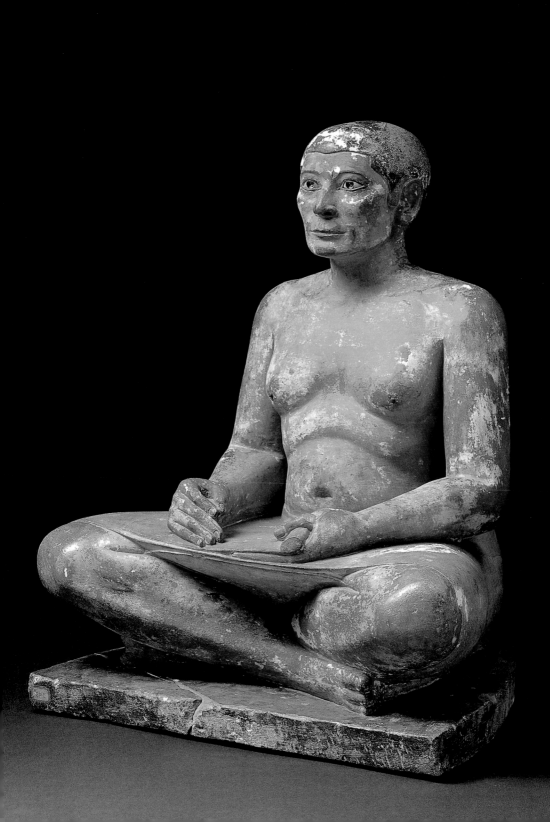

74
Rock-cut
statues in
the tomb of
Meryre-nufer
Kar, Giza,
c.2250 BC.
Limestone

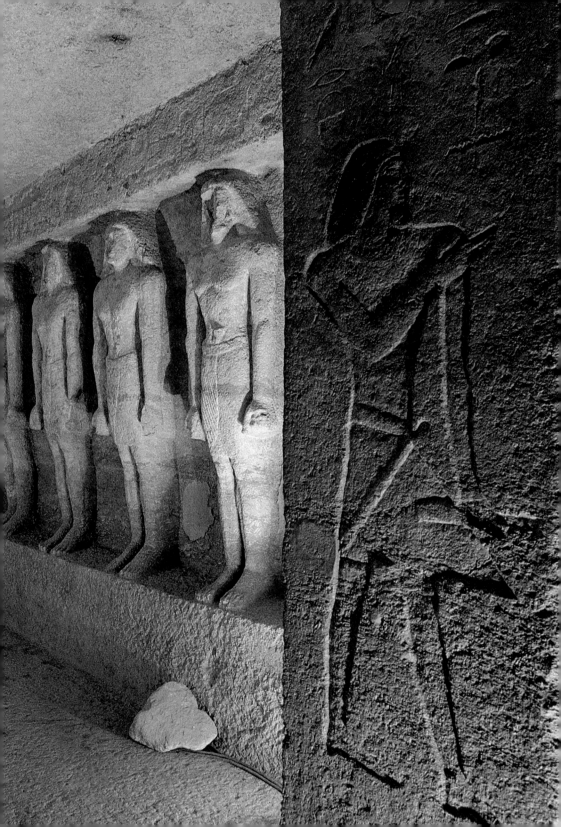

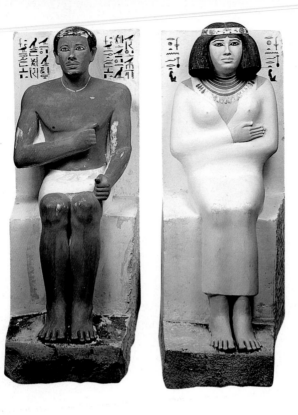

75
Prince
Rahotep and
his wife Nofret,
from his tomb
at Maidum,
c.2570 BC.
Painted
limestone;
h.121 and
122cm, 47⅝
and 48in.
Egyptian
Museum,
Cairo

76
Irukaptah and
his family,
from his tomb
at Saqqara,
c.2300 BC.
Limestone;
h.73·5cm,
29in.
Brooklyn
Museum of
Art, New York

approach (75). They are not more than average quality sculptures, but their original colouring is almost perfectly preserved and this, in spite of their formal postures, lends them a vivacity and animation that rarely survives in Egyptian private statues of the Old Kingdom. Nofret's heavy wig is held down by a diadem and she wears a necklace of several strands of beads with pendants. The heavy feet of the couple are striking but this is characteristic of Old Kingdom statuary.

It was not unusual for wives to be shown on a much smaller scale than their husbands. The wife was buried in the tomb of her husband, in her own burial chamber at the bottom of a subsidiary shaft, so the presence of the statues of the couple in what was primarily the man's tomb was perfectly logical. Family groups contain figures of different sizes, with one or more children, often nude and on a much smaller scale, standing by the legs of their parents. The family group of Irukaptah dates from about 2300 BC and was found at Saqqara (76). Irukaptah's wife is kneeling by his

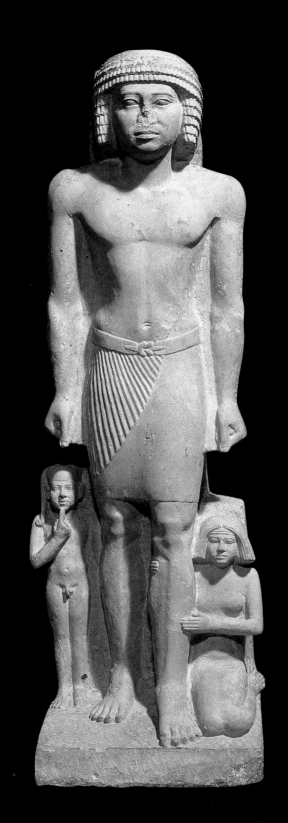

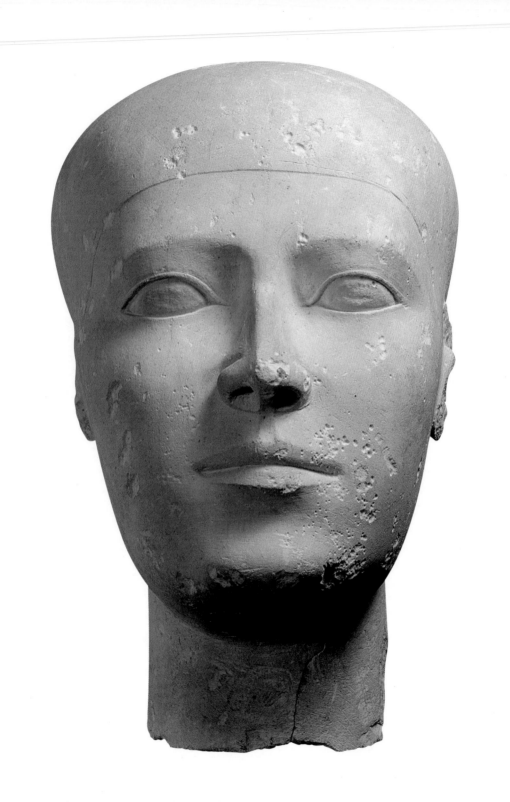

left leg. His small son is shown wearing a sidelock of hair and holding a finger to his mouth. In Egyptian visual arts these were standard indicators of youth that were applied to representations of children as well as young gods.

There are also statues of male groups of two or more, for example brothers. Less usual are statues where the same man is represented twice or three times. It seems likely that these represent the person's different modes of existence (for example being accompanied by his *ka*) or in different stages of life. Statues of two women are also known, such as a mother with a daughter.

Great emphasis was laid on the completeness of the body in tomb sculptures. Yet there are at least two types of Old Kingdom statues that provide exceptions to this rule. The first is the 'reserve head' type (77), known mainly from the stone mastabas around the pyramid of Khufu at Giza. The other type are figures of the deceased on the jambs of a false door where only the upper part of the body was carved, creating the impression of a person emerging from the false door. These works are ultimately related to the more standard symmetrically oriented representations, carved in relief, of the deceased standing facing towards the centre of the false door. Because the false door was seen as a boundary between this life and the afterlife, it is possible to see why this curious type of sculpture may have been acceptable, but it never became popular. A similar reasoning may have prompted the creation of the bust of Ankh-haf (78), a vizier of King Khephren. The remarkable modelling of the face makes it one of the undisputed masterpieces of the Old Kingdom.

The practice of carving tomb sculptures also gave rise to relief representations in which a person is shown on a false door in front view. It was as if a sketch was made for the carving of a standing statue, but then the artist changed his mind and carved a relief figure instead. The full-face pose is quite exceptional in Egyptian art; rare examples include the hieroglyph of a human face and, in the later periods, the central figure among the captives being slain in the traditional scene of royal triumph (see 123).

77
Reserve head from a tomb at Giza, c.2500 BC. Limestone; h.27·7 cm, 10⅞ in. Kunsthistorisches Museum, Vienna

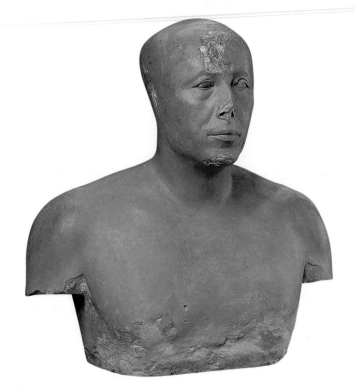

78
Bust of
the vizier
Ankh-haf,
from his tomb
at Giza,
c.2500 BC.
Plastered
and painted
limestone;
h.51cm, 20in.
Museum of
Fine Arts,
Boston

79
Lector priest
Kaaper
('Sheikh
el-Beled'),
from his tomb
at Saqqara,
c.2450 BC.
Plastered and
painted wood;
h.110cm, 43¼in.
Egyptian
Museum,
Cairo

Private tomb statues were relatively small, on average below 30 cm (12 in) high, although larger and life-size statues existed. The majority of those made during the third millennium BC were of limestone, but some were of granite or alabaster. Surprisingly many of the earliest statues were made of hard stone, especially granite, probably because they were made in royal workshops that were able to procure the desirable hard stone. Later, when most tomb statues were made in necropolis workshops which specialized in turning out large numbers of sculptures, the much more easily accessible limestone became the most common material.

Native wood or imported hardwoods such as ebony, often covered with plaster, were also used extensively, although fewer of these sculptures have survived. Wooden statues were usually made in several parts, with the arms made separately and joined to the body at the shoulders. This allowed a certain freedom, so that it was possible, for example, to show a standing man holding a

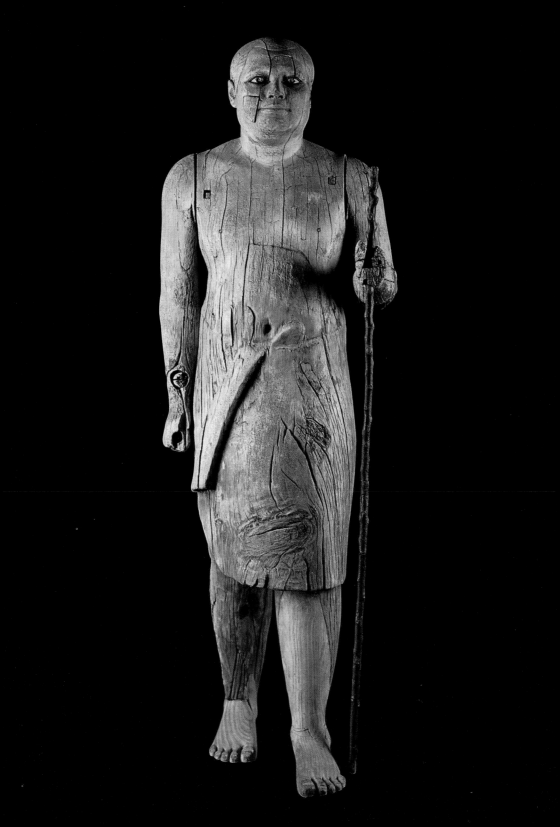

sceptre and staff, something which presented serious problems in stone sculptures (see 57). The eyes of these wooden figures were often inlaid with stone (for example rock crystal or alabaster, sometimes in a copper setting). All statues were painted; the complexion of men was red-brown while women were yellow, a colour convention that was also applied in painted reliefs. The number of wooden statues progressively increased towards the end of the Old Kingdom, notably in the output of provincial work-shops. The reason for this was probably the greater ease with which the material could be modelled by less skilled sculptors. However, some remarkable pieces were made, such as the wooden statue of a corpulent middle-aged man in Cairo ('Sheikh el-Beled'; 79), dating to shortly after 2450 BC.

Some statues were set up in the tomb's accessible rooms, but more often they were placed in a closed statue room. This was usually to the west of the false door or behind a wall flanking the approach to it, and a narrow slit sometimes enabled the statue to 'look out'. A single statue was usual in a tomb, but the number of sculptures of the same person, sometimes of different types and materials, deposited in the statue room could reach several dozens or more. Safety in numbers was, no doubt, the initial motivation, but it is also likely that the wealthier tomb-owners liked to flaunt their ability to provide for their tomb. In this period there were no sculp-tures showing the deceased in the company of the king or the gods.

There was yet another special category of sculptures made for tombs, the so-called servant statuettes (80). These were three-dimensional equivalents of the scenes on tomb walls that showed domestic activities, especially those connected with the prepara-tion of food (grinding grain, kneading dough, baking, brewing beer, etc.). It seems that at first such statuettes were made of stone but towards the end of the third millennium BC most of them were made of wood.

So far this discussion of sculpture and painting has focused on work from tombs (royal and private) and temples or chapels asso-ciated with tombs. Temples to local gods worshipped during the

80
Servant statuette, female brewer, from the tomb of Mersuankh at Giza, c.2350 BC. Painted limestone; h.28cm, 11 in. Egyptian Museum, Cairo

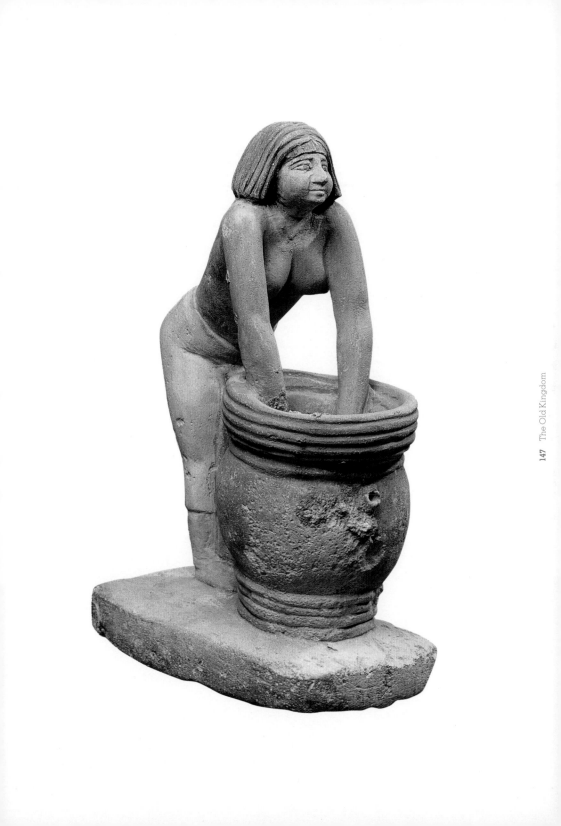

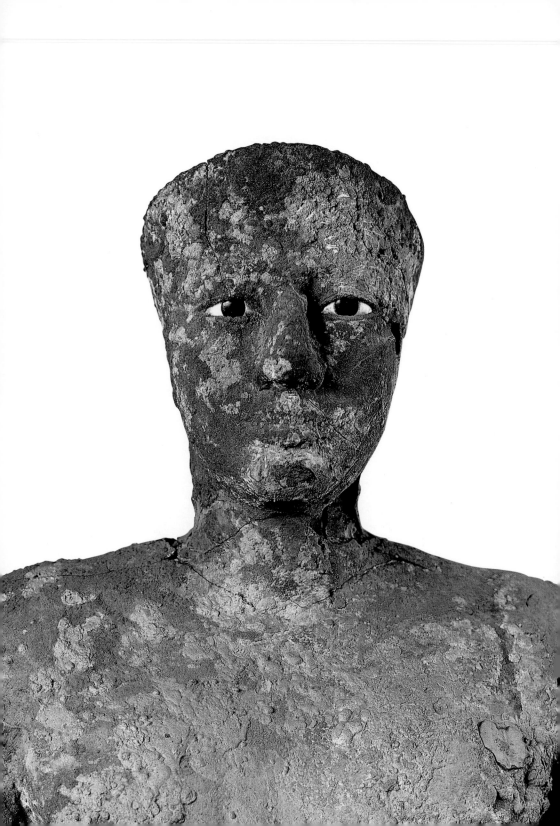

Old Kingdom were mainly brick-built, with a few stone elements. Thus, the temples and their decoration disappeared during modifications and enlargements of later periods. The temple of the sun god Re at Heliopolis, containing some reliefs dated to the reign of Djoser, was specially favoured because of the close relationship of the sun god to the king. However, it seems that the Old Kingdom rulers generally paid only limited attention to non-funerary temples of any kind. Statues showing the deity, the king, or both are known, but reliable information on the circumstances of their discovery is invariably missing. The standing statues of Pepy I and his son Merenre I (2242–2237 BC), made of copper plates over a wooden core (81), found in the temple of Horus at Hierakonpolis, are honourable exceptions.

Temples of local gods probably did not contain statues of private individuals. Yet at least one unusual sculpture, of a kneeling man inscribed with the names of the Second Dynasty kings Hetepsekhemui (2793–2765 BC), Raneb and Ninutjer on his shoulder, may be a temple statue. This granite piece probably comes from the Memphite area. The names would have recorded the entitlement of the statue, and so of its owner, to have a share of offerings presented on behalf of the kings, offered in the name of the owner. On a small statue, the shoulder was a prominent place suitable for a record and would be unlikely to be overlooked by a temple priest walking past it. While such cases are associated with later temples, the provenance of this statue is not known and it is conceivable that the same thinking could have applied even to a tomb statue.

Our knowledge of decorative arts of the Old Kingdom is also limited. Later parallels suggest that the walls of Old Kingdom royal palaces and also some houses were decorated with paintings. This might explain the unexpectedly high standard and the rich repertory of scenes found in tomb paintings from the very beginning of the Third Dynasty. If the tomb was regarded as a posthumous house of the person's *ka*, this concept may offer a completely new explanation for the introduction of paintings in

tombs, and one which is independent of provisioning concerns. So little is known of Old Kingdom civil architecture in mud brick, however, that the precise nature of palace and house decoration remains conjectural. Furniture such as chairs, palanquins and beds is represented in reliefs and paintings on the walls of Old Kingdom tomb chapels, and examples of the elegantly designed palace furniture of Queen Hetepheres, the wife of Snofru and the mother of Khufu, have been found at Giza (82, 83). Interpretation of this discovery presents problems, however: the tomb was intact and contained an alabaster canopic chest (the equivalent of canopic jars in other tombs) containing the queen's internal organs removed during mummification, but her mummified body was missing.

The furniture, now beautifully restored, comes from the queen's bedroom and includes a bed with an inlaid footboard, bed canopy, headrest, two armchairs, a palanquin, curtain chest and a box containing the queen's bracelets. All were made of wood richly decorated with faience and other inlays in gold and silver settings. The legs of the bed and armchairs terminate in lion's paws (this, and a bull's lower legs with hooves, had been favourite motifs since the Early Dynastic Period). The arms of one of the

82–83
Hetepheres's
furniture
from Giza,
c.2530 BC.
Gilded and
inlaid wood.
Egyptian
Museum,
Cairo
Below
Bed:
178×97cm,
70×38¼in
Opposite
Chair:
h.79·5cm,
31¼in

chairs are formed by an openwork design imitating three lotus flowers lashed together. Those of the other chair are decorated with Horus-hawks with partly spread wings, as if about to take off, perched on columns with palm capitals. These capitals predate the earliest examples of palmiform columns in temple architecture. The chair's back is decorated with a row of emblems associated with the goddess Neith. The back of the palanquin is inscribed with the queen's name and titles expressing her status as the king's consort in hieroglyphs made of gold and set in ebony. The queen's heavy silver bracelets are decorated with a butterfly design in turquoise, lapis lazuli and carnelian (84).

Knowledge of Old Kingdom jewellery is restricted by the almost complete lack of intact tombs of this period. 'Diadems', which held down the massive wigs of Old Kingdom ladies, are sometimes shown in statuary (see 75). Similar objects, made of copper inlaid with gold and carnelian and decorated with the motif of a lotus flower and papyrus umbels with birds perching on them, have been found in tombs. The lotus flower, which suddenly appears above the water's murky depths, was a symbol of rebirth and indicates that these diadems had been specially made for funerary

84
Hetepheres's
bracelets
from Giza,
c.2530 BC.
Silver inlaid
with
carnelian,
turquoise and
lapis lazuli;
outer diam.
9–11cm,
3½–4⅜in.
Egyptian
Museum,
Cairo

purposes. Such items worn in daily life were probably made of
textile or leather inlaid with semiprecious stones. Many stone
vessels of imaginative forms were used for ceremonial and funer-
ary purposes rather than in daily life. Particularly interesting are
alabaster vases, some in the shape of a monkey with a baby,
which commemorate royal jubilees. Their symbolism has not yet
been fully explained.

The heights reached by architecture, sculpture, painting and the
decorative arts during the Old Kingdom are undisputed. However,
the pattern of ancient Egypt's history was of long periods of stabil-
ity and outstanding achievement interspersed with short periods
of disintegration and disarray. By 2123 BC the forces of disorder
were unstoppable.

4

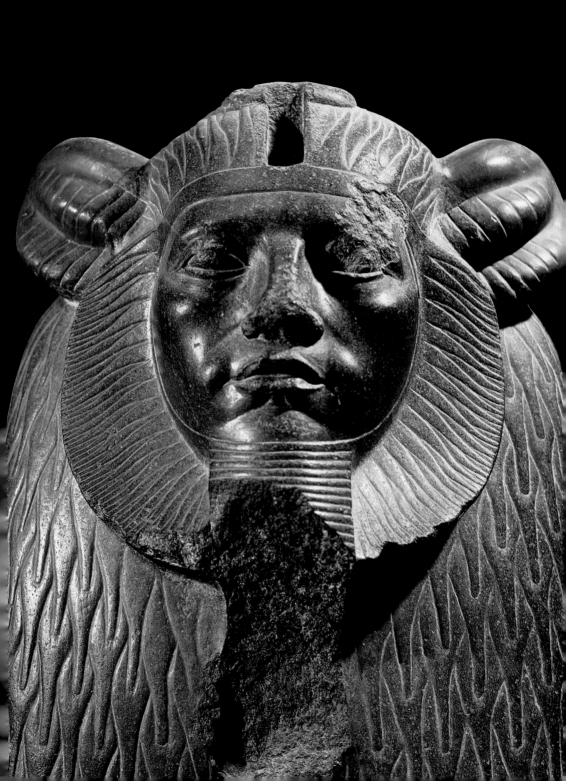

In the century that followed the Old Kingdom, from 2123 to
2040 BC, Egypt was divided between two power centres, one
in the north, at Heracleopolis, the other in the south, at Thebes.
(This is sometimes called the First Intermediate Period, but a
term which so completely disregards history's dynamics is better
avoided.) The northern kingdom, based at Heracleopolis (Ninth
and Tenth Dynasties), continued the artistic tradition of the Old
Kingdom while the arts of the First Theban Kingdom in the south
(Eleventh Dynasty) progressed from humble and austere begin-
nings to much more energetic and innovative forms.

85
Head of the
sphinx of
Amenemhet III
from Tanis,
c.1820 BC.
Granite;
h.150cm, 59in.
Egyptian
Museum,
Cairo

The end of the Old Kingdom was brought about by a deep
political and economic crisis that engulfed Egypt. This was
neither a social uprising nor an invasion from abroad but a
result of the fact that reality had overtaken the religious and
other beliefs on which the system was based, and no further
progress was possible without substantial adjustments.
The absolute power of the king, especially his control over the
land, was weakened to such an extent that he was no longer
able to carry out effectively the duties delegated to him by the
gods and expected from him by his subjects. It was a crisis of
ideas as much as a decline in the country's economy. Such an
outcome, after some 450 years of conspicuous prosperity, was
inevitable, but the form that it took was determined by the chance
occurrence of a number of contributing factors: a period of low
Nile inundations which augured the onset of a drier climate and
led to worsened conditions for agriculture; a deep crisis in royal
succession following the immensely long reign of Pepy II, which
produced a large number of elderly heirs vying for the royal
throne; a drive for greater autonomy among local administrators
who exploited the weakness of the royal house; and unrest at
Egypt's borders.

It is unlikely that the northern capital at Heracleopolis (modern Ihnasya el-Medina), some 100 km (62 miles) south of Cairo, ever replaced Memphis in its role as the manufacturing and trading centre. The necropolis at Heracleopolis suggests that the city, though important, nevertheless remained provincial in many of its characteristics. The Heracleopolitans were the true successors of the Old Kingdom rulers, but their authority was soon challenged by a new line of kings that arose in the south, at Thebes (modern Luxor).

The building activities of the Heracleopolitan kings were on a much smaller scale than their predecessors'. Only one pyramid, of King Merykare (2065–2045 BC), is known and this is situated in the old Memphite necropolis at Saqqara. It is so poorly preserved that even its identification is in some doubt. At present, there is no evidence that workshops responsible for the relief-carving and the making of statues for royal monuments continued to be productive. Private tombs were built, but the restricted circum-stances were clearly visible. The decoration of the brick-built freestanding tombs at Heracleopolis and Saqqara was confined almost exclusively to their false doors and stone panels (called 'side pieces' by Egyptologists) flanking them on either side. The false doors carried the traditional scene of the deceased person at a table with offerings, while the side pieces were decorated in low relief with a selection of scenes previously shown on the walls of mastabas, especially those connected with the tomb's supplies of offerings. But cases where these representations are more than pale miniature reflections of the magnificent wall-reliefs of the Old Kingdom are few. The relief showing people brewing beer and cooking meat, from a tomb at Heracleopolis, is one of such rare cases where the connection between Heracleopolitan reliefs and their Old Kingdom predecessors is clear (86).

Asyut, some 320 km (199 miles) south of modern Cairo, was the most prosperous outlying province of the Heracleopolitan king-dom and an important centre of artistic production with its own recognizable style. There must have been contacts with the traditional workshops further north, but local conditions and the

86
Servants
brewing beer
and cooking,
from a tomb at
Heracleopolis,
c.2100 BC.
Limestone,
painted raised
relief;
80 × 35 cm,
31½ × 13¾ in.
Egyptian
Museum,
Cairo

character of artistic production at Asyut were quite different.
The tombs of the Asyut nomarchs (at first local administrators,
now local princes) were rock-cut and rather sparsely decorated
with scenes executed in raised relief in which only the surface
surrounding the image was cut away. In these, the presence of
soldiers was a new feature that mirrored political reality in the
country. But the number of such tombs was small.

Almost all private statues were made of local wood and show a
standing figure (87). These were the best Egyptian sculptures of
their time and continued the tradition of the Memphite workshops
in a new local Asyut style. Long limbs and rather fierce and unso-
phisticated facial expressions were among its characteristics.
There are only a few seated statues made of stone. Small wooden
figures, often grouped to form scenes, were placed in the tombs'
burial chambers. They were the successors of Old Kingdom

servant statuettes (see 80), and their function was the same as that of tomb reliefs. They showed processions of offering-bearers, workshops, agricultural activities and even boat funerals. Wooden painted coffins were made in large numbers and were for most people the only item in the tomb with any artistic pretensions. Rectangular coffins had already been used during the latter half of the Old Kingdom, but their decoration, either carved into the wood or painted, had been limited to simple texts and a list of offerings required by the deceased in the afterlife. The painted decoration of coffins of the Heracleopolitan Kingdom became more complex and artistically more interesting. Pictorial lists of items needed by the deceased in the afterlife and religious compositions called Coffin Texts were often included on the coffin's interior. Their purpose was to provide the deceased with the religious spells required in the afterlife. In this they may be compared with the Pyramid Texts that performed a similar function for kings and from which they partly derived. The arts of the Heracleopolitan Kingdom attempted to uphold the earlier tradition in very restricted forms. But the main importance of the period lay in the political situation rather than its artistic achievements, which could not surmount the unfavourable conditions in which the artists were obliged to work.

At about the time that the Heracleopolitan kings replaced the last rulers of the Old Kingdom in Memphis, in 2123 BC or shortly afterwards, a serious challenge to their freshly asserted supremacy emerged in the south. The descendants of the local administrators at Thebes exploited the inability of the Heracleopolitans effectively to control the southern part of the country. Thebes was a district capital of modest importance during much of the third millennium BC and its local princes may at first just have been anxious to preserve the autonomy gained at the end of the Old Kingdom. But soon these self-proclaimed kings became more ambitious and through alliances or aggression gained control of the southernmost districts of Egypt. Eventually, they confronted the Heracleopolitans in a series of armed clashes interspersed with periods of peaceful coexistence. For much of this time the boundary between the two rival kingdoms remained in the region of the city of Abydos.

87
Statue of
Chancellor
Nakht from his
tomb at Asyut,
c.2050 BC.
Painted wood
with inlaid
eyes;
h.179cm,
70½ in.
Musée du
Louvre, Paris

Provincial centres of artistic production that had developed in the south differed in two important ways from similar centres in the Heracleopolitan Kingdom. First, most of the southern districts enjoyed a period of autonomous development before they were absorbed into the Theban Kingdom. Second, the contacts of the local workshops in the south with the traditional artistic centres in the north were very limited, possibly nonexistent. These two characteristics led to greater originality and a more pronounced local character of artistic production in the southern part of Egypt.

Southern nomarchs were buried in rock-cut tombs near their residences at sites such as el-Mialla and Gebelein. Because of the

88
Bringing produce to the granary, from the tomb of Iti at Gebelein, c.2100 BC. Painting on plaster; h. of register 84cm, 33in. Museo Egizio, Turin

lack of skilled sculptors and the poor quality rock, these tombs contain almost exclusively painted decoration (88). The new unsophisticated character of their art is shown in the rather unusual, almost clumsy, design of the scenes, their less strict division into registers and the loosening of the proportions of figures. All this is compensated for by the fresh approach to representations and the artists' willingness to innovate: new subjects or new variations of traditional scenes were introduced, and unusually bright colours were distributed in ways previously unknown. The less rigorous insistence on registers was probably a reflection of a new way of perceiving space rather than of a lack

of skills. Such a reinterpretation of one of the main artistic conventions of Egyptian two-dimensional representations was made possible by the weakening of central control over artistic production. While the topics of these tomb paintings did not change substantially, even ordinary agricultural scenes such as the transport of grain to granaries are quite distinctive.

Relief survived mostly on stelae (89). These were generally no longer of the false door type but reverted to the rectangular stone slab. This is the Old Kingdom false door reduced to its main element – the rectangular panel above the 'door' itself. On the stela, the dead person and his family, usually standing, are the

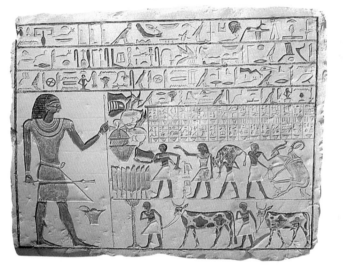

main figures. Sometimes they are accompanied by their dogs and small figures of their servants and attendants. The stelae also contain representations of food offerings and a text in which such offerings are asked for; the subjects of its decoration were thus reduced to those regarded as being the most important for the wellbeing of the deceased. Artistically, the grotesquely disproportionate sizes of the major and minor figures are a striking feature. The relative sizes of figures conveyed their importance in Old Kingdom reliefs, but the differences had not been so pronounced as on some of these stelae. Hieroglyphic signs never lost their pictorial character and they now changed their forms in a process

in which palaeographic differences mirrored the divergence in artistic conventions.

The tombs which the three early Theban kings, all called Inyotef, made for themselves at el-Taraf, on the west bank of the Nile opposite Luxor (90), bear eloquent witness to the situation at Thebes between 2123 and 2050 BC. These tombs are rock-cut and resemble the tombs of provincial nomarchs, but are large in size and ambitious in design, with a grand forecourt displaying a series of openings cut into the rock which create the impression of a pillared portico. But the rooms behind the portico are undecorated, presumably because of the lack of skilled craftsmen and artists.

90
Map showing
the Theban
area

The representations of the kings on the royal stelae are cut in bold raised relief reminiscent of the decoration of royal funerary monuments at the end of the Sixth Dynasty. The accompanying texts are in sunk relief. These royal stelae are much superior in the precision of their carving and the modelling of the details of the figures to other contemporary monuments. On one of the stelae, now badly damaged, Inyotef II (2107–2058 BC) was shown with his dogs. All of them were named: one was called Oryx, another Blackie, but some of their names are Libyan and thus difficult to understand. The newly self-elevated Theban king was still very much a provincial hunter at heart rather than a refined monarch, and it would be hard

to find a monument which shows this with greater eloquence.

At Thebes, the succession within the royal family was orderly, with the three Inyotefs ascending the throne in turn, but at Heracleopolis the reigns were short, a sure sign of dynastic trouble. The struggle for supremacy in Egypt ended around 2040 BC when the Theban king Nebhepetre Mentuhotep II (2050–1999 BC) emerged victorious over the last Heracleopolitan ruler, although it is not known precisely how he achieved this. His reign introduced a new historical and artistic period, usually described as the Middle Kingdom (2040–1648 BC). Although Nebhepetre Mentuhotep became sole ruler of Egypt, his attention nevertheless remained focused on his home city and Upper Egypt. While little survives from his reign or those of his two successors, also called Mentuhotep, he is associated with one outstanding architectural achievement. This is his funerary monument, a temple combined with the royal tomb, at Deir el-Bahri, on the west bank of the Nile opposite Thebes (91, 92). The monument is situated in a large bay overlooked by steep cliffs. The overall conception was similar to that traditionally associated with Egyptian pyramid complexes (which consisted of a lower temple, causeway and upper temple with the royal tomb). This was presumably a symbolic or pragmatic reference to the reunification of Egypt during Nebhepetre Mentuhotep's reign. In the upper temple, the external appearance of the rock-cut tombs of Nebhepetre Mentuhotep's predecessors was retained, but it was brilliantly transformed into a structure with pillared porticos on two levels (A), a hall with columns (B) surrounding a mastaba-shaped structure at its centre (C), and a court (D) with another columned hall behind it (E). The entrance to the royal tomb was in the court but the tomb itself was cut some 150 m (492 ft) into the rocky mountain. The avenue and ramp immediately before the temple were lined with precisely planted sycamore and tamarisk trees. The temple is a good example of the Egyptian architects' ability to retain the essential characteristics of an earlier structure in a completely new design. Although there is no documentary proof to confirm this, it appears that the architect deliberately took into account the general appearance of the

rocky landscape to enhance the effect of his architecture. If so, then it was the first such case in the history of Egyptian architecture and one for which there are few parallels.

The long causeway approaching Nebhepetre Mentuhotep's monument from the lower temple was flanked by royal statues. These showed the king standing draped in a close-fitting cloak, his arms crossed on his chest, with the royal insignia of a crook and a flail-like flagellum in his hands. This probably represents the king taking part in his posthumous jubilee festival, during which his physical powers and his entitlement to rule were tested and renewed. However, the mummy-like posture, cross-armed gesture and royal attributes also link these images with representations of the god Osiris. Such a skilful reinterpretation of traditional iconography would not be at all unusual. The belief that the deceased king continued his existence in the kingdom of Osiris may date back at least five hundred years to the time of King Snofru (2573–2549 BC). By the reign of King Unas (2341–2311 BC), the deceased king was identified with Osiris, the Pyramid Texts referring to the king as 'Osiris Unas'.

Osiris was at first a local deity of a Delta region, probably Busiris in the eastern Delta. According to myth he was murdered by his wicked brother Seth, but his wife, the goddess Isis, with the help of her sister, Nephthys, was able to restore the dismembered body. Isis then succeeded in conceiving and bearing his son, the god Horus. The Pyramid Texts contain elements of this myth. Although not a complete account, the events are roughly in keeping with the story as recounted by the Greek historian, biographer and philosopher Plutarch in the second century AD. Osiris' death and resurrection, in a process comparable to that witnessed annually in nature, perhaps because of the accessibility of the imagery, eventually became a universal symbol of death and rebirth in ancient Egypt that was embraced by ordinary people as well as kings. The identification of Nebhepetre Mentuhotep with Osiris may also be intended in another statue (93) which was found in a second rock-cut burial chamber of the funerary monument. Here the dark

91–92
The upper part of the funerary temple of Nebhepetre Mentuhotep II, Deir el-Bahri, Western Thebes, c.2000 BC
Top
Reconstruction drawing. (A) Porticos, (B) 1st columned hall, (C) Mastaba-shaped structure, (D) Court, (E) 2nd columned hall
Bottom
View

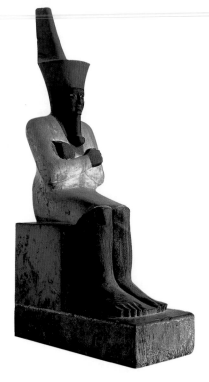

93
Statue of
Nebhepetre
Mentuhotep II,
from his
funerary
temple at
Deir el-Bahri,
Western
Thebes,
c.2000 BC.
Painted
sandstone;
h.183 cm, 72 in.
Egyptian
Museum,
Cairo

complexion of the figure may allude to the colour of soil (Osiris was often shown with a green complexion, reminiscent of vegetation).

Some of the walls of Nebhepetre Mentuhotep's funerary monument were decorated in a rather flat relief, a departure from the bold relief on the stelae of his predecessors but very much the contemporary trend. Sunk relief was also used. The decoration, now very badly damaged, resembled the temples of the Old Kingdom pyramid complexes in the variety of scenes. Some new subjects were added, such as battle scenes, no doubt a legacy of the insecurity prevalent during the preceding period.

The sculptor Irtisen, a contemporary of Nebhepetre Mentuhotep II, claimed in his biographical inscription on a stela from his tomb at Abydos that:

I was, indeed, an artist who excelled in his art, one who achieved pre-eminence because of what he knew ... I knew [how to represent] the stride of a man and the walk of a woman ... the poise of the arm harpooning a hippopotamus, the movements of a runner ...

The word 'artist' that Irtisen uses is the same as that which in other contexts is translated as 'craftsman'. It is tempting to think that the change in the appearance of the reliefs in Nebhepetre Mentuhotep's funerary monument was due to artists such as Irtisen who were brought to the Theban region from the north after the reunification of the country. The text on Irtisen's stela does not make this quite clear, however, and so it may be that the artistic tradition of the Old Kingdom survived, in a very limited fashion, at Thebes through the century or so of Egypt's disunity. Some of the trends that can be observed in the arts of the Middle Kingdom may have developed in Upper Egypt, away from the traditional artistic centres in the north, and were then adopted into the arts of the Middle Kingdom after the country's reunification.

Tombs and chapels of the female members of Nebhepetre Mentuhotep's family were incorporated into his funerary monument during modifications of its plan. Their sarcophagi are decorated in deep sunk relief and the deceased appear in scenes similar to those previously known from tomb walls. The carving is of a high quality with an almost fussy attention to detail. The figures are tall and slim, a legacy of the arts of the First Theban Kingdom. They can be seen in the depiction of Princess Kawit being presented with an ointment jar by a female servant (94). The rock-cut tomb of the chief queen, Nofru, also in the vicinity of the Deir el-Bahri temple, contained reliefs in which women predominated (these include members of her retinue, and servants such as her hairdressers). Both bold raised relief and sunk relief were used in the tomb. This was a significant departure from the earlier specialized use of these techniques (raised relief for the diffused light inside the tomb, sunk relief for the bright sunlight outside). In a custom somewhat similar to that of the Old Kingdom pyramid complexes where officials were buried in adjacent necropolises, the tombs of officials of Nebhepetre Mentuhotep II and his immediate successors are located in the vicinity of the royal funerary monument at Deir el-Bahri and at nearby Asasif. While there were earlier tombs, from the end of the Old Kingdom (after c.2200 BC) and the First Theban Kingdom

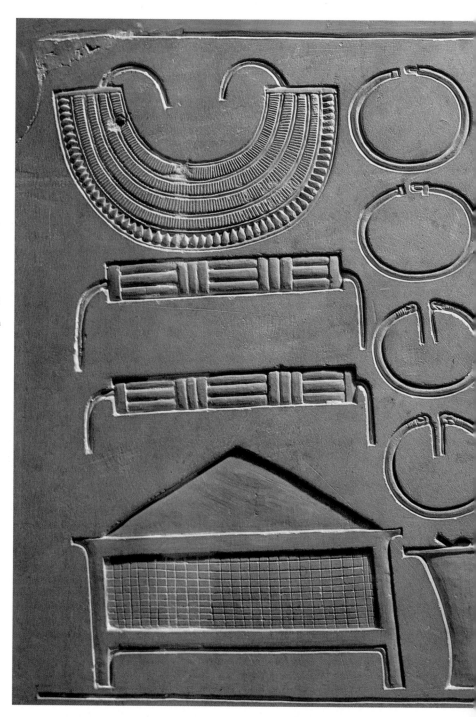

94
Princess Kawit
being
presented with
an oil jar in a
relief from her
sarcophagus,
c.2030 BC.
Limestone,
sunk relief;
h.119cm,
46⅞in.
Egyptian
Museum,
Cairo

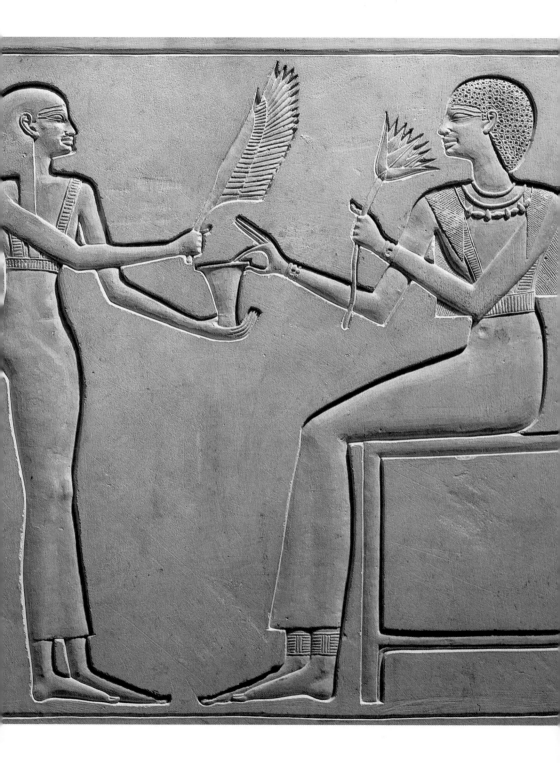

(2123–2040 BC) on the Theban west bank, it was those made under Nebhepetre Mentuhotep II and his successors which truly inaugurated the long line of Theban rock-cut tombs that was to flourish so magnificently some six hundred years later, during the Eighteenth Dynasty (after 1540 BC).

A small but interesting archaeological find from the reign of Sankhkare Mentuhotep III (1999–1987 BC) comes from the rock-cut tomb of his chancellor, Meketre, located in a valley to the southwest of Deir el-Bahri. It contained a remarkable collection of small wooden figures like those known from earlier sites, especially the provincial tombs in the Heracleopolitan Kingdom. These show various activities which had once been represented on the relief-decorated walls of tomb chapels of the Old Kingdom: a carpenter's shop, spinning and weaving, men netting fish from boats, the inspection of cattle (95), brewing and baking, a granary, a slaughterhouse and offering-bearers. These models demonstrate how different approaches to tomb equipment and decoration were able

95
Inspection of cattle, figures from the tomb of Chancellor Meketre, southwest of Deir el-Bahri, Western Thebes
c.1990 BC.
Painted wood; l.175cm, 69in.
Egyptian Museum, Cairo

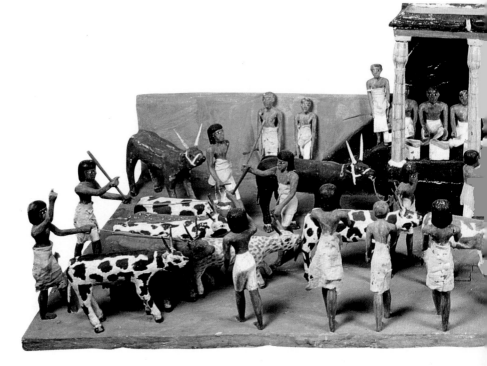

to perform the same function. The choice of the appropriate method did not, however, depend on the preferences of the person commissioning the tomb, but was governed by the customs prevalent in a particular area at a given time. This was probably decided in the workshops supplying the tombs with the approval of the priesthood attached to the necropolis.

The Thebans, who achieved their goal of reunifying Egypt, remained essentially Upper Egyptian kings who regarded the northern part of the country as an adjunct to their Theban kingdom. This changed with the reign of Amenemhet I (1980–1951 BC), the first king of the Twelfth Dynasty (1980–1801 BC). Probably the vizier of the previous Theban king, Nebtawyre Mentuhotep IV (1987–1980 BC), and so a usurper to the royal throne, he succeeded in breaking out of this self-imposed provincialism and restored the balance of the country disturbed during the century of political disunity. He established his new royal residence and capital, appropriately named Itj-tawy ('The Seizer of the Two Lands'), at the

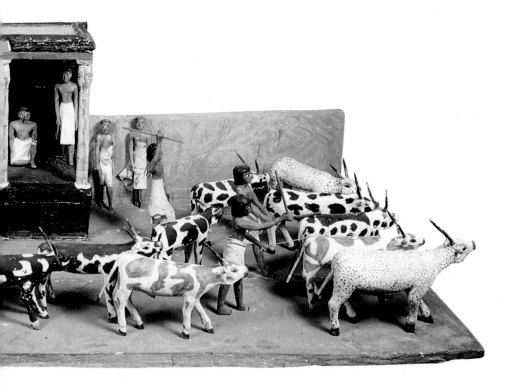

southern edge of the traditional Memphite area, near modern el-Lisht. His native city, Thebes, was too far south to serve conveniently as the administrative centre of Egypt. The Memphite area, between the Delta and the Nile Valley, had attracted Egyptian kings from the beginning, but a return to the Old Kingdom city of Memphis was probably not possible because of local environmental conditions around 2000 BC, especially the unpredictability of the river which at that time was rapidly retreating eastward. In moving the administrative centre of the country and the royal residence to the north, to Itj-tawy, Amenemhet I, in fact, created the duality of two capitals which, in varying intensity, would last for the rest of Egyptian history. While Itj-tawy/Memphis was the secular capital of Egypt, the religious centre would from then on remain at Thebes.

Amenemhet I marked his return to the Memphite area by reverting to the traditional pyramidal form for his tomb. And rather than choosing the Theban west bank as the site for the royal necropolis, he built his pyramid complex near his new capital at el-Lisht. The pyramid was of the standard Old Kingdom size. But in at least one respect Amenemhet I retained an innovation of his predecessor Nebhepetre Mentuhotep II and so a link with Thebes. The pyramid and the upper temple were built on two different levels. During the construction of his pyramid, Amenemhet I used a large number of stone blocks taken from the dilapidated Old Kingdom pyramids and their temples at Giza, Abusir and Saqqara, many of them with the remains of relief decoration. The decorated faces of the blocks were concealed in the core of the pyramid, so it was not an attempt to incorporate them into the decoration of Amenemhet's own funerary monument (such cases are known from later periods, but are very rare). This was a curiously ambiguous approach to the monuments of the king's predecessors. But stone blocks, decorated or not, had been reused as building material on earlier occasions (though not on this scale), and Amenemhet I would be surpassed in this activity by Haremhab (1323–1295 BC, Eighteenth Dynasty) and Ramses II (1276–1213 BC, Nineteenth Dynasty). It is intriguing to speculate whether the builders of Amenemhet I regarded such an activity

as a simple reuse or whether it was more significant. It may be that the king wished to associate himself with some of the most illustrious kings of the Egyptian past.

Amenemhet I was the first of a line of powerful rulers who restored Egypt's fortunes during the first two centuries of the second millennium BC. The country's economy benefited from the attention paid to it by state administration. This was new and possibly due to the memory of the disastrous famine which had ravaged parts of Egypt during the previous years of political disunity. Large-scale reclamation work was undertaken in the Faiyum Oasis in order to increase arable land, and the resultant conspicuous prosperity was to give a new lease of life to the arts.

In its foreign policy, Egypt first turned to the south, to Nubia, where the previous crude exploitation through plunder and pillage was replaced by permanent occupation secured by a series of military expeditions early in the Twelfth Dynasty (after 1980 BC). The large fortresses built in the region of the second Nile cataract at Buhen, Mirgissa, Uronarti, Semna and elsewhere are the earliest examples of specialized military architecture in ancient Egypt. Their tasks were to protect Egypt's southern frontier, to control downstream river traffic and to maintain observation of the desert caravan routes joining the Nile Valley. Some of the defensive ideas and arrangements may have been adopted from Western Asia, but as examples of military architecture these forts are undoubtedly Egyptian structures.

The forts were densely packed with houses, administrative buildings and storerooms, with no open spaces left between them. They were built at the river's edge so that they were approachable by boat. Their sides facing the desert were protected by massive brick-built walls (96). It is easy to understand that the soldiers and civilians who were stationed here felt uneasy in the hostile environment, which was quite unlike their homeland, and wanted maximum security. In military terms, however, these brick-built fortresses with their glacis (slopes), moats, bastions, crenellated walls and cleverly protected gates represented overkill on a huge

scale – their size and the sophisticated defence arrangements bore no relationship to the threat posed by the nomadic population of the neighbouring deserts decimated by the military expeditions at the beginning of the Twelfth Dynasty.

The situation is faintly reminiscent of that encountered in pyramid construction during the Old Kingdom, although the motivation is entirely different. But even here, in the case of structures whose main function could hardly be more pragmatic, the modern notion of practicality does not apply. These forts were probably an early example of the use of architecture as an expression of power and authority, and their main task was to intimidate and deter any potential trespasser on to Egyptian territory. An Egyptian text tells us that even sculpture may have been used in this area for the same purpose. King Senwosret III (1878–1859 BC) encourages the defenders of Egypt's southern limits: 'My Majesty has had a statue of My Majesty made at this border in order that you maintain it, in order that you fight for it.'

In its relationship with Western Asia, Egypt relied on commerce rather than warfare. Intensive trading contacts were maintained with the Syro-Palestinian region, especially the city of Byblos on the Lebanese coast, where vases and other objects bearing the names of kings of the Twelfth Dynasty, as well as Egyptianizing items of local manufacture, were found in the tombs of local rulers.

Fortifications were built along the border in order to prevent any encroachment on Egyptian territory by nomads living in the adjoining deserts. Expeditions were sent to the copper and turquoise mines at Wadi Maghara and Serabit el-Khadim in Sinai. In home affairs, however, Egyptian pharaohs were unable to act with the flourish that had characterized the great rulers of the Old Kingdom some 750 years earlier. Initially, there was a price to pay for the allegiances and support that the Theban rulers received in their struggle against the Heracleopolitans. Local princes were able to cling on to a considerable degree of autonomy in local affairs, and attempts to reduce the independence of the nomarchs coloured most of the history of the Twelfth Dynasty.

While royal phraseology and iconography did not change much from Old Kingdom usage, this was in reality a different kind of kingship. It was not accidental that some of the texts which extol the virtues of the ruling king in the most glowing terms and in the most persuasive fashion date to this period, for example on the stela of Sehetepibre found at Abydos (the king is Amenemhet III):

He illuminates the Two Lands more than the sun disc, he makes the land more green than the great inundation. He has filled the Two Lands with strength and life. The noses go cool when he starts raging; when he is friendly disposed the air is breathed again. He gives food to those who follow him, he nourishes him who is loyal to him. The king is food, and his mouth is wealth, and he is the creator of that which will be. He is Khnum [ie the creator god] of everybody, the begetter who creates mankind. He is Bastet [ie the friendly aspect of the lioness goddess] who protects the Two Lands; he who worships him will be protected by his arm. He is Sakhmet [ie the bellicose aspect of the lioness goddess] to him who transgresses that which he has commanded; he whom he hates shall be in distress.

The funerary monuments of the later kings of the Twelfth Dynasty were characterized by modifications of the pyramid's internal design (especially the abandonment of the entrance from the north) and the creation of an upper enclosure, which now encompassed all the features of the pyramid complex (pyramid, pyramid temple,

subsidiary pyramids and pyramidal tombs of queens) apart from the lower temple and causeway. Constructionally, a major change occurred when the core of the pyramid of Senwosret I (1960–1916 BC) at el-Lisht was built of stone retaining walls and cross-walls, form-ing compartments which were then filled with rubble. Senwosret II (1886–1878 BC) used mud bricks in his pyramid at el-Lahun and so inaugurated a series of what were, in fact, brick-built pyramids. The pyramids were, of course, encased in stone and in their pris-tine state their appearance did not betray such a radical labour-saving procedure. This was a victory of down-to-earth pragmatism over idealistic perfection and a far cry from the accomplishment of Khufu's pyramid some six centuries earlier (see 8). The immediate practical consequences of this change may have been limited, but it was a watershed in Egyptian thinking and the beginning of a process of coming to terms with reality which was to characterize much of the Middle Kingdom.

The pyramid of Senwosret II at el-Lahun had a walled settlement near its lower temple which housed the workmen employed in its construction as well as the personnel of its temples. Similar settlements, although on a much smaller scale and far less well preserved, have been located in the vicinity of some Old Kingdom pyramids. There is a clear distinction in size and internal plan between the dwellings in a closed-off workmen's quarter, the houses of the officials and priests, and the residence of the gover-nor. This was, of course, purpose-built housing which was hardly typical of civil architecture in Egyptian villages or the housing of the poor in Egyptian cities. El-Lahun workmen must have repre-sented the élite of the Egyptian working population.

Egypt's successes during the Twelfth Dynasty were due to the abil-ity of its kings to assert themselves against the power of the local nomarchs. This was a protracted battle that could not be won quickly. Sadly for Egypt, in the end the pharaohs simply ran out of time when unfavourable climatic changes, especially a decline in precipitation, intervened and led to a period of economic stagna-tion and political stalemate. After 1800 BC royal authority rapidly

declined until the pharaoh became little more than the most powerful among the local princes. It is even possible that rival claimants for the Egyptian throne made their appearance as early as this period. Architecture reflected the changes: some of the kings did not have pyramids but were buried in tombs built inside the precincts of earlier pharaohs. A handful of royal pyramids are known – at Saqqara, Dahshur and Mazghuna – but they are small structures built of mud brick, and some have no surviving inscriptions or reliefs in their temples and so are unidentifiable. These were among the last pyramids built on Egyptian soil and they brought to a close a glorious chapter in ancient Egyptian architectural history that had started with the Step Pyramid of Djoser (see 43) a thousand years earlier.

The temples which accompanied the pyramids of Twelfth Dynasty kings displayed relief decoration that combined tradition with innovation. The architects of Amenemhet I and his successor Senwosret I deliberately imitated the themes and techniques in the temples of Old Kingdom pyramids, especially that of Pepy II (2236–2143 BC) at Saqqara. Sometimes they were so successful that it is now difficult to distinguish between fragments of Sixth Dynasty and Twelfth Dynasty reliefs. This was the first, though not the last, time in the history of Egyptian art that imitation of past styles occurred on a large scale; superficially it is almost as if the two centuries separating these kings from the last great ruler of the Old Kingdom never happened. The similarity must have been achieved by studying the buildings and their decoration while stone blocks were being extracted for reuse as building material in the pyramids of contemporary kings.

On closer examination, however, some differences do become apparent. Just like the architecture, these reliefs retain traces of their less orthodox Theban ancestry, for example in their greater preoccupation with detail when compared with the more austere reliefs of Pepy II, and in the less idealized faces of the minor figures. This was, no doubt, due to the fact that the sculptors carving these reliefs were brought from the south. They introduced

elements of their early training in the southern artistic workshops into their work even when they tried to imitate the Memphite style of the Old Kingdom. The local artistic studios in the Memphite area had probably withered away in the aftermath of the Heracleopolitan defeat or were unable to cope with such a large-scale task. One can draw a partial comparison with the situation that was to occur early in the reign of Tutankhamun (1336–1327 BC), when the court, accompanied by its artists, moved from el-Amarna to Memphis (see Chapter 6). Then, the Amarna artists were asked to revert to the traditional ancient Egyptian style, and while they successfully achieved this, the influence of their early training showed unmistakably in their work.

During the Twelfth Dynasty, a canonical grid (97) came into use, where the height of a standing figure, measured from the lowest point where the wig touched the forehead down to the soles of the feet, was the equivalent of eighteen squares. The line marking the

97
Canonical
grid of
eighteen
squares,
drawn over a
scene from the
White Chapel
of Senwosret I
at Karnak,
Thebes,
c.1930 BC

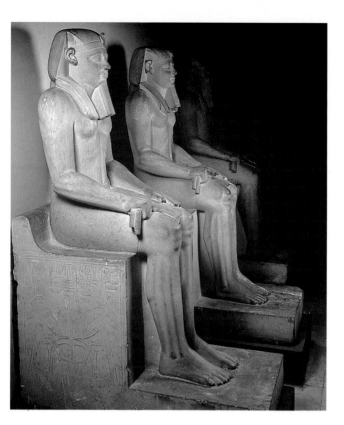

98
Statues of
Senwosret I
from his
pyramid
temple at
el-Lisht,
c.1950 BC.
Limestone;
h.200cm,
78³⁄₄ in.
Egyptian
Museum,
Cairo

top of the sixth square up from the baseline intersected the leg at
the knee, the eleventh at the waist, the twelfth at the elbows, the
fourteenth at the armpits and the sixteenth at the shoulder. The
square (module) of the canonical grid was directly linked to
Egyptian metrology: it was the equivalent of one fist (the thumb
and four fingers), or 1^1_3 palm-breadth.

As in the carving of reliefs, a tendency towards imitation of earlier
Memphite prototypes may also have affected sculptures associ-
ated with the pyramid complexes of the early Twelfth Dynasty.
Continuing the custom introduced in the funerary monument of
Nebhepetre Mentuhotep II at Deir el-Bahri (see 91, 92), the cause-
ways of pyramid complexes were lined with colossal statues of the
king. Ten colossal seated statues of Senwosret I, in this case prob-
ably intended to be placed in the upper temple's columned hall,
are good examples of such works (98). The statues are, however,
markedly different from earlier royal statues, and the contrasts are

considerably greater than those that might reasonably result from later sculptors attempting to recreate an earlier style. Like their Old Kingdom counterparts, they show the king in an idealized 'timeless' way which was obviously thought appropriate for a funerary monument. The sculptors were technically competent, but while their products display serenity and exert indisputable charm, further enhanced by the softness of the limestone, the bland face of the king has none of the confidence and authority of the best royal statues of the Old Kingdom (comparisons with the very finest Old Kingdom statues may be unfair, but, unlike reliefs, few statues from Sixth Dynasty pyramid complexes are known).

The attention paid to the temples of local deities by the kings of the Old Kingdom had been limited, but the situation changed considerably in the second millennium BC. It is possible that this was a reflection of the political situation in Egypt, where the correct royal policy towards the provinces was of the utmost importance. Access to these officially sanctioned temples was restricted to their priests, and since most local administrators also held priestly

99
Obelisk
of Senwosret I
at Heliopolis,
c.1920 BC.
Granite;
h.c.20m, 66 ft

offices linking them to the local deities (there were few, if any, professional priests at this time), this further deepened the gap between the officials/priests and the rest of the peasant population, who were left to worship in their unofficial primitive shrines.

The architecture of temples dedicated to local gods is hard to reconstruct because these buildings were pulled down or restructured beyond recognition during later rebuilding and restorations. This is true even of the temple of the god Amun at Karnak in Thebes. Although originally perhaps not a local god of Thebes, by the end of the third millennium BC Amun became the city's most important deity. His name appears as an element of the name Amenemhet, which means 'Amun is at the front' (ie 'I am in Amun's following'). As Thebes remained Egypt's religious capital even after the foundation of Itj-tawy in the north, Amun became the deity most closely associated with the Egyptian state and was regarded as the most 'senior' among the gods of the Egyptian pantheon.

Relief decoration in the Middle Kingdom temples of local gods was apparently confined mainly to scenes showing the king in the company of deities associated with the locality. However, evidence is scanty as almost all of these temples fell victim to rebuilding and expansion during the New Kingdom. Of the temple that the Twelfth Dynasty kings built at Karnak, only parts of walls decorated in raised relief and a few inscribed architectural elements remain. The same is true of temples in the vicinity of Thebes, at such sites as Tod, Armant, Nag el-Madamud and Qift (Koptos), which had already been graced by the building activities of Nebhepetre Mentuhotep II. Other remains include an obelisk (a monolithic pillar with a pyramid-shaped summit) of Senwosret I, which stands at the site of the temple of the sun god Re at Heliopolis (99), now subsumed into the northeastern part of Cairo, and a small shrine of the serpent goddess Rennutet built by Amenemhet III (1859–1814 BC) at Medinet Madi in the Faiyum. The latter has survived nearly complete, but it cannot convey the scale and variety of temple construction during the Middle Kingdom, nor can the small temple at Qasr el-Sagha which dates to the late Twelfth Dynasty.

Another structure has been preserved because it was completely dismantled in antiquity. This is a shrine known as 'The White Chapel' (100), built in fine limestone by Senwosret I at Karnak in connection with his jubilee festival. Its components were recovered from the pylon (monumental gateway) erected by King Amenhotep III (1391–1353 BC) in the temple of Amun-Re at Karnak, where they had been reused as filling material. This is one of the few cases where almost all elements of a structure were preserved,

allowing for its reconstruction. This was facilitated by the building's systematic dismantling and its small size, only 6·5 × 6·5 m (21 × 21 ft). The chapel's walls and pillars are decorated with reliefs showing Senwosret I in the company of the deities Amun, Montu, Atum, Re-Harakhty and Horus. The scene in which the king is granted life (shown by the hieroglyph *ankh* held to his nose) by the god Atum, while being led to the ithyphallic Amun (with erect penis), is characteristically hemmed in by hieroglyphics on all sides (101).

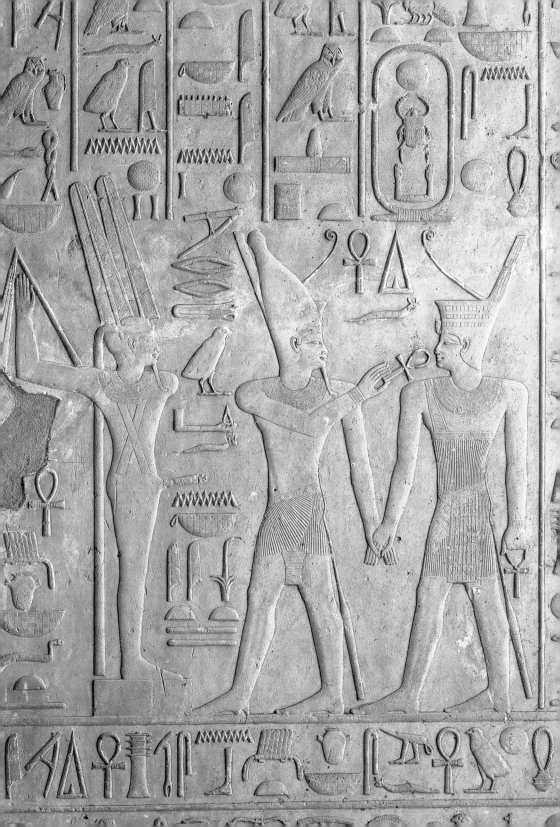

In the long-established Egyptian tradition, the kings presented the temples with statues of themselves to ensure their continuous presence in the temple and to affirm their link to the god. Standing or seated colossal statues, usually in red granite, now became frequent. But the situation is obscured by the fact that many were later partly recarved in order to accommodate the features of other kings, especially Ramses II, who placed them outside the pylons of their own temples. Most of these temple statues, regardless of their size, were quite different from those associated with the royal pyramid complexes of the early Twelfth Dynasty. They can be described as naturalistic and represent the most striking artistic achievements of the first half of the second millennium BC. It must be remembered, however, that the original provenance of these statues is often not known. Not only were some recarved, others were 'usurped' by later kings, who added their own names to the inscriptions and removed them to new locations. It is therefore not always possible to make a secure distinction between sculptures from royal funerary monuments and those from the temples of local gods.

Statues and sphinxes made of granite, quartzite or similar hard stone were common. The unusual feature of these naturalistic statues is the face of the king, quite unlike the eternally optimistic expression of the sculptures from the Memphite funerary monuments of the early Twelfth Dynasty. Now the king appears careworn, world-weary and pessimistic, with heavy eyelids and lips pressed together in an almost intimidating manner, large ears and a strong chin, a monarch who brooks no opposition and who is ready to resort to drastic measures should the situation demand them. The face seems to be a lifelike, possibly even realistic, representation. The statues of Senwosret III provide the most extreme cases of such depictions of Egyptian kings (102, 103). In view of the restricted access to Egyptian temples, it may be significant that many such heads and faces come from sphinxes which were presumably situated outside the temples' gates and so were publicly accessible. It is tempting to suggest that these sculptures hold a mirror to contemporary political reality, or that they should be regarded

as realistic portraits of the strong men of the ruling dynasty, but there is no guarantee that these interpretations are correct.

The sculptures of Amenemhet III show some softening of the facial expression, especially in the less bulging eyes and straighter lips (104, 105, see 85). Some of his sphinxes were reinscribed with the names of later kings (eg Ramses II and Merneptah, 1213–1203 BC) and were eventually set up at San el-Hagar (Tanis), the contemporary capital of Egypt in the northeastern Delta, under Psusennes I (1039–991 BC). These are most impressive statues and rather special sphinxes, in fact lion statues with human faces (rather than completely human heads; see 49, 50). Early Egyptologists could not believe that the brutal and awe-inspiring expression of these sculptures could have belonged to an Egyptian king, and saw in them statues of the foreign Hyksos rulers who gained

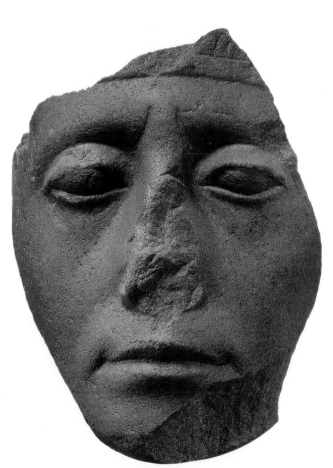

102
Head of
Senwosret III,
c.1860 BC.
Quartzite;
h.16·5cm, 6½in.
Metropolitan
Museum of
Art, New York

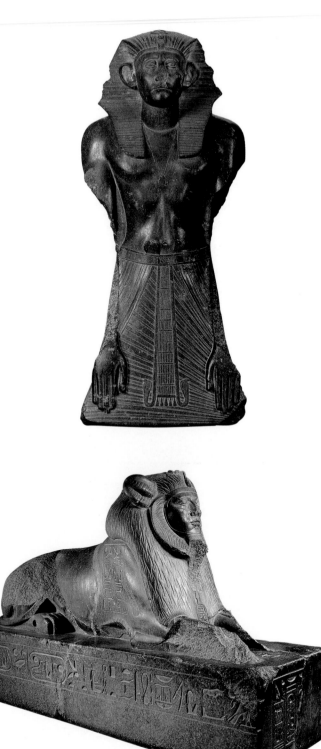

103
Statue of
Senwosret III
from the
funerary
temple of
Nebhepetre
Mentuhotep II
at Deir
el-Bahri,
Western
Thebes,
c. 1860 BC.
Granite;
h. 122 cm, 48 in.
Egyptian
Museum,
Cairo

104
Sphinx of
Amenemhet III
from Tanis,
c. 1850 BC.
Granite;
h. 150 cm, 59 in.
Egyptian
Museum,
Cairo

105
Head of
Amenemhet III,
c. 1820 BC.
Obsidian;
h. 12 cm, 4¾ in.
Museu
Calouste
Gulbenkian,
Lisbon

control of Egypt around 1648 BC, but their identification as statues of Amenemhet III is now generally accepted. Much of this misidentification was due to rather dramatic accounts of the Hyksos takeover left by classical authors and to the fact that views on Egyptian royal sculpture were initially based on rather bland and highly idealized heads of rulers of the Late Period (see 228).

Once again, the contrast with the best examples of Old Kingdom royal statues could not be greater. Both groups are magnificent works of art in their own right, but they are completely different in spirit. While in Old Kingdom statues the pharaoh is self-assured and confident in the eternal permanence of his inalienable semi-divine status, the Middle Kingdom statues show a man who knows that his position is not unchangeable. It is as if the realization had dawned that one man alone, albeit a monarch who sits on the

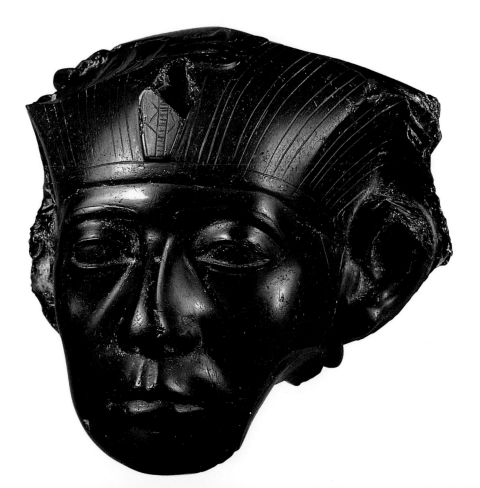

throne of Egypt, cannot guarantee the course of future events. From this time onward, divine intervention would be sought and the king would always remain in the shadow of a powerful state god: Amun became the real divine ruler of Egypt, with whom the pharaoh would share his reign.

The profound differences between naturalistic royal statues destined for non-funerary monuments (*ie* temples of local gods) and idealistic sculptures created for pyramid complexes may have been due to the different purpose for which they were made, but there are no other instances of such a deliberate dichotomy in later Egyptian art. More likely explanations include the possibility that the statues came from the studios of sculptors working in different traditions and at different places – some drawing their inspiration from the earlier Memphite works and deliberately

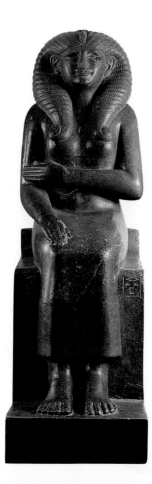

106
Statue of
Nofret from
Tanis,
c. 1880 BC.
Granite;
h. 165 cm, 65 in.
Egyptian
Museum,
Cairo

imitating their idealizing style, others following and developing the naturalistic style of the sculptors of the Theban area. Even this is not completely convincing. It may have been symptomatic of the political situation in Middle Kingdom Egypt that varied artistic approaches to royal sculpture were allowed to coexist. But in the conditions of a centralized state that exerted considerable control over the production of its artists, such differences might be expected to disappear before long.

The explanation may be much more prosaic. The idealizing statues known from the pyramid complexes belong to the early Twelfth Dynasty, before c.1900 BC, while the naturalistic sculptures are later. These chronological differences may be of crucial importance and provide the simplest but most acceptable explanation of the problem: the idealizing sculptures represent an early approach to royal sculpture that was rejected sometime during the reign of Senwosret I and replaced by a new, naturalistic, style. The exact reasons for such a radical change in the portrayal of the king remain unclear. Apart from pointing out that Senwosret I was probably an old man towards the end of his reign, we may have to resort, once again, to the idea that royal statues mirrored the political situation in the country. The certainties of the Old Kingdom had been replaced by worries and doubts and the need for the king to assert himself as the strongest figure in the land.

Pyramid temples as well as temples of gods also contained large statues of queens and also female sphinxes, which are a special feature of this era of Egyptian artistic history. They show rather heavily built women wearing massive bouffant wigs, the lappets of which fall on their chests (106). They appear as worthy companions to their royal husbands. It was for the first time during the Twelfth Dynasty that the enhanced status of royal women was reflected so clearly in Egyptian art. Later occasions, such as the end of the Seventeenth and the beginning of the Eighteenth Dynasties (around 1540 BC) or the Amarna Period (after 1350 BC), show that this was due to their importance to the royal succession. The king invariably had more than one wife, and there was a clear

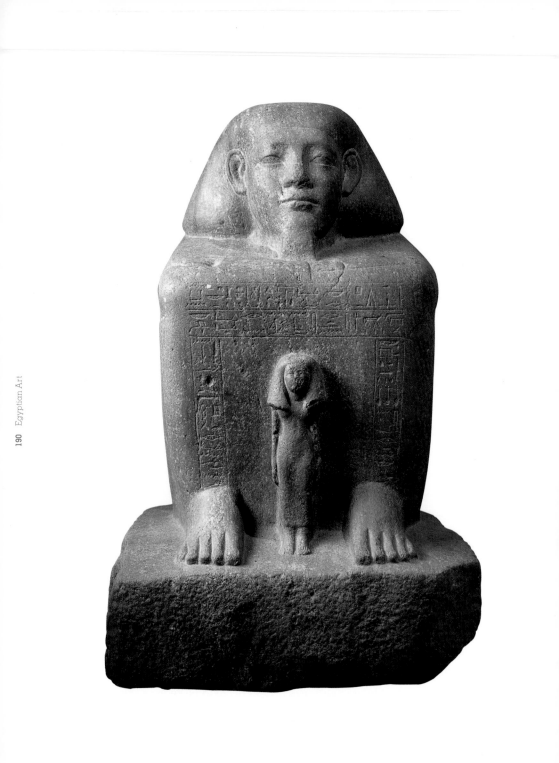

hierarchical order that had a profound bearing on the chances their offspring had of succeeding to the throne. Another feature of the Twelfth Dynasty was the institution of co-regencies, where an aged king, nearing the likely end of his reign, shared the throne with a younger man. This also suggests that there was some anxiety at this time about securing royal succession.

During the Middle Kingdom, non-royal statues appeared in temples and shrines. The best of these were probably made by the same sculptors who carved royal statues. During the Old Kingdom, it had been the quality of workmanship that identified such statues, but now physical similarities also link them to their royal counterparts, for example the treatment of the eyes, ears and mouth. These similarities may have been intentional or a matter of contemporary preferences, but were possibly just a natural consequence of the sculptors' training, which would have been primarily focused on royal statues. Non-royal statues were subject to the same rules that governed access to temples by ordinary people, and were thus mostly concentrated in the temples' outer parts. However, unless found *in situ* or described as such in inscriptions, it is not always possible to tell whether a sculpture was made for a temple or a tomb.

Two new types were introduced and became very popular as temple statues. The first of these is a block statue which shows a person (almost always a man; statues of women exist but are very exceptional) seated on the ground, with his legs drawn up in front of him, his arms resting on his knees. These statues sometimes include another smaller figure, which could represent a wife, as in the case of the block statue of Senwosret-senbefni, of the late Twelfth Dynasty (107). A long garment conceals the body except for the head, arms and feet, and the sculpture resembles a cube with the head stuck on top of it and the feet protruding at the front. It seems that these statues, or ones very similar to them, started as tomb statues at Saqqara but gradually became almost exclusively temple statues. It is easy to see why they were so popular: the posture was very common for a resting man (and still is in rural

107
Block statue of Senwosret-senbefni and his wife from the Memphite area,
c.1850 BC.
Quartzite;
h.63·8cm,
25⅛in.
Brooklyn Museum of Art, New York

parts of modern Egypt), they were relatively easy to make due to their compact form, and they provided ample space for inscriptions. This was an interesting departure that endowed the sculpture with a curious ambiguity: on the one hand, it was an image of a person which aspired to a likeness of a human body, if not a specific person, but on the other, it became a convenient surface on which to inscribe a text. Something similar had already been known to the makers of Predynastic sculptures who drew on them when they tried to indicate their context. But even scholars have been confused by this concept: when in later periods the surface of statues was also used for representations, often on the naked torso, such cases have been interpreted as evidence of body tattooing.

The second type of sculpture shows a seated man with legs either crossed in the manner of a scribe, or concealed by a long garment. The statue of Ameny, of the second half of the Twelfth or the Thirteenth Dynasty, probably comes from el-Qusiya in Upper Egypt and is a good example of the former type (108). Such statues were often set up in temples. Many remarkable private statues were found in the shrine of Hekaib, an administrator at Elephantine (Aswan) towards the end of the Old Kingdom, who came to be regarded as the area's patron and whose posthumous cult as a semi-deified person flourished especially during the Middle Kingdom. They were probably made locally, and their high quality indicates that differences in the output of sculptor's studios in various parts of the country during the Middle Kingdom were substantial, perhaps greater than in other periods of Egyptian history.

Already in the late Old Kingdom, after about 2300 BC, nomarchs (district administrators) and other officials began to be buried in the provinces, away from the Memphite necropolis. The king no longer provided them with a tomb in the vicinity of his pyramid, and as their wealth and influence were based on their offices and estates in the provinces, it was much easier for them to have their tombs made there. This became a necessity during the Heracleopolitan and the First Theban Kingdoms when the king was in no position to present his favourites with tombs. The

custom of being buried away from the royal tomb did not disappear after the reunification of Egypt under Nebhepetre Mentuhotep II, and the size and quality of the tombs of these provincial administrators provide some indication of their fluctuating degree of independence during the Twelfth Dynasty. The nomarchs whose districts were farther away from Thebes, particularly those on the territory of the former Heracleopolitan Kingdom, fared better than those in its immediate neighbourhood, presumably because they were relatively late converts to the Theban cause and so were able to retain more of their former independence.

The most important among the provincial tombs of the Middle Kingdom are at Beni Hasan, Deir el-Bersha, Meir, Asyut and Qaw el-Kebir in Middle Egypt and the northernmost part of Upper Egypt, some 250 to 350 km (155 to 217 miles) south of Cairo. The tombs at Qubbet el-Hawa (opposite Aswan) at Egypt's southern border can be explained by the exceptional importance of the local nomarchs for the defence of the country's southern border

and commerce with the areas further south. Large rock-cut tombs at Thebes are very rare, and the most important of them was made for Antefoker, the vizier of both Amenemhet I and Senwosret I. He has another tomb in which he was actually buried near the pyramid of his first royal master at el-Lisht. Egyptian administrators were often assigned to different parts of the country, away from their home cities, at various stages of their careers. They might make provision for burial at more than one place. Antefoker's Theban tomb was the earliest in which the figure of the king appeared in the decoration of a private tomb, something that would have been quite unthinkable in Old Kingdom tombs.

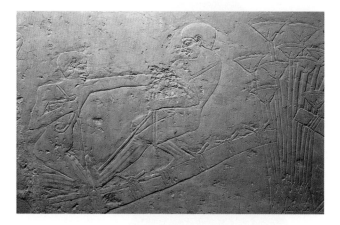

109–110
Reliefs from the tomb of Ukh-hotep at Meir, c. 1920 BC. Limestone, raised relief
Left
Making papyrus canoes
Right
Lions mating

There are some local differences in the plans of rock-cut tombs of the nomarchs. They usually consist of a portico (columned entrance) and one or more rooms on the same axis, sometimes with rock-cut pillars and a barrel-vaulted ceiling. The focus of the funerary cult was a centrally placed niche at the far end of the innermost room, often with a large seated statue of the deceased. The burial chamber was at the bottom of a shaft sunk into the floor of this room. At Qaw el-Kebir the rock-cut part of the tombs was preceded by several courts, a causeway and a valley building, almost as if the nomarch imitated the layout of Old Kingdom pyramid complexes.

The decoration in these tombs may be in raised relief, either very flat or of the labour-saving variety in which only the minimum of the surface was cut away around the figures. More often, however,

these tombs are just painted. The quality of the representations
varies considerably even at one site. Sometimes the artist produced
a scene capable of holding its own against good Old Kingdom
reliefs, for example the hunting scene in the tomb of the nomarch
Senbi, a contemporary of Amenemhet I at Meir. The hunt takes
place in a closed-off area of a desert wadi into which animals
are being driven and where Senbi, on foot and accompanied by a
retainer, is waiting. The artist modified the division of the scenes
into registers and chose a much freer scheme by using uneven
lines indicating the sparsely overgrown terrain instead of the
standard straight baselines. This enabled him to provide a much

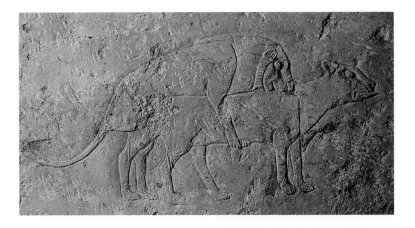

more homogeneous design, which comes surprisingly close
to Western perspective. In a later example at Meir, the tomb of
Ukh-hotep (which dates from the reign of Senwosret I), the artists
were less successful. Here, competently carved scenes arranged
in the traditional way, such as the making of papyrus canoes (109),
are combined with others where the loosening of formal organiza-
tion produced a less pleasing overall effect (110).

In most cases, however, the overall design of the scenes and the
use of space are poorly executed, often with large blank areas
which would not have been tolerated in the Old Kingdom.
The greatest contribution these Middle Kingdom artists made
to Egyptian art was their introduction of a whole range of new
subject matter. The painted tombs at Beni Hasan (111, 112) are very

unusual in their choice of subjects for depiction. In remarkable detail they show scenes of battles and siege warfare. Other events, such as wrestling bouts and children's games, are depicted in cartoon-like sequences. There are scenes of men feeding antelopes, detailed depictions of birds, a fig-harvest with pet baboons as participants, a house scene in which the cat makes its first appearance as a domestic animal, and many others.

At Beni Hasan, the artists' interest in recording movement is noticeable and its depiction is typically Egyptian. The process was divided into a series of consecutive stages which were then shown in a cartoon-like sequence, placed side by side on the

baseline, as if all of them could have been seen at the same time. A girl jumping in the air would be seen standing on the ground, taking off, and then seemingly suspended in the air. This method was used by artists throughout Egyptian history and there are many other examples: a pellet of incense being thrown on to a censer would be seen as a stream of such pellets issuing from the hand of the king and heading for the censer's bowl; a defecating animal was shown as if producing a virtual cascade of excrement.

As for the human remains contained within these rich and elaborately decorated Twelfth Dynasty tombs, they were enclosed

within massive wooden rectangular coffins. Those found at sites in Middle Egypt particularly excelled in painted decoration and carried the torch of Egyptian painting during the Middle Kingdom as much as the decoration in tombs themselves. The coffins were perceived as miniatures of the burial chamber itself and their decoration is therefore similar and appears mainly on their interior walls (113). The subject matter continued the tradition begun at the end of the Old Kingdom and established during the Heracleopolitan Kingdom: lists of offerings and various items of funerary equipment, such as jewellery, tools, weapons, vases and garments, and also representations of granaries. Sometimes there were small scenes showing the deceased in the presence of the priests performing funerary rites such as burning incense. Many coffins were inscribed with Coffin Texts and similar religious compositions regarded as essential for the deceased person's wellbeing in the afterlife, a custom comparable to the inclusion of the Pyramid Texts in Old Kingdom pyramids. Some of the highest officials of state administration were buried in freestanding mastabas built near the pyramids of their royal masters. The chapels of these mastabas were not decorated, but in some of them the walls of the burial chambers were covered with the Pyramid Texts. In the few large mastabas at Saqqara the subjects of the relief decoration are restricted almost exclusively to representations of the deceased and rows of offering-bearers and priests.

During the Twelfth and Thirteenth Dynasties (1980–1648 BC) the popularity of Osiris as a necropolis god increased enormously at all levels of Egyptian society. This was a true democratization of beliefs which had previously been the prerogative of the king. Osiris was particularly associated with the temple and necropolis at Abydos. In addition to tombs and graves, many small memorial chapels and stelae were set up there by private individuals. These were not associated with real tombs but their purpose can be compared to that of temple statues: they ensured the person's permanent presence by proxy in the vicinity of the god and their participation in temple festivals. The scenes on the stelae show almost exclusively the deceased, often accompanied by their

111–112
Paintings in the tomb of Khnumhotep II at Beni Hasan, c. 1880 BC. Painting on plaster
Left
Feeding antelopes
Right
Birds in a tree

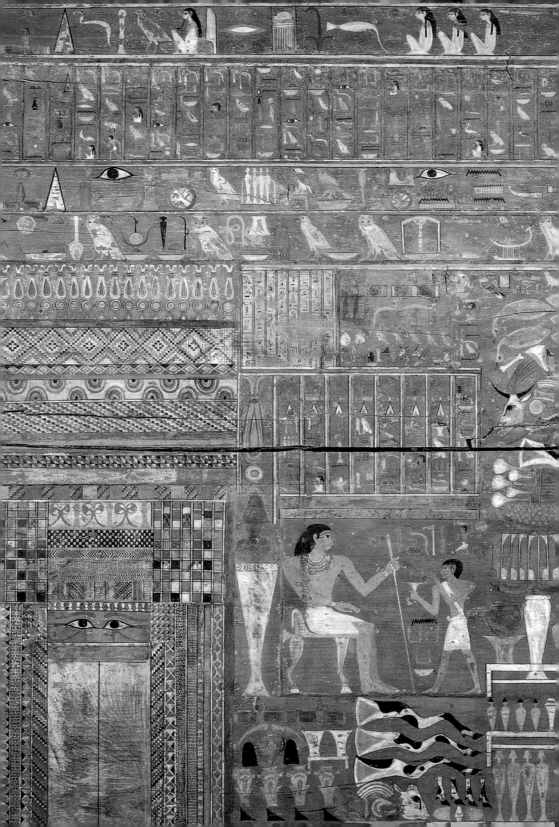

113
Interior of the outer coffin of Djehutinakht from Deir el-Bersha, c. 1980 BC. Painted wood; whole coffin: 114 × 263 × 113cm, 44⅛ × 103½ × 44½in. Museum of Fine Arts, Boston

family and other members of their household, and the texts rarely deviate from an invocation of Osiris and the names of persons represented on the stelae. In quality they range from competently carved relief to execrably incised representations accompanied by poorly written inscriptions.

The growing number of people who were able to afford funerary arrangements in the first half of the second millennium BC can be seen in the increase in modest tombs and graves of the period. Many of these tombs were little more than a small vaulted super-structure built over the mouth of the tomb shaft. Such tombs did not have a special statue room; sculptures representing the dead

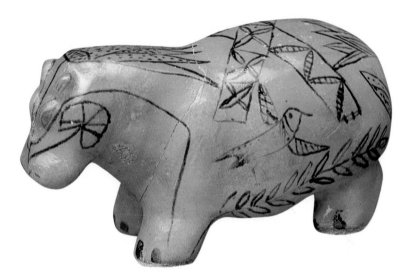

114
Funerary stela of the chief scribe Horhirnakht, c.1900 BC. Painted limestone; h.68·5cm, 27 in. Museo Egizio, Turin

115
Statuette of a hippopotamus, c.1800 BC. Faience; h.12 cm, 4³⁄₄ in. Musée du Louvre, Paris

person now accompanied the body into the burial chamber. These statues were small, and although they often have considerable charm, their craftsmanship is rather commonplace. The only decorated element of the tomb above ground was usually the gravestone stela (114). The design of these stelae follows the principles of the wall decoration of large tomb chapels: a division into registers, unequal sizes of human figures, and a combination of texts and representations. Although the topics do not, as a rule, go beyond the depiction of the deceased, his family and his retainers, these stelae represent tomb decoration reduced to its essentials. Blue or green faience statuettes of hippopotami (115)

were placed in Middle Kingdom tombs, probably because the animal was linked to the ideas connected with fertility and pro-creation, but the exact reasons for this funerary custom have not yet been convincingly established.

Some tombs have produced rich evidence for other arts. The Middle Kingdom was a period in which Egyptian craftsmen made jewellery that was to remain both technically and aesthetically unsurpassed for the rest of Egyptian history. The best examples come from the burials of royal women near the pyramids at Dahshur and el-Lahun. Delicate goldwork is combined with inlays of turquoise, carnelian, rock crystal and lapis lazuli in circlets, diadems, collars, bracelets, girdles and pectorals (ornaments, usually in the form of a plaque, suspended on a necklace and worn on the chest). Bright semiprecious stones were combined to produce a dazzling colour effect. A variety of techniques, including openwork, granulation (in which surface patterns were created by soldering small granules of gold or silver onto the object) and chasing were used. Some of these techniques may have been introduced from abroad, most likely Western Asia, at least judging by the fact that they had been known there before they were used in Egypt. Floral and vegetal motifs, especially lotus flowers, which were linked to rebirth, were arranged in inge-nious geometrical patterns and combined with elements such as animals (lions or bulls), birds (hawks) and mythical

116
Necklace of
Princess
Khnumet from
Dahshur,
c. 1890 BC.
Gold,
carnelian,
lapis lazuli,
turquoise;
35×3cm,
13³⁄₄× 1¹⁄₈in.
Egyptian
Museum,
Cairo

117
Pectorals
of Princess
Mereret, with
the names of
Senwosret III
and
Amenemhet III,
from Dahshur,
c. 1820 BC.
Gold,
carnelian,
lapis lazuli,
turquoise,
amethyst;
6·1×8·6cm,
2³⁄₈×3³⁄₈in, and
7·9×10·5cm,
3¹⁄₈×4¹⁄₈in.
Egyptian
Museum,
Cairo

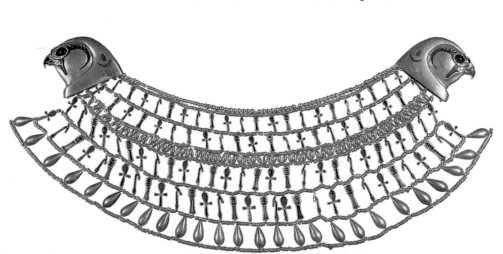

beasts (griffins). Also included among the motifs used by Middle Kingdom jewellers were parts of the royal titulary and hieroglyphs referring to 'protection', 'joy', 'life' and similar key words of ancient Egyptian good wishes. These were also used as pendants on collars and necklaces which often terminated in hawk's heads (116). Cowrie shells were imitated in gold to form necklaces.

Gold pectorals inlaid with lapis lazuli, turquoise and carnelian presented by Senwosret II, Senwosret III and Amenemhet III to the princesses Sithathor and Mereret are among the most successful jewellery designs known from ancient Egypt (117). The openwork

frame is made in the shape of the façade of a small shrine with a decorative cornice at the top. The name of the king written in a cartouche forms the central element and is flanked by other motifs, such as the king's Horus of Gold name (one of the five names of the pharaoh), in which the hawk is prominently represented, or hawk-headed griffins trampling on fallen enemies. The inlays create a riot of bright red, blue and green surfaces that set off the gold silhouettes of the figures and hieroglyphs, yet the openwork, which leaves large spaces free, acts as a restraining force and gives the impression of controlled elegance. Another astonishing design is the diadem of Princess Khnumet, the daughter of Amenemhet II. It consists of strands of very thin gold wire which provide a support for a scattering of small five-pointed stars inlaid in turquoise and carnelian. The delicacy of this creation is breathtaking, and the restraint shown in the use of the precious metal is unusual for ancient Egypt.

118–119
Scarab,
c. 1800–1600 BC.
Glazed
steatite;
h. 1·9 cm, ³⁄₄ in.
British
Museum,
London

There was an interchange of design motifs, especially for jewellery and weapons, between Egyptian and Syrian craftsmen at Byblos. And there was also an artistic interaction with the Minoan civilization of Crete, as evidenced by decorative patterns used in tombs that were probably adopted from Cretan pottery. To the south, the influence of Egyptian art can be seen in the complicated patterns found on faience vessels at Kerma, beyond the third Nile cataract, which was the centre of the important African kingdom of Kush (this name was used by the Egyptians when referring to the southern part of Nubia). The exchange of these motifs was probably effected by importing and then imitating objects rather than the exchange of craftsmen, but the available evidence is not conclusive.

Amulets in the form of the scarab beetle became very common early in the second millennium BC (118, 119). The Egyptian name for this beetle, *kheprer*, derived from the word *kheper*, 'to become', 'to come into being'. This was associated with the wish for rebirth and for a happy afterlife, a desire shared by all Egyptians. The flat base of the scarab was inscribed with 'good wishes' hieroglyphs,

the names of kings and later also of various deities. Scarabs which display names and administrative titles were used as seals.

The reign of the last monarch of the Twelfth Dynasty, Queen Sobekkare Sobeknofru (1805–1801 BC), was followed by a century and a half of slow and apparently uneventful stagnation. Large decorated tombs disappeared, and although royal as well as private statues continued to be made for tombs and temples, most of these are of mediocre quality, with few outstanding works among them. Some two- as well as three-dimensional representations, though by no means all, show a change from the 'classic' canons of the Twelfth Dynasty and a trend towards lanky figures.

This can probably be explained by the increasing provincialism of artists' workshops, where the strict rules of proportion were no longer followed, a departure that mirrored the political situation in the country. The quality of other pieces, especially private tomb statuettes and stelae, was little short of atrocious – badly proportioned, with clumsy scenes and poorly written inscriptions.

The situation changed abruptly when in 1648 BC the leader of the Western Asiatic immigrants in the northeastern part of the Delta declared himself a king of Egypt. It is certain that most of this immigrant population had been settled in Egypt for some time,

as part of a continuous process which accelerated towards the end of the Middle Kingdom, and that weak and incompetent central authority contributed just as much to the success of the *coup d'état* as any fresh influx of peoples from abroad. The term Hyksos was used by the Ptolemaic historian Manetho to describe them as an ethnic group, but the etymology of the word is Egyptian, from *heka* (ruler) and *khasut* (foreign lands), and so, strictly speaking, it applied only to their rulers, now Egyptian kings. It is also doubtful that these peoples represented a homogeneous ethnic group. Disunited and militarily weak, Egypt had no option but to acknowledge, rather unenthusiastically, the suzerainty of the first Hyksos, called Salitis. The Hyksos Kingdom was a loose coalition of foreign ethnic groups and Egyptian princedoms whose leaders recognized

the authority of the Hyksos king. The Hyksos (Manetho's Fifteenth Dynasty) adopted the external trappings of the Egyptian kings, and their position differed in only one substantial respect from their Egyptian predecessors of the Thirteenth Dynasty: they were the undisputed military power in the land. But they did not attempt to achieve much more than universal recognition throughout Egypt, thus being able to collect taxes. It may be that they were content to imitate the loose tribal system of their Western Asiatic origins.

The Hyksos residence remained in the northeastern Delta, at Avaris (modern Tell el-Daba). There were other local rulers contemporary with the Hyksos, some of them foreigners, others Egyptians, who were described as kings in later compilations

(Manetho's Fourteenth and Sixteenth Dynasties). Technologically, Egypt benefited, especially in military equipment: a horse-drawn chariot was introduced and became the first wheeled conveyance in common use in Egypt, and the army was equipped with a copper battle-axe of an improved type and a composite (laminated) bow. Artistically, however, the Hyksos made no impression on the Egyptian scene. Scarabs and seals with the names of the Hyksos rulers are the only objects which might with some justification be regarded as minor works of art.

Soon, however, the situation in Egypt began to resemble that which had prevailed during the period of political disunity following the end of the Old Kingdom. Once again, the most serious opposition appeared in the south, at Thebes. Like the rest of Egypt, the Theban princes (later regarded as the Seventeenth Dynasty, 1648–1550 BC) at first recognized the Hyksos overlordship. When their military power and confidence grew sufficiently, the kings of this Second Theban Kingdom declared their opposition to the Hyksos king at Avaris. Senakhtenre Teo I, Seqenenre Teo II and Kamose actively took up arms and campaigned against the enemy in the north.

The rulers of the Seventeenth Dynasty were soldiers rather than diplomats. It is not surprising that richly decorated 'parade' weapons and jewellery are the most remarkable artistic achievements of the period. Most of them come from tombs at Dra Abu el-Naga, on the Theban west bank. Some of the motifs on the weapons have been interpreted as showing Minoan influences, such as a crested winged griffin on the battle-axe of King Ahmose (1550–1525 BC) who links the Seventeenth and Eighteenth Dynasties, and a lion pursuing a calf against a row of locusts on his dagger. But the symbolism of the lion/king, and the locusts representing the multitude of enemies is purely Egyptian. The other motifs on Ahmose's battle-axe are also typically Egyptian (120), such as the small figure of Heh (personifying eternity) holding two curved wands which represent hieroglyphic signs for 'years' (thus wishing the king a long reign), and the cobra and vulture

120
Ceremonial battle-axe of Ahmose, from the tomb of his mother Ahhotep at Dra Abu el-Naga, Western Thebes, c.1530 BC. Gold, electrum, copper, semiprecious stones, wood; 16·3×6·7cm, 6⅜×2⅝in. (blade only). Egyptian Museum, Cairo

goddesses Wadjit and Nekhbet. The sphinx holding the decapitated head of an enemy is unusual.

In Theban cemeteries during the Seventeenth Dynasty a new type of coffin began to be used (121). These are anthropoid coffins, resembling a body completely wrapped up in bandages, with only the head showing. They are made of rather inferior local wood and their name, *rishi* coffins (from the Arabic word for 'feather'), derives from the massive feathered wings which cover the whole of the lid. The wings probably indicate a desire for protection by the goddesses Isis or Nephthys. In spite of their crude workmanship, these coffins make a direct and powerful impact.

In 1540 BC King Ahmose brought the fighting to a successful end and replaced the last Hyksos on the throne, assuming control over the whole of Egypt. Out of the debris of stagnation and political disintegration, another period of artistic magnificence was about to emerge.

121
Rishi coffin,
probably from
Western
Thebes,
c.1550 BC.
Painted wood;
h.191 cm,
75¼ in.
British
Museum,
London

5

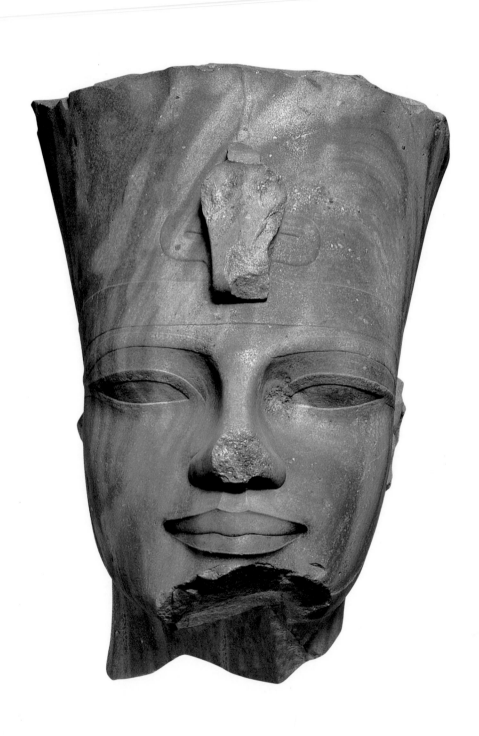

Under the kings of the Eighteenth Dynasty, Egypt experienced a
new period of artistic excellence, although the age began in war.
King Ahmose (1550–1525 BC) spent at least his first decade on the
throne fighting the Hyksos. Despite this militaristic beginning,
however, his reign inaugurated a long period of increasing eco-
nomic prosperity in Egypt and of far-reaching influence abroad,
now known as the New Kingdom (1540–1069 BC). This chapter
looks at the art and architecture of the New Kingdom through to
the reign of Amenhotep III (1391–1353 BC). Chapter 6 takes up with
the changes that occurred in the New Kingdom during the reign of
Akhenaten (1353–1337 BC) with the introduction of new religious
ideas and the building of a new capital at el-Amarna.

Ahmose's vision of Egypt was quite different from that of his Hyksos
predecessors. He quickly reintroduced the traditional model of
Egyptian monarchy, especially the centralized administration. His
task was much easier than it had been for the rulers of the Middle
Kingdom, since no resistance was offered by the local princes. At
some stage, the administrative capital of the country was also re-
established at Memphis. Ahmose's decisive restoration of the old
order put Egypt on course for some two hundred years of internal
stability – only once did potential disruption threaten, when
Queen Hatshepsut (1479–1457 BC) reigned on behalf of her young
nephew Thutmose III (1479–1425 BC) and a struggle for the right to
succeed loomed. A crisis, however, was successfully averted.

After defeating the Hyksos, Ahmose was immediately forced to
intervene militarily in the Syro-Palestinian region, probably in
order to eliminate the residual threat from former Hyksos allies.
He secured the northeastern border, and the power vacuum
created by the defeat of local rulers there who had come under
Hyksos influence quickly led to Egypt's emergence as a dominant

122
Colossal
head of
Amenhotep III,
from his
funerary
temple at
Western
Thebes,
c.1360 BC.
Quartzite;
h.117 cm, 46 in.
British
Museum,
London

regional force. Soon, however, opposition emerged in the state of Mitanni, centred on the upper reaches of the Euphrates river. For the first time in its history, Egypt entered the international superpower arena by becoming embroiled in a struggle for control of Syria and Palestine. Egypt fought to retain its influence in this region for much of the fifteenth century BC. Some of these encounters, such as Thutmose III's battle against the coalition led by the princes of the cities of Qadesh and Megiddo in his twenty-third regnal year, were recorded in detail in Egyptian texts and also

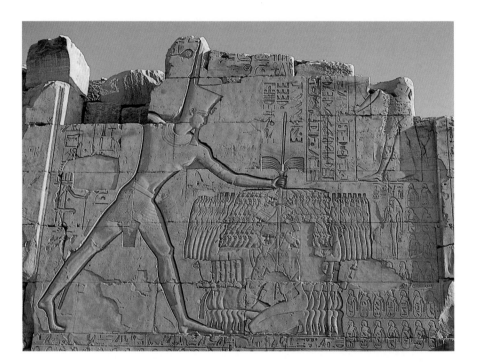

represented in reliefs. The image of the pharaoh as a mighty warrior who carries out the wishes of the god Amun by destroying Egypt's enemies dominates temple reliefs of this period (123). The traditional depiction of the pharaoh smiting enemies remained the most common, but occurred in a number of variations. Indeed, the military prowess and the heroic exploits of the pharaoh form a constant theme until the Amarna Period, when the qualities desired and celebrated in a monarch underwent a dramatic change.

Military campaigns were also undertaken in Nubia. The Kushite rulers at Kerma, south of the third Nile cataract, had been on friendly terms with the Hyksos and paid for this alliance by the loss of their kingdom to the victorious Egyptians. Egypt's territory was thus further enlarged, and its southern boundary remained in the area of the fourth or fifth Nile cataracts throughout the rest of the New Kingdom. Concerns for Egyptian security, which motivated incursions into the Syro-Palestinian region and Nubia, were coupled with a desire to control trade routes in both directions. Further, tributes were extracted from Syro-Palestinian chiefs, mainly luxury goods and products of advanced technology, such as chariots and weapons. Control of Nubia secured traditional economic interests such as access to gold, copper, mineral deposits, wood and manpower. Trade and tributes seem to have introduced subtle but significant foreign influences in many aspects of domestic life, including the arts.

Memphis was a thriving city with palaces, administrative buildings, workshops, harbours and arsenals. It was the centre of lively commerce with the Minoan and Mycenaean civilizations of the Aegean and with the Levant (the countries along the eastern Mediterranean shore), and was also a departure point of military expeditions sent to Palestine and Syria. Thebes, 485 km (301 miles) to the south, was Egypt's religious capital: it contained the temple of the main state god Amun, now linked to the sun god and described as Amun-Re. The remains of this temple are at Karnak in the northern part of the modern city of Luxor.

The recovery of the Egyptian economy from the stagnation of the late Middle Kingdom and the neglect under Hyksos rule was swift and far-reaching. Temples, especially those connected with Amun-Re, were the largest landowners after the king and their estates were found in all parts of Egypt. Amun-Re, now a true state god, was believed to guide the king in his military planning and victories were attributed to him. His temples benefited most from the spoils reaped by military expeditions abroad and the tribute exacted from the foreign territories which fell under Egyptian

123
The warrior king Thutmose III on the southern face of the 7th pylon of the temple of Amun-Re at Karnak, Thebes, c. 1450 BC. Sandstone, sunk relief

control. The peak of this new prosperity came during the long and peaceful reign of Amenhotep III, although in retrospect this period now seems like the lull before a spectacular storm.

New Kingdom temple building began in earnest during the reigns of Amenhotep I (1525–1504 BC) and Thutmose I (1504–1492 BC). Three main types of temples were constructed during the Eighteenth Dynasty. First, there were temples of local deities, such as had already existed in the Middle Kingdom, in all the important towns of Egypt. Second were funerary temples, which were associated with royal tombs and built on the west bank of the Nile at Thebes. They combined the maintenance of the deceased kings' posthumous cult with the worship of Amun. Third were memorial temples, built outside Thebes at important religious centres. For example a memorial temple might be built within the temple precinct of the god Ptah at Memphis where the maintenance of the cult of the deceased king would be combined with worship of Ptah. Because of later rebuilding no memorial temples of the Eighteenth Dynasty have survived in their original state. The following discussion looks first at general principles that applied to most temples and then at several specific examples.

Although every temple had its own individual characteristics, most shared a recognizable overall pattern (124). The tendency was towards large-scale structures fronted by massive pylons. The many festivals in the Egyptian religious calendar made ease of access an important consideration, and the entrance of a New Kingdom temple usually faced the river so that it could be approached by boat (temples of the Amarna period are an exception). This facilitated processions in which the image of the deity travelled to visit other temples, such as the annual 'Beautiful Festival of the Valley' when the image of the god Amun was taken from Karnak to visit funerary temples on the west bank at Thebes. The temple usually consisted of a series of open courts in its outer part and roofed halls in the inner part placed on the same axis. The room containing the barque in which the cult statue was carried during processions preceded the shrine with the cult

statue of the deity, or a stela (false door), which provided the focus for religious ritual. This scheme developed the principles already established in Middle Kingdom temples.

The plan of most Egyptian temples was based on the dimensions of its main element, the sanctuary or room in which the main cult image was kept. Measurements of other parts of the temple were usually established during the surveying of the site by a geometrical procedure. The method of surveying gave rise to interesting proportional relationships within a structure, which when discovered by later enthusiasts, unaware of the methodology, have given rise to bizarre theories. It gave the whole structure the homogeneity

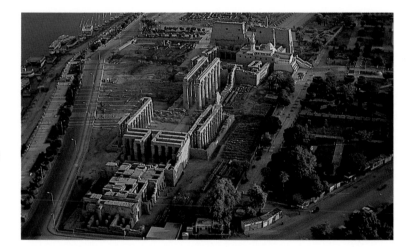

124
Aerial view
of the temple
complex at
Luxor,
c.1360–330 BC

that was so characteristic of Egyptian architecture. The process of establishing dimensions was given religious interpretations that became part of foundation ceremonies, but there is little doubt that this was initially a purely practical method for achieving a degree of uniformity in all buildings. The main building material was stone (limestone, but sandstone in Upper Egypt), with only occasional use of mud bricks. Smaller structures, for example shrines for the divine barque on its temporary stops during religious processions, may have been made of hard stone such as quartzite.

The pylon that stood in front of large temples provided a monumental gateway consisting of two wings with a central doorway,

and also served as the façade. A temple might be enlarged simply by building a new pylon which could be linked by walls to the earlier pylon. The enclosed area formed in this way might be left open to the sky, or lined with columns to form covered walks around its perimeter (a peristyle court), or filled with columns and roofed over (a hypostyle hall).

Architecturally, the Egyptian temple grew out of the simple sanctuary which housed the cult image, usually a statue, believed to be the deity's manifestation. This original concept of the house of the god was always present. During the New Kingdom, and possibly even earlier, the temple was endowed with an important additional cosmic symbolism, in which it represented the ordered world and the very site of its creation (several gods were now regarded as creators). The pylon was a barrier separating the chaotic conditions outside the temple from the order prevailing inside. Large-scale figures of the king triumphing over his enemies were carved on the pylon as a visual expression of this idea. They protected the act of creation symbolically re-enacted in the temple ritual. The open, brightly sunlit court between the pylon and the columned hypostyle hall was a middle ground between the inner part of the temple which the pharaoh had to protect, and the world outside. Its walls were often decorated with representations of religious festivals and processions during which the god's image left the safety of the temple. The hypostyle hall and its rows of tall, upright, brightly painted columns with vegetal-type capitals recalled the primordial marsh. Some light could penetrate through windows near the ceiling, but the hall was shrouded in semidarkness. The shrine containing the cult image in the innermost and narrowest part of the temple was its most elevated and darkest point, suggesting the mythical mound on which life appeared out of the watery chaos at the moment of creation.

The daily temple ritual carried out by priests consisted of caring for the cult statue, by clothing, washing and anointing it, and purifying it by burning incense, as well as presenting food and drink offerings. The only time that ordinary people were able to see the cult statue was during the festivals when it was carried by boat or overland in its ceremonial barque to 'visit' deities in other temples. Access to the inner part of the temple itself remained as tightly restricted as ever.

Statues in various parts of the temple formed an integral part of its religious and decorative programme. Royal statues were often made on a colossal scale, especially those set up outside the pylons and gates. These places were publicly accessible, and the statues clearly identified the builder of the temple in a most impressive way. This, however, was not the sculptor's main aim. The size of the sculptures was related to the scale of the buildings and the places where they stood. Similarly colossal statues showing the king in the traditional jubilee festival image were often addorsed against the walls or pillars inside the temple.

125
Headless statue of Amenhotep III as an old man, c.1360 BC. Serpentine; h.22·5cm, 8⅞in. Metropolitan Museum of Art, New York

Royal sculpture workshops must have been at their busiest during the reign of Amenhotep III, which was perhaps the greatest period for experimentation in the forms of royal statues. The king was represented in all stages of life, from youthful images to those showing him as a mature man in the prime of his life (see 122) and others where he is distinctly rotund and well into middle age (125). In his colossal statues, particularly those dating from his later years, the face of the king was carved with stylized simplicity, becoming a composition of beautifully shaped planes which nevertheless retains its individuality. The resulting image of the king is handsome but rather coldly impersonal and artificial.

Some temples received literally hundreds of statues representing the king, deities, or the two combined, especially on the occasion of religious feasts and jubilee festivals. The temple of the goddess Mut, in the southern part of Karnak, received statues representing 365 different aspects of the lioness goddess Sakhmet (126), one for each day of the year, though this is an extreme example. Statues of

private individuals were also eventually permitted in certain parts of temples. Some show the person in the presence of a deity, for example the statue of Nebmertef shown as a scribe before the baboon god Thoth, the patron of scribes (127). Others combine images of two or more persons, such as the family group of Sennufer, his wife and small daughter (128), dating to the reign of Amenhotep II (1427–1401 BC) and the statue of Senenmut, the architect of Queen Hatshepsut, holding the small princess Neferure (129), both from Karnak. Block statues showing a man whose body is almost completely concealed by his cloak became even more popular than during the Middle Kingdom, and several new statue types appeared, among them one of a kneeling man holding a large sistrum, a rattle used by priestesses, decorated with the head of the goddess Hathor.

The king's relationship to the deities was underlined by reliefs showing the king and the gods together in scenes that express both affection and the mutual benefits each derived. In many

126
The lioness-headed goddess Sakhmet, from the temple of the goddess Mut at Karnak, Thebes, c.1360 BC. Diorite; h.210cm, 82⅝in. Museo Egizio, Turin

127
Statue of the scribe Nebmertef and the baboon god Thoth, c.1360 BC. Schist; h.19·5cm, 7⅝in. Musée du Louvre, Paris

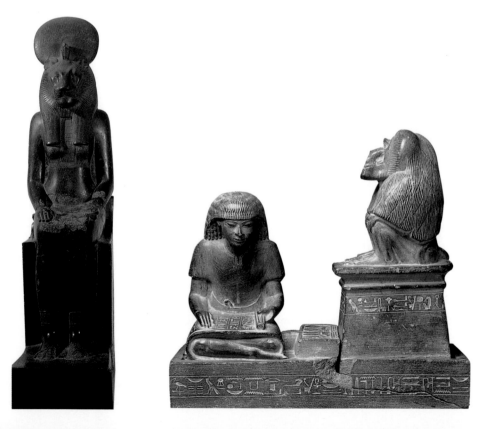

scenes, for example, the king presents the gods with material offerings such as food (bread, cakes, etc.), drink (water, milk, wine, beer, etc.), and various types of cloth, as well as items required in purification, such as natron (a naturally occurring mixture of sodium salts) and incense, and abstract gifts such as an image of the goddess Maet symbolizing truth or established order. The king is shown performing acts which please the god, for example consecrating offerings or taking part in temple ceremonies. In return, he is seen receiving such things as the symbol of the jubilee festival that guaranteed him continued celebration and a long reign (the festival was symbolized by the hieroglyphic sign for the double kiosk in which the king was enthroned during part of the ceremony), or symbols of life, dominion and stability.

The orientation of Egyptian temples (and tombs) governed the placement of many scenes. So, for example, those related to Upper Egypt (*ie* the southern part of the country) would be on the southern wall,

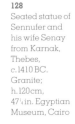

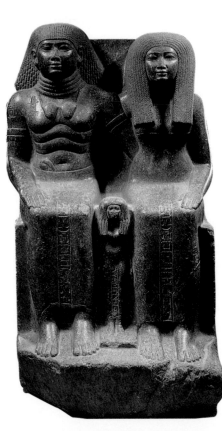

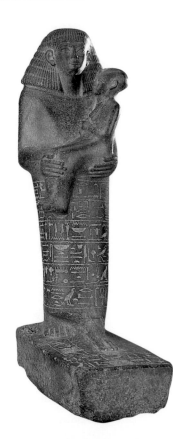

while those connected with Lower Egypt would be on the northern wall. The temple's orientation, usually determined by the cardinal points, sometimes deviated as a result of the setting, which depended on the course of the Nile. In such cases the location of scenes followed a symbolic orientation, defined in terms of the temple's structure but with little relationship to reality outside. In temples (and tombs) the direction in which gods or people faced in individual scenes was also subject to clearly defined rules; the 'owner' of a building – eg the deity of the temple (or the person buried in the tomb) faces out, as if meeting the visitors. Correspondingly, the visitors face towards the inside of the structure; they may include the king approaching the god with offerings (or offering-bearers in a tomb). Often, the orientation of reliefs virtually signposts the route of visitors or processions. As well as the temples of major deities, almost all the temples of local gods benefited from royal patronage during the early New Kingdom. These were the first non-funerary structures in Egyptian history to be copiously decorated with reliefs and so began a trend which culminated spectacularly in the temples of the Ptolemaic and early Roman periods.

The temple of the god Amun (or Amun-Re) at Karnak in Thebes (modern Luxor) was the largest temple in Egypt (130, 131). Called Ipet-isut (possibly translatable as 'The Reckoner of the Places of Worship'), it gradually developed into a true national shrine: all kings strove to contribute to it by adding new buildings or rebuilding and restoring the old ones. Thus, architecturally the Karnak temple is a complex of temples rather than a single structure. By the end of the reign of Amenhotep III around 1353 BC, the temple had four pylons (numbered III–VI by Egyptologists because another two were added by later kings) along its main approach from the west to the east, and another two pylons (VII and VIII) along a subsidiary north to south axis. Obelisks, tall monolithic pillars with a pyramid-shaped summit associated with the sun god Re, marked the entrances to the temple during the reigns of Thutmose I, Queen Hatshepsut and her successor Thutmose III. The last king also built a shrine at the east end of the temple for the barque and the cult image of Amun.

130
Plan of the temple of Amun-Re, Karnak, Thebes, c.1930–150 BC.
(A) Precinct of Montu,
(B) Temples of the Aten,
(C) Avenue of Sphinxes,
(D) Pylon,
(E) Hypostyle hall,
(F) Sanctuary,
(G) Great Temple of Amun,
(H) Temple of Thutmose III,
(I) Sacred Lake,
(J) Temple of Khons,
(K) Precinct of Amun,
(L) Precinct of Mut

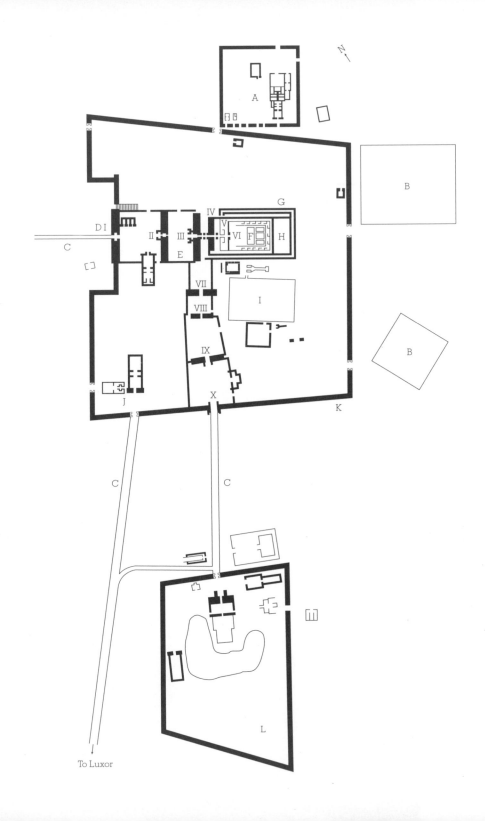

To Luxor

131
The temple
of Amun-Re,
·Karnak,
Thebes,
standing and
restored
structures
c.1930–150 BC

By the time of the Eighteenth Dynasty (after 1540 BC) many local gods were grouped into neat 'holy families'. The senior deity, usually male (eg Amun at Thebes or Ptah at Memphis), was given a female companion (eg the goddess Mut was linked to Amun, and Sakhmet to Ptah), and they were joined by a junior member of the group, a youthful god or a child (Khons at Thebes, Nefertum at Memphis). Egyptian religious architecture of the Eighteenth Dynasty expressed these group relationships by building a temple of the female member of the triad to the south of the main temple and that of the third member to the north. The arrangement was followed subsequently whenever large religious complexes were planned, for example at Memphis during the reign of Ramses II (1279–1213 BC) and at San el-Hagar (Tanis) during the Twenty-first Dynasty (1069–945 BC). At Karnak while the southern part of the complex was dedicated to the goddess Mut, the north-ern part belonged to the traditional Theban god Montu. Later, Khons had a temple within the precinct of Amun.

The relationship between the king and Amun-Re was so close that the Karnak temple was considered the appropriate place to record in writing and pictures some of the king's achievements, espe-cially his military victories. The most interesting such record is the copy of the war daybooks (also called annals) of the campaigns of Thutmose III in Western Asia. Unlike almost anything else found in Egyptian temples, these texts are true historical records. (Copies of the real annals, or yearly records, were probably held in the temple of the god Ptah in Memphis.) The great warrior Thutmose III also built a temple in the easternmost part of the temple complex of Amun-Re, behind the sanctuary, which contains remarkable representations of foreign plants and animals.

Also dedicated to Amun was the temple called Ipet-resyt ('The Southern Harem'). It is located in the centre of the modern city of Luxor, just 3 km (nearly 2 miles) to the south of the Karnak temple. There the god Amun appeared in an ithyphallic form thus resem-bling the god Min of Koptos (see 27). The southern part of the temple was built almost entirely by Amenhotep III, while its northern part

was added by Ramses II. Amenhotep III's temple consists of an entrance colonnade with papyrus-capital columns, a large peristyle court and a hypostyle hall with slim and elegant palm-capital columns, and the barque room and shrine surrounded by ancillary rooms. One room contains reliefs showing the 'divine' birth of Amenhotep III, with his mother, Queen Mutemwia, and his 'father', Amun. The main purpose of this temple was probably to serve the cult of the royal *ka*, one of the aspects of the king's being. The *ka* is usually shown as a small human figure, with the open-arms hieroglyph (reading *ka*) on his head, following the king. The close link between the two Amun temples was demonstrated in the spectacular annual Opet festival, when the image of Amun at Karnak made a journey south to visit his southern place of worship.

Shrines of Amun or Amun-Re were also built in other parts of Egypt, and the god appeared as a 'guest deity' in the temples of other local gods where arrangements were made for his worship. To mark the celebration of his jubilee festival after the first thirty years of his reign, Amenhotep III built a large temple for Amun-Re at Soleb, close to the third Nile cataract in Nubia. He was not the first king to build in Nubia, but the large scale of this project shows that, although the territory was administered separately, it was now regarded as permanently annexed to Egypt proper and was fully Egyptianized. This foreshadowed the intensive temple building which later took place there under Ramses II. Interestingly, no comparable temple building activity was ever undertaken in the Palestinian and Syrian territories occupied by the Egyptians, which could, at best, be described as Egyptian colonies.

New Kingdom royal funerary temples effectively replaced the temples attached to royal pyramids (the pyramid was replaced by the rock-cut tomb, discussed below, for royal burials). During the Eighteenth Dynasty (after 1540 BC) the royal tomb became physically separated from the funerary temple. Royal tombs were now made in the desolate valleys on the west bank of the Nile, opposite the city of Thebes. This followed the tradition that regarded the

132
'Memnon
Colossi' of
Amenhotep III,
at the
entrance to
his funerary
temple in
Western
Thebes,
c.1360 BC.
Quartzite;
original height
c.20 m, 66 ft

west, the direction in which the sun set, as the abode of the dead. The realm of the god Osiris was also in the west. Funerary temples, also located on the west bank, were lined up close to the river, some 2 km (1¼ miles) from the tombs. This is not such a radical departure from earlier practice as it may seem: even in the past the royal pyramid tomb was physically separated from the funerary temple (the upper temple of the pyramid complex). The new form of royal tomb was simply distanced in a more obvious way from the funerary temple.

Most royal funerary temples of the early New Kingdom are now very poorly preserved, but it is clear that in plan they generally followed the established temple concept. The site of the largest of them, the temple of Amenhotep III, is still marked by the huge (c.20 m or 66 ft high) seated statues of the king, made of quartzite, known as the Memnon Colossi (132). These once stood in front of the temple's pylon, and fragments of other colossal statues of Amenhotep III were found nearby. Although, as in other similar cases, it has been possible to reconstruct the plan of the temple on paper, the structure itself is almost completely lost.

133
View of the funerary temples of Hatshepsut, c.1460 BC, and Nebhepetre Mentuhotep II, c.2000 BC, at Deir el-Bahri, Western Thebes

The funerary temple of Queen Hatshepsut at the foot of the steep cliffs at Deir el-Bahri (133), directly opposite the temple of Amun-Re at Karnak, is better preserved than most, and also architecturally distinctive. It was built for the queen's funerary cult, and for the god Amun-Re, the necropolis god Anubis and the goddess Hathor. Its design imitates and develops that of the nearby Middle Kingdom temple of Nebhepetre Mentuhotep II (2050–1999 BC) of the Eleventh Dynasty (see 91, 92), although it is not clear why this should be so. It may have been the decision of Hatshepsut's architect Senenmut; if so, it is one of the few cases in Egyptian history where an individual profoundly influenced the established architectural form. Such courageous originality would link Senenmut with the handful of Egyptian architects whose work departed radically from tradition – Imhotep, responsible for the construction of the Step Pyramid of Djoser (see 43); the anonymous designer of the first true pyramid of Snofru; and the architect of Nebhepetre's funerary monument. Less than a

hundred years after the temple of Hatshepsut, in the reign of Amenhotep III, another remarkable architect, Amenhotep, son of Hepu, was responsible for some of the largest architectural projects ever undertaken, including the funerary temple of Amenhotep III (see 132) and possibly the temple at Luxor (see 124).

The names of Egyptian architects such as these survive not from any desire to immortalize creative achievement but because they were high-ranking officials whose tombs contained biographical texts and other evidence. This explains why the names of the artists who carved reliefs, painted wall-paintings or sculpted

statues are hardly ever known. They would not be wealthy enough to be buried in elaborate tombs containing records of their life and status. By contrast, the official in charge of a building project was a member of the governing élite.

The originality of Senenmut's work on the temple at Deir el-Bahri may also reflect the fact that Queen Hatshepsut was herself no ordinary ruler. She was the queen of Thutmose II (1492–1479 BC) who, after the death of her husband, ruled on behalf of her young

nephew, Thutmose III. The unusual design of her funerary temple may express a conscious effort to distance herself from her predecessors on the Egyptian throne. Deir el-Bahri was traditionally associated with the goddess Hathor, and this may have also played a part, as the female pharaoh may have wanted to associate herself as closely as possible with one of the area's main female deities. Statues of Hatshepsut interestingly reflect the re-evaluation of her position that took place during her reign: they progressively lost many of their female characteristics – indeed, shared family characteristics make late statues of Hatshepsut little different from those of her successor, Thutmose III.

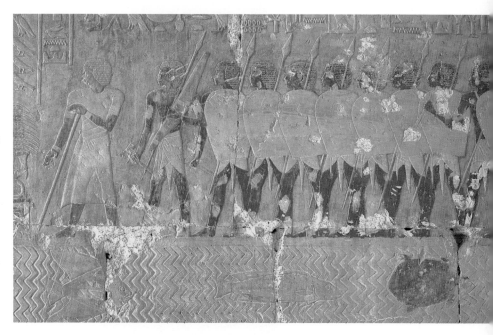

134–136
Reliefs from the funerary temple of Hatshepsut at Deir el-Bahri, Western Thebes, c. 1460 BC. Limestone, painted raised relief; h. of register 46 cm, 18⅛ in
Far left
Men carrying baskets with incense trees
Left
Expedition to the land of Punt
Right
Egyptian troops in the land of Punt

Hatshepsut's temple at Deir el-Bahri is partly freestanding and partly rock-cut, and is built on several levels. Three of these are fronted by pillared porticos, and the walls behind them contain some of the most remarkable reliefs known from Egypt (134–136). They were carved in very low relief, perhaps in a further reference to the decoration of the neighbouring temple of Nebhepetre Mentuhotep II, and include a detailed pictorial record of a naval expedition sent to the African land of Punt, and of the transport of

obelisks from the granite quarries at Aswan to the temple of Amun-Re at Karnak. These representations of landmark events in Hatshepsut's reign recall similar features in some Old Kingdom pyramid complexes, especially the transport of columns and other architectural elements for the pyramids of Sahure (2447–2435 BC) and Unas (2341–2311 BC). The temple also contains scenes depicting Hatshepsut's divine birth as the result of a union between her mother and the god Amun, who had appeared in the form of Hatshepsut's father, Thutmose I. This is a clear attempt to legitimize her right to the Egyptian throne by showing that, like other kings, she had been chosen by the state god Amun. A chapel devoted to the funerary cult of Hatshepsut's father was also located in the temple.

Almost all the sculptures in funerary temples represented the pharaohs for whose funerary cult a temple was built. At Deir el-Bahri there were some two hundred or more statues of Hatshepsut. Many of these were sphinxes, some of them curiously reminiscent of the lions with human faces of Amenemhet III (1859–1814 BC; see 85, 104), and there were large 'Osiride' statues, or perhaps better 'jubilee statues', addorsed to the pillars of the colonnades and elsewhere. These show the queen draped in a close-fitting cloak with her arms crossed on her breast, a posture usually adopted by the god Osiris but also one associated with the pharaoh during royal jubilees. Other figures, some of them colossal, showed the queen seated (137), standing or kneeling.

Temples are one main New Kingdom architectural form. Another is the tomb. The royal tombs on the west bank of the Nile at Thebes are entirely rock-cut, with no superstructure above ground and no conspicuous entrance, although originally they were not necessarily meant to be concealed. The royal necropolis, in the inhospitable and desolate wadi now known as the Valley of the Kings, was closed off and guarded, but the locations of the tombs were known to a large number of people. The apparent secrecy surrounding the location of the tomb of Tutankhamun (1336–1327 BC), for example, was not actually deliberate, but due to carelessness on the part of the builders of later tombs and centuries of neglect

which eventually concealed the tomb's entrance. The typical New Kingdom rock-cut royal tomb consists of a series of rooms, at first along a straight axis and then veering to the left. The overall impression is that of a long and spacious corridor, gently descending towards the burial chamber containing the royal sarcophagus. The decoration is mainly concentrated in the burial chamber (138) and consists of texts and scenes from the large corpus of religious texts called Imi-duat ('That which is in the underworld'). The architecture may to some extent reflect contemporary ideas about the underworld into which the sun god Re, accompanied by his retinue and the deceased king, descended in the evening. There were many dangers to overcome in the underworld, especially the great snake Apophis, before Re was able to emerge triumphantly the following dawn. By sharing this journey, the king ensured his smooth transition from this world to the next one.

The Imi-duat texts inscribed on the walls of royal tombs provided the king with a handbook for use in the underworld, with detailed

138
Scenes from
the Imi-duat
in the burial
chamber of
Amenhotep II,
Valley of the
Kings,
Western
Thebes,
c.1410 BC.
Painting on
plaster

139
Wall-painting
showing
scenes from
the Imi-duat
in the burial
chamber of
Thutmose III,
Valley of the
Kings,
Western
Thebes,
c.1430 BC.
Painting on
plaster

descriptions and illustrations of the surroundings and its inhabi-
tants. They are divided into sections according to the nocturnal
hours that the sun god must spend there. This is a weird and fever-
ishly unreal world, far removed from the dignified and reassuring
representations of gods depicted on temple walls – at times, these
images of winged snakes, unusual deities with two human heads
or two bird heads, female figures seated on large cobras or with
serpents on their shoulders and captives being decapitated can
be deeply disturbing (139). The custom of inscribing the Imi-duat
texts on tomb walls continued the tradition of the Pyramid Texts,
which began nearly a thousand years earlier in the reign of King
Unas. It is not known whether the Pyramid Texts, which consisted
of religious formulae of various dates, were copied on to the pyra-
mid's interior walls from papyri kept in temple or palace archives,
but the manner in which these hieroglyphic texts were inscribed
was probably designed especially for the walls of monumental
tombs. The Imi-duat texts are shown differently, as if the walls
of the royal tomb were covered with huge sheets of papyri: the

inscriptions are in cursive script and the images are loosely sketched, both techniques used on papyri (it is possible that papyri with the same texts and images accompanied the king to the tomb). Further scenes show the dead ruler with such deities as Anubis, Osiris, Hathor, who presided over the Theban necropolis, and the sky goddess Nut, who played an important part in Egyptian funerary beliefs and was often described as 'enfolding' the body of the deceased. The king is also shown suckled by Isis in the form of a tree goddess. At first, most of these additional scenes were not depicted in the burial chamber itself but in the outer parts of the tomb. By the reign of Amenhotep III, they had become more extensive, and this trend continued.

None of the early New Kingdom royal tombs has escaped the attention of tomb robbers, which makes it impossible to know for certain what the deceased king was buried with or the quality of the items. Some sculptures showing the king or deities were certainly included, although these were small and mostly made of wood. They were mainly associated with the religious texts inscribed on tomb walls and their accompanying images and show deities related to those depicted in the Imi-duat illustrations, which had never before been seen in three-dimensional sculpture. They provide yet another example of the close connection in Egyptian art between two- and three-dimensional images.

By the Eighteenth Dynasty, wealthy subjects were no longer buried close to the tomb of the reigning king. The majority of the tombs were now built by private enterprise and the ability to raise resources for their construction and maintenance locally became paramount. The two largest cemeteries were located near the two main cities, Thebes in the south and Memphis in the north. The overwhelming religious prestige of Thebes became the main attraction of its necropolis, located on the west bank of the Nile opposite the city. The city of Memphis on the west bank had a large cemetery, Saqqara, in the desert to the west of it (few tombs of any artistic importance, however, were made there before the reign of Thutmose III). Private tombs of the Eighteenth Dynasty can also be found in

other parts of Egypt where there were people able to command the resources for their construction. In keeping with the idea of the west as the abode of the dead, most Egyptian cemeteries are on the west bank of the Nile, and tombs tend to be oriented westwards, although for practical reasons inhabitants of the east bank often buried their dead in the vicinity of their own towns and villages.

Local geological conditions considerably influenced the development of cemeteries and the forms of tombs. The geology of the Theban west bank allowed the making of rock-cut tombs, the type evidently preferred by the richest customers of local necropolis workshops. The plans of the tomb chapels varied considerably but there was a basic cruciform pattern, a distinct departure from the plans of Middle Kingdom tombs. In the simplest plan, the entrance from an open court brings the visitor into a short corridor. This opens into a broad, short hall. A central doorway at the back then leads into a long, narrow room at the rear of which is a niche with a rock-cut or freestanding statue of the deceased, often accompanied by his wife. The walls of all these rooms are decorated in painted low relief or, more often, simply painted. The ceiling may have a variety of geometric patterns, probably based on contemporary textiles. The opening of the shaft that leads to the burial chamber on a lower level can be in almost any part of the chapel, and the chamber itself was usually left undecorated. Later tomb chapels, especially those dating to the reign of Amenhotep III, may have much more elaborate versions of the basic scheme, containing more rooms, some of them with ceilings supported by columns. There are some parallels between New Kingdom royal and private tombs. The underground burial chambers of large private tombs were inaccessible (back-filled and sealed), as were the royal tombs themselves. The chapels of private tombs were the counterparts of royal funerary temples. Funerary cults were kept up in both, but access to the temples would have been restricted to priests while the chapels of private tombs were open to relatives.

At first, the decoration of Theban rock-cut tombs shows close links with Middle Kingdom style and iconography, but it soon begins to

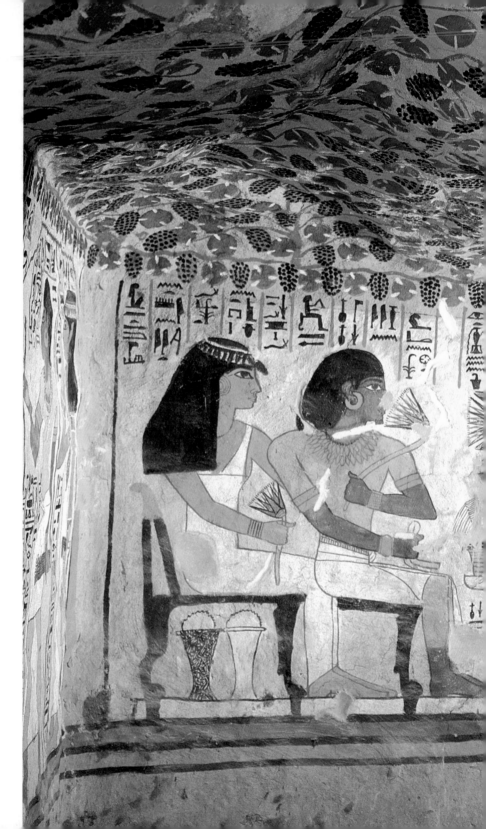

140
Scenes in
the tomb of
Sennufer at
Sheikh Abd
el-Qurna,
Western
Thebes,
c.1410 BC.
Painting on
plaster

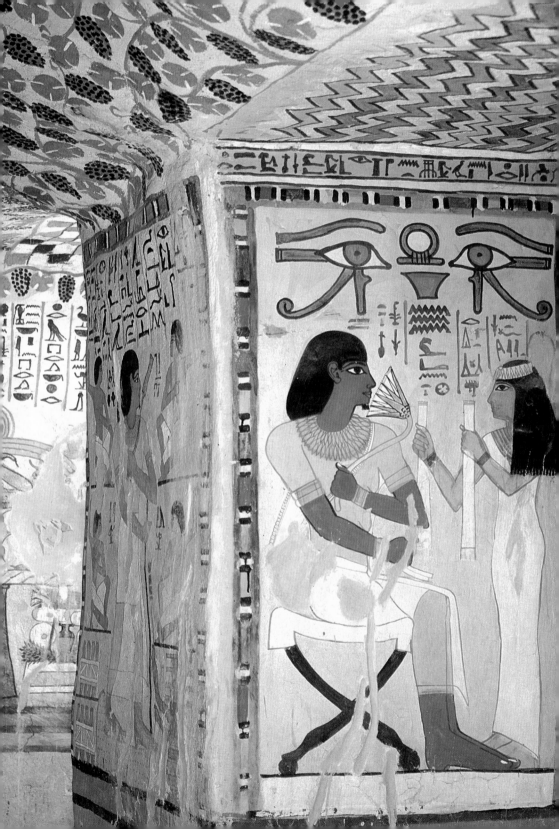

develop its own unmistakable style (140), which reaches a high point under Thutmose IV (1401–1391 BC) and Amenhotep III. Domestic family scenes are frequent. Sumptuous parties, sometimes interpreted as funerary repasts (although this is far from certain), are shown, with musicians, singers, dancers and gymnasts (141). The atmosphere is one of luxury and opulence: elaborate wigs, long flowing robes and jewellery are worn by men as well as women. Some guests are shown being spectacularly sick as the result of overeating or intoxication, perhaps in order to convey

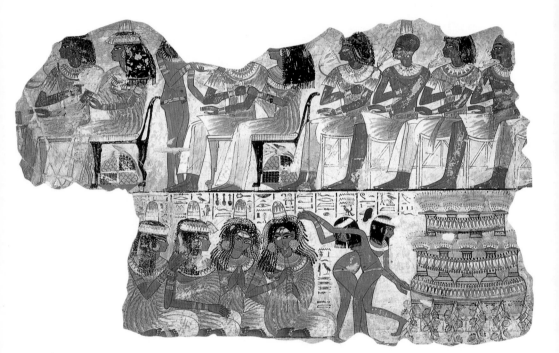

the richness and quantities of food available. It has been suggested that intoxication was associated with the goddess Hathor and was seen as a way of breaking down barriers between the living and the dead, but this explanation seems unlikely.

The way in which people are depicted shows subtle but significant modifications. Earlier the approach to the human figure was to build it up from its constituent parts, creating an attractive completeness but also a rather cold and impersonal impression. It seems that now Egyptian artists could at last view the figure as a

whole, a skill gained at least partly by sketching freely without the laborious adding on of individual elements. An interesting example of this new approach can be seen in the tomb of Rekhmire, the vizier of Thutmose III, where one of the serving girls is shown turning away from the spectator and displaying her back (142), instead of the usual front view. Particularly noticeable in female figures is a new sensuality. Some of the changes in details ran counter to this more naturalistic approach, however, particularly during the reign of Amenhotep III (143): the eyes of female figures became conspicuously almond-shaped, unnaturally large and dominant, while the slightly pouting lips gave the face a youthful idealized

141
Female musicians and dancers entertaining guests at a meal, from the tomb of Nebamun, Western Thebes, c.1360 BC. Painting on plaster; h.61cm, 24 in. British Museum, London

142
Servant girls and a guest at a banquet, tomb of the vizier Rekhmire, Sheikh Abd el-Qurna, Western Thebes, c.1420 BC. Painting on plaster

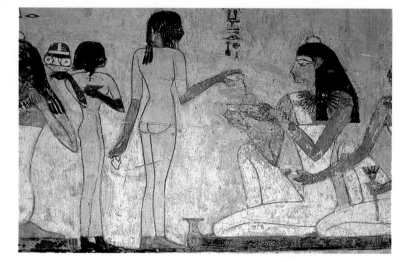

expression. In representations of men, the earlier rather solemn gaze was replaced by a more open and optimistic expression.

The subject matter of New Kingdom tomb decoration is far more varied than in the mastabas of the Old Kingdom. The overall impression is that New Kingdom artists were less inclined to follow and elaborate on well-established themes, but instead produced variations on old subjects in which the whole design, and not just details, was new. A freer and more impressionistic style of painting appeared, which departed from the earlier, more painstaking drawings. The individuality of these anonymous artists is now quite clearly reflected in their work.

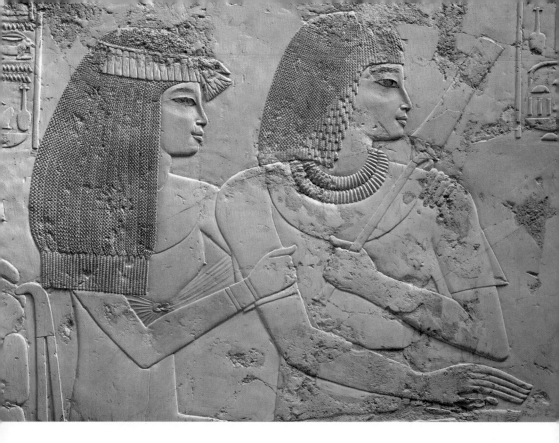

In private tombs, images of the king and queen often appear, as do royal children, especially where the dead person had been involved in their education and upbringing. The tomb of Hekerneheh shows the small prince Amenhotep (later King Amenhotep III) on the knee of his male nurse, who was either Hekerneheh or perhaps his father. Scenes showing foreigners bringing tribute are frequent at this period of Egypt's dominance abroad, for example the inhabitants of the Aegean shown in the tomb of Rekhmire, while the gods make their appearance for the first time, usually receiving homage or offerings from the deceased. Long religious texts and small vignettes illustrating them were commonly included, especially from the so-called Book of the Dead. This was a large corpus of texts which the deceased person was thought to need in the afterlife. It is related to two earlier compositions that served a similar purpose, the Pyramid Texts and the Coffin Texts. Selected spells from the Book of the

Dead could be inscribed in the tomb or on various funerary objects, but the most extensive versions of the Book of the Dead were inscribed on papyri that accompanied the deceased person into the tomb (144).

143
A brother and sister-in-law of the vizier Ramose, in his tomb at Sheikh Abd el-Qurna, Western Thebes, c.1355 BC. Limestone; painted raised relief

The traditional representations of offerings still appeared. These scenes may be less prominent than previously, but they maintained the original purpose of tomb decoration, as a guarantee that the deceased's needs in the afterlife would be satisfied. Mourners were often shown (145), as were aspects of the funeral, in particular the Opening the Mouth ceremony performed on the mummified body of the dead person. The purpose of this rite was to enable the mummified body to act as the deceased person's manifestation in the afterlife. (It is significant that statues also underwent the Opening the Mouth ceremony.) The career of the deceased might also be illustrated, with scenes showing the inspection of foreign tribute, palace workshops and storerooms, or soldiers. It is questionable, though, whether these reflect the reality of any particular occasion. It is much more likely that they present a stylized image, although this was modified by the artist for each individual burial by the addition of realistic contemporary detail.

A particularly notable feature of New Kingdom tomb decoration is the astonishingly large number of subjects apparently taken from everyday life. These include scenes of craftsmen and tradesmen such as sculptors, vase-makers, metalworkers, jewellers, carpenters, leather-workers, brick-makers, men making boats and chariots, net and rope-makers, weavers, dyers and laundry-workers, butchers, bakers and brewers. Agriculture, cattle-breeding and horticulture are represented, as well as viticulture (146) and various activities in the marshes, including the netting of fish and wildfowl. While all this gives the impression of spontaneity and realism, it should be recalled that Egyptian art always needs to be interpreted and not accepted at face value. A good example of this is provided by one of the best-loved Egyptian tomb paintings, which shows the Theban official Nebamun hunting wildfowl in the marshes and dates to about 1360 BC (147).

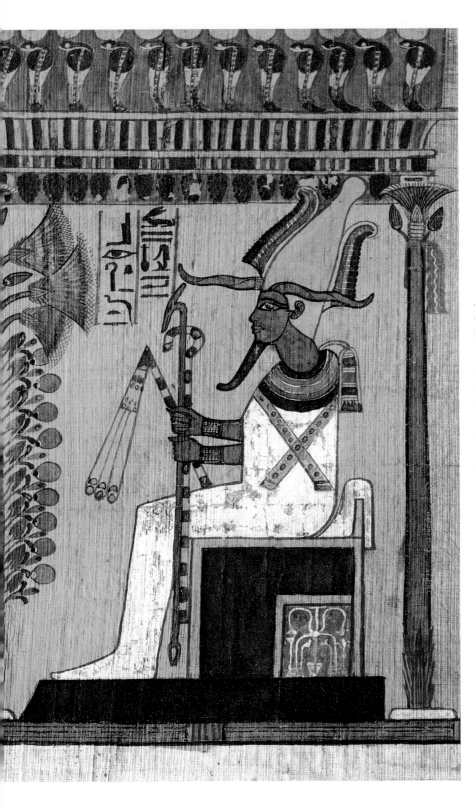

144
The overseer
of works, Kha,
and his wife
Meryt before
the god Osiris,
in a vignette in
his Book of the
Dead papyrus
from his tomb
at Deir
el-Medina,
Western
Thebes,
c.1400 BC.
h.35cm, 13¾in.
l. of the whole
papyrus,
14m, 45ft 11in.
Museo Egizio,
Turin

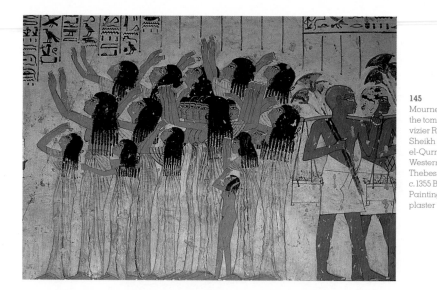

145
Mourners in
the tomb of the
vizier Ramose,
Sheikh Abd
el-Qurna,
Western
Thebes,
c. 1355 BC.
Painting on
plaster

In his tomb Nebamun is represented standing in a small skiff glid-
ing through the marshes with no obvious means of propulsion. He
is holding several birds in his left hand (the arm is attached to the
right shoulder – a convention discussed in Chapter 3), while in his
raised right hand he holds a snake-shaped throw-stick which he
is about to hurl among the multitude of birds rising from a papyrus
thicket. A small daughter is kneeling by Nebamun's feet, and his
wife, holding a large bouquet, is standing in the skiff behind him.
A cat is shown wreaking havoc among the agitated birds; it has
sunk its teeth into the wings of one and grasps another two with
its claws. The depiction of wildlife is very convincing, and so are
the fish in the water under the skiff. The scene seems to show a
favourite pastime of Egyptian officials, and the cat appears to be
used in such a fowling expedition to retrieve the birds brought
down by the hunter's boomerang.

This would be a completely wrong interpretation, however. First
of all, even a thousand years earlier in Old Kingdom mastabas,
marsh scenes depicting the deceased spearing fish or fowling
with a throw-stick were no longer reflections of contemporary life.
In the tomb of Nebamun, the artist attempted to update a tradi-
tional scene by giving the man a contemporary wig, throwing a

146
Men picking grapes in the tomb of Nakht, Sheikh Abd el-Qurna, Western Thebes, c. 1390 BC. Painting on plaster

long-stalked lotus flower and a couple of lotus buds over his right shoulder, and changing the form of his throw-stick from a functional weapon to a decorative snake-shaped object. This does not seem very plausible attire and equipment for an arduous trip into the marshes, and the figure of Nebamun's wife dressed up in all her finery, which is typically mid-fourteenth century BC in style, only enhances the feeling of unreality. She is wearing a cone of scented fatty substance on her head, such as can be seen on the heads of revellers in banquet scenes (see 141), and is ready for a party rather than a hunting expedition.

Second, how can the 'retrieving' cat be explained? Family scenes became very common in Theban tombs, and by the mid-fourteenth century BC a cat was a frequent participant in scenes of domestic happiness. When the family group consisting of husband, his wife and their daughter was transposed into the fictional marsh surroundings, it seemed natural to bring the cat with them. But here tradition and reality merged. The artist knew only too well how the cat would react to the presence of birds, and he showed it behaving naturally. This fusion of a fictitious scene brought up to date by contemporary detail and containing real-life observation is typical of New Kingdom Egyptian tomb decoration.

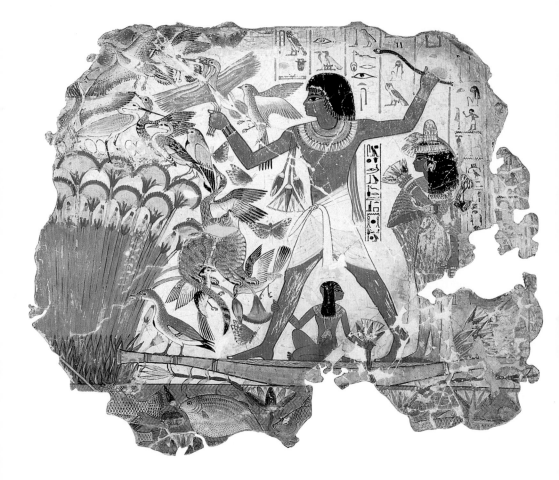

147
Nebamun and
his cat hunting
birds in the
marshes, from
his tomb in
Western
Thebes,
c.1360 BC.
Painting on
plaster;
h.81cm, 31⅛in.
British
Museum,
London

At Saqqara, the main cemetery of the Memphite area, private tombs developed somewhat differently. The Theban cemetery and Theban artists dominated the Egyptian funerary scene to such an extent that despite the economic importance of Memphis, Memphite tombs of the second half of the sixteenth and the fifteenth centuries BC were always overshadowed by them. The rock at Saqqara is of very poor quality, though a few large rock-cut tombs were made there from the reign of Thutmose III onwards. Some of these are decorated in relief with scenes that, in both their technique and subject matter, display marked differences when compared with their Theban counterparts. Other Saqqara tombs were painted and their subject matter is not substantially different from Theban tombs. This picture of an unexpectedly eclectic and heterogeneous approach to tomb decoration may soon be better understood as a result of recent discoveries at Saqqara, including a number of previously unknown tombs dating to the first half of the Eighteenth Dynasty. One of the most interesting is that of Aperel, a vizier of Amenhotep III and possibly also Amenhotep IV. The burial chamber contained the remains of exquisite wooden coffins. These are poorly preserved but there is a good chance that it will be possible to reconstruct them.

New Kingdom tomb statues show a range of interesting types. One that occurs frequently in all parts of Egypt shows husband and wife seated side by side, with their arms round each other's waists or hands resting on one another's shoulders. Single individuals were portrayed in a new type of statue, kneeling and holding a stela which is usually inscribed with the text of a hymn to the sun, or a shrine with the statue of a deity. Many tomb statuettes were made of wood (148); they tend to be restricted to simple, small standing figures, but some, especially those made during the reign of Amenhotep III, display all the qualities associated with his reign – technical accomplishment, elegance and sensuality.

From the Eighteenth Dynasty also comes the first detailed information on royal palaces. Because the king had to travel and visit local temples, and because Egypt now had two capitals at

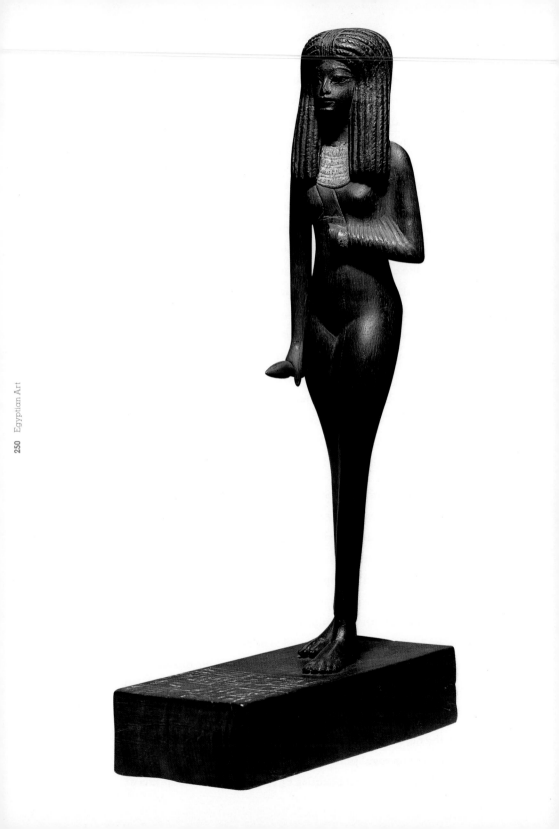

Memphis and Thebes, he was obliged to stay in different places as state or religious affairs demanded, with the result that there were several royal residencies in various parts of the country. Amenhotep III built a new palace complex at el-Malqata, on the west bank of the Nile opposite Thebes. This is not the earliest known palace, although it is the first that has been preserved in some detail. It contained living and ceremonial quarters for the king and his family, buildings housing the palace personnel as well as some of the highest state officials, and there was also a temple dedicated to Amun. When the king was in residence, this was the hub of the kingdom, where all the major decisions were taken. When the king's presence was required elsewhere, some of his officials and staff probably accompanied him – thus the royal residence moved with the king.

Unlike funerary architecture, domestic buildings were mostly built of mud bricks and wood, although stone elements were introduced when necessary. The plan of the part of the palace where the king probably spent most of his time was not unlike that of a temple, with a columned hall preceding the throne room. The dais of the throne replaced the shrine with the god's cult statue as the focus of the building and was decorated with images of subjugated foes. The king's bedroom and bathroom were situated behind the throne room, and the harem (ie domestic quarters for the king's family) flanked the columned hall. The decoration on plastered and painted walls, floors and ceilings of the living quarters was dominated by representations of aquatic plants, birds and animals; human figures were absent. This was strikingly different from the religious and political formalities of the art of the throne dais. These natural themes may have been religiously inspired, but this interpretation seems strained – it is much more likely that this was the traditional decoration of Egyptian palaces and, possibly, even less exalted domestic dwellings.

Fragments of wall-paintings found in palace gardens at Avaris (modern Tell el-Daba), the former capital of the Hyksos, clearly derive their style and subject matter from Minoan Crete rather

than Egypt (149). They depict bulls and bull-leapers, lions, leopards and other animals, and floral motifs. Although difficult to date, these paintings were probably made during the first half of the Eighteenth Dynasty. While subtle artistic influences deriving from the Aegean civilization, especially imitations of the spiral designs and geometric patterns of its pottery, are noticeable in Egyptian art as early as the beginning of the Twelfth Dynasty (1980–1801 BC), contacts may have intensified under the Hyksos. It was during the reigns of Queen Hatshepsut and Thutmose III, however, that representations of people from the Aegean islands and their products appeared most frequently in Theban tombs; after these reigns such scenes disappeared.

The paintings found at Tell el-Daba, however, represent much more than artistic influences: it seems that they actually were made by Minoan artists working in their own style on Egyptian soil. Further work on these fascinating paintings may change current ideas about how foreign influences were received in Egyptian art.

There are many surviving works which testify to the fact that the ancient Egyptians liked having attractively designed and decorated objects of daily use in their houses. Such items include jewellery, dyed textiles, elaborate basketry and decorated musical instruments, game boxes, scribe's palettes, medicinal

containers and animal-shaped weights. Many were found in tombs where they had been deposited as goods that the deceased person might like to have in the afterlife. Some of these were, indeed, specially created for tombs and are made of particularly expensive and long-lasting materials such as precious metals. Because so much tomb material from the New Kingdom has survived compared with other eras, these objects provide more information about the New Kingdom than is available for any other period.

Many pieces of furniture have been preserved: mainly beds, chairs, stools, small low tables, chests and boxes. Some are fairly utilitarian, for example those recovered from burials associated with the workmen at Deir el-Medina, on the west bank of the Nile at Thebes, but many are elegant items designed for the sophisti-cated tastes of the rich. Native as well as imported hardwoods were used, and the standard of the best Egyptian cabinet-making was very high: the furniture could be painted, varnished, gilded, inlaid in ivory, glass, faience or other materials, veneered, or its decoration might be carved. Latticework was common, and a wooden frame was often combined with rush or palm fibre matting woven in geometric patterns or with leather, giving complex and interesting surface textures. The decorative legs are sometimes carved as lion's paws, and some folding stools terminate entertainingly in duck-head carvings (150).

The technology for making small objects of faience, such as amulets and small figurines, was known already in the Predynastic Period (before 2972 BC). Egyptian faience was manu-factured by grinding materials such as quartz and calcite, mixing them with natron (a naturally occurring mixture of sodium salts) and copper or iron oxides. The mixture was then moulded by hand or cast into the required shape and heated to high temperatures, when it hardened and acquired a surface glaze of a characteristic bright and resonant turquoise shade. By the time of the New Kingdom (after 1540 BC) faience vessels, especially bowls and chalices, were common. The typical bowl of this period is decorated

with drawings applied before firing (151). These usually consist of freely-drawn and sinuous fish, lotuses and other marsh motifs, probably in reference to rebirth and the afterlife (the lotus flower opens at sunrise, and the Egyptians were much intrigued by the spawning habits of some fish, which they saw as self-propagation). These bowls may have been specially manufactured for tombs.

Most vessels used for everyday purposes were of wheel-made pottery, often undecorated. The variety of forms and materials

150
Folding stool, probably from a tomb in Western Thebes, c.1350 BC. Wood inlaid with ivory; h.48·3cm, 19 in. British Museum, London

151
Bowl with fish, c.1400 BC. Faience with painted decoration; diam. 15·7cm, 6⅛ in. Museum of Fine Arts, Boston

increased during the reign of Amenhotep III, and polychrome and applied relief decoration became widely used. Animals were the favourite subject, and Bes (the dwarf demi-god with a leonine face who was linked to family happiness) occurs often. Painted floral decoration imitates the real flowers that were draped over vessels during banquets and on festive occasions. The shapes of some pottery vessels imitate bottles and flasks made of such materials as leather. Others are as much

sculptures as containers and probably had a special purpose.
Those made in the form of a woman suckling a child are quite
plausibly thought to have been used for human milk, but it is less
evident what may have been kept in vases in the shape of female
musicians. Precious containers were also made of copper, bronze,
gold and silver using various techniques employed in the manu-
facture and decoration, but stone never went completely out of use.

Multicoloured glass dishes, flasks and goblets, with horizontal
wavy garlands in contrasting shades, probably developed under
Western Asiatic influence during the fifteenth century BC (152).
Possibly craftsmen visited Egypt or techniques were learned
through trade contacts. The contemporary civilizations of Minoan
Crete and Mycenae also provided some models for Egyptian
imitation. The manufacturers of the Eighteenth Dynasty knew how
to make enamelled glass by applying crushed glass to the surface
of an object which was then fired. This was one of the methods
used to provide vessels with inscriptions. Some cosmetic items,
such as various boxes and containers and tubes for kohl (black eye
paint), spoons (153), ladles and kohl sticks, were highly decorative.

They were often made in the form of a servant girl or a gentle and attractive animal or a bird. Mirrors were in the shape of a metal disc with an ornamental handle, sometimes in the form of a girl (154) or the composite demi-god Bes. Manicure implements were made to resemble an animal such as a horse, leopard or cheetah. Combs and hairpins often had animal-form handles or finials.

To the Egyptians who lived through almost forty years of peace and prosperity under Amenhotep III, it must have seemed that good times were there to stay. But a rude awakening was soon to come, in the form of a brief but very significant interlude, the Amarna Period.

154
Mirror,
c. 1400 BC.
Bronze;
h. 21 cm, 8¼ in.
Musée du
Louvre, Paris

155
Colossal
statue of
Akhenaten
from Karnak,
Thebes,
c.1350 BC.
Painted
sandstone;
original
h.c.4m, 13ft.
Egyptian
Museum,
Cairo

The Egypt of King Amenhotep III was sophisticated and
cosmopolitan. The economy prospered: farms, workshops, gold
mines and quarries were efficient and dependable providers of
the nation's wealth, which was the envy of the whole Ancient Near
East. The influence of religion was felt in all spheres of life and
united the land; the king's colossal statues at temple gates
commanded respect and inspired awe. Egypt's international
standing, relying as much on its overflowing coffers and diplo-
matic marriages as on its mighty army, was unchallenged, and its
external relations were conducted with consummate dexterity and
shrewdness. Foreign trade supplied abundant quantities of luxury
goods for the privileged, while the royal family led a charmed life
of opulence at el-Malqata and in other seasonally inhabited
palaces along the Nile. The country's administration boasted indi-
viduals of outstanding intellect, abilities and prowess. Arts and
architecture flourished in an unprecedented way.

Yet towards the end of Amenhotep's reign, or immediately after,
the country was plunged into one of the most traumatic periods
in its history, made worse by the fact that the crisis was entirely
home-grown. It is only with hindsight that any signs of the
impending upheaval can be detected in the surviving sources.
Art of the reign of Amenhotep III betrays no self-consciousness,
doubt or hesitation. On the contrary, it is full of vigour, confidence
and a willingness to experiment and search for new forms of
expression within the allowed artistic limits, and represents the
true peak of the development which had taken place over the
preceding two centuries. A profound break in all aspects of artistic
creativity was, however, about to emerge with startling rapidity.
New monumental temples would appear, revolutionary in their
architecture, building techniques and decoration. Traditional
subjects would vanish from the walls of temples and tombs, to

be replaced by topics which would draw their inspiration from a contemporary rather than imaginary world. New ways of portraying reality would be introduced, sometimes so strange that even now, more than three millennia later, they can seem perturbing and difficult to accept. The reasons behind such dramatic developments can be understood only in their historical and religious context.

Amenhotep III was succeeded by his son of the same name. The mother of the new Amenhotep was the 'great royal wife' Teye. Amenhotep IV (1353–1337 BC) was a young man when he ascended the throne in 1353 BC (his exact age is unknown), but he had probably married Nefertiti, his chief wife and the most ardent supporter of his religious reforms, well before this. Unfortunately, it is not clear whether the new king reigned at first jointly with his elderly father or succeeded him only at his death. The solution to this historical problem is of profound importance for the understanding of the arts of the period. Some historians believe that a joint rule of these two kings may have lasted merely a few months, others claim that it was as long as eleven years. If the latter is correct, then two entirely different and often diametrically opposed artistic styles – the 'orthodox' Egyptian art of Amenhotep III and the new 'Amarna' style (named after the new capital of the country at el-Amarna) – must have coexisted side by side, sometimes even on adjoining walls of the same building. With the exception of the Ptolemaic period, during which traditional Egyptian art had to come to terms with the art of the country's new Greek rulers, such a dichotomy is unknown in Egypt. On the whole, the evidence suggests that there was no co-regency between Amenhotep III and his son, or that it was so short as to be of little practical consequence.

The term 'revolution', which some apply to the period beginning shortly after the accession of Amenhotep IV, needs to be qualified. Amenhotep IV did introduce truly revolutionary ideas into the intellectual foundation of ancient Egypt – its religion – and these concepts were reflected in the arts, language and literature. Some

of them had a significant effect on Egyptian economy and the upper strata of Egyptian society, but they did not result in a true social revolution. In fact, the further an individual lived from the new capital at el-Amarna, and the lower down he or she was on the social scale, the less direct the impact of the 'revolution'. Moreover, Amenhotep IV's objectives appear to have been far from idealistic. His reforms focused mainly on his own relationship with the divinity. By monopolizing it completely he removed any doubts about his role as the sole intermediary between the god and the people, and in this way he corrected in one sweep any erosion of the royal status and removed the religious justification for the power wielded by the priesthood of the traditional gods.

The religious reforms of Amenhotep IV were, in fact, an attempt to introduce a form of monotheism (a belief in one god) into polytheistic Egypt. The seeds of these new religious teachings are evident in textual as well as iconographic sources of earlier periods, especially from the reign of Amenhotep III. Now they were developed further, moulded into a coherent system, and put into practice with logic and determination. The new king must have arrived at an intellectual justification of these ideas before his accession to the throne. From the beginning, he was an ardent follower of Re-Harakhty, a deity combining the characteristics of the sun god Re and the hawk-headed Horus, as Harakhty, literally Horus on the horizon.

The link between the sun god Re and the pharaoh ('the son of Re') was very old. The influence of beliefs which centred on the sun god increased steadily during the Eighteenth Dynasty, particularly in connection with the king's afterlife. Amenhotep IV followed a still more recent and radical trend towards elevating the sun god to the position of supreme deity. Re now embodied the qualities of all the other gods and, in this way, rendered them superfluous (this was different from the process known as syncretization in which two or more deities combined without fully losing their own identities). Signs of this had been noticeable during the previous two or three reigns, but the speed with which the

changes in religious thought gathered pace under Amenhotep IV was astonishing.

The cornerstone of the new religious doctrine, and quite likely the king's personal contribution to it, was the preference for the sun god's special manifestation, the impersonal radiant sun-disc (the Aten). The so-called 'Hymn to the Aten' inscribed on the walls of several private tombs at el-Amarna, and which may have been composed by Amenhotep IV himself, contains the main tenets of the new credo. The sun god is the creator addressed as the 'unique god, without another beside you; you created the earth as you desired, alone, [before] mankind, all cattle, all beings on land who walk on their feet, and all beings in the air who fly with their wings.' The 'Hymn to the Aten' has a spiritual predecessor – a similar concept was conveyed around a thousand years earlier by the reliefs on the walls of the so-called Room of the Seasons in the sun temple of King Neuserre (2408–2377 BC) at Abu Ghurab in the northern part of the Memphite necropolis. There, before the watchful gaze of Re-Harakhty and through his life-giving powers, the Egyptian countryside and every living thing in it change as one season succeeds another. Amenhotep IV, however, added a universal character to the sun god, who was now regarded as creator of all life, not only in Egypt, but in all countries 'encircled by the Aten', that is, all countries on which the sun shone.

The monotheism of the 'Hymn to the Aten' and its praise of god as creator have been compared to Psalm 104 of the Old Testament of the Bible. From the 'Hymn to the Aten':

The earth brightens when you rise on the horizon, when you shine as the Aten by day; as you dispel darkness and give forth your rays, the Two Lands are in festival ... The whole of the country goes about its business: all beasts browse on their pasturage; trees and plants sprout; birds fly from their nests, their wings stretched in praise of your *ka*; all flocks prance on their feet; all that fly and alight come to life when you have risen; ships sail north and south and roads are open when you appear; the fish in the river leap before you when your rays are in the depths of the waters.

From Psalm 104:

He sendeth the springs into the valleys, which run among the hills …
He causeth the grass to grow for the cattle, and herb for the service
of man: that he may bring forth food out of the earth …
He appointed the moon for seasons: the sun knoweth his
going down …
O Lord, how manifold are thy works! In wisdom hast thou made
them all: the earth is full of thy riches.

Eventually, the Aten was worshipped exclusively, at least on the
official level, while the old gods were consigned to the religious
wilderness. With the disappearance of royal patronage, which
was now diverted to the new deity, their temples lost much of their
former wealth and influence. The new religious thinking also
altered traditional funerary customs; even there the Aten now
reigned supreme. The earlier aspirations to life after death in the
kingdom of Osiris were transformed to a desire for perpetual exis-
tence under the rays of the Aten, although the material needs of
the person's *ka* in the afterlife did not change. Considering the
enormous importance of the old concept of the afterlife for all
Egyptians, this change may have been the new religion's Achilles
heel and the most difficult idea to accept. Moreover, Egyptian
religion was always multi-faceted, and different social groups
worshipped in various ways; among the poorest the pre-Amarna
beliefs continued unaffected.

The names of Egyptian kings, especially those received at corona-
tion, expressed ideas about kingship and the relationship of the
king to gods, and some of them were written in cartouches, orna-
mental oval frames. In order to stress the Aten's unique position in
Egyptian religion and to make a direct comparison with the simi-
larly exclusive role of the king in Egyptian society, the Aten was
given two 'programmatic' names which, in a similar fashion,
defined the deity's character and were written in cartouches, like
royal names. The royal family were close to the Aten to the point of
monopolization. For the pharaoh such a role was not new, but it
was expressed in an extreme form, as if the time-honoured ability

to delegate did not exist; the king and the queen were the new deity's main officiants, and it was only to them, as representatives of mankind, that the sun-disc extended its arm-like rays in the new religion's principal icon (156). This relationship was recorded in the change of the king's name from Amenhotep ('The God Amun is Satisfied') to Akhenaten, a name which lends itself to several interpretations: 'One who is Beneficial to the Aten', 'The Radiance of the Aten' or 'The Shining Spirit of the Aten'.

Changes of this magnitude profoundly affected all the arts associated with Egyptian temples and tombs, and Akhenaten and Nefertiti themselves may have inspired some of the artistic innovations of the period. Akhenaten's chief sculptor Bak (see 160), in an inscription carved on the rocks at Aswan, boasts proudly that it was the king himself who taught artists the rudiments of their arts. Bak's father Men probably directed the carving of the famous 'Memnon Colossi' (see 132) at the entrance to the funerary temple of Akhenaten's father, Amenhotep III, so the sculptor's pedigree was impeccable. It remains unclear whether this was the flattery of an obsequious court artist anxious to please his master and to preserve his status in the maelstrom of change and uncertainty engulfing his profession, or whether the king did indeed take a close interest in the arts. The fact that it was deemed useful and desirable to make such a statement illustrates the enormous gulf which separated the new Amarna art from that of earlier periods. The basic principles of Egyptian art had previously been regarded as given by the gods, thus perfect and impervious to change, a no-go area even for the pharaoh.

In order to observe the first flourishing of what is known as Amarna art we have to go to Thebes, and the heart of Egypt's religious capital, the great temple of the god Amun-Re at Karnak. The earliest traces of activities of Amenhotep IV in the temple are the reliefs on the walls of the third pylon, later disguised by the decoration of Sety I (1294–1279 BC) which was superimposed over them. These date from the very beginning of the reign and were probably begun by his father, but it was not much later that the king forsook

Stela from a house shrine showing Akhenaten and Nefertiti with three of their daughters beneath the rays of the Aten, from el-Amarna, c.1345 BC. Limestone; h.32·5cm, 12¾in. Ägyptisches Museum, Berlin

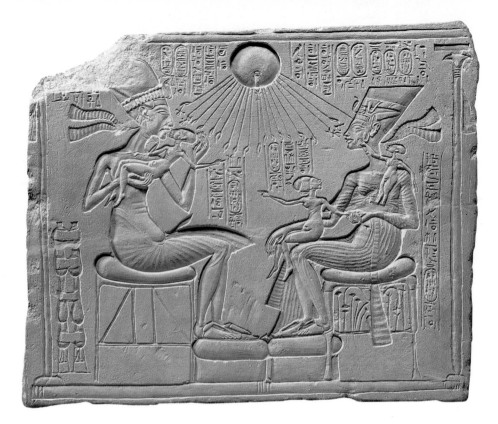

continuity and embarked on an ambitious project of his own – the building of several completely new sanctuaries for the sun god.

Already at this early stage the reluctance to come to any arrangement with the traditional gods demanded a site untarnished by their presence. The place chosen for the largest of them, called Gempaaten ('The Discovery of the Aten'), was several hundred metres to the east of Amun's sacred precinct. There may have been as many as eight of these new temples at Karnak. In the earliest structure, probably dating from Amenhotep IV's first year, if not the first few months of his reign, the god was still described as Re-Harakhty and represented as a hawk-headed figure with a large sun-disc on his head. In the others, he was shown in the form of a sun-disc, the relief technique employed to depict it giving it an almost the appearance of a globe. This was the only way the Aten was ever portrayed; during the whole of the period when the new religion held sway there were no iconographic variations in its depiction.

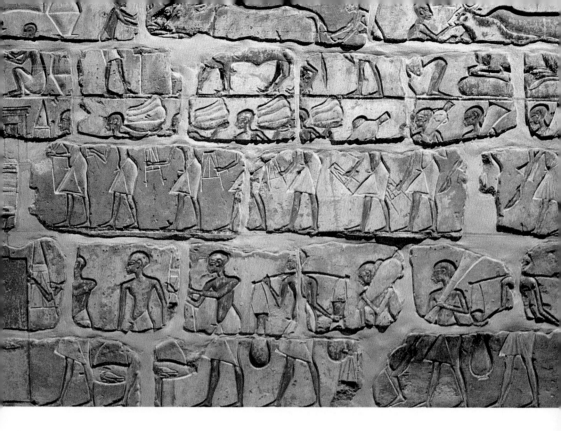

The forms of the worship of the Aten differed from those of the old gods and required new architectural forms. None of the Karnak sanctuaries remain; they were dismantled shortly after the end of the Amarna Period by King Haremhab (1323–1295 BC), and their blocks were reused as cheap building material in new structures. The reconstruction of the plans of these temples is a matter of careful analysis of the preserved blocks, the study of the surviving traces on the ground, and comparison with representations of such structures in the scenes on the blocks themselves. The major features of the temples were large courts open to the sun, surrounded by rows of rectangular pillars and fronted by pylons.

The pace at which events were unfolding suggests that Akhenaten was a man possessed, consumed with impatience, as if he felt that the time for accomplishing all his reforms was limited. The builders of the temples which were now being hastily put up at Karnak employed stone blocks of unusual dimensions, much smaller than anything that had been used in Egypt before.

157
Reconstructed
talatāt wall
from the
temple of
Amenhotep IV
(Akhenaten),
at Karnak,
Thebes,
c.1350 BC.
Sandstone,
painted sunk
relief;
l.17·2m,
56ft 5in,
h.3m, 9ft 9in.
Luxor Museum
of Ancient
Egyptian Art

This may have been partly due to the relatively thin layers of sandstone in the quarries at Gebel el-Silsila, near Kom Ombo, some 150 km (93 miles) south of Thebes, where the building material was quarried, but the main reason was probably the ease with which smaller blocks could be handled. Of a fairly uniform size (about $52 \times 26 \times 24$ cm or $20^{1}_{2} \times 10^{1}_{4} \times 9^{1}_{2}$ in, weighing about 50 kg or 110 lb), these are usually called *talatāt*, a term borrowed from medieval Islamic architecture where stone blocks of similar size were commonly used (*talāta* means 'three' in Arabic, *ie* three hand-spans long). Some forty thousand *talatāt*, most of them with at least one side decorated, have been recovered from structures of later kings at Karnak and Luxor, and they present archaeologists with the equivalent of a huge jigsaw puzzle (157).

Except for the earliest building, the walls of the new Karnak temples were decorated in sunk relief, a technique that relies for its effect on the contrast created by the dark shadows cast by the sharp edges of the higher planes on to the incised lines or lower surfaces. This was quite logical since large areas of the temples of the Aten were open to daylight. Sunk relief has, however, another advantage over raised relief – it is less laborious to carve because the amount of material that has to be removed is smaller. This was almost certainly an important incentive for its use in the new structures of Amenhotep IV, and it was probably the reason why the builders of the Amarna Period preferred it even where the absence of appropriate illumination made the technique less suitable. The sunk relief of the Amarna Period is characterized by the careful modelling of details which makes it appear more three-dimensional. All representations carved in relief were painted in bright colours, and selected details may have been accentuated by inlays in faience, glass or other materials.

The new focus on a single deity did away with almost all traditional themes of temple reliefs, in particular those showing the king in the presence of various gods. This was of profound importance; the complex, varied and immensely elaborate repertory, full of symbolism and allusions, which had evolved over the preceding

fifteen hundred years, had to be replaced by new subjects. Realistic images were now introduced into temple scenes and at once became predominant. A few of the scenes on the walls of the new temples at Karnak represented variations on well-tried topics, such as the king with his family presenting offerings, or the king's jubilee festival, but most of the others were completely new: the preparation of offerings in the Aten's temples, activities taking place in and around royal palaces, ceremonial processions involving the king and his queen, and depictions of palaces and temples detailed enough to be architectural drawings. All these themes were inspired by aspects of everyday life which they probably depicted quite faithfully. Only the arms of the sun-disc, sometimes clutching little symbols of life and dominion in their hands and proffering them to Akhenaten and his family, and the symbol for 'life' suspended from the disc, were concessions to metaphysical ideas and the imagination. The new art rejected tradition in favour of realism, and replaced timelessness with immediacy.

Another innovation is that Queen Nefertiti features as prominently in the decoration of the Karnak temples as the king. Some of the roles in which she appears – for example massacring prisoners (no doubt a fictitious, symbolic image) – were traditionally a prerogative of the king alone. It would be difficult to explain Nefertiti's pre-eminence except by her personal influence over the king and possibly also over the religious changes then under way.

The introduction of a completely new repertory of temple scenes led almost inevitably to changes in the way the subjects were depicted. A tendency towards greater realism was reflected in the decline of standard idealized portrayals of human figures in favour of recording individual characteristics, such as signs of age, or momentary feelings such as triumph, elation or grief. Artists now positively delighted in the attention they paid to some details of the human body – hands, fingers, feet and toes – while the accentuation, almost exaggeration, of others, such as the well-fed rounded stomach above a precariously sagging kilt, became a cliché and the stylized hallmark of the Amarna Period, suggesting

that even here appearances should not be taken too literally. There was a greater willingness to show transient states – the movement of a reckless chariot dash, the fluttering of a garment or the ribbons attached to the royal crown ruffled by the breeze. Almost as a consequence of this freedom, a loosening of the typically Egyptian axial symmetry can be observed. The traditional standardized proportions of the human body were slightly modified and a twenty-square grid from base to hairline was now used for the depiction of a standing figure. Attempts to indicate depth and three-dimensionality by showing figures and objects overlapping and partly obscuring each other, in order to achieve a near-perspectival representation, were frequent. The artists of Amenhotep IV came quite close to the concept of a single unified space, as compared with the earlier (and later) understanding of it as a series of stacked-up two-dimensional planes.

If it is accepted that the artists now tried to come to terms with reality in a way not seen before, it comes as a complete shock to be confronted with the seemingly distorted and exaggerated features of the king – the long narrow face with hollow eyes, prominent jutting nose, large sensuous lips, high cheekbones, projecting lower jaw and strikingly narrow chin, long neck, conspicuous breasts, almost swollen stomach, feminine buttocks, heavy thighs and thin, spindly calves. These features can be seen in reliefs as well as in statues, and are clearly not just undisciplined experiments or the aberrations of one artist. Perhaps the most striking examples are the colossal statues of the king that adorned pillars around the courts of his temples at Karnak (155, 158). The greatest degree of this near-caricature grotesqueness dates from the early part of the reign of Amenhotep IV; in later years the tendency was less pronounced.

There is no agreement on the reasons for the distorted portrayal of the king in the early years. It can hardly be explained by a desire to imitate a divinity – the only deity whose features the king might have wished to make his own actually had no human form. It is equally difficult to regard it as a special 'Amarna' way of seeing

the human figure; in spite of all the changes in the visual arts which took place during the Amarna Period, their main *raison d'être*, as an expression of religious ideas, remained intact. The simplest explanation is that the physical appearance of the king was indeed unusual (possibly as the result of a medical condition) and that his features were consistently, faithfully and, from our point of view, completely mercilessly recorded because of the striving for realism which he personally endorsed.

There is something similarly strange in the early representations of Nefertiti: her profile resembles her husband's and sometimes

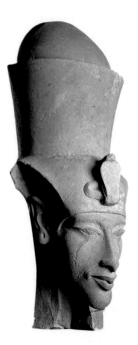

158
Head of a
colossal statue
of Akhenaten
from Karnak,
c. 1350 BC.
Sandstone;
h. 141 cm,
55 ½ in.
Luxor Museum
of Ancient
Egyptian Art

159
Female torso,
probably
Nefertiti,
c. 1345 BC.
Quartzite;
h. 29 cm, 11 ½ in.
Musée du
Louvre, Paris

acquires an almost apelike appearance. Yet in the quartzite torso from the early part of the Amarna Period (159) and the bust found at el-Amarna (see 161, 162) from the latter part of the period, Nefertiti is shown as a beautiful and sensuous woman. The 'reality' that the artists of the early years of Amenhotep IV portrayed was probably 'the king's reality', dominated by his unusual physiognomy. He was the prototype that the court artists imitated and which influenced the early representations of Nefertiti and, to a lesser degree, those of the royal princesses. Perhaps as a proof of

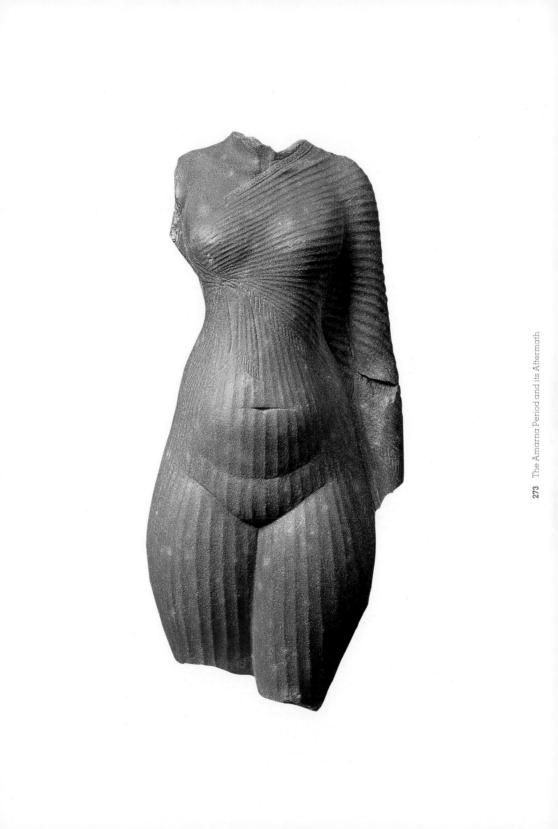

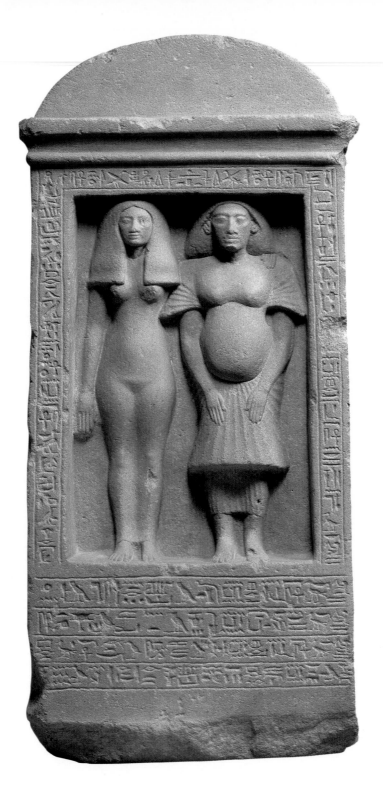

his proficiency in the new artistic style, the king's chief sculptor, Bak, adopted it for his own three-dimensional self-portrait (160), carved in a niche-shaped stela, which showed him with fat pendant breasts and a large stomach, and so related him closely, at least in physical terms, to his royal master. Even so, it was unusual for people outside the royal family to be represented in a similarly grotesque fashion.

The chasm separating the Egyptian visual arts before and after Amenhotep IV's accession is vividly demonstrated in the tomb of Ramose (see 143). He was a vizier of Amenhotep III whose rock-cut tomb in the Theban necropolis was still being completed under Amenhotep IV. On the west wall of the first columned hall, to the left of the doorway leading into the inner room, Amenhotep IV and the goddess Maet are shown seated in a kiosk, in a style typical of the reign of his predecessor. On the same wall, to the right of the doorway, the king and his queen Nefertiti appear in a palace window, this time shown in the style of the early years of his reign. The Aten's rays are extended towards them with the signs of life and dominion. It is extraordinary that only a few months or weeks may have separated the two scenes.

It was around his fifth regnal year, well before the massive building programme at Karnak could be completed, that Amenhotep IV made a clean break with the traditional religious centre of Egypt and, now as Akhenaten, moved to a previously sparsely inhabited area of Middle Egypt, some 260 km (162 miles) to the north of Thebes. There, at a place now known as el-Amarna, in a deep bay on the eastern bank of the Nile, whose shape recalled the Egyptian hieroglyphic sign for 'horizon' (akhet), he founded a new royal residence and state capital called Akhetaten, 'The Horizon of the Aten'. It was as if he had decided to reject and abandon everything linked to the time before the Aten was promoted to the supreme deity, and had sought refuge in a new city totally unconnected with the past. There he could create an ideal world for himself and for the Aten, a truly 'heretic city' in the eyes of his successors. It was to serve as the king's residence, the administrative centre of

160
Niche-shaped stela of the sculptor Bak and his wife, c.1340 BC. Quartzite; h.67cm, 26in. Ägyptisches Museum, Berlin

161–162
Overleaf
Bust of Nefertiti from a sculptor's studio at el-Amarna, c.1340 BC. Painted limestone; h.50cm, 19⅝in. Ägyptisches Museum, Berlin

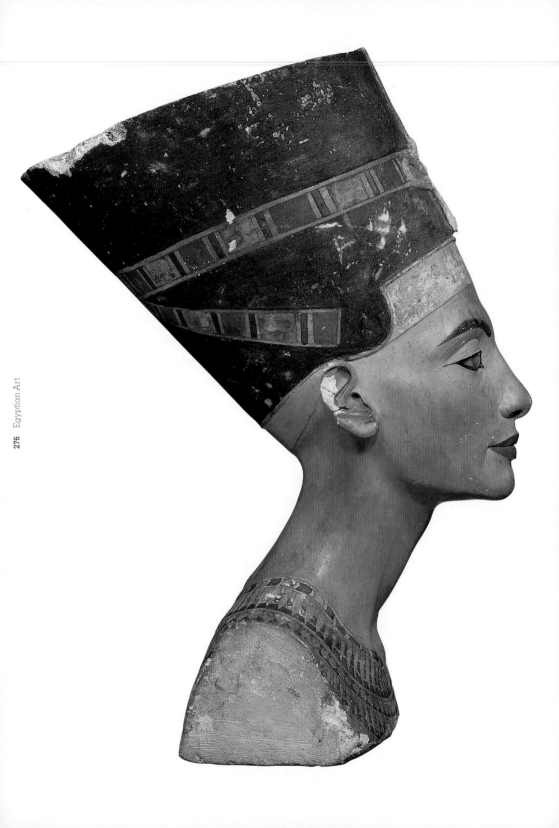

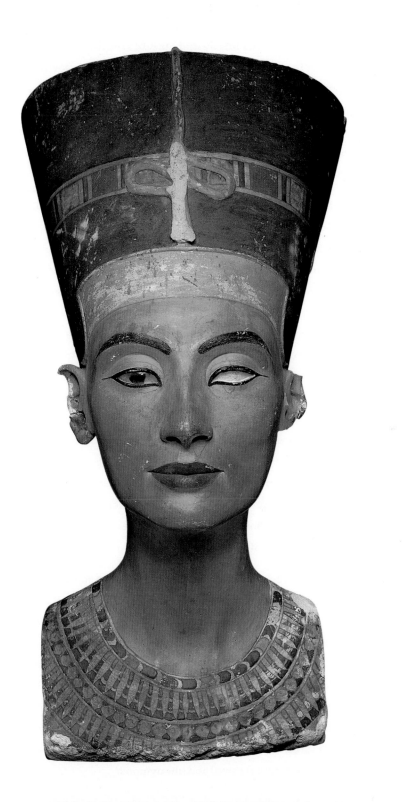

the country, the main place of worship of the Aten, and the burial place for the king, his family and his officials. It was one of the few occasions in ancient Egyptian history when a whole town was purposefully planned and built, thus providing a contemporary idea of the 'ideal' city, although it was Akhenaten's special personal vision. Memphis, some sixteen hundred years earlier, and Alexandria, a thousand years after el-Amarna had been abandoned, were created in a similar way.

The city extended over an area measuring about 7 km (4 miles) north to south, 1 km (5_8 mile) east to west. It was bisected by a broad road, and its ceremonial and administrative centre contained a huge jubilee-festival palace and the king's house, linked by a bridge over the street which separated them. There were also two large temples of the Aten, offices, archives and other administrative buildings, as well as kitchens and stables. To the north and south of the central city were densely populated residential areas. Dwellings of rich officials at el-Amarna were more like country villas, with spacious courtyards and gardens; others belonged to master craftsmen and artists. There were further palaces, temples and administrative buildings on the outskirts of Akhetaten, particularly in the north. Here, in an area unpolluted by the noises and smells of the metropolis (the prevailing north winds carried them in a different direction), may have been Akhenaten's main palace. Additional places for the worship of the Aten were situated in the desert near to the city.

A house in the southern suburb belonging to the sculptor Thutmose was found to contain a remarkable collection of sculptures of the royal family, among them the famous bust of Nefertiti (161, 162). This probably served as a prototype for her statues, which perhaps explains her 'blind' eye – there was no need to complete both eyes on a mere model. A group of remarkably realistic faces in plaster from the same sculptor's workshop (163) should probably be seen in the same way. Although the names of a few Amarna artists, such as Bak and Thutmose, are known from inscriptions, most art remained anonymous.

163
Head of
Akhenaten
from a
sculptor's
studio at
el-Amarna,
c.1340 BC.
Painted
plaster;
h.25cm, 9⅞in.
Ägyptisches
Museum,
Berlin

Images of the 'holy family' were everywhere; some private houses contained shrines with representations of the Aten, Akhenaten and Nefertiti, often accompanied by their daughters (see 156). These shrines were reserved for private worship and thus replaced the veneration of house-gods and household spirits in the semi-official religion of old. The two- and three-dimensional representations of the 'holy family' are remarkable for their sympathetic and almost sentimental portrayal – at which other time during Egyptian history could the 'great royal wife' be depicted seated on her husband's knee, or the king joyously kissing his little daughters?

Although the temples at el-Amarna were no longer built of sandstone but of locally quarried limestone, the builders retained the

talatāt dimensions of the building blocks. The plans of these temples confirm the evidence provided by remains of the early temples of the Aten at Karnak. They consisted of several large courts separated by pylons. Altars, sometimes surrounded by a large number of smaller offering tables, were placed in these courts and in the sanctuary at the far end of the structure. The courts as well as the central part of the sanctuary were open to the sun. The walls of the temples were decorated with scenes in sunk relief, with subjects similar to those found in the temples of the Aten at Karnak. A block with three antelopes may have been part of a scene showing animal pens belonging to the palace (164). Limestone was better suited to the carving of fine details than the rather coarse sandstone of the Karnak *talatāt*, and this

may have contributed to the softening of the line of the reliefs in the later phase of Amarna art.

Large numbers of statues, almost all showing the king and the royal family, and mostly executed in the style which abandoned the extreme caricature of the early years, were placed in the temples at el-Amarna. Images of the king are characterized by the conspicuously long skull, also recorded in reliefs. Statues of Nefertiti and the princesses (165), similarly rendered, were nearly as frequent as those of the king. Sometimes figures were composite, with different parts made of different materials, and inlays were frequently used for eyes and eyebrows. Few statues of private individuals are known, since the royal monopoly on communion with the Aten did not encourage their presence in temples.

164
Talatāt block with two antelopes, from el-Amarna, reused at Ashmunein, c.1340 BC. Limestone, painted sunk relief; h.23·1cm, 9 in. Brooklyn Museum of Art, New York

165
Head of a daughter of Akhenaten and Nefertiti, c.1340 BC. Quartzite; h.21cm, 8¼in. Egyptian Museum, Cairo

166
Two daughters of Akhenaten and Nefertiti, from a palace at el-Amarna, c.1345 BC. Painting on plaster; whole painting 40×165cm, 15¾×65in. Ashmolean Museum, Oxford

Amarna palaces and houses were mostly built of mud brick, although relief decoration carved in stone is also found in the palaces and represents a new departure in their architecture. Practically all the interior walls, ceilings and floors of civil dwellings were whitewashed or plastered, and the decoration was painted on this white background. In private houses, it often consisted of simple geometric patterns, such as alternating rectangles of different colours, floral friezes and complex garlands – lotus flowers, bunches of grapes, cornflowers and the fruits of the mandrake. Palaces contained elaborate mural paintings of daily life, similar to the scenes that occur in Amarna Period temples and tombs. Sometimes these included representations of the royal family (166). Polychrome faience inlays and tiles with repeated vegetal motifs, such as lotus flowers, marguerites and mandrake fruits, were frequently used, but more complex compositions, for example cattle amid tall rushes, are also found. Gardens and ponds teeming with aquatic life and birds – a subject known in Egyptian paintings from as early as the Old Kingdom – occur only on palace walls and floors.

167
Vessel in the form of a fish, from el-Amarna, c.1340. Polychrome glass; 1.14·5cm, 5¾in. British Museum, London

The Amarna Period was in no way a retreat into austerity and contemplation of divinity, and many small objects, especially those made of glass and faience, show that the religious zeal that pervaded contemporary thinking did not diminish the desire for luxury and the enjoyment of beautiful things which characterized the preceding period. Extremely beautiful jars and flasks, sometimes in the shape of fish (167), were made of multicoloured glass. Indeed, Egyptian glass manufacture reached its peak during the Amarna Period.

As the final resting place for himself and his family, Akhenaten chose a remote and desolate spot in a desert valley some 10 km (6 miles) east of the central part of the city. There a tomb was cut into the rock, but its decoration, executed in sunk relief, is quite unlike that of the earlier royal tombs. There are no representations showing the pharaoh in the company of gods and no scenes or texts from the Imi-duat, the Book of the Dead or other

similar compositions. Instead, the subject matter echoes that of the temples of the Aten: the royal family, accompanied by courtiers and attendants, worship the Aten; the Aten appears over the horizon (perhaps in a visual pun on the name of Akhenaten's city) and is greeted by gazelle and ostriches 'dancing' in the desert as the sacred disc sends its life-giving rays over the bustling city of Akhetaten, where it is hailed by the king and his family. Representatives of foreign lands pay their respects, as do courtiers and soldiers; rows of their chariots wait nearby. Quite unexpected are two scenes which show the royal family in grief, probably mourning the deaths in childbirth of two of Akhenaten's

daughters. The tomb would have been made inaccessible once the burials were deposited there, so this was not a public display of emotions. Such a record of tragic events in the life of the royal family is unparalleled in Egyptian art.

Although two groups of officials' and priests' tombs were begun in the cliffs to the northeast and southeast of the central city, most were left unfinished and were probably never used. Tomb architecture was the weakest aspect of Amarna art, not surprisingly in a society in which the brightly shining disc of the sun was the supreme deity. As in the rock-cut tombs at Thebes, these tombs

comprised an entrance corridor leading to one or two halls where the ceiling was often supported by two or four columns, and a centrally situated shrine with a statue of the tomb-owner. Their decoration was executed in sunk relief. The poor quality of the rock forced the artists to resort to an extensive use of plaster in order to make the surface suitable for receiving the reliefs. As in temples, the subject matter drew on scenes of everyday life. Some of these are connected with the tomb-owner, such as scenes in which he is rewarded for his exemplary service by the king before the other members of the royal family and courtiers. The majority of them are, however, similar to those found in temples, and here again are the ubiquitous set scenes with the king and royal family resplendent under the rays of the Aten.

Akhenaten's religious reform, which for the only time in Egyptian history reversed many of the basic and time-honoured conventions of Egyptian art, did not see out two decades, and the 'Amarna revolution' came to an end with the death of its main protagonists. Akhenaten died in his seventeenth regnal year, in 1337 BC. The exact circumstances of the closing chapters of the Amarna Period are not yet fully known. Many modern accounts seem to delight in lurid stories of revenge exacted on the representatives of the Amarna regime and its deity. They tell of Akhenaten's body 'torn to pieces and thrown to the dogs', and of destruction wrought upon Amarna works of art by fanatical supporters of the old gods. These tales are certainly fictions, however, inspired largely by unwarranted comparisons with revolutionary events in modern history.

More often than not, the reign of Akhenaten is portrayed in negative terms. His successors had good reasons for vilifying him because his reforms represented a challenge to their own right to rule, in that they rejected the religious foundations on which the pharaoh's powers and his relationship to Egyptian society were based. Egyptian priesthood had a similarly vested interest in removing all traces of the Amarna Period. In modern times, Akhenaten is often regarded as an anomaly, a freak who dared to challenge the religious and artistic values that, even in modern

Western eyes, embody the spirit of ancient Egypt. He is held up to criticism not least because his mission ultimately failed. There is, however, another less popular but more plausible interpretation, namely that this was the period during which Egypt made a brave attempt to anticipate difficulties ahead and to come to terms with the rapidly changing world by reforming its ideological foundations from within.

The reality of the Amarna aftermath was, remarkably, fairly benign and tolerant, perhaps because the changes were not brought about by an opposing faction that wrested power from the old regime by force. An era of reconciliation and restoration was inaugurated under King Tutankhaten (better known as Tutankhamun, 1336–1327 BC), probably a son of Akhenaten and only a child of about ten or, at most, in his early teens, at the beginning of his reign. The ideas of Akhenaten's 'revolution from above' were gradually abandoned and a return to orthodoxy in all respects was under way. Official Egyptian art followed the same course. Temples and shrines of the traditional deities that had been seriously affected by neglect and sometimes open hostility during the preceding years regained their previous religious and economic status. Their buildings, decoration, statues and other furnishings were restored or replaced, and in this a conscious effort was made to return to the earlier artistic conventions. The god Amun, the chief loser during the Amarna years, was the main beneficiary. Tutankhamun's restoration efforts focused mainly on the temples of Amun at Karnak and Luxor; completely new building projects were few.

In the third year of his reign, in an act which was a reversal of that performed by his father fifteen years earlier, Tutankhaten formally proclaimed his renunciation of the sun-disc doctrine by replacing the 'Aten' in his name with 'Amun', thus becoming Tutankhamun. The role of the king's advisers in these moves is difficult to assess, but in view of Tutankhamun's youth it probably was considerable. The city of el-Amarna was abandoned and the king with his court and officials moved to the old Egyptian capital of Memphis in the

north. Many of the craftsmen and artists who had previously worked under Akhenaten migrated with the court. But, just as a complete eradication of the ideas which the Amarna interlude produced was not possible, so the artistic innovations of the period were not lost altogether. It was here, in the Memphite area, that a very remarkable artistic development was taking place.

Tutankhamun's Memphis has not yet been rediscovered, but there is plenty of evidence that the necropolis at Saqqara, to the west of the city, was now the focus of activities on a scale not witnessed since the end of the Old Kingdom a millennium earlier. Three things fortuitously combined: firstly, the presence of the court at Memphis and its demand for richly decorated tombs, and secondly, the availability of a large number of immensely skilled tomb-builders and artists who had become redundant as the result of the abandonment of the Amarna projects. Thirdly, the geological conditions at Saqqara rendered the site unsuitable for rock-cut tombs. The form which finally resulted was a masterpiece of Egyptian private tomb architecture, the Memphite freestanding chapel of the post-Amarna Period.

The plan of these Memphite tomb chapels had all the features of the earlier, pre-Amarna, Theban rock-cut tombs, but reinterpreted to suit a freestanding structure as demanded by the local setting. In its simplest form, the chapel consisted of a single room with a stela in its western wall, and in its most elaborate version, the tripartite complex of rooms with a stela at the western end was approached through a pylon and a series of peristyle courts and rooms with stelae and statues. If the visitors lifted their gaze, they could just see the tomb's small pyramid looming above the western end of the chapel. The mummified body of the tomb-owner was placed in underground rock-cut rooms. The walls of these tomb-chapels were adorned with exquisite reliefs that subtly combined the Amarna innovations with traditional pre-Amarna representations.

Perhaps the earliest large tomb to be built at Saqqara under Tutankhamun belonged to General Haremhab, whose support for the young ruler was essential. He himself, as an old man,

was destined to ascend the Egyptian throne when the Thutmoside line came to an end. He was buried in a tomb on the west bank of the Nile at Thebes in 1295 BC. The reliefs in his Saqqara tomb are a heady and confusing mixture of styles and techniques. The badly damaged and incomplete figures of his royal masters, originally on the western wall of the second court, can only represent Tutankhamun and his queen Ankhesenamun (168). The sensuous but cruelly unflattering portrayal of their young bodies running to fat, clad in diaphanous garments that conceal little, are unmistakably Amarna in style. Elsewhere, the irregularly uneven baseline in the military encampment scenes (169) also betrays the hand of an Amarna-trained artist, but all is executed in raised relief, a technique which was almost unknown under Akhenaten. Sunk relief was, however, used for a scene showing a group of African captives (170). As is to be expected, the figures quite unaffected by the Amarna Period are the representations of deities.

While the king and the court now resided at Memphis, Thebes was once again acknowledged as the country's religious capital. The most important tomb created there during this period belonged to the viceroy Amenhotep Huy who was governor of gold-bearing Nubia (see 6). Some influence of the preceding Amarna Period is still felt in the tomb's painted decoration, particularly in the interest in scenes of everyday life and the depiction of the well-fed minor figures, but in the more formal representations of the king the link with the art of Amenhotep III seems closer. It is difficult to escape the impression that in the immediately post-Amarna Period artists at Memphis worked in much more relaxed conditions than their colleagues at Thebes.

Tutankhamun died during the tenth year of his reign when he was only eighteen or, at most, in his mid-twenties (the results of the examination of his mummy were ambiguous). As an ultimate repudiation of his Amarna origin, a tomb was made for him on the west bank of the Nile at Thebes, opposite the Karnak temple of Amun, in the Valley of the Kings. It is the only royal tomb in

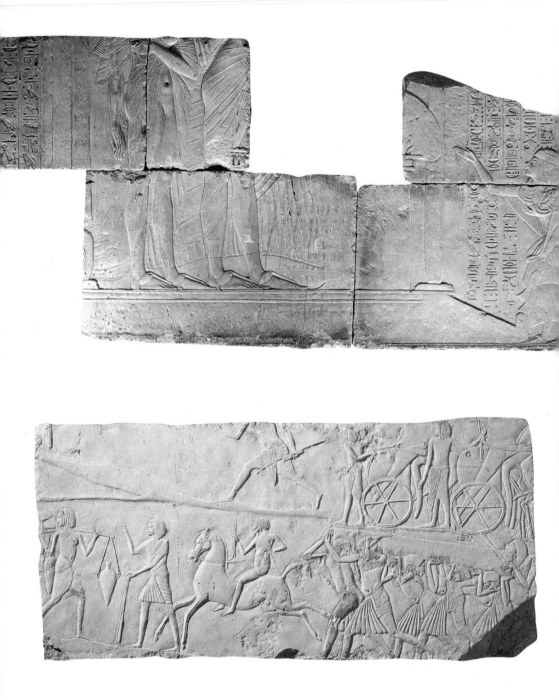

168
General Haremhab (the future King Haremhab) and Syrian chiefs being received by Tutankhamun and his queen, from his tomb at Saqqara, c.1330 BC. Painted limestone; 102×350cm, 40⅛×137¾in. Rijksmuseum van Oudheden, Leiden

169
Military camp with a horseman, from General Haremhab's tomb at Saqqara, c.1330 BC. Limestone, painted raised relief; 60×127cm, 23⅝×50in. Museo Civico Archeologico, Bologna

170
African captives, from General Haremhab's tomb at Saqqara, c.1330 BC. Limestone, painted sunk relief; 68×85cm, 26¾×33½in. Museo Civico Archeologico, Bologna

ancient Egypt, before the royal burials at Tanis several hundred years later, which has been found intact (171–173). The fame of its discovery is forever linked with the names of Howard Carter and Lord Carnarvon – in a remarkable story of courage, optimism, romance and sheer bloody-mindedness which, for once, had a happy ending. It would have been difficult to foresee in 1891, when Carter was appointed by the Egypt Exploration Fund to assist Percy E Newberry in copying tomb-scenes, that some thirty years

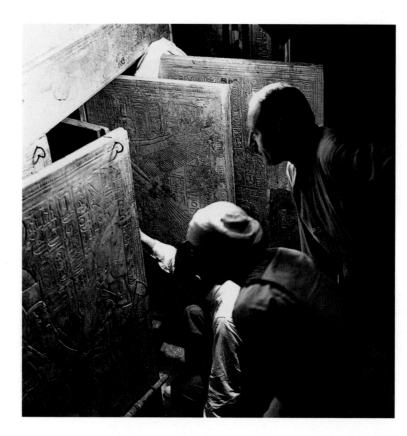

171
Howard Carter opening the shrines of Tutankhamun's sarcophagus, 1922

172
View of the 'Treasury' of Tutankhamun's tomb in the Valley of the Kings, Western Thebes, 1327 BC. As found by Howard Carter in 1922. Photograph by Harry Burton

later he would make the greatest archaeological discovery in Egypt, and possibly in the world. Carter's archaeological career was far from smooth and nearly came to an end in 1905 when he was forced to resign from his position as Chief Inspector of the Antiquities Service for Lower Egypt for defending the actions of his Egyptian site guards in an altercation with a group of disorderly European tourists. His support for his Egyptian employees

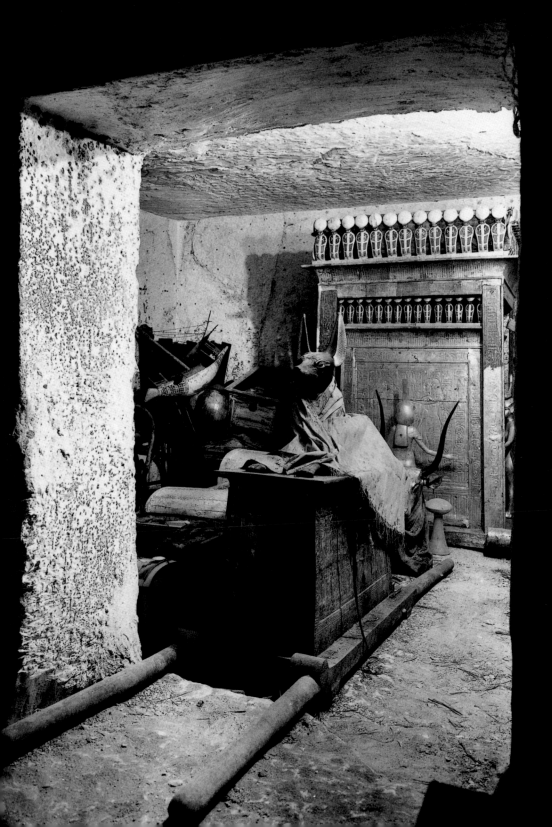

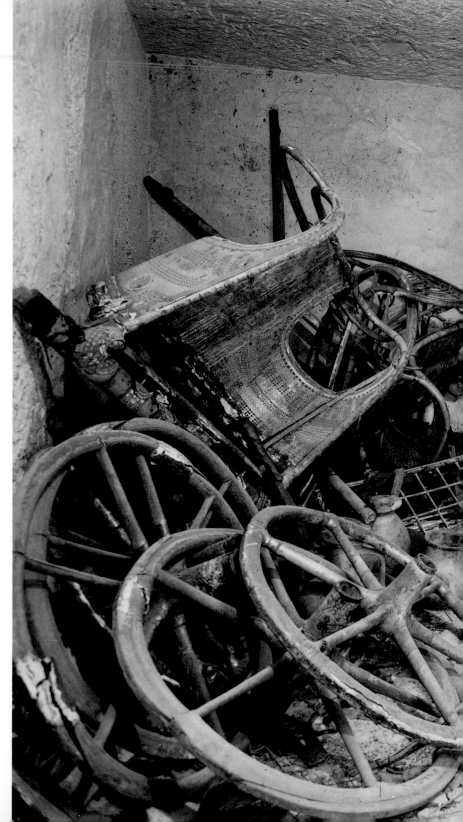

173
View of the
antechamber of
Tutankhamun's
tomb,
1327 BC.
As found by
Howard Carter
in 1922.
Photograph by
Harry Burton

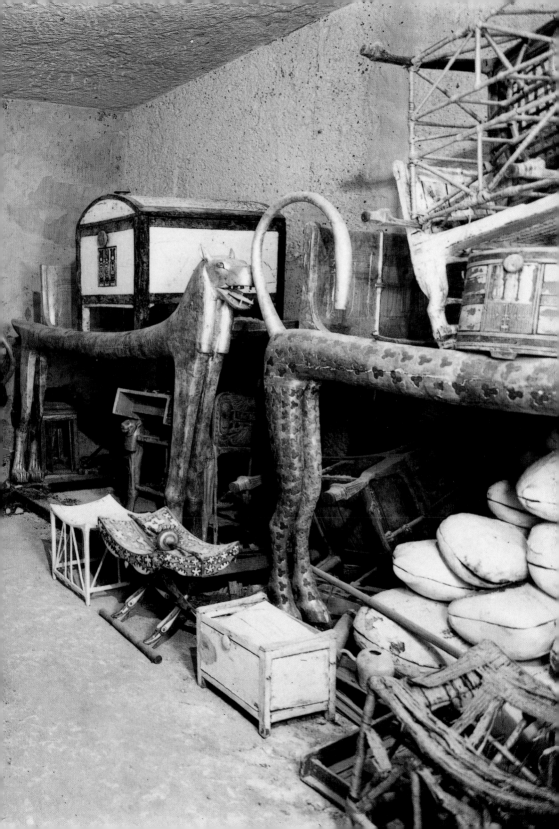

astonished his contemporaries and still seems to baffle some of his biographers. He was, thus, available when some three years later Lord Carnarvon was looking for an archaeologist to take charge of excavations financed by him on the Theban west bank (and later in other parts of Egypt). However, it was some fourteen years before he made his great discovery.

It came as Carnarvon's patience was running out and funding was at risk. On 5 November 1922 Carter noted in his diary: 'Discovered tomb under tomb of Ramses VI. Investigated same and found seals intact.' He telegrammed Lord Carnarvon, who immediately set out from England for Luxor. On 26 November Carter, Lord Carnavon, his daughter Lady Evelyn and Arthur R Callender, Carter's close collaborator, opened a sealed doorway. Carter later wrote:

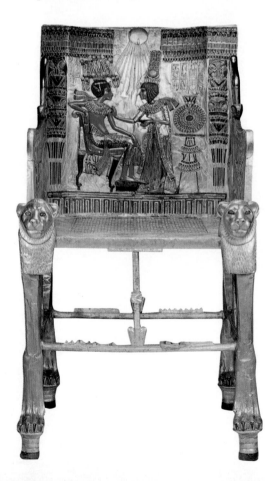

174–175
Tutankhamun's 'Golden Throne', c.1335 BC. Wood, gold, silver, glass, faience and semiprecious stones; h.104cm, 41in. Egyptian Museum, Cairo
Right
Detail showing Tutankhamun and Queen Ankhesenamun

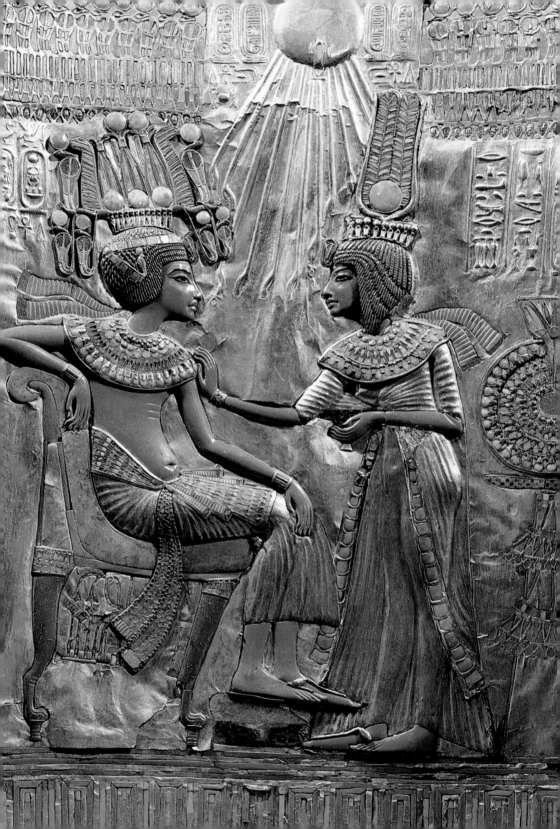

I inserted the candle and peered in, Lord Carnarvon, Lady Evelyn and Callender standing anxiously beside me to hear the verdict. At first I could see nothing, the hot air escaping from the chamber causing the candle flame to flicker, but presently, as my eyes grew accustomed to the light, details of the room within emerged slowly from the mist, strange animals, statues, and gold – everywhere the glint of gold. For the moment – an eternity it must have seemed to the others standing by – I was struck dumb with amazement, and when Lord Carnarvon, unable to stand the suspense any longer, inquired anxiously, 'Can you see anything?' it was all I could do to get the words, 'Yes, wonderful things.' Then, widening the hole a little further, so that we both could see, we inserted an electric torch.

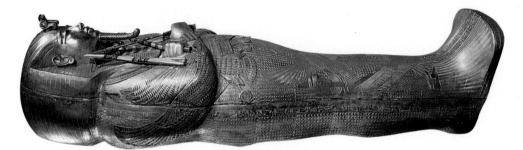

176
Upper part of
Tutankhamun's
third
(innermost)
coffin,
c.1330 BC.
Gold;
l.188cm, 74in.
Egyptian
Museum,
Cairo

177
Tutankhamun's
gold funerary
mask,
c.1330 BC.
Gold, lapis
lazuli, glass,
faience,
semiprecious
stones, etc.;
h.54cm, 21¼in.
Egyptian
Museum,
Cairo

The tomb of Tutankhamun gives us some idea of the wealth, both artistic and in terms of precious metal, which was deposited in royal tombs of the New Kingdom. There are occasional glimpses of the work of Amarna workshops. On one of the thrones (174, 175), probably dating to the king's early years, the Aten confidently shines over the figures of Tutankhamun and Queen Ankhesenamun. In other pieces, the return to orthodoxy is complete, and there is little to connect Tutankhamun's coffins (176) and gold mask (177) with the art that flourished under Akhenaten. The tomb's most striking contribution to our knowledge of art lies in items which are not attested elsewhere, such as the gold coffins, gold mask and various other objects found on the mummy, and the gold covered shrines (178). There are some unusual sculptures, including one showing Tutankhamun standing on a black leopard (although there is some question as to whether the piece was originally intended for Tutankhamun). An enigmatic 'mannequin'

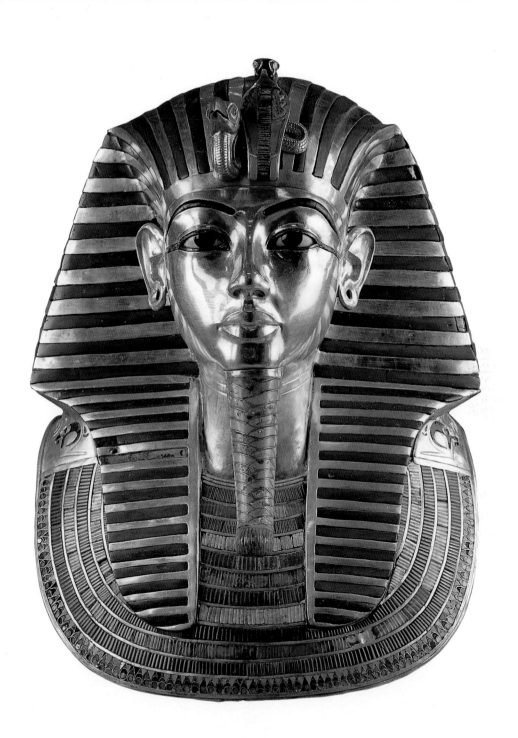

appears to be one of the rare examples of sculptures in which the human body is not shown in full, but it may have been used for the display of jewellery or garments. There are also statuettes of some rarely attested deities. The tomb was a treasure trove of elegantly designed furniture: chairs (179), beds, couches with grotesque animal heads, chests (180) and boxes, small tables. These pieces can be studied and information about their manufacture can be gathered which mere representations on tomb or temple walls would never be able to provide. Garments preserved in Tutankhamun's tomb have provided some completely new insights, including the type of underwear worn by the king, but perhaps more importantly they display the variety of decorated textiles used in their manufacture. Some of the alabaster vases have such

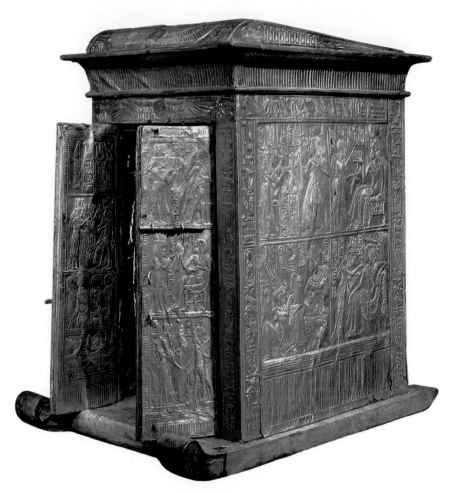

unexpectedly complicated whimsical forms that, for a moment, one wonders whether they belong in an Egyptian setting at all.

Many everyday objects are found in the tomb in highly decorative forms: sandals where the soles bear the figures of captives over which Tutankhamun actually physically trampled (181), walking sticks decorated with foreign foes which the king firmly grasped in his fist, torch-holders in the form of *ankh* (life) symbols provided with arms, a fan with a beautifully engraved chariot scene, *ankh*-shaped mirror cases, a trumpet with its bell imitating a lotus flower, and many others. But most of all, it is the variety of unexpected forms and the astonishing accomplishment of the jewellery which fires the imagination (182, 183).

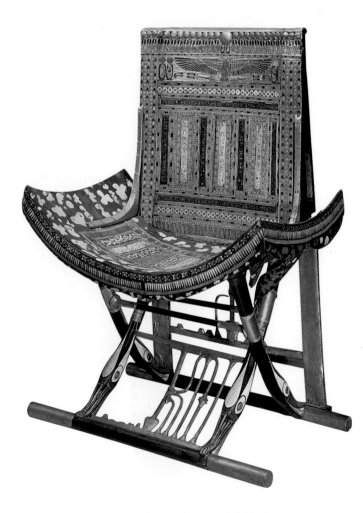

178
Tutankhamun's 'Little Golden Shrine', c. 1330 BC. Wood overlaid with gold; h.50·5 cm, 19⁷⁄₈ in. Egyptian Museum, Cairo

179
Tutankhamun's 'Ecclesiastical Throne', c. 1330 BC. Wood, gold, glass, faience, semiprecious stones, etc.; h.102 cm, 40¹⁄₈ in. Egyptian Museum, Cairo

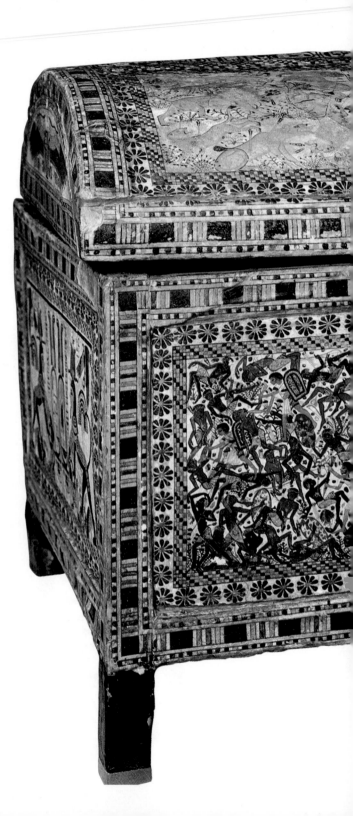

180
Tutankhamun's
'Painted Box',
showing the
king waging
war on the
Nubians and
hunting in
the desert,
c.1330 BC.
Plastered and
painted wood;
h.44cm, 17⅜in.
Egyptian
Museum,
Cairo

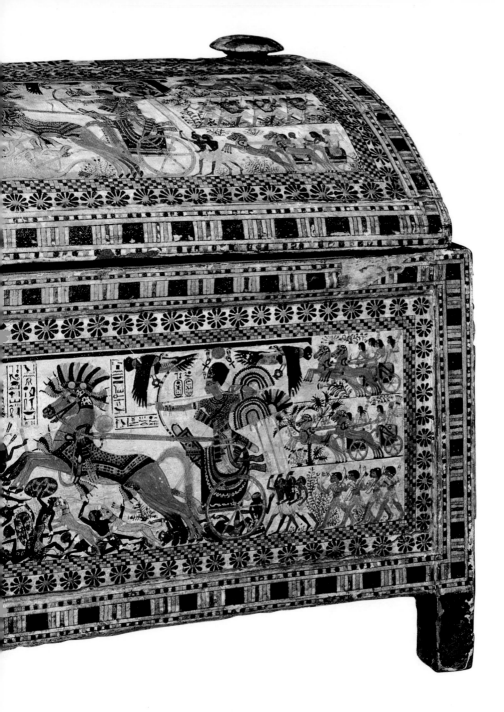

The wall decoration in the tomb of Tutankhamun (184) is painted, minimal, self-conscious and hesitant, as if the artist responsible was unsure of his task, and it is confined to the four walls of the burial chamber. It contains curious echoes of the royal tomb at el-Amarna, with its scenes of the royal funeral and the Opening the Mouth ceremony performed by Tutankhamun's successor Ay (1327–1323 BC) on the king's mummy. Only one wall displays a scene from the texts of Imi-duat and so rather shyly demonstrates a return to the former funerary beliefs.

Tutankhamun was the last credible representative of the royal family which ruled from the 'heretic city' of Akhetaten. With his death, the curtain finally fell on the drama of the Amarna Period; the Thutmoside line of kings had reached the end of their journey. After the brief reign of the elderly Ay it was Haremhab's task to pick up the pieces of the Egyptian state and continue with the massive task of restoration of the pre-Amarna values. As a sign of his elevation to the royal status, the royal uraeus (cobra) was

Egyptian Art

181
Tutankhamun's sandals, c.1330 BC. Wood overlaid with bark, leather and gold; 1.28·4cm, 11⅛in. Egyptian Museum, Cairo

182
Tutankhamun's pectoral, c.1330 BC. Gold, silver, polychrome glass and semiprecious stones; 14·9×14·5cm, 5⅞×5¾in. Egyptian Museum, Cairo

183
Tutankhamun's vulture collar and counterpoise, c.1330 BC. Gold, polychrome glass, obsidian; 46·4×36·5cm, 18¼×14⅜in. Egyptian Museum, Cairo

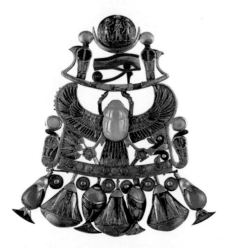

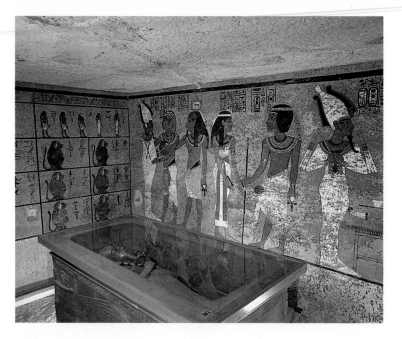

added to some of the representations in his existing tomb at Saqqara. A new large rock-cut tomb was made for him in the Valley of the Kings on the west bank of the Nile at Thebes and eventually became his final resting place. At Karnak, three pylons were worked on simultaneously during Haremhab's reign, while the structures erected by Amenhotep IV (Akhenaten) were dismantled and their relief-decorated blocks reused in the pylons' cores. In Egyptian art, recollections of the excitement and innovation of the Amarna episode could still be felt, but otherwise the way was now clear for a new departure. Haremhab can be seen as the first of a new line of kings, the Ramessides.

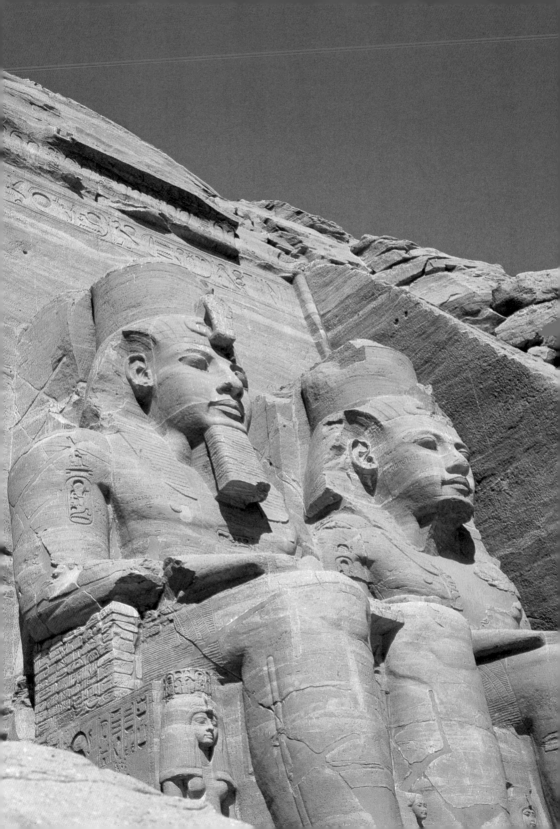

The inner strength of Egypt at the height of its economic prosperity
was such that even the profoundly troubled Amarna Period proved
no more than a temporary aberration. It left indelible scars on
the spiritual life of the country, but in Egyptian art its legacy
enhanced rather than detracted from earlier traditions. After King
Haremhab's death in 1295 BC, royal authority passed to Ramses,
a commoner of military background from the eastern Delta who
had previously held the post of a vizier (chief minister). The elderly
Ramses I (1295–1294 BC) became the founder of a new line of rulers
usually described as the Nineteenth Dynasty (1295–1186 BC). Since
many of his successors bore the same name, these kings, and
those of the Twentieth Dynasty (1186–1069 BC) are known as the
Ramessides and the next two centuries (the final phase of the New
Kingdom) as the Ramesside Period.

185
Detail of the
façade of the
large temple
at Abu Simbel,
c.1250 BC.
Sandstone;
h. of statues
c.21 m, 69 ft

Ramses I's son Sety I (1294–1279 BC) and his grandson Ramses II
(1279–1213 BC) fought hard to restore Egyptian authority in Syria and
Palestine, which had been compromised during the Amarna Period,
but the situation had changed and there were formidable new
players in the international arena. Like Egypt, the Hittite empire in
Anatolia sought to gain control of the northern region of Syria. At
first, the Egyptians enjoyed considerable success in the hostilities
which inevitably broke out, but the balance of power gradually
swung in favour of the Hittites. While Egypt's expansive ambitions
were checked, repeated military clashes such as the Battle of
Qadesh on the Orontes river in Syria in Ramses II's fifth regnal year
proved indecisive. Finally, when the Hittites came under pressure
from Assyria, another regional superpower emerging further to
the east, a non-aggression treaty between Ramses II and the Hittite
king Hattusil III was agreed, ushering in peace which lasted for
the rest of the reign. Nevertheless, in spite of all the bombast and
bravado displayed on monuments, internationally Egypt was no

longer able to dictate its own terms in its power relations with the Near East. Instead, it reacted to moves initiated by others.

During the reigns of Merneptah (1213–1203 BC) and Ramses III (1184–1153 BC) the country faced a new threat in the form of land and sea invasions by a heterogeneous coalition which was part of a massive movement of peoples taking place throughout the whole of the eastern Mediterranean. The intention of these migrating peoples, sometimes referred to as the Sea Peoples, was to settle in Egypt, but Egyptian military might triumphed and repulsed the potential immigrants in a series of bloody battles.

Initially, Memphis and Thebes remained the country's administrative and religious capitals. During the reign of Ramses II a new royal residence, Pi-Ramses ('Domain of Ramses', modern Qantir), was founded in the northeastern Delta, close to the site of the former Hyksos capital Avaris. The centre of gravity of Egyptian state affairs was shifting to the north for reasons connected with the economy (the agricultural wealth of the Delta and the prosperity of its cities) as well as foreign policy. This trend was to intensify even more in the Post-New Kingdom Period (1069–715 BC), during which Delta cities were at the forefront of political affairs that determined the destiny of the country.

186
The hypostyle hall between the 2nd and 3rd pylons in the temple of Amun-Re at Karnak, Thebes, c.1250 BC. Sandstone, sunk relief

Most of the stone elements and sculptures from the new Ramesside capital Pi-Ramses were later taken to other Delta sites for reuse, in particular to Tanis (modern San el-Hagar), further to the north. As a result, Pi-Ramses remains little known; but it must have been an impressive city, since its beauty is mentioned with admiration in several Egyptian literary compositions. Nevertheless, the religious importance of Thebes and of the royal necropolis on its west bank remained unaffected throughout the Ramesside Period.

An overwhelming impression of monumentality and striving for the colossal is often regarded as the hallmark of the Ramesside Period. Ramses II, who was on the throne some sixty-five years, one of the longest reigns in Egypt's history, is remembered particularly as a builder on a gigantic scale. His reputation is only partly

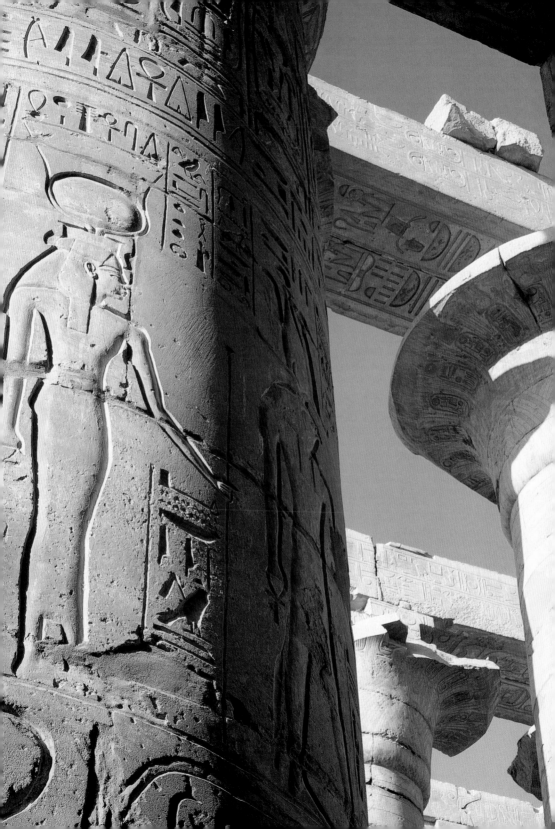

justified. Ramses's architects and sculptors did not invent colossal architecture and sculpture, but followed in a spectacular way the trend begun earlier, especially under Amenhotep III (1391–1353 BC). During the thirteenth century BC Egypt was economically strong, and the state was able to muster the resources needed for such large building enterprises. Ramses II's long reign enabled him to complete large projects, and at many sites he was the last pharaoh to build on a massive scale. His temples were, therefore, relatively little affected by the building activities of later kings, and, thus, even today remain highly conspicuous monuments.

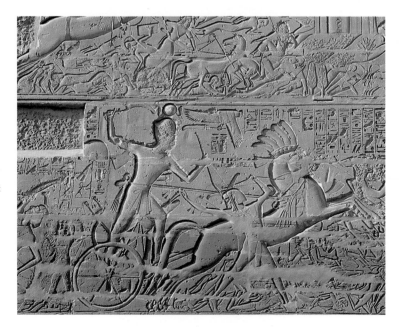

187
Sety I in a chariot charging the Libyans, on the exterior wall of the hypostyle hall in the temple of Amun-Re at Karnak, Thebes, c.1280 BC. Sandstone, sunk relief

At Karnak Haremhab began a new pylon (numbered II by Egyptologists) for the temple of Amun-Re, which was completed by Ramses I. It provided the façade for a vast hypostyle hall (186), which was completely roofed over, although some light was admitted through clerestory grilles along the central aisle. The walls and 134 massive columns of the hall were decorated by Sety I and Ramses II in a scheme that follows impeccable temple logic: on the temple's interior walls, the pharaoh is shown making offerings to the gods of the Theban triad (Amun-Re, Mut and Khons) during festivals and other religious ceremonies. On the exterior

walls there are representations of the triumphant military campaigns in Syria and Palestine which were conducted under the guidance of the temple's chief god Amun-Re. In the design of these battle scenes (187), each horizontal register forms a wide band, defined by the height of the heroic figure of the king, usually shown charging in his chariot. Within these wide registers, much smaller battle episodes take place. The battle is portrayed as though conducted personally by the king with his army in a supporting role. The contorted bodies of the slain enemy (Egyptian casualties are not shown), their dead horses and upturned

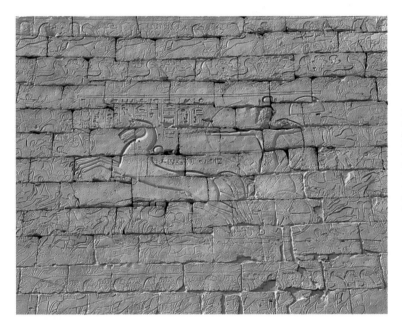

188
Ramses II in a chariot charging the Hittites during the Battle of Qadesh, on the pylon of the temple at Luxor, c.1250 BC. Sandstone, sunk relief

chariots are strewn over the battlefield, which is seen almost as if from above. Compositions of this complexity had not been known in Egyptian reliefs before and would not be seen again after the Ramesside Period.

At Luxor, Ramses II enlarged the temple built by Amenhotep III by adding a peristyle court and a pylon (189). The outer faces of both wings of the pylon bear representations and texts describing the Battle of Qadesh (188), although the result, snatched out of the jaws of defeat by Ramses II's display of courage and inspired

189
The pylon and
avenue of
sphinxes in
the temple
at Luxor,
c.1250 BC
(pylon) and
c.370 BC
(sphinxes)

leadership, was by no means the unqualified triumph suggested by Egyptian sources such as these. The known disparity between historical fact and political iconography in this case has led to these reliefs being claimed as the earliest example of the use of art as political propaganda. But this is to misinterpret the motivation behind them: in spite of all their strategic and tactical detail, the main reason for their creation was not to provide a historical record. The Qadesh representations belong instead to the category of the 'king suppressing the forces of chaos' scenes – the standardized depiction of the king slaying foes known from the very beginning of dynastic Egypt and perhaps even earlier (see 30, 31). The Qadesh reliefs also show Ramses II as the god Amun-Re's favourite, stressing his qualities as a fearless warrior. Seen in this way, the precise outcome of the battle was less important – it was not, after all, a full-scale military disaster.

The Egyptians did not share the modern Western concept of history, but that does not mean that they had no regard for historical events. Instead, they saw them as manifestations of the god-given, immutable (and so, from our point of view, unhistoric) state of affairs which the pharaoh defended. For the Egyptians, history was by no means confined purely to the rituals surrounding the person of the king and his dealings with the gods, but extended to military and political affairs. This is how we should see the seemingly paradoxical inclusion of a real historical event in a temple context. Moreover, the Battle of Qadesh may well have been one on which Ramses II looked back with pride; it was represented in several other temples built during his reign, and these representations are also important for the history of Egyptian art, especially the composition of relief decoration. They present the battle in a way that almost, though not entirely, abandons the restrictive division of the wall into registers and delimits scenes by their own logic. Beyond this, the various Qadesh reliefs are also of considerable interest for the history of warfare: while they were not motivated by a desire to provide a historical record, the reliefs contribute to making this the first major military encounter in human history which can be reconstructed in detail.

At Hermopolis (modern Ashmunein), not far from Akhenaten's capital at el-Amarna, Ramses II built a pylon in the temple of the local god, Thoth. In its core, large numbers of decorated blocks from the dismantled temples of Akhenaten were reused as filling material, thus unintentionally ensuring their preservation. Ramses II also undertook an unprecedented amount of building activities in Lower Nubia, between the first and second Nile cataracts. Although no longer a foreign policy problem, Nubia represented a large blank space on the religious map of Egypt, and the king tried to allocate its territory to the main state deities: the Theban Amun-Re, the Heliopolitan Re-Harakhty and the Memphite Ptah. There may have been other reasons too, including the king's attempts at self-deification, which can be seen in the decoration of these structures. The scope for this would probably have been more restricted in the traditional religious centres of Egypt than in the area freshly claimed for the Egyptian gods.

The most remarkable of the seven temples built in Lower Nubia by Ramses II are the two temples at Abu Simbel, both of which are entirely rock-cut. To convert the plan of a freestanding temple into a rock-cut version requires the ability to think in 'three-dimensional reversal' (a similar relationship can be demonstrated between the plans of private rock-cut tomb chapels at Thebes and freestanding tomb chapels in the Memphite area). The façade (the equivalent of a temple pylon) of the large Abu Simbel temple displays four huge (c.21 m, 69 ft high) seated statues of the king (185, 190). These correspond to the colossi outside earlier temple pylons (see 132) but here they are carved out of the sandstone cliff. Inside, the temple follows the well-established plan in its progression towards the sanctuary, the innermost part. The cult images in the shrine consist of the three state gods accompanied by a fourth figure, that of Ramses II himself. The smaller temple at Abu Simbel was dedicated to the local form of the goddess Hathor and Ramses II's wife Nofretari. Its façade (191) is formed by six colossal standing statues of the king and the queen.

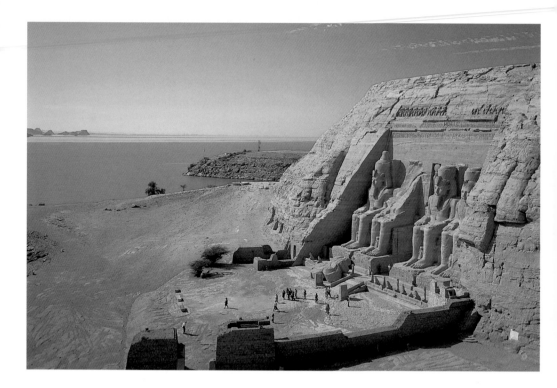

Because these colossi were carved from the same rock as the temples, there was no space on the façade for the images of the king suppressing the forces of chaos, traditionally shown on the outer face of the pylon. In the large temple representations of the Battle of Qadesh were, therefore, carved in sunk relief inside the first pillared hall. This demonstrates the remarkable flexibility of the Ramesside artists responsible for temple decoration, who were prepared when necessary to break some fundamental rules concerning the location of scenes.

The temples became world famous in the 1960s when UNESCO launched a campaign to save Abu Simbel and some twenty other Nubian monuments threatened by the waters of the new Nile dam at Aswan. All the sculpted and decorated parts of the Abu Simbel temples were cut away from the mountain in blocks of stone weighing up to 2 tons (2,200 lb), transported some 200 m (656 ft) to higher ground and reassembled. Each of the statues outside the great temple was the height of a modern six-storey building. The

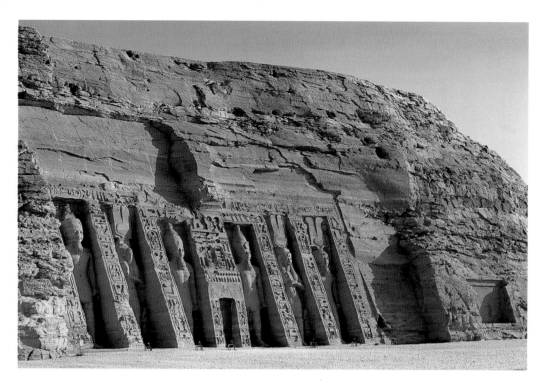

scale of ancient Egyptians monuments, often difficult to appreci-
ate in photographs, was brought home to a mass audience as the
huge blocks were lifted.

The adaptability of Ramesside architects is evident in features of
a number of temples. The court added by Ramses II to the Luxor
temple is a parallelogram rather than a rectangle. The memorial
temple of Sety I at Abydos is L-shaped, while the outer and inner
faces of the pylon of Ramses II's memorial temple at Memphis are
not parallel but convergent. There were good reasons for such
unusual features – for example an attempt to respect the much
earlier astronomical orientation of neighbouring structures at
Memphis, or the presence of earlier shrines at Luxor – although
sometimes these motives are not immediately obvious.

The Ramesside rulers built their funerary temples on the west
bank of the Nile opposite Thebes. The plan of these temples
conformed to the generally accepted New Kingdom pattern. An
interesting development is the prominent inclusion of a feature

191
View of the
small temple
at Abu Simbel,
c.1250 BC.
Sandstone;
h. of statues
9·5 m, 31 ft

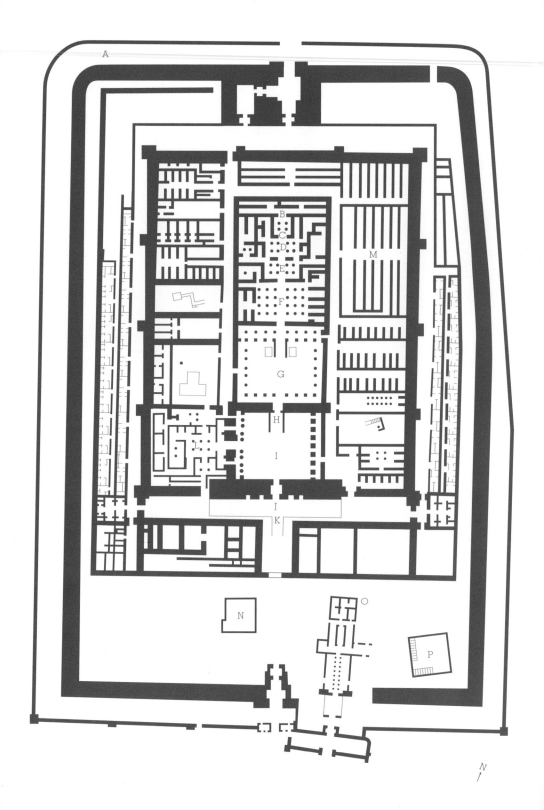

built to imitate a royal palace. This was connected to the first of the temple's open courts by a 'window of appearances', possibly used for ceremonies during the king's lifetime in which he would have been able to show himself to the crowds allowed into the outer part of the temple. This feature is already present in the temple of Sety I, ambitious in its design but left unfinished at the king's death, and also occurs in the temple of Ramses II, now known as the Ramesseum. The colossal statues of the Ramesseum

192–193
The funerary temple of Ramses III at Medinet Habu, c. 1160 BC
Left
Plan.
(A) Enclosure wall,
(B) False door,
(C) Barque chapel,
(D) 3rd hypostyle hall,
(E) 2nd hypostyle hall,
(F) 1st hypostyle hall,
(G) 2nd court,
(H) 2nd pylon,
(I) 1st court,
(J) 1st pylon,
(K) Funerary temple of Ramses III,
(L) Temple palace,
(M) Magazines,
(N) Tomb-chapels of God's Wives of Amun,
(O) Temple of Amun,
(P) Sacred lake
Right
Aerial view

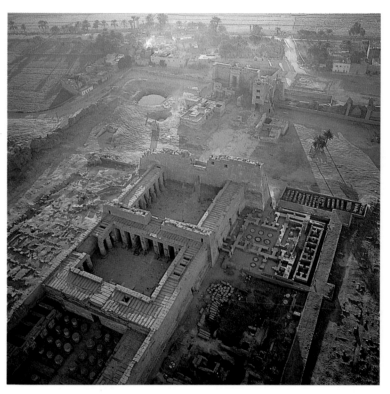

were celebrated in the first century BC by the Greek historian Diodorus Siculus who transcribed Ramses II's throne name Usimare-setpenre into the Greek as 'Osymandyas'. The English Romantic poet Percy Bysshe Shelley (who never visited Egypt) was inspired by the Greek account to write his poem *Ozymandias* (1818).

The funerary temple of Ramses III at Medinet Habu is remarkably well preserved (192, 193). It contains reliefs depicting Ramses III's campaigns against the Libyans and the migrants known as the

Sea Peoples (194, 195) which continue in the stirring, though rather formal, spirit of the Karnak reliefs of Sety I and Ramses II. The reliefs of the sea battle between the Egyptian navy and the boats of the invaders are unprecedented in Egyptian art and of great historical and naval engineering interest. The hunting scenes, in particular the wild bull hunt, on the outside of the pylon at Medinet Habu, appear refreshingly new, but the subject is traditional, referring to the king's symbolic battle against the untamed forces of nature, and the main innovation is probably their huge scale.

194
A sea battle between the Egyptians and the 'Sea Peoples', in the funerary temple of Ramses III at Medinet Habu, c. 1160 BC. Sandstone, sunk relief

Memorial temples for the joint cult of the king and the state gods continued to be built outside Thebes. Sety I erected such a temple at Abydos, the cult centre of Osiris, although the completion of the scenes in its outer parts was left to his son Ramses II. Other temples which were unfinished at the death of the reigning king show that temple decoration was approached in a logical and practical manner: the inner parts of the temple and the sanctuary were completed first (so that the temple could function even though its

decorative programme was not fully carried out), while the decoration of walls was invariably executed before that of pillars, columns and doorways in order to minimize any damage during subsequent work. The part of the decoration of the Abydos temple which was finished at Sety's death was carved in the low relief characteristic of his reign. Its delicacy and precise delineation were to remain unsurpassed for the rest of the Ramesside Period, but its bland perfection produces a rather dull, contrived effect which lacks the vitality of many technically less accomplished reliefs. Nearby, and

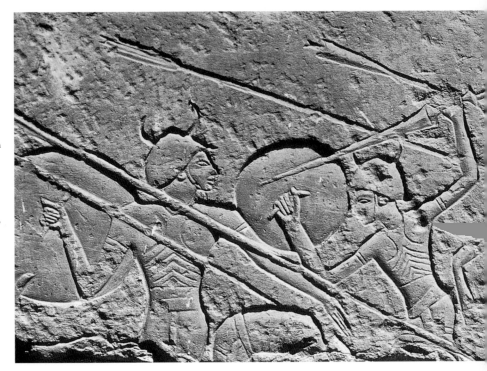

connected with the temple, there is a curious 'cenotaph for Osiris' constructed of huge granite blocks reminiscent of those used in Old Kingdom buildings. For this reason it attracts the attention of various esoteric but basically unsound theories which attempt to date its origin to a much earlier period of Egyptian history, or even prehistory. The centre of the underground structure is completely surrounded by water and appears to imitate the primeval mound on which, according to Egyptian creation myths, life appeared.

At Memphis, Ramses II embarked on a large project to mark his jubilee festival celebrating the first thirty years of his reign. The area chosen for this was to the east of the temple of Ptah and, except for a small temple of the Aten which had been built there during the Amarna Period, was virgin land. A whole complex of new temples and chapels was now erected there, with a memorial temple for the royal cult and that of the god Ptah as its centrepiece. Ramses II's architects followed the arrangement of the temples in the Karnak complex at Thebes. The southern part of the central complex was for the worship of the goddess Sakhmet, the female companion of Ptah (this corresponded to the precinct of Mut at Karnak). There were also smaller temples and shrines flanking the approach to the main temple, including one dedicated to Hathor and a shrine which may have served the cult of the deified Ramses II himself. Much of the material for the construction of these buildings was taken from earlier monuments, mainly Old Kingdom pyramid complexes and their temples, which by then were more than a thousand years old. There is little doubt that some of them were dilapidated and partly sanded up. All the same, it is difficult to establish the contemporary justification for such a practice. The High Priest of Ptah at Memphis during whose tenure of office this took place was Khaemwese, one of the many sons of Ramses II. Khaemwese left 'restoration texts' on various Old Kingdom monuments stating that he found the building in ruin, that he had the name of the original owner re-inscribed on it and that he had offerings renewed for him, probably in the temple of Ptah at Memphis. Based on these inscriptions, he has been called the world's first antiquarian. But his reputation now appears to rest on rather shaky foundations as many monuments were, in fact, plundered for building material.

In their own turn, the Ramesside temples at Memphis have survived only in a dilapidated state, often reduced to mere foundations. The contrast between the preservation of temples in Upper Egypt (Thebes) and in Lower Egypt (the Delta and Memphis) could hardly be greater, but the explanation is easy. In the flat expanse of the alluvial Delta, stone was always a valuable material and

was reused again and again, often being transported over considerable distances. The destruction of Ramses II's Memphite temples was due in part to the proximity of Cairo and its voracious need for building material. Although there were plentiful quarries in the Memphite area and across the river on the east bank, reusing existing blocks was much easier than quarrying. Medieval builders thus dismantled the pharaonic temples at Memphis and used their stone blocks to construct the Islamic capital of Egypt.

The number of statues made for Ramses II was unparalleled in pharaonic Egypt. In addition to many new sculptures, others were created by partly recarving statues of earlier kings, for example those at Luxor and Memphis. This practice may have contributed to the confusing variety of facial types which purport to show Ramses II, although other reasons may include the existence of a number of local sculptor's studios working in somewhat different styles, and modifications of the king's official portrait which took place during his reign. The consequent difficulty of identification is well demonstrated by one of the best known of these royal sculptures, the granite statue of Ramses II in the Museo Egizio in Turin (196). It is slightly over life-size and shows the king seated; he is wearing the blue crown, the third most common royal crown, which was preferred for less ceremonial occasions to the older and more traditional white and red crowns. The royal uraeus (cobra) is coiled on the front of the crown. The king is dressed in a contemporary long, pleated garment with short sleeves and a wide front panel; on his feet he wears sandals. His left hand, clenched in a fist, rests on his left knee, while in his right hand he holds the *heka*-crook, a sceptre which was the symbol of royal authority. His favourite queen, Nofretari, is shown on a much smaller scale standing by his left leg; Amenhirkhopshef, one of his sons, stands by his right leg. To his contemporaries, this was the image of a modern monarch – not of a bare-chested semidivine hero – and it combined tradition, expressed by the crown, sceptre and the king's posture, with the modern world, reflected in his fashionable garment and sandals. Such modernization of the royal image was the greatest contribution of the Ramesside sculptors to the portrayal of their pharaohs.

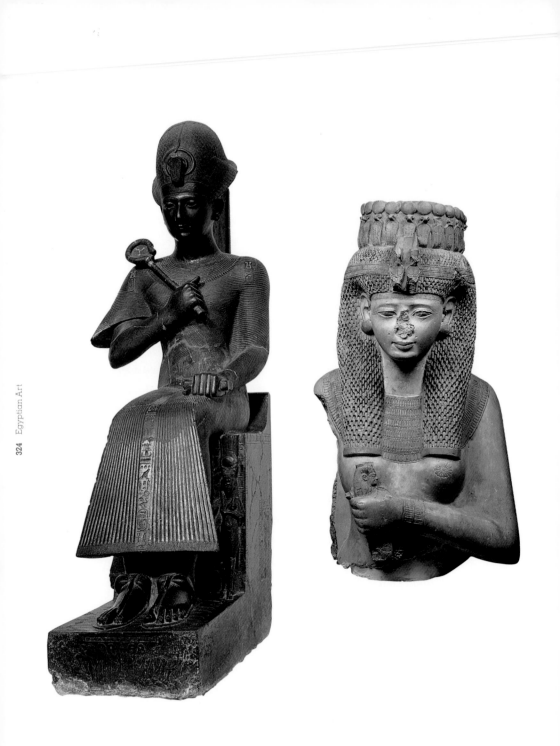

An inscription unequivocally identifies the Turin statue as Ramses II, but the face does not have the lean, delicate features and gentle smile of the king, but instead the fleshy cheeks and prominent curved nose of his father Sety I. This discrepancy has led to extensive discussion. Is this just a family likeness? An image of Ramses II which, for one of many possible reasons, does not conform to the standard facial type? Or a sculpture which was originally intended to show Sety I? The original subject of the statue is still a matter of argument.

The control exercised by sculptors over the correct proportions of even the largest of colossal statues is admirable. An extraordinary degree of sophistication can be seen in adjustments which were made to colossal statues in order to compensate for the visual distortion caused by their size when viewed from the ground. An example of this is the colossus nowadays known as Abu el-Hol ('father of terror') which once stood outside the southern pylon of the memorial temple of Ramses II at Memphis. The head was tilted forward in order to make the whole face visible to the person standing in front of it. The rather squat and solid proportions of the seated colossi from the façade of the large temple at Abu Simbel are sometimes said to result from the difficulty of carving the living rock. More probably, however, they represent an intentional attempt to avoid a distortion of the sculpture's profile which would have arisen because of the close proximity of this 'engaged' statue against the temple façade. The heads of the Abu Simbel colossi are, therefore, larger and their faces noticeably fuller, but their torsos shorter, than those of the colossi in Theban temples, which in spite of their size retain the delicacy and sweetness of most statues of Ramses II. Altogether, the design of colossal statues was brought to a formal perfection during the Ramesside Period that would not be equalled in later times. Most are addorsed against a fairly wide back panel that gives them stability but also provides ample space for inscriptions, which generally comprise repetitions of the five names by which each king was formally known. The modelling of the musculature of the face, torso, arms and legs, and especially of the bony structure of the knees, is conventional and simplified but convincingly realistic.

Other members of the royal family may be represented on a smaller scale beside the king's legs, either as statues or carved in relief. At Abu Simbel, for example, small figures of Ramses II's family are carved beside his legs: his mother Muttuya, his queen Nofretari, and his daughters and sons. The area often used for such reliefs is the support connecting the king's leg to the back panel. The shoulders and chest of the colossus were used for inscribing the names of the king and epithets linking him to the gods. The original position of the colossal statue outside the gate or pylon can be deduced from the orientation of the texts, which always start from the point nearest the spectator. Like royal names, the names of Ramesside queens were also often written in cartouches (ornamental but also symbolic oval frames), and this heightened recognition of female members of the royal family is also evident in the increase in the number of colossal statues of Ramesside queens (197).

Almost all Egyptian statues can be fitted into an imaginary stone cube on which the sculptor drew his initial grid and out of which he then began to carve. In private sculpture, creating a space between the torsos or heads of the couple in pair statues and so liberating them partly from the original mass was about as far as the average sculptor was prepared to go in freeing the form. From representations in reliefs and paintings, it is known that there was a limited number of stone statues which were more experimental and departed from the standard types, although few such works have been found. Among royal statues, which were made by sculptors who were technically more competent and who worked for a more demanding customer, the number of less orthodox works was larger. Earlier unusual compositions range from the triads of Menkaure (see 56) and the statuette of Queen Ankhnesmeryre II and King Pepy II (see 58) to the statue of the seated god Amun accompanied by the standing King Tutankhamun. During the Ramesside Period, however, sculptors became much more daring. A granite statue showing Ramses III crowned by Horus (representing Lower Egypt) and Seth (for Upper Egypt), found in the king's funerary temple at Medinet Habu (198), is a good example of an Egyptian sculpture which leaves the original cubic form well behind.

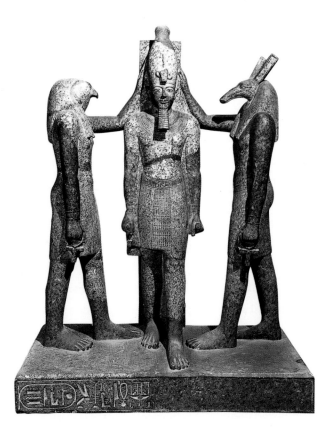

As for private statues of the Ramesside Period, the variety is astonishing although their quality ranges from indifferent to downright poor. These characteristics are probably two sides of the same coin, the inevitable side effect of the democratization of statue production which now served a much wider range of customers than ever before. Sculptures made of hard stone, especially granite, were not unusual, and in the Memphite area the material was often reused from Old Kingdom monuments, such as pyramid casing. In tomb sculpture traditional types persisted, in particular the seated pair statue, which depicted both sexes in contemporary fashionable clothes: men in the early Ramesside Period wore long pleated garments, while Ramesside women had long wigs with their front lappets almost touching their breasts. Other sculptures were placed elsewhere in the tomb chapel; a popular type showed the deceased kneeling and holding a small shrine with the image of a deity. In temples, meanwhile, standard-bearing statues which

show a man carrying a sacred staff, usually portraying the head of the deity, became popular. Block statues were as numerous as ever, but might now be combined with a small figure of a god on the front or with a small shrine containing such an image.

A group of sculptures is known from the Ramesside Period which intentionally did not show the complete body, an apparent contradiction of one of the basic rules of Egyptian representations. These were the ancestral busts (199) which served the cult of the deceased ancestors in private houses. Ancestors were thought to be able to intercede with divine beings on behalf of the supplicants. The concept of intercession by proxy, of a person of a more elevated status looking after the needs of the less fortunate or pleading on their behalf with a higher authority, was one of the basic tenets of Egyptian morality and social responsibility, and in this respect ancestors were well placed to plead one's cause: they had undergone the ritual which enabled them to be reborn and live on in the realm of the 'glorified' dead. The most elevated form of such a relationship was of course the mediatory position of the king between the gods and people. This general concept is mirrored in

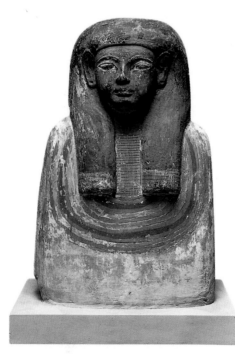

199
Ancestral bust, c.1200 BC. Painted limestone; h.24cm, 9½in. British Museum, London

the introduction of shabtis, small figurines placed in the tomb that were intended to act as the deceased's substitutes should he or she be summoned to forced labour in the realm of Osiris in the afterlife.

The ancestral busts' disregard for completeness is probably explained by the fact that the cult of the deceased ancestors was part of unofficial popular religion. Before the Ramesside Period it is known only from a few textual references; the busts for the first time reveal the artistic dialect of semiofficial art. They display no individuality and in this respect may be compared to the upper parts of anthropoid coffins or mummy masks. The beliefs associated with these busts and the religion reflected on the walls of temples and tombs were vastly different.

Another material expression of popular piety was the stone stelae (usually round-topped) that were set up in the public areas of large temples or in small, less official, shrines. Often crudely executed despite their quite sophisticated design, they show the person who dedicated the monument, sometimes accompanied by members of their family, worshipping a deity. The artistic solutions adopted are quite ingenious. A common problem was how to show the zoomorphic deities which were preferred in popular religion; these may have been quite small (*eg* a bird or a snake), and a larger human figure would have obscured the fact that the deity was the more important of the two. The official art of temple and tomb walls solved this by introducing mixed forms in which a human body was combined with an animal head. Ramesside artists chose to place small zoomorphic deities on pedestals or to show the human figure kneeling, thus maintaining the proper religious decorum of the relationship between a god and a human being. The stelae performed the same function as temple statues: they ensured the person's presence at the side of the deity and were a permanent reminder of the wishes inscribed upon them (although these were never too specific).

The construction of royal tombs continued on the Theban west bank, in the Valley of the Kings. But the plan of the Ramesside royal tomb was streamlined and its central axis lost its earlier tendency

to veer to the left. Decoration expanded to cover most of the wall areas, as in the tomb of Sety I, which displays the fine painted low relief characteristic of his reign. There were now more scenes showing the king in the company of gods, and also representations of funerary rites such as Opening the Mouth performed on royal statues. Having undergone this ceremony, the statues were able to act as a physical abode for the king's *ka*. Additional religious texts and their illustrations, called 'Underworld Books' by Egyptologists, were included: the Book of the Dead, the Book of the Gates and the Book of the Caverns, but also the Litany of the Sun God Re and others. They present a compendium of ideas about the king's after-life in which the god Re (in his daily journey across the sky and his nightly sojourn in the netherworld) and the god Osiris (ruler of the kingdom of the dead) play major roles. Astronomical ceilings are also common in burial chambers, providing some idea about contemporary astronomical knowledge. Needless to say, none of these tombs has survived unviolated. (A tomb which served as the communal burial place of some of the sons of Ramses II was found by Egyptologists in the first half of the nineteenth century but remained unknown to modern archaeologists until 1995 because its entrance was covered up by debris. But even that had not escaped the attention of tomb robbers in antiquity.) The impor-tance of the Theban necropolis for burials of private individuals also remained undiminished throughout the Ramesside Period. Rock-cut tombs of high officials and priests attached to the temple of Amun continued to be constructed along well-established lines. The subject matter of their decoration moved further away from scenes drawing their inspiration from the contemporary world and turned increasingly towards purely religious themes and texts.

Many Ramesside royal wives and children were buried in rock-cut tombs in another valley on the Theban west bank known as the Valley of the Queens. These are in fact elaborate burial chambers without chapels; in their style and in the quality of their painted decoration they are closer to kingly than to private tombs. This is especially true of the subject matter of their decoration, which is limited almost exclusively to the relationship of the dead person

200
View of the tomb of Nofretari, a queen of Ramses II, Valley of the Queens, Western Thebes, c.1250 BC. Painting on plaster

(or of the reigning king acting as intermediary) with the gods. The texts are the usual Underworld Books. The best known among these tombs belongs to Nofretari, one of the queens of Ramses II (200).

Another group of tombs should be mentioned here. When royal tombs began to be made on the west bank of the Nile opposite Thebes during the Eighteenth Dynasty, a community of workmen and artists entrusted with this task, including stonemasons,

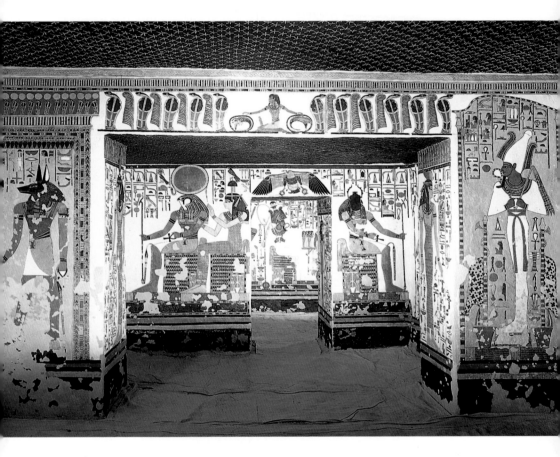

draughtsmen, sculptors and painters, was established nearby. Theirs were steady jobs and they were never out of work (although they were also the first workers on record to strike on account of overdue pay). The preparation of the royal tomb started early in the reign of each king, and there were obvious advantages in having a permanent specialized workforce. The village in which these workmen and their families lived was at Deir el-Medina, on

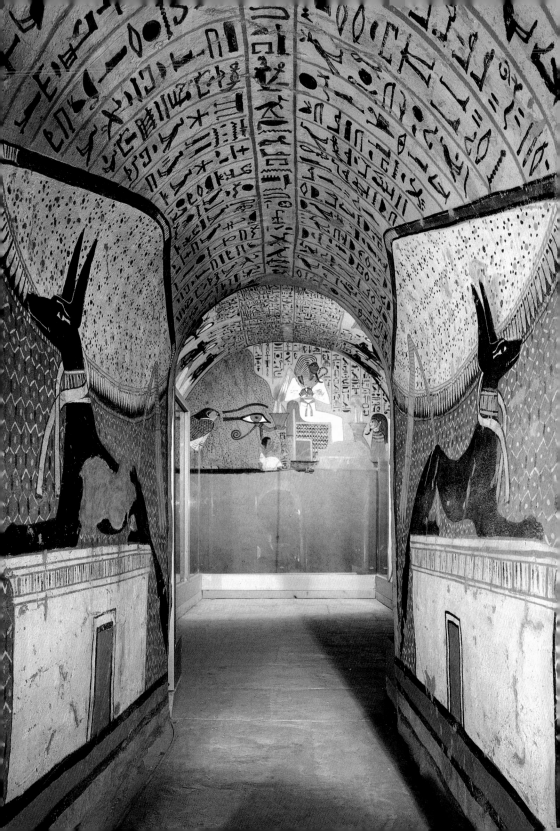

the west bank about 1·5 km (less than a mile) from the Valley of the
Kings. The settlement was established in the Eighteenth Dynasty,
possibly under Amenhotep I, but the heyday of this enclosed,
close-knit community, in which a son succeeded his father in his
profession, came in the Ramesside Period. These men were the
élite of Egyptian craftsmen and artists. Their way of life is better
known than that of any other group of manual workers in ancient
Egypt because of many papyri and ostraca (flakes of smooth lime-
stone used as a cheap substitute for papyri) recording details of
their work and everyday lives. The ostraca were used for adminis-
trative records of all kinds: lists of workmen present at work,
receipts, contracts, records of property transactions, private
letters. They even record literary compositions used as school
exercises. Although artists are never mentioned in royal tombs
and there are no signatures under the scenes they painted, the
genealogies of Deir el-Medina workmen are so well known from
these texts that their names can be linked to royal tombs with near
certainty. Because of their skills, and in spite of their lowly status
(they were neither officials nor priests), they were able to build for
themselves modest rock-cut tombs near their village, each one
marked on the outside by a small brick-built pyramid. The painted
decoration of these tombs (201), often found even in their burial
chambers, is not radically new but it contains a great deal of
charm in the use of colours as well as the choice of subject matter.
Spectacular vignettes accompanying the texts of the Book of the
Dead dominate the decoration.

The spontaneity of the scenes in the tombs at Deir el-Medina
contrasts forcefully with the more formally executed representa-
tions in other Ramesside private tombs on the Theban west bank.
The difference is due to the fact that workmen who made these
standard Ramesside tombs belonged to other funerary workshops,
probably associated with temples, and their procedures had been
much more strictly controlled. Deir el-Medina artists were trained
in a different way because of their work on royal tombs, and much
of their work on their own tombs was in any case moonlighting,
and therefore a less formal and less regulated enterprise.

201
The burial
chamber in
the tomb of
the workman
Pashed,
Deir el-
Medina,
Western
Thebes,
c.1250 BC.
Painting on
plaster

The Deir el-Medina artists also produced drawings on ostraca and papyri. These sketches depict a topsy-turvy world of animals behaving like people. Cats are particularly prominent: they are nurses of baby mice, act as hairdressers for rats, or fan them with large fans and ply them with wine and food (202). They also act as duckherds (203). A mouse in a dog-drawn chariot charges a fort defended by cats. A hippopotamus is picking figs in a tree, but a bird needs a ladder to climb it. A fox is playing the oboe while a goat dances to the music. There is little doubt that these drawings were made by the same men who were involved in the decoration of royal tombs: they are superbly fluent and economical in the use of the brush. It has been suggested that these are illustrations of

fables which were transmitted orally, but this explanation seems unsatisfactory. More likely the drawings were quickly sketched while the men were resting, and express a mischievous wit and humour, parodying the formal scenes in tombs or caricaturing real people. Probably, when the ostraca were passed round, few were ignorant of whom the animals and their behaviour mimicked. Such an uncensored insight into the minds of the Egyptian artists responsible for formal funerary works is very rare.

In the Memphite area, large freestanding tomb chapels were built by private individuals at the main necropolis, Saqqara, at least until the reign of Ramses IV (1153–1147 BC). This was an uninter-rupted progression which started when King Tutankhamun

(1336–1327 BC) moved the capital from el-Amarna to Memphis. Some of these tomb chapels are very large and their plan can be compared with contemporary temples as well as with the Theban rock-cut tombs. The procedures by which the latter were created were, of course, very different, but the main elements of tomb chapels were the same: a forecourt at Thebes corresponds to a pylon and an open court at Saqqara; one or more columned or pillared rooms at Thebes to columned or pillared courts at Saqqara; and an inner room with a stela or statue at Thebes to a corresponding room or rooms at Saqqara. The courts and rooms of the Memphite tomb chapels were placed on a straight east–west axis. Many of these chapels had a small pyramid at their western-most end behind or partly over the stela. Unlike the pyramid in the earlier pyramid complexes, this was unconnected with the burial

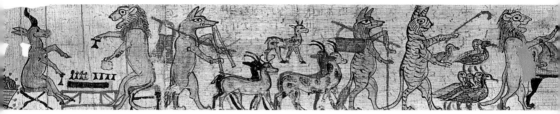

chamber. The opening of the shaft leading to the burial chamber was usually in the chapel's open court. Internally, the decoration was of variable quality. From the reigns of Haremhab, Sety I and Ramses II there are some examples of a delicate low relief (204), but sunk relief soon established itself as the main technique. Much of it was quite crude and its quality deteriorated seriously during the Ramesside Period. The sculptors responsible for these reliefs knew all the tricks of the trade to make their work easier: the carving in the less visible areas was sometimes superficial or was replaced by painting. The quality of the initial design in Memphite tombs is invariably superior to its final execution.

There are several theories as to how tomb designs were transmit-ted. Architectural handbooks with plans of structures and pattern books for decoration are practically unknown in ancient Egypt. It

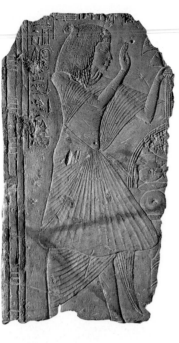

seems more likely that the tomb-building tradition was main-
tained by apprenticeship procedures rather than by keeping a
record of the repertory. These learned skills were then pragmati-
cally applied as the site was surveyed and the designs were
sketched on the walls, with probably little in the way of any
intermediate models or sketches.

In terms of subject matter, the influence of the Amarna Period is still
evident in the tomb-chapels at Saqqara, but it was weakening fast.
As in Theban tombs, representations of deities, especially Osiris,
and illustrations from the Book of the Dead began to occur more
frequently. However, there were still some scenes reflecting contem-
porary realities, for example the tomb-owner being rewarded with
gold collars and other jewellery for his faithful services, or repre-
sentations of the funeral of the deceased, with the coffin dragged on
a sled, items of funerary equipment brought to the tomb and the
funeral group being received by musicians and dancers (205).

Alongside freestanding tombs, some rock-cut tombs were also
made at Saqqara in this period. Superficially, they do not appear to
be exact parallels of the tombs at Thebes, but further excavations

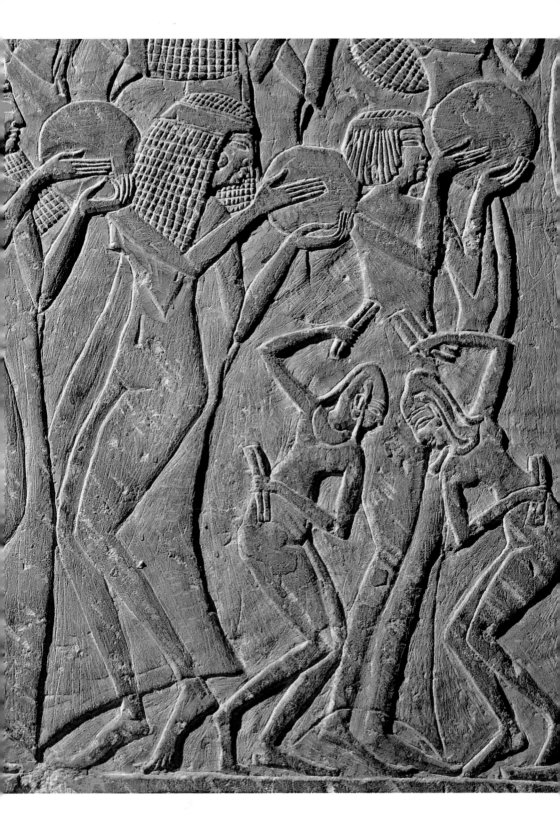

may make a detailed comparison possible. Local conditions, such as geology, may have affected the form of these tombs but not the concept itself – there is no doubt that during the Ramesside Period there was a generally accepted idea of what constituted a tomb.

The contents of Ramesside tombs included such utilitarian objects as large, painted pottery vessels that, despite being turned out in large numbers by funerary workshops, were minor works of art (206). Wooden anthropoid coffins resemble the mummified body of the deceased person with arms crossed on the chest. The surface of the lid is usually carved in relief, painted in bright colours on a yellow background and varnished. It is divided by inscribed

206
Pottery vase,
c.1250 BC.
Painted
terracotta;
h.26·8cm,
10½in.
Musée du
Louvre, Paris

207
Shabti box
and shabtis of
Henutmehyt,
the Songstress
of Amun,
probably from
Thebes,
c.1250 BC.
Plastered and
painted wood;
h.33·5cm,
13⅛in.
British
Museum,
London

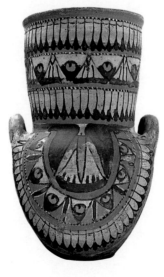

horizontal and vertical bands, derived from the pattern of mummy bandages, into a number of rectangular fields which contain representations of protective deities linked to the burial, such as the so-called Sons of Horus (the human-headed Imset, baboon-headed Hapy, jackal-headed Duamutef and hawk-headed Kebehsenuf). Shabtis sometimes show their owner dressed in contemporary garments, and many of them are not inferior to tomb statuettes, in spite of their small size. The wooden boxes in which they were stored (207) were often decorated with painted scenes showing the deceased and his wife seated side by side at a table. The four canopic jars, in which the viscera removed during

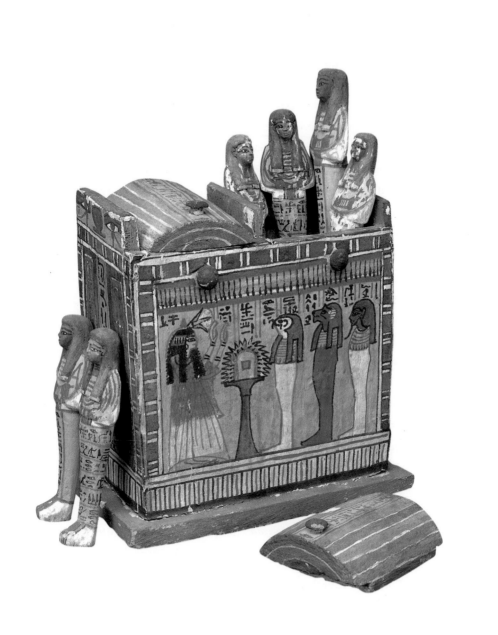

mummification were kept, were human-, jackal-, baboon- and hawk-headed, in reference to the four protective deities.

From the mid-twelfth century BC Egypt entered a period of economic and political stagnation and growing internal insecurity, even anarchy. The robberies of royal tombs that occurred in the Valley of the Kings were but one example of the lawlessness and disorder which intermittently broke out. This led to the gradual disintegration of the country following the death of the last pharaoh bearing the name Ramses, King Ramses XI (1099–1069 BC). Egypt's influence abroad was severely restricted, and effective control of areas outside its borders, including Nubia, was lost. Military expeditions abroad, such as that of Shoshenq I (945–924 BC) into Palestine, may have been temporarily successful but their achievements could not be sustained. Inside the country, two power centres initially emerged. Tanis, not far from the Ramesside capital Pi-Ramses in the Delta, was the residence of the kings of the Twenty-first Dynasty (1069–945 BC) who took over power in a bloodless coup from the Ramessides. Environmental conditions played an important part in the economic life of Egypt's cities, and Pi-Ramses's decline may have been due to the silting up of the local waterways. The southern part of the country, at first nominally recognizing the suzerainty of the kings at Tanis, was in effect controlled by the soldier priests at Thebes, the High Priests of Amun. The office of the High Priest of Amun (literally, the First Prophet of Amun) was the highest in the Theban priestly hierarchy. The High Priest of Amun was in charge of the largest and most influential temple in Egypt and controlled its worldly as well as spiritual matters. Later, local rulers claiming the royal titles also appeared in several other cities.

This Post-New Kingdom period (Twenty-first to Twenty-fourth Dynasty), also known as the Third Intermediate Period, is characterized by political volatility. The names of the rulers of the Twenty-second and Twenty-third Dynasties (945–715 BC), such as Shoshenq, Osorkon and Takelot, are non-Egyptian, and this era is sometimes described as the Libyan Period. This does not mean that these were foreign rulers, but rather that they were

descendants of Libyan immigrants who settled in Egypt. The arts, meanwhile, shone like a beacon through the clouds of the country's fragmentation. For once, political decline was not followed by a corresponding artistic loss of excellence. It seems paradoxical that considerable artistic vitality and creativity persisted and often surpassed the achievements of the last Ramessides.

The focus of artistic production changed, however, as the making of large tombs declined. The reuse of earlier tombs for new burials became common. At the same time, the attention paid to funerary equipment directly connected with the burial increased enormously. Sometimes the transfer of decorative themes from the walls to tomb equipment is obvious, as in the painted scenes on coffins, which were now arranged in registers, almost as if they were on tomb walls. Papyri inscribed with the spells of the Book of the Dead and other religious compilations, accompanied by illustrations in which the deceased person appears, were more frequent than ever before, whereas previously such scenes had been painted or carved in relief on tomb walls. The lavish decoration both on the outside and the inside of coffins, shabti boxes and canopic jars reached unprecedented levels. Not for the first time in Egyptian history, these works became the main vehicle for the artistic expression of ideas concerning the afterlife.

Wooden coffins from tombs in the Theban necropolis are anthropoid, with massive collars (208). The arms are crossed and the hands shown as if protruding from the body's wrappings. The goddess Nut spreading her wings is the most conspicuous feature of the lid, which is completely covered with small scenes where the deceased appears with various deities. Brief texts accompany the scenes. The decoration is painted on a dark yellow, almost orange background, but important details are emphasized by modelling in plaster. The surface of the coffin is varnished. Inside, the coffins are painted yellow or red, often with the figure of the Goddess of the West (Hathor), the patroness of the Theban necropolis. Anthropoid coffins were often made of cartonnage (209, 210), a material made by application of layers of linen and plaster.

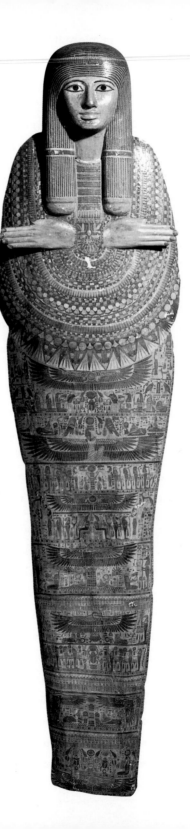

208
Mummy board
of a Songstress
of Amun-Re from
Thebes,
c.1050 BC.
Painted wood;
l.162 cm, 63¾ in.
British Museum,
London

209–210
Cartonnage
coffin of
Espaneterenpere,
the priest
of Amun,
probably from
Thebes,
c.970 BC.
Painted
cartonnage
inlaid with glass
and lapis lazuli;
l.177 cm, 69¾ in.
Brooklyn
Museum of Art,
New York

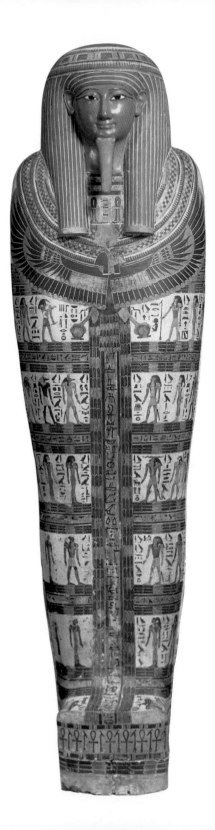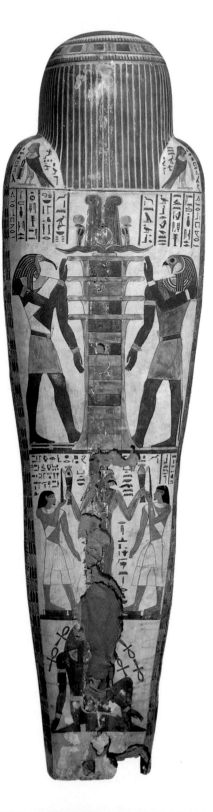

In the decoration painted on the cartonnage, the figures found on earlier coffins were often replaced with symbols.

Burials were provided with wooden stelae. The scenes painted on them are new and show the deceased standing in front of a deity, often the hawk-headed Re-Harakhty. The increase in the number of women, mostly members of the temple personnel of various deities, who had such stelae in their own name is quite striking (211). For much of Egyptian history, women were included in the funerary monuments of their husbands – they were buried in their husband's tomb and mostly appeared in his company on false doors, stelae and in the tomb-chapel's decoration (although sometimes the wife had her false door or stela in the chapel of her husband, and exceptionally even a whole room or part of the tomb-chapel).

Building projects continued during the Post-New Kingdom Period, especially at the new royal residence at Tanis, where a temple complex, based on the Karnak prototype, was built for the state god Amun-Re and the deities associated with him. Some good relief decoration was still carved at Karnak in the reign of Shoshenq I and even in the hard granite at Bubastis (modern Tell el-Basta, near Zagazig in the eastern Delta), where a substantial building project was undertaken by Osorkon II (874–850 BC). Royal statues of this period that were found in temples show a variety of types which had formerly been rare, for example a kneeling king offering up a model barque. In private sculpture, the block-statue reigned supreme, and the statues found at Karnak compare more than favourably with products of the Ramesside Period. A characteristic feature of the statues of the Post-New Kingdom Period is the highly developed use of relief decoration on their surfaces.

A major consequence of the new political situation was that the kings resident at Tanis, in the north of Egypt, ceased to be buried in the south, in the Valley of the Kings. The glorious series of royal tombs and their funerary temples on the Theban west bank came to an end, as did the decorated private tombs in the Theban area.

211
Stela of Denitenkhons, the songstress of Amun-Re, probably from Thebes, c.900 BC. Plastered and painted wood; h.33cm, 13in. British Museum, London

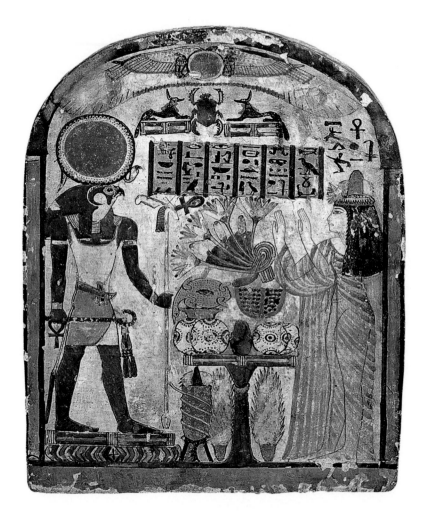

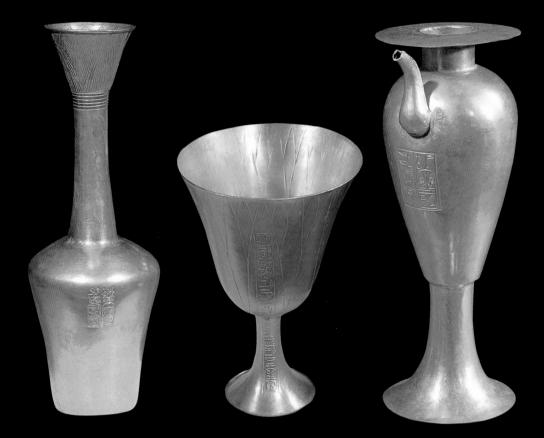

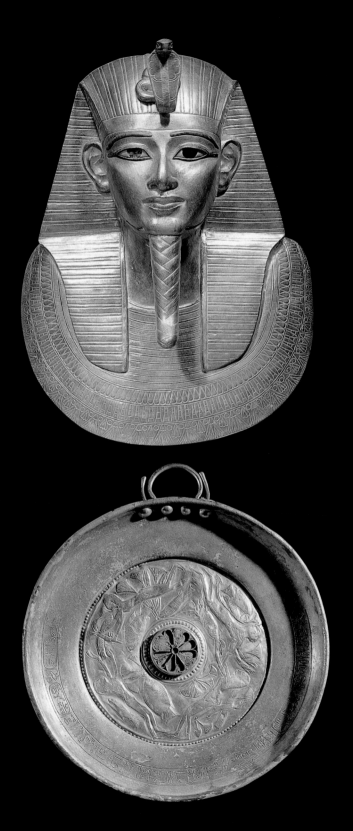

212–216 ·
Gold items from
the royal tombs
at Tanis.
l to r:
Vase of
Psusennes I,
1039–991 BC.
Gold;
h.39 cm, 15³⁄₈ in.
Goblet of the
High Priest of
Amun,
Pinudjem, and
Princess
Henuttawy,
c.1060 BC.
Gold;
h.21·5 cm, 8½ in.
Libation vessel
of Amenemope,
993–984 BC.
Gold;
h.20 cm, 7⁷⁄₈ in.
Funerary mask
of Psusennes I
from his tomb
at Tanis,
1039–991 BC.
Gold, lapis lazuli
and glass;
h.48 cm, 18⁷⁄₈ in.
Shallow dish
of General
Wendebaunded.
Gold and silver;
diam. 18·2 cm,
7¹⁄₈ in.
Egyptian
Museum, Cairo

Instead, tombs of kings and exceptionally privileged private individuals were now built within the walled temple precincts or in their vicinity. This may have been influenced by religious factors, such as the wish to be buried in the closest possible proximity to the god, but the main reason for this change was the increased insecurity and inability to police cemeteries effectively. Six intact royal tombs, including those of Psusennes I (1039–991 BC), Amenemope (993–984 BC), Osorkon II and Shoshenq III (825–773 BC), were found at Tanis. The walls of their burial chambers were inscribed and decorated in relief following the earlier Theban royal tomb tradition, albeit on a much more modest scale. But the main artistic attraction of these tombs was their burial equipment, including vessels (212–214, 216), coffins, mummy masks (215) and jewellery, many of them made of silver and gold.

Metalwork, especially in bronze, became popular in the manufacture of small statuettes, made by the lost-wax process. To obtain a hollow image the beeswax model was made on a sand core. The statuettes, often inlaid, represented kings, private individuals and deities. Small sculptures entirely made of precious metal are also known (217) and their numbers were to increase enormously. Such statuettes were now cast in one piece, rather than by fitting beaten metal sheets over a wooden core. The appearance of metalwork on a large scale was the most significant artistic development of the Post-New Kingdom Period. Sculptors were finally emancipated from the material restrictions imposed by stone; for example, a figure's arms could be freed from the body. The undisputed masterpieces of the Post-New Kingdom Period are large statues of the priestesses of Amun, with heavy wigs, delicately modelled faces and slim bodies under richly decorated gowns (218). All such works were mainly votive objects donated to temples; there are hardly any tomb statues. The high standard of metalwork was also displayed in items of jewellery (219) and funerary equipment. A bowl from one of the royal burials at Tanis (see 216) is decorated with girls swimming among large fish and lotus flowers, a variant of a motif which had often been adopted for the form of luxurious cosmetic spoons and containers, and had been painted on faience bowls.

217
Gold statuette of the god Amun, c.900 BC. Gold; h.17·5cm, 6⅞in. Metropolitan Museum of Art, New York

218
The god's wife Keramama, probably from Karnak, Thebes, c.830 BC. Bronze inlaid with gold, electrum and silver; h.59cm, 23¼in. Musée du Louvre, Paris

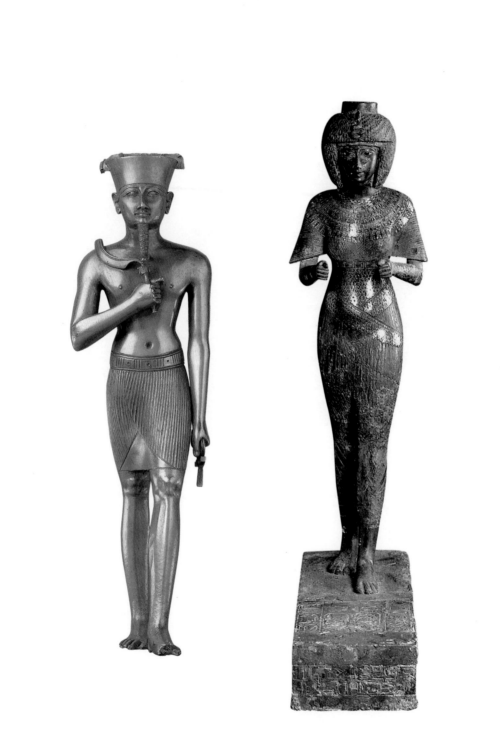

Despite its continued artistic vitality, a disunited Egypt was no match for the powers beyond its borders; its enemies were poised to invade. The first such incursion came from the south, when the Kushites swept in and for a time became the undisputed masters of Egypt. This was the beginning of a new chapter in Egyptian political as well as artistic history.

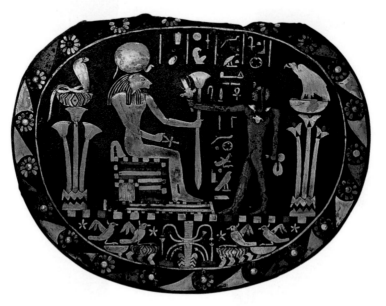

219
Counterpoise
of a necklace,
c.870 BC.
Bronze with
inlays;
w.9.5 cm, 3³⁄₄in.
Ägyptisches
Museum,
Berlin

The concluding chapter of the independent pharaonic state, repre-
sented by the Twenty-fifth to the Thirty-first Dynasties of Egyptian
kings, is usually called the Late Period (715–332 BC). It was marked
by political and military upheavals whose origins can be traced
to the Ramesside period (1295–1069 BC). During this time, Egyptian
presence in Nubia (south of the third Nile cataract) weakened,
virtually disappearing after 1069 BC. In the power vacuum thus
created, a kingdom centred on the city of Napata (modern Gebel
Barkal), close to the fourth Nile cataract, was allowed to emerge and
gather strength without interference from its northerly neighbour.
Although undeniably Sudanese, many of its characteristics derived
from previous links with Egypt and these continued to develop
without any further direct contact with the country of their origin.
In religion, the god Amun, whose worship had been taken to Napata
in the New Kingdom, became the most important deity worshipped
in the area. Some three hundred years later, in the second half of the
eighth century BC, this Kushite kingdom (from Kush, the Egyptian
name for Sudanese Nubia) forcefully re-established its links with
a now disunited Egypt, profoundly affecting the political situation
in northeastern Africa and the Ancient Near East.

Sometime around 730 BC a Napatan ruler named Piye (747–716 BC;
previously called Piankhy by Egyptologists) gained control of the
southern part of Egypt, including Thebes. The High Priest of Amun
at Thebes had been the virtual ruler of Upper Egypt but his power
was now restricted by the practice of the divine marriage, usually
of a daughter of the king, to the god Amun. The Divine Adoratress
or God's Wife of Amun (see 218) thus became the nominal head
of the Theban priesthood. Each God's Wife, in turn, adopted her
successor. (This was not a Kushite invention but a practice intro-
duced during the Post-New Kingdom period.) From the reign
of Piye, Kushite influence at Thebes was strengthened by the

220
Upper part
of a statue
from
Memphis,
c.450 BC.
Schist;
h.25·1 cm, 9⅞ in.
Musée du
Louvre, Paris

adoption of a daughter or sister of the Kushite king as successor to the powerful position of God's Wife.

In order to extend their rule over the whole of Egypt both Piye and his successor Sabacon (716–702 BC; 221) campaigned in the north and suppressed opposition from local princes, especially in the city of Sais (Sa el-Hagar, in the western Delta). Although this was a conquest of Egyptian territory by a foreign power, the Kushite kings (Manetho's Twenty-fifth Dynasty) adopted all the external trappings of Egyptian pharaonic kingship, enthusiastically embraced and supported Egypt's religion, culture and arts, and generally tried very hard to become more Egyptian than the Egyptians themselves.

There was an exciting possibility that Egypt would become a leading element in a huge African kingdom, a successor to the ancient Egyptian unified state, stretching from the shores of the Mediterranean to the fifth Nile cataract, and possibly even further south, as well as into the Syro-Palestinian region. This would have been the restoration of the Egyptian empire at the height of its glory.

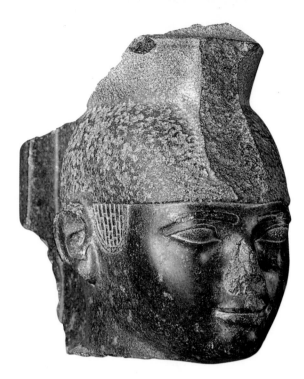

222
Head of
Taharqa
from Thebes,
c.670 BC.
Granite;
h.36·5cm, 14 in.
Egyptian
Museum,
Cairo

Unfortunately, the pharaohs of the Kushite dynasty were thwarted in their ambitions by events beyond Egypt's borders that were outside their control. By then, the Assyrians had replaced the Hittites as the leading power in the Ancient Near East and their military might was irresistible; even the combined Kushite and Egyptian armies were no match for it. In the final stages of the confrontations which ensued, King Taharqa (690–664 BC; 222) was defeated by the Assyrian King Ashurbanipal in 667–666 BC, and an attempt by Taharqa's successor Tantamani (664–656 BC) to regain the control of Egypt was crushed. The relatively brief period of Kushite dominance – less than seventy years – was over. As the consequence of this defeat Thebes was sacked by the Assyrians in 663 BC, the Kushites withdrew to their homeland and after a while ceased to interfere in Egypt's internal affairs. Their contribution to Egypt's fortunes should not, however, be underestimated; they were the force that ended the country's political fragmentation and so created conditions for a new period of a united rule, the so-called Saite Renaissance (Twenty-sixth Dynasty, 664–525 BC).

At the time of their newly gained sovereignty over Egypt, Kushite rulers had begun to build their tombs, and those of their queens and princes, in the form of a small pyramid with steeply inclined sides (this probably derived from Ramesside tombs of Egyptian officials in Lower Nubia, rather than from Egyptian royal pyramids; 223). Their royal necropolises were at el-Kurru and Nuri, near the Kushite capital Napata in Sudan, but the representations and texts in the pyramids' burial chambers and small chapels attached to the pyramids are purely Egyptian in origin. The Kushite kings felt particularly closely linked to the god Amun, the deity of their own home city, and specifically Amun's manifestation in the form of a

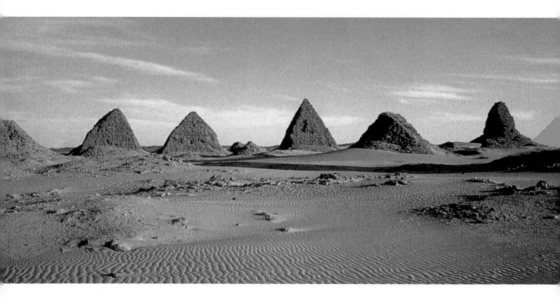

ram. (They are often depicted wearing a ram's-head amulet.) Almost all their building activities concentrated on temples of this god, in particular at Napata, Sanam and Kawa in Nubia. These were, no doubt, executed by builders and artists brought from Egypt for this purpose, and their architecture is traditionally Egyptian. At Karnak, the domain of the god Amun governed by the God's Wife, several smaller structures were erected during the Kushite dynasty, but there was no attempt to build there on a really large scale. The same is true of the additions to the temple of Amun at Medinet Habu, on the Theban west bank.

Buildings at Karnak during the Twenty-fifth Dynasty seem to have been characterized by the use of columns in an innovative way to spectacular effect. (In this, the Kushite structures seem to be distant ancestors of the columned kiosks of the Ptolemies and Romans, especially in their use of decorated intercolumnar screen walls which allowed much more light into the rooms behind.) The grace of the papyriform column in the court between the first and second pylons, the last remnant of a columned building of Taharqa (224), provides a hint of the former elegance of these now almost-vanished buildings. But even here, the architecture is purely Egyptian and it is only their depiction in reliefs which

223
View of the Kushite royal cemetery at Nuri, after c.670 BC

224
Papyriform column of Taharqa in front of the 2nd pylon at Karnak, Thebes, c.670 BC. Sandstone

betray the fact that the royal family was Kushite. North of Thebes, Kushite monumental presence is negligible, although Memphis continued to serve as the administrative capital of Egypt.

At Medinet Habu, tombs and relief-decorated chapels of the God's Wives of Amun were created inside the temple precinct dominated by the funerary temple of Ramses III (1184–1153 BC). There were two reasons for this. First, a temple burial was customary during the Post-New Kingdom Period, and continued to be favoured by kings during the rest of the pharaonic period. The religious position of the God's Wives at Thebes, built up during the preceding period in

order to neutralize the role of the High Priest of Amun, was such that a temple tomb was an obvious choice. Second, in addition to being an important administrative centre of the west bank of Thebes, Medinet Habu was also a site traditionally associated with the gods Amun and Osiris, and so eminently suitable for such tombs.

The reliefs carved under the Kushite kings are a remarkable amalgam of the old and new. They drew their inspiration from the past but tempered it with features which proudly displayed the ethnicity of the new ruling dynasty. Earlier monuments were enthusiastically imitated: reliefs with a grid drawn over them, and therefore clearly used for copying, have been found, and it is likely that these date to the Kushite or immediately following periods. Such attention paid to earlier works of art, especially those of the Old and Middle Kingdoms (2647–2124 BC and 2040–1648 BC) and of the first half of the Eighteenth Dynasty (after 1540 BC), is just one manifestation of a more general trend in Egyptian culture, for example the copying of old literary and religious compositions written on papyri. These 'archaizing' tendencies must be interpreted with caution, however. In the temple of Amun built by King Taharqa at Kawa, the artists included a relief showing the king's triumph over the Libyans. This is an almost faithful copy of such scenes in the pyramid temples of Sahure (2447–2435 BC), Pepy I (2280–2243 BC) and Pepy II (2236–2143 BC). It was therefore copied at least twice before Taharqa's time, and can be seen as part of an established practice in Egyptian art in which – well before the Kushites – certain motifs were used repeatedly by artists of different periods.

Most of the reliefs made under the Kushite dynasty, however, are creations of their own time, especially in the way they capture the African physiognomy of the new ruling group, with their round heads, full faces and prominent lips (225). The bones and musculature of the body, in particular the legs, tend to be indicated by what are virtually incised lines rather than modelling, a technique probably occasioned by the shallowness that characterizes many Kushite reliefs. Rather attractively, the attention paid to horses reflects the affection felt for these animals by the Kushite

225
Relief of
Taharqa from
the exterior
wall of a
shrine at
Kawa,
c.670 BC.
Sandstone,
raised relief;
width of
shoulders
40 cm, 15³⁄₄ in.
Ashmolean
Museum,
Oxford

pharaohs. This is known both from horse burials in the royal
necropolis and from textual sources, such as the inscription
on a large stela that King Piye set up in the temple of Amun at
Napata recording his anger when one of the Egyptian local rulers
failed to feed his horses during a siege: 'I swear, as the god Re
loves me, as my nose is refreshed by life, that letting my horses
starve causes me more pain than any other wickedness which
you may have committed in your recklessness!'

Human figures were subject to different rules of proportion. The
size of grid squares was reduced, with six new squares equalling
five old. A standing person now measured twenty-one squares from
the baseline to the upper eyelids instead of the previous eighteen
from the baseline to the hairline (see 97), and other measurements
were adjusted accordingly (there had, in fact, been slight varia-
tions in the canonical proportions of the body throughout Egyptian
history, for example during the reign of Akhenaten, and at periods
when local workshops were able to develop their own styles).

The most impressive achievements of the artists of the Kushite
dynasty were, without doubt, their statues, produced by Egyptian
sculptors who were for the first time working extensively under
the rule of pharaohs of foreign extraction (few statues had been

made during the Hyksos Kingdom). Despite the succession of traumatic events that marked the period of Kushite rule, Egyptian art maintained extraordinarily high standards of achievement. The variety of approaches to both royal and private statues is reminiscent of the situation in royal sculpture in the early Twelfth Dynasty (after 1980 BC) or at the period of great experimentation under Amenhotep III (1391–1353 BC), but Kushites statues are unmistakable. The kings display the facial features traditionally associated in Egyptian iconography with Nubians or Africans, such as the fleshy furrow extending from the sides of the nose down to the mouth. Sometimes they wear a special close-fitting cap bearing a double uraeus (cobra). Some statues resemble works of the second half of the Post-New Kingdom Period (945–715 BC). These statues have a traditional impersonal quality, enhanced by simplified detail and their technical perfection. In other statues, however, the classic postures carried contemporary naturalistic, probably even realistic, features, in particular in the treatment of the faces and sometimes also the bodies. These sculptures are technically superb, and many even display unflattering realism in their representation of mature corpulence or signs of ageing. They strive to show a strong, able and resolute – though not necessarily handsome – figure, whose qualities of maturity and experience are valued more highly than youth and promise. This approach is epitomized by statues of Montuemhet (226, 227), probably the most

226
Head of Montuemhet from the temple of Mut at Karnak, Thebes, c.660 BC. Granite; h.50cm, 19¾in. Egyptian Museum, Cairo

227
Statue of Montuemhet from Karnak, Thebes, c.660 BC. Granite; h.137cm, 54in. Egyptian Museum, Cairo

influential official in Thebes at the end of the Kushite Dynasty (who continued in this powerful role into the reign of their successors). Concessions to the past sometimes include such 'archaizing' elements as old-fashioned wigs and garments. Occasionally the same person had sculptures made in the traditional idealizing style as well as in the new naturalistic style.

This naturalistic approach was an original and lasting contribution made to Egyptian art during the Kushite period. It also marked the beginning of a new, and final, phase of artistic development during which the tension between idealizing and naturalistic representations, especially in sculpture, is keenly felt. Were the naturalistic statues a reflection of the turbulent times during which they were made, or a style instigated by the new Kushite masters? A third, intriguing possibility is that this development had nothing to do with the hypothetical Kushite preferences for a greater degree of realism but was entirely Egyptian and artistically formal in origin. Representations of foreigners were always outside the strict rules governing depictions of Egyptians, and sculptors working during the Kushite dynasty may thus have had more scope to 'create' freely. This theory, however, does not answer the question of why Egyptians were also portrayed in the same way.

After the Assyrian expulsion of the Kushites from Egypt, skilful opportunism and diplomacy combined with a temporary weakness of the Assyrians to bring to power a member of the family of local princes at Sais, in the western Delta. This was Psammetichus I (664–610 BC), the first king of the Twenty-sixth (Saite) Dynasty, whose ancestors had previously resisted the domination of the Kushites. Psammetichus and his successors were powerful and able pharaohs who restored the political unity and economic prosperity of Egypt, now once again under native rule. They recognized that the future of the country would be bound up with the Mediterranean rather than the African world, actively supported overseas trade, and did not hesitate to use mercenaries from abroad when they needed

them. The presence of foreign minorities in Egypt increased and a settlement for Greek traders was created at Naukratis, in the western Delta. The term 'Saite renaissance' is often used for this period, but artistically the term is inaccurate because the most important changes had already begun to take place under Kushite patrons, and many artists of the Twenty-sixth Dynasty had also worked under the Kushites. Moreover, Egyptian monumental art was generally affected little by the increasingly intensive foreign contacts, probably because of its undiminished function-alism, still closely linked to the unique Egyptian belief system.

During the Twenty-sixth Dynasty, the focus of political and commercial activities returned to the Delta and especially the city of Sais. The kings of the new dynasty were buried there in tombs which, as the Greek traveller and historian Herodotus recounts, were in the city's temple precinct, although these have not yet been located. Sais itself, with its temples and other monuments, is today little more than ruins, a fate that befell many other Delta cities as stone, particularly limestone, was taken from ancient sites and recycled in later building. The residence of the Saite kings may at first have been at Sais, but Memphis continued to be the country's administrative capital – a role that was confirmed when a large palace was built to the north of the temple of Ptah by King Apries (589–570 BC). The Memphite temples, like those of Sais, have disappeared, while at Karnak, the Saite kings' modest contribution to the temple of Amun adds to a general impression that their building activities were limited. This is almost certainly, however, a misconception resulting from the destruction of their monuments.

Sculptures of the Saite kings mostly survive as mere heads separated from the inscriptions on their back pillars which would have identified them. Perhaps intentionally, as a reaction to their Kushite predecessors and in an attempt to go back to the style favoured by their Egyptian ancestors, Saite kings gave up the naturalism and realism of the Kushites. Their statues began to show them in an increasingly idealizing, timeless style. Their

gently and rather superciliously smiling faces (228) below the blue crown with a double-coil uraeus are characteristic of royal sculptures during much of the Twenty-sixth Dynasty. (The form of the serpent represented on the crown changed through time and serves as a useful dating criterion.) Other parts of the statue were carved with increased attention, but their high quality was achieved through stylization with no aspirations towards naturalism. Hard materials, such as basalt, greywacke and quartzite, were most commonly used and allowed a fine finish and a high shiny polish. These statues appear impersonal and artificial, but there are few other royal sculptures known from ancient Egypt that can match them in the sheer overall perfection of the sculptor's craft.

228
Head of
Amasis (or
Nectanebo II?),
c.530 BC
(or c.350 BC?).
Quartzite;
h.43 cm, 17 in.
University of
Pennsylvania
Museum of
Archaeology
and
Anthropology,
Philadelphia

229
Seated
statue of the
official Bes,
c.650 BC.
Limestone;
h.32·2 cm,
12⅝ in.
Museu
Calouste
Gulbenkian,
Lisbon

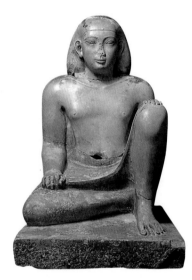

The vast majority of private statues of the Twenty-sixth Dynasty are from temples, where the number of such statues must have increased substantially; few sculptures were now placed in tombs. The many examples of the former that survive indicate the astonishing number that must originally have been made. Certain types, especially those such as seated statues which had occurred mainly in tombs, practically disappeared. Statues representing a man seated on the ground, as if in the posture typical of Egyptian scribes, but with one knee up, are ambitious variations of a well-established type (229). Inscriptions on the statue of Bes record that

he was a companion of His Majesty, that he lived during the reign of Psammetichus I and that the statue comes from the temple at Athribis, in the central Delta. Only a small number of statues of women survives (with the exception of women of a very high rank, such as queens, it was unusual to place their statues in temples).

Statues showing more than one person are also rare. There are many statues of kneeling figures, often with a shrine containing a small image of a deity, and a new type, with the palms of the hands held flat on the thighs. Standing and, more frequently, block-statues often show people with a shrine or the figure of a deity. As in royal statues, the naturalistic approach of the Kushite dynasty was gradually abandoned and replaced by formally perfect but idealizing representations, showing a bland, slightly suppressed smile. The bare torso and old-fashioned kilt reappeared. Hard stone and highly polished surfaces became the norm for larger works, while small bronze statuettes were also made in large numbers. The majority represent deities, often zoomorphic, while some show kings or private individuals. These statuettes were intended as donations to temples, and the name of the person who commissioned them is sometimes inscribed on the base. Such inscriptions are usually quite crude, contrasting unfavourably with the quality of the statuette, a feature that can be explained by the fact that the text was hastily added on to ready-made pieces.

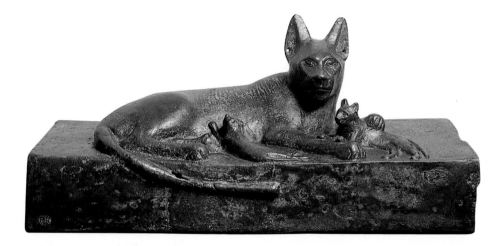

As far back as the Predynastic Period (before 2972 BC), ordinary people had presented small images of deities to local shrines, a custom which had continued but remained confined to the area of popular religion and 'unofficial' places of worship. It was only in the Ramesside Period (after 1295 BC) that small numbers of such images were allowed in the public areas of official temples. The frequency with which these presentations by devotees and pilgrims, especially those attending religious festivals, occur in the Late Period is a sign of the democratization of religious beliefs. It was probably felt that the act of donating such a statuette established a personal relationship with the deity. Some images were inscribed with a standard formula asking for the gift of life and other things of a general character, and with the donor's name. Most such statuettes, however, did not have texts and, as in the shrines of the popular religion, the mere act of donation was deemed to be sufficient. A large bronze statuette of a mother cat with kittens (230) was probably offered as a donation to the temple of the goddess Bastet at Bubastis, in the eastern Delta.

The most impressive tombs of this period are the 'funerary palaces' constructed on the west bank of the Nile at Thebes for the priests of the temple of Amun, members of the household of the God's Wives and high officials of state administration. These combined the earlier rock-cut tombs with massive brick-built superstructures; they have brick-built pylons and enclosure walls above ground, and an open court and extensive rock-cut rooms sunk below ground level. Although sometimes displaying deceptively low-ranking titles, the people buried in these tombs were the real power in Thebes during the transitional period from the Kushite to the Saite rule and during the Saite dynasty. They were among the most remarkable individuals of their time: the Governor of Thebes and the Fourth Prophet of Amun, Montuemhet, the Chief Lector-Priest, Pedamenope, the Chief Steward of the God's Wife of Amun, Ibi, the Vizier Espekashuti and others. The earliest of the 'funerary palaces' belong to the end of the Twenty-fifth Dynasty or the beginning of the Twenty-sixth Dynasty, about 670 BC or shortly after.

230
Statue of a cat
and kittens,
c.650 BC.
Bronze;
h.25·5 cm,
10 in.
Museu
Calouste
Gulbenkian,
Lisbon

Only a few of these impressive tombs survive. Their huge wall areas are decorated in low and rather shallow or sunk relief in which scenes showing the deceased with gods or in various ritual settings largely displaced depictions of contemporary situations. The texts are taken from the Book of the Dead and similar compositions, but also include the Pyramid Texts. When non-religious scenes occur, such as craftsmen at work, activities in the marshes, cattle-breeding, a funeral or a woman nursing a child from the tomb of Montuemhet (231), they appear to be copies or modified variants of representations in earlier tombs or temples. They attest to the continued interest in the art of the past but also show that

231
Lower part of a register with a woman pulling a thorn from a companion's foot, and another with a child in a fig harvest scene, from the tomb of Montuemhet at Asasif, Western Thebes, c.660 BC. Limestone; h.24cm, 9½in. Brooklyn Museum of Art, New York

232
Women pressing oil, c.360 BC. Limestone, raised relief; h.26cm, 10¼in. Musée du Louvre, Paris

'daily life' scenes were now completely divorced from the contemporary reality they appear to depict. They had become traditional themes comparable to the historical representations of fishing and fowling in the marshes known from private tombs throughout ancient Egypt (see 147). The inspiration for such scenes sometimes came from local tombs but was occasionally brought from afar. In the tomb of Ibi, of the reign of Psammetichus I, some scenes are clearly based on representations in the tomb of another Ibi, a nomarch buried at Deir el-Gabrawi, in Middle Egypt, some 1600 years earlier. It is interesting to speculate as to whether this

can be ascribed to the fact that the two men were namesakes, albeit separated by an enormous time span.

Freestanding tomb-chapels were built in the Memphite area, at Heliopolis and probably also some Delta sites at the end of the Twenty-sixth Dynasty and later, until the conquest by Alexander the Great in 332 BC. These chapels were decorated in fine low relief which in its subject matter harked back to the decoration of earlier tombs, perhaps even more conspicuously than in the Theban 'funerary palaces'. These reliefs survive as mere fragments, and little is known about the architecture of the tombs themselves. The term 'neo-Memphite' sometimes applied to the

reliefs does not mean that the inspiration for these reliefs came from Old Kingdom tombs in the Memphite area; it seems more likely that, like their Theban counterparts, they drew on Eighteenth Dynasty models. But representations of people, especially women, were given new, fuller and more curvaceous forms that anticipated the style of the Ptolemaic Period. Scenes depicting offering-bearers, the presentation of jewellery, musicians, dancers and everyday activities such as the manufacture of oil (232) seem to be inspired by the traditional themes, and there is little attempt to disguise the fact that these reliefs do not relate very closely to contemporary reality.

Tombs with a burial chamber at the bottom of a wide shaft, some 30 m (98 ft) or more deep, became common in the Memphite area at the end of the Twenty-sixth Dynasty and during the Twenty-seventh Dynasty, when Egypt was under Persian domination. The body of the deceased was placed in a massive stone anthropoid sarcophagus in the vaulted burial chamber built at the bottom of the shaft. The sarcophagus and the walls of the chamber were decorated with texts and vignettes taken from religious compositions, especially the Book of the Dead. After the burial the shaft leading to the chamber was filled with sand and rubble. The only way of reaching the burial chamber was by emptying the shaft. Paradoxically, this was a more difficult procedure than cutting through the stone blocking of some earlier tombs and it represented the ultimate in security arrangements devised to protect against tomb robbers. An intact tomb of this type, of Iufaa, a priest attached to the temple of the goddess Neith at Sais, was found in 1997 at Abusir and represents one of the most exciting archaeological discoveries of recent years. Tombs of this kind tended to be located near prominent monuments of the past and contemporary religious sites. A series of them stretches from the Step Pyramid of Djoser (see 43) past the Serapeum (the communal burial place of the Apis bulls, the animals associated with the Memphite god Ptah) as far as Abusir, and they also occur at Giza.

In addition to the large tombs of the Egyptian élite, however, there were many less pretentious burials in which stelae and coffins were the main item of funerary equipment, often the only element which carried decoration. Stelae of wood (233) were just as frequent as those made of stone. They were almost always round-topped, with a large winged sun-disc at the top, under which the area is divided between a register with one or two scenes showing the deceased before one or more deities, and several lines of a standard invocation usually addressed to Osiris. The scenes as well as the text are often painted rather than incised or carved in relief. In such burials two or three anthropoid coffins were often nested together (234). The decoration was painted on a yellow or white background and contained texts from the Book of the Dead,

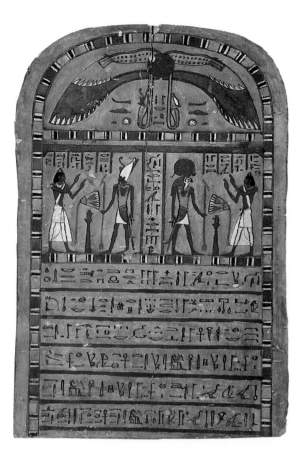

233
Funerary
stela of
Ankhefenkhons,
the priest of the
sacred staff
of Amun,
probably from
Thebes,
c.600 BC.
Painted wood;
h.47·3cm, 18⅝in.
British Museum,
London

arranged in lines or columns, sometimes accompanied by small
scenes. These usually included a mummy lying on a bier and the
deceased being judged by Osiris, who tested his or her entitle-
ment to continued existence in the realm of the dead. A new type
of outer coffin, the so-called four-poster coffin (235), recognizable
by the four upright posts at the corners of the coffin's rectangular
body, was introduced. With their vaulted lids, these coffins resem-
bled shrines of the gods. This impression was enhanced by the
painted representations on the exterior of deities standing in
shrines. Small wooden figures of jackals and hawks, linked to the
necropolis gods Anubis and Sokar, were attached to the posts of
the lid. The small figures (or shabtis) placed in burials were now
renamed ushebtis, 'answerers', a description appropriate for their
function, which was to 'answer' on behalf of the deceased when

234
Outer coffin
of Espamai,
a priest at
Akhmim,
c.600 BC.
Plastered and
painted wood;
l.210 cm, 82⅝ in.
Ägyptisches
Museum,
Berlin

235
'Four-poster
coffin' and
cartonnage of
Hori, the priest
of the god
Montu, from
Thebes,
c.650 BC.
Painted wood;
l.215 cm, 84⅝ in.
British
Museum,
London

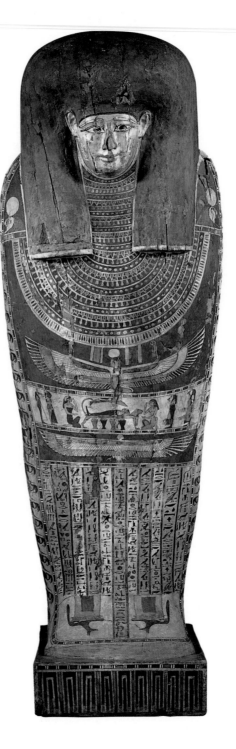

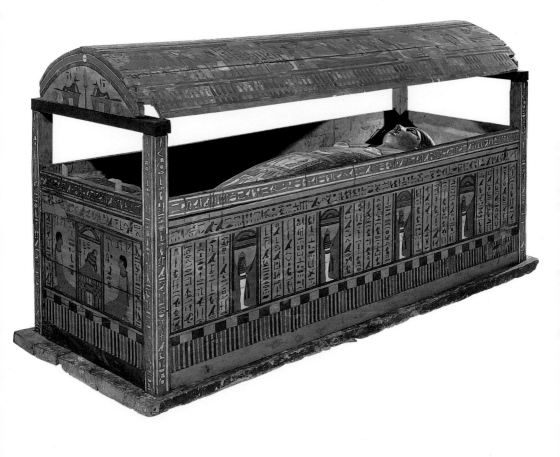

called upon to perform tasks in the kingdom of the dead. Many of those dating to the Twenty-fifth Dynasty were made of stone, but later ushebtis were made of bright green or blue faience. The standard inscription on them was taken from the Book of the Dead. Another new artistic development of the Late Period was beadwork covers, often resembling netting, which were sometimes placed over mummies. Faience beads of different colours were strung in such a way as to create complicated geometric patterns, various religious symbols and even inscriptions.

Late Period pottery shows a general decline in the variety of forms and standard of decoration but also some interesting trends. The increasingly cosmopolitan outlook of society and the growing divisions between the Egyptian and foreign communities are reflected in the imitation of Greek painted pottery, especially at Naukratis. Purely Egyptian traditions continued, for example in jars with the head of the demi-god Bes modelled as a three-dimensional image. Stone vessels were still produced, especially as containers for perfumes and face and body paints. Those made in the form of a lion curiously echo vases found in the tomb of King Tutankhamun some eight hundred years earlier. Funerary goods included alabaster canopic jars (236).

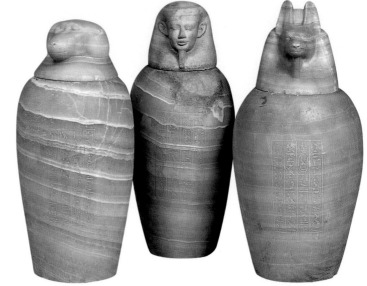

Egypt's fortunes were now far from secure, and its return to economic prosperity and artistic excellence under the Saite rulers was possible only because there was little interference from the outside world. When the Persians became the leading military power of the Ancient Near East, the army of King Cambyses occupied Egypt in 525 BC and the country became a mere satrapy (province) of the Persian empire. Although the productivity of Egyptian artists does not seem to have been seriously affected, Egyptian art of the Twenty-seventh (Persian) Dynasty did not remain entirely impervious to contemporary influences. Beside the idealizing style, there was also a renewed trend towards more naturalistic depictions (see 220). In sculpture, contemporary garments appeared, for example the Persian cloak, a wraparound, chest-high male garment that occurs in sculpture until the Roman period. However, in contrast to art produced under the Kushite dynasty, naturalism was limited to the faces of statues and the detailed modelling of their bald or close-shaven heads.

During the fourth century BC, there was another short period of Egyptian independence. Kings Nectanebo I (380–362 BC, Thirtieth Dynasty) and Nectanebo II (360–342 BC) enlarged existing temples and erected new ones on a scale not seen since the times of the Saite Twenty-sixth Dynasty. They were also great builders of brick enclosure walls encircling temples and avenues with hundreds of sphinxes in front of the temple entrances (see 189). The unreality of idealizing statues was sometimes enhanced by archaizing details, such as an old-fashioned wig, as in the diorite statue of a priest of Amun-Re which probably comes from one of the Delta temples (237). In private sculpture, the tendency towards naturalism intensified during this period, thus anticipating the sculpture of the Ptolemies. In religion, the trend towards greater democratization which had gathered pace during the first millennium BC became overwhelming. As the relationship between the gods and ordinary people became closer, the need for an intermediary in the form of the king or his priestly deputy was at least in certain situations rendered unnecessary. Even ordinary people were now able to approach the gods directly in the outer parts of temples, and

236
Canopic jars of General Psametek-sineit, from his tomb, probably at Saqqara, c.530 BC. Alabaster; max. h.58cm, 22⁷⁄₈in. Musée du Louvre, Paris

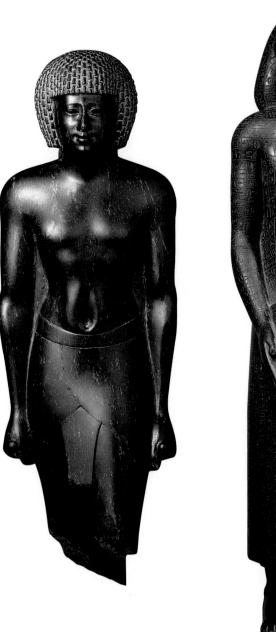

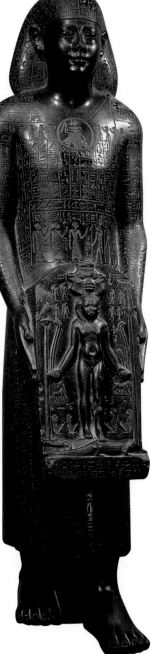

religious festivals became popular occasions in which large numbers of people took part.

At the same time, certain concepts that had earlier belonged to the sphere of popular religion were now promoted to the level of official religious beliefs. Egyptian art, especially sculpture, reflected these developments. For example, a new type of private statue appeared during the fourth century BC and continued into the Ptolemaic Period showing a person standing or kneeling with a stela which is known as a cippus, or a 'Horus-on-the-Crocodiles' stela (238). These were small stelae with the representation of Horus as a naked child standing on crocodiles and grasping dangerous creatures, such as snakes or scorpions, or those representing the untamed forces of nature, such as lions or gazelles. The presence of Horus referred to an Egyptian myth about his childhood in the Delta marshes and the dangers he encountered there. These stelae were inscribed with magical spells and were meant to protect against accidents and misfortunes, or to provide cures. Water was poured over the stela which was then used for ritual washing or possibly for drinking. Such statues themselves were completely covered with magical texts and small scenes and probably served a purpose similar to the stelae. These superbly accomplished works were set up in temples, and provide a rare glimpse of a popular aspect of Egyptian religion. Statues showing a king or a private individual 'protected' by a zoomorphic form of a deity also became more frequent during this period (239). In these statues, the animal or bird form of a deity is shown behind the person who is 'protected' by its wings or sheltered under its forequarters. These statues occur in Egyptian art as far back as the Old Kingdom (see 54), but at first only the king could be shown in such a close proximity to a god or goddess. Fully zoomorphic forms of deities were originally associated with popular religion but became more acceptable from the reign of Amenhotep III.

Throughout these politically stirring and extremely volatile times, Egyptian art of the Late Period remained remarkably stable. A history based entirely on the evidence of artistic

237
Statue of a priest of Amun-Re, c.360 BC. Diorite; h.51·2cm, 20⅛in. Brooklyn Museum of Art, New York

238
'Magical statue', man holding a Horus stela, c.350 BC. Basalt; h.67·7cm, 26⅝in. Musée du Louvre, Paris

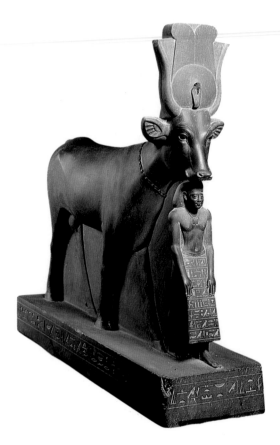

239
The chief steward, Psametek, protected by a Hathor-cow, from his tomb at Saqqara, c.530 BC. Schist; h.104cm, 41 in. Egyptian Museum, Cairo

production would suggest a much more prosperous and peaceful time than was the case. But these were the final days of ancient Egypt. The reign of Nectanebo II was cut short by another invasion by the Persians (the founders of the Thirty-first and last royal dynasty of pharaonic Egypt). They in their turn were ousted by the Macedonian conqueror Alexander the Great in 332 BC. One of the greatest civilizations of the ancient world had reached the end of its independent journey.

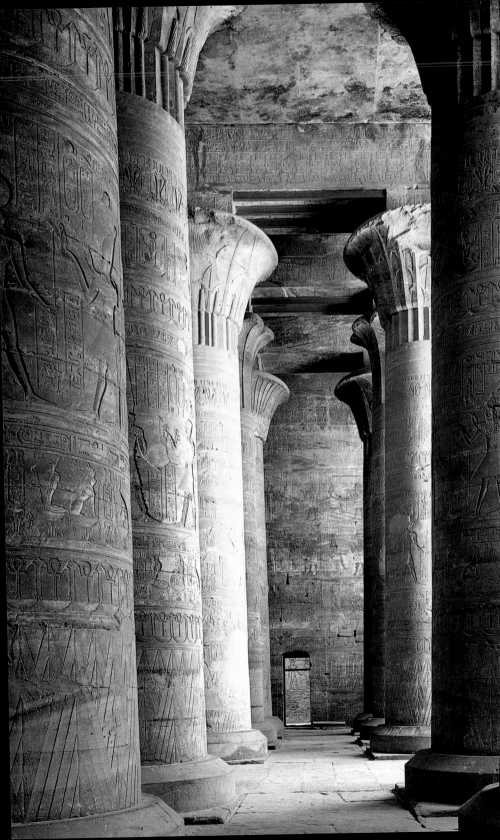

The Persians reconquered Egypt in 343 BC, but only managed to hold on to it for some ten years. As part of a larger strategic plan, Alexander the Great and his army seized Egypt from the Persians in 332 BC and incorporated it into his huge empire. But the Macedonian military genius was preoccupied with plans for further, more distant campaigns, and his stay in Egypt was short. Its most celebrated event, his journey to the oasis of Siwa, in the Western desert, was not a romantic adventure but a shrewd political move. Here the god Amun, speaking through an oracle, proclaimed Alexander as his son, and so legitimate ruler of Egypt. After his death in Babylon in 323 BC, Alexander's empire disintegrated. One of his generals, Ptolemy, took control of Egypt, which in this somewhat unorthodox way regained its independence. In 304 BC, Ptolemy proclaimed himself the first ruler of the country's new royal dynasty, placing Egypt's destiny once again in the hands of foreign kings. The Ptolemies resided in their new capital, Alexandria, which had been founded on the Mediterranean shore in the western Delta in 331 BC. Internationally, the auspices were good: Egypt's power and influence in the Eastern Mediterranean were greater than at any time during the last centuries of pharaonic Egypt, and it also held large parts of Palestine, modern Libya and Cyprus.

The Ptolemaic dynasty remained on the Egyptian throne for some three centuries. As ever, the country proved remarkably resilient to adversity and was able to reach accommodation with the new ruling group; its agricultural production, the envy of the ancient world, was the basis of its economic prosperity. Egypt was the strongest and most important among the Hellenistic kingdoms of the eastern Mediterranean, where, mainly as a legacy of Alexander's conquests, Greek civilization and art now flourished amid foreign cultural and artistic surroundings. Alexandria

240
The outer
hypostyle hall
in the temple
of Horus at
Edfu,
c.125 BC

quickly became one of the industrial, commercial, cultural and scholarly centres of the ancient world, replacing Memphis as Egypt's metropolis. It boasted a royal palace (the Brucheion); the Museum, which was a centre of Alexandrian scholarship; and many temples including the Serapeum (the temple of the god Serapis). There were also an amphitheatre and a stadium, the famous Alexandrian library, theatres and public baths. As recent discoveries in Alexandria's harbour show, ancient Egyptian statues, sphinxes and obelisks were brought from various other parts of Egypt to embellish the city. Alexandria's great lighthouse (the Pharos) was regarded as one of the Seven Wonders of the Ancient World; its remains have also been found submerged in the harbour. Alexander the Great was eventually buried in the city which bore his name, though his tomb has not yet been discovered.

The Ptolemies remained aloof from the Egyptian population in the isolation of their luxurious palaces, and Alexandria was always a Hellenistic centre on the Egyptian coast, rather than a truly Egyptian city. Another thirteen kings followed Ptolemy I; the last of them, Ptolemy XIV Philopator (47–44 BC) was succeeded by Queen Cleopatra VII Thea Philopator (51–30 BC), usually known simply as Cleopatra. The queen's ambitions for Egypt were high, but during her reign the country became embroiled in the civil war dividing Rome. Cleopatra made an ill-fated alliance with the Roman general Mark Antony, and in September 31 BC their navy was defeated at Actium by Antony's rival, Octavian (who was to proclaim himself Emperor Augustus in 27 BC). Less than a year later Octavian's army occupied Alexandria and Cleopatra and Mark Antony committed suicide; the Ptolemaic dynasty came to an end, and with it Egypt's existence as an independent nation. Egypt thenceforth was a mere province, first of the Roman Empire and then of Rome's successor in the east, the Christian Byzantine Empire, with its capital at Constantinople (modern Istanbul).

Superficially, the situation in Egypt under the Ptolemies was not new: one group of foreign rulers was replaced by another. But this was much more than the superimposition of a thin stratum of

foreign ruling class over the mass of the native population. During previous periods of foreign domination, the country's administration had remained essentially Egyptian, with Egyptian minions acting on behalf of the new rulers. But now non-Egyptians, mainly Greek immigrants who were arriving in large numbers, formed a privileged section which monopolized Egypt's administration. The Egyptians were, in fact, second-class citizens in their own country, separated from the administrative élite by their language, religion and culture. This situation gradually eased only during the latter half of the Ptolemaic rule.

These factors were decisive for the way Egyptian arts developed under the Ptolemies. The Hellenistic (Greek) arts and culture of the ruling élite (241) now existed alongside Egyptian arts. Outstanding Hellenistic works of art were created in Alexandria, Memphis and elsewhere in Egypt, while other artists worked in the traditional Egyptian style. At sites which attracted visitors from both ethnic elements, for example along the approaches and in the temple adjacent to the Memphite Serapeum (the

241
Colossal head of Ptolemy VI Philometor from Abukir, c. 150 BC. Granite; h. 61 cm, 24 in. Graeco-Roman Museum, Alexandria

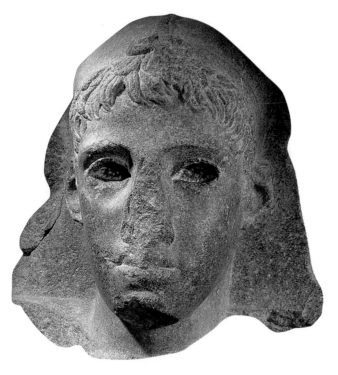

underground tombs of the Apis bulls at Saqqara), sculptures made in the two entirely different styles were set up side by side. The same subjects were sometimes represented in both styles, notably images of the Ptolemaic kings and queens. In order to legitimize their rule and make themselves more acceptable to the Egyptian population, the Ptolemies had to show support for traditional Egyptian religious institutions, especially temples, but also for other customs of the country, such as burials of sacred animals. In such contexts, they appeared as Egyptian pharaohs, with all the customary designations and accoutrements, and if it was not for their names, it would be difficult to recognize the royal figures offering to Egyptian deities on temple walls as the non-Egyptian Ptolemies. Roman emperors were later represented in the same way, perhaps with even less justification, since some of them never set foot on Egyptian soil. But conformity to the country's prevailing customs was only skin-deep, and the Ptolemies always remained foreign rulers in a foreign land.

During the Ptolemaic Period there was little exchange of artistic ideas between Egyptian and Greek arts or mixing of styles in tombs and temples, where different approaches to religion and ideas about the afterlife reflected the deep divisions in the social status of Egypt's inhabitants. The Egyptian arts had always been profoundly functional and served specifically Egyptian religious beliefs; they were therefore unable to change fundamentally with-out jeopardizing the very reason for their existence. Egyptian religion, and in its wake Egyptian art, reacted to the situation in the country by becoming more exclusive and introverted. The situation is in fact a remarkable illustration of art's ability to divorce itself from prevailing political realities, provided it can feed on a continued spiritual support. In freestanding sculpture, the main preoccupation continued to be the tension between idealization and naturalism. Some of the most astonishing exam-ples of naturalistic sculpture were created by Ptolemaic artists, but it is not clear why, in any given situation, one style was preferred to the other. It is unlikely that the intended context of these statues was a factor, because the vast majority were temple

statues. It seems that Egyptian sculptors' workshops, perhaps even individual sculptors, were able to create statues in both styles as required.

In royal sculpture, the idealizing trend continued to be favoured. Egyptian statues are often compared with those made in purely Greek style, and especially with portraits of Ptolemaic rulers known from coins, which can be dated with great precision. However, the fundamental differences between Greek portraiture and the Egyptian composite approach towards the three-dimensional representation of the human figure, based on the combination of the profile and the frontal view, make such comparisons unfruitful. In private sculpture, meanwhile, the difference between idealizing statues, for example the Brooklyn 'Black Head' (242) which dates to the closing years of the Ptolemaic Period, and naturalistic, almost veristic, works, such as the statue of the wrinkled and aging Harsitutu from Sais (244), probably of the early Ptolemaic Period, or the late Ptolemaic 'Green Head' in Berlin (243), can be seen mainly in the modelling of the head. But it is hard to distinguish between a naturalistic but formalized representation, and a realistic portrait. Indeed, it can be argued that wholly realistic sculptures (ie portraits), did not exist, despite the ability of Ptolemaic sculptors to endow their work with qualities of individuality and character rarely met before in Egyptian sculpture. In most cases, the natural colouring of the stone and the contrast created by different surface finishes probably replaced the polychrome painting of statues of pharaonic Egypt. One feature, in particular, continued to be associated with Egyptian manufacture: the presence of the back pillar, often with a rhomboidal or triangular summit.

The connection between idealization and naturalism was so close in Egyptian sculpture at this time that it sometimes seems as if only a different facial mask was slipped over the anatomically accurate skull. This could belong to one of several possible types: for example a bald or close-shaven 'egg-shaped head', usually with an idealized face; or a similarly bald 'polygonal head'

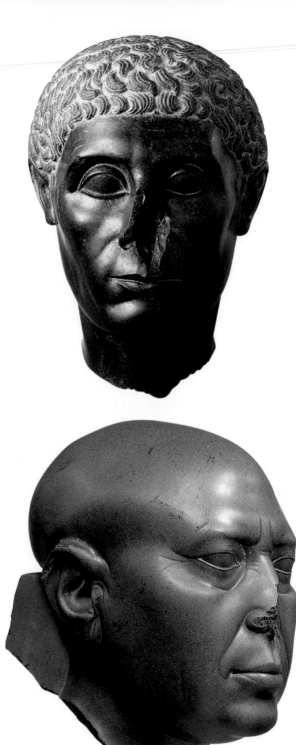

242
The Brooklyn
'Black Head',
c.50 BC.
Diorite;
h.41·4cm,
16¼in.
Brooklyn
Museum of
Art, New York

243
The Berlin
'Green Head',
c.50 BC.
Schist;
h.21·5cm, 8½in.
Ägyptisches
Museum,
Berlin

244
Statue of
Harsitutu,
possibly
from Sais,
c.250 BC.
Granite;
h.113 cm,
44½in.
Ägyptisches
Museum,
Berlin

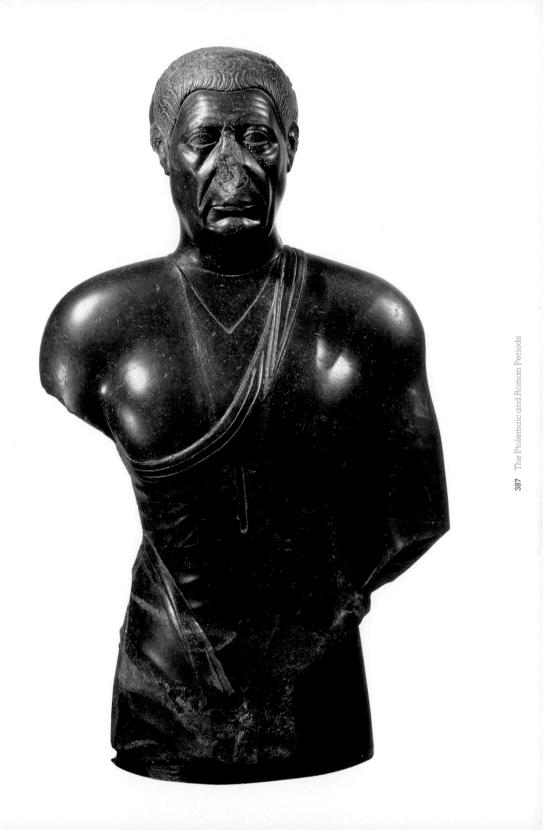

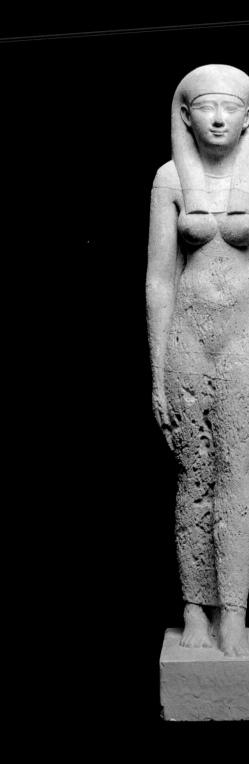

appearing to consist of several relatively straight planes when viewed in profile. Both types sometimes have closely cropped, curly hair. Female figures (245) have smiling faces and are always carved in an idealizing style; they are solidly built, with heavy breasts (perhaps the most conspicuous difference when compared with pre-Kushite statues), and strong legs and bodies under their long garments. This feminine type continues the tradition that began under the Kushites and reflects the general trend towards fuller female, as well as male, figures which is evident in the reliefs of the Ptolemaic and Roman Periods.

There are many examples of small royal busts or heads (246), often with a grid drawn over them, whose purpose is difficult to interpret, especially since hardly any have been found in controlled excavations. The presence of the grid and the incompleteness of the representation – a cardinal sin in Egyptian art – might suggest that these were sculptor's models which were used in workshops to control the form of the royal statues; another theory (again rather inconclusive) is that these objects were donated to sanctuaries by pious devotees.

245
Statue of a
woman,
c.250 BC.
Limestone;
h.78·3cm,
30⅛in.
Musées
Royaux d'Art
et d'Histoire,
Brussels

246
Royal bust
with a grid,
perhaps a
sculptor's
model,
c.100 BC.
Limestone;
h.12cm, 4¾in.
Museo Egizio,
Turin

The Ptolemaic rulers, as well as local administrators and the temple priesthood, inaugurated a massive programme to complete and decorate existing temple structures, especially those left unfinished by the kings of the Thirtieth Dynasty (380–343 BC), and to construct new buildings. The temples served the cult of the local gods; and some also the cult of the reigning king or his deified predecessors. These activities took place in the cities of the Delta, for example the temple of Isis at Behbeit el-Higara; at Thebes, in the Karnak temple, and also at Deir el-Bahri, at Deir el-Medina and Medinet Habu. In the southern part of Upper Egypt building

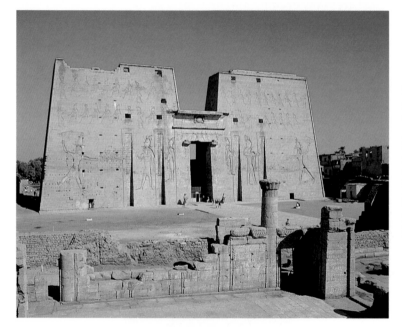

247
The temple of Horus at Edfu, 237–57 BC

248
View of the hypostyle hall in the temple of Horus and Sobek at Kom Ombo, c.50 BC. Photograph by H Béchard, 1880s

was carried out at such temples as that of Hathor at Dendara, of Min and Isis at Koptos, of Montu at Armant, of Khnum at Esna, of Horus at Edfu (240, 247, 249), of Horus and the crocodile god Sobek at Kom Ombo (248), and of Isis on the island of Philae. Building was also undertaken in the oases of the western desert; as well as in the northern part of Lower Nubia, south of the first Nile cataract, especially at Kalabsha and el-Dakka. Unfortunately, the wholesale destruction of temples in the Delta and in the Memphite area has considerably distorted the picture of the geographical

distribution of Ptolemaic work. This astonishing level of building activity, which marked the close of pharaonic civilization, continued at many temples, apparently with little interruption, during the early period of Roman occupation, after 30 BC.

The structures of the Ptolemaic and Roman Periods show Egyptian temples at their most developed and, since they were not affected by subsequent building activities, often also their purest. The basic plan is the same as that of the temples of earlier periods, but new elements were also added. Low intercolumnar walls (249),

which usually constitute the façade of columned halls and greatly add to the amount of light flooding in, now became a regular feature. There is a variety of imaginative composite column capitals. The innermost part of the temple, the sanctuary, is now regularly surrounded by one or even two corridors with entrances to additional small chapels on the temple's perimeter. Chapels for ceremonies requiring sunlight or a starry sky are on temple roofs (these were almost certainly not new introductions). These chapels were used on occasions such as the New Year festival,

when the temple cult statue was taken to the roof of the temple in order to receive the first rays of the rising sun on New Year's Day. Rooms actually built into the temple walls (crypts), sometimes decorated, were apparently a new idea, and seem to have been used for the storage of temple equipment. There are also new structures next to the main temple building, the most important of which are the so-called *mammisi* or birth-houses, in which the god of the temple was thought to be periodically reborn. These occasions were marked by grand religious festivals. Most temples had sacred lakes representing the primeval waters in which creation took place, and these also played an important part in the ceremonies and re-enactment of mythical events performed during such festivals. Special buildings served the large numbers of pilgrims and devotees who gathered around temples on these occasions, for example sanatoria where the sick and infirm could take healing baths.

249
The façade
of the outer
hypostyle hall
in the temple
of Horus at
Edfu, with a
colossal statue
of the god
Horus,
c.125 BC

Enormous wall areas in the temples built during the Ptolemaic and Roman Periods were covered with inscriptions and reliefs in an idealizing style. On the walls, the representations and texts are frequently divided into three horizontal areas: at the top a narrow band of small-scale representations; below them several registers with the main scenes (250); and on the base of the wall a row of offering-bearers and figures personifying various localities. This arrangement can be found in Egyptian reliefs at least as early as the New Kingdom (1540–1069 BC), but during the Ptolemaic and Roman Periods it was employed more systematically and more often than ever before. Both raised relief for interior walls and sunk relief for outside walls exposed to direct sunlight were used, while the registers consist of what superficially appear to be monotonously regular sequences of scenes distributed as if on a huge chessboard, most of them showing the pharaoh offering or performing a rite before a deity. Very little in the decoration of Egyptian temples was accidental, however, and each scene and every element – be it the deity who appears in it, the type of crown worn by the king, the offering presented or the rite performed, the position of a scene in the temple or its placement on a wall, or the

250
Reliefs in the
temple of
Horus and
Sobek at
Kom Ombo,
c. 120 BC.
Sandstone,
raised relief

251
Offering-
bearers in
the tomb of
Pedusiri,
the high priest
of Thoth,
at Tuna
el-Gebel,
c. 330 BC.
Plastered
and painted
limestone,
raised relief

direction in which the figures are facing – were parts of an overall design. All this is purely Egyptian; there is nothing in temple decoration to show that the makers worked in a country in which other works of art were being created in a non-Egyptian, Hellenistic, style at the same time.

Private tombs with freestanding chapels were still occasionally made during the Ptolemaic Period, but their decoration was reduced to a few inscribed or decorated elements. It is all the more surprising, therefore, to find a tomb like that of Pedusiri, a high priest of the god Thoth, at Tuna el-Gebel (near Hermopolis, modern Ashmunein in Middle Egypt), which is fully decorated in painted relief (251). Interspersed with purely Egyptian representations are distinctly Greek elements, such as figures shown in front and three-quarter views. This is not an attempt to modify Egyptian representations but rather a mixture of the two different artistic styles on the same wall and in the same scenes. That it remains unique in Ptolemaic reliefs is usually taken as an indication that

the attempt failed, although the true reason may be somewhat different. Ptolemaic artists working in the traditional Egyptian style simply did not have enough opportunities to develop a mixed style in scenes where such innovations might have been admissible: it is significant that the Greek elements occur in scenes of the 'daily life' variety rather than in depictions of deities or in more obviously religious contexts.

Private tombs made during the Roman Period developed in a way that combined Hellenistic architectural forms, as well as stylistic features and motifs with traditional ancient Egyptian subjects and remnants of representational conventions. Some of the best examples are in the catacombs at Kom el-Shuqafa in Alexandria, the painted freestanding tombs at Tuna el-Gebel, the rock-cut tombs in Akhmim in Upper Egypt, and the painted tombs in the oases of the Western Desert, especially in Dakhla and Siwa. Ancient Egyptian subjects include funerals during which the body of the deceased is shown on a bier being transported in a wheeled

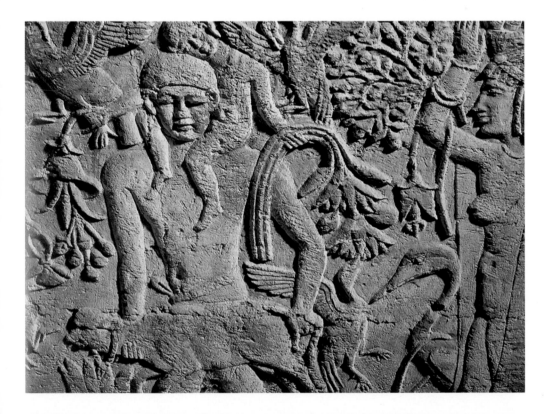

carriage, presentations of offerings by the king to the Apis bull, and other scenes with Egyptian deities. But interspersed with these subjects are others, such as representations of the deceased, which are purely Hellenistic. Hieroglyphic inscriptions sometimes accompany both. The people buried in these tombs were not exclusively followers of ancient Egyptian gods, and it is clear that the religious considerations which had previously made the mixture of Hellenistic and ancient Egyptian styles so difficult to achieve now lost their power. These reliefs and paintings were the first in a long line of works of art that imitated Egyptian creations or were inspired by them, but which can no longer be classified as truly ancient Egyptian art. In a related development from the first century AD some coffins were provided with portraits of the deceased painted on wood or canvas (252). The style of these remarkably lifelike 'mummy portraits' is purely Hellenistic, but the custom is curiously reminiscent of the heads on ancient Egyptian anthropoid coffins and sarcophagi.

252
Mummy of
a youth from
Hawara,
c.100 AD.
Painting
on wood;
1.132cm, 52in.
British
Museum,
London

Egypt may have lost its political independence in 30 BC, but its economic importance, especially its grain production, secured it a special position among other Roman provinces and ensured its continued prosperity for at least the first three centuries of Roman domination. Economic advantages accrued from closer integration into a large Mediterranean market. The cities in the Faiyum and in the northern part of the Nile valley, such as Oxyrhynchus, Antinoopolis and Hermopolis, were populated by mixed communities in which Greeks and Egyptians predominated. These towns and also large villages now began to flourish in an unprecedented way. Their public buildings included council offices, temples (and later churches and synagogues), baths, gymnasia (which served for physical as well as spiritual education) and also theatres or a hippodrome (for chariot races). Greek continued as the main language of administration.

In the minor arts it soon became difficult to distinguish between works of art in the Egyptian style and those made in the Hellenistic tradition. The close coexistence of Egyptian and Greek craftsmen

and artists resulted in a shared technology whose products reveal more about the tastes of the consumer than the ethnicity of the creator. Glass (253) and textiles were among the more prominent items of daily use. Ptolemaic and Roman glass factories in Alexandria, Memphis and the Faiyum were famous, and commonly employed many specialized techniques. Some of these were probably invented in Egypt, including cameo glass with raised relief on a background of a different colour; an elaborate gold version where sections of gold and glass were laminated together; and mosaic glass made by assembling threads of glass into a cane which was then fused and cut into sections. Vases of various forms and ornamental panels and plaques with Egyptian as well as Hellenistic motifs were produced by the glass factories. Characteristically Egyptian was the use of polychrome glass hieroglyphic signs as inlays on the lids of wooden coffins. The manufacture of tapestries, rugs and garments was a special feature of several Upper Egyptian cities, especially Akhmim and Antinoopolis, during the late Roman Period. Most of the famous Coptic (Egyptian Christian) textiles continued to be made in these workshops throughout the first millennium AD.

The Romans regarded Egyptian culture, which was manifestly older than their own, with respect and even admiration, and credited it with deep and esoteric knowledge. It was this Roman enchantment with Egypt which ensured that the country and its art remained implanted in European imagination long after the last days of the Roman Empire. The cults of Egyptian deities had spread to Greece, Asia Minor and Rome under the Ptolemies and soon became an important element of the religion of all the Greco-Roman world. The goddess Isis and the god Serapis were especially popular in Rome. The latter had been artificially created during the Ptolemaic Period with the intention of bridging the very different religious beliefs of the Egyptians and the foreign, mainly Greek, immigrants. The name of the god derived from that of the Apis bull (in Egyptian religion linked to the Memphite god Ptah) who at his death was identified with the god Osiris and called 'Osiris-Apis', which became 'Serapis'. But the

253
Inlay showing
a king or
a god,
c.250 BC.
Glass;
13×6cm,
5⅛×2⅜in.
Brooklyn
Museum
of Art,
New York

appearance of this deity was entirely anthropomorphic and Hellenistic. Objects connected with Egypt were regarded as essential in the sanctuaries of such deities, for example at Isaeum Campense, one of the sanctuaries of the goddess Isis, in Rome. The demand for Egyptian works of art was such that Egyptian statues were imitated in Rome, often so skilfully that it is not easy to distinguish between a genuine Egyptian piece and a Roman imitation. Many Egyptian monuments, especially obelisks, sphinxes and statues, were brought to Rome as an act of triumphalism and also because of their exotic appeal. There they were used to embellish public squares and gardens of the imperial capital and the villas of emperors and wealthy private citizens.

Many Roman works of art were created in an Egyptianizing style. Emperor Hadrian (117–138 AD) filled his villa at Tivoli with such statues, among them sculptures of his lover Antinous (254) who had accidentally drowned in the Nile and was commemorated in Egypt by the foundation of a new city, Antinoopolis (modern el-Sheikh Ibada in Middle Egypt). Antinous is shown in these statues as an Egyptian pharaoh, wearing the royal headcloth and the archaic short kilt, but the modelling, especially of Antinous' arms and legs, leaves no doubt that this is Roman work. Here is the essence of all Egyptianizing works: they use selected aspects of Egyptian art, usually subjects, forms or attributes, and reinterpret them in their own contemporary artistic style. Decorative elements deriving from ancient Egypt also appeared in Roman architecture, in particular the winged sun-disc and the frieze of uraei (cobras). Among pyramidal tombs the most celebrated is that of Caius Cestius (255), dating to the reign of Augustus (27 BC–14 AD), near the Porta San Paolo in Rome, now overlooking the Protestant Cemetery where the English Romantic poets John Keats and Percy Bysshe Shelley are buried. The pyramid's function as a tomb and its exterior form are broadly the same as those of Egyptian pyramids, but its sides are much steeper.

Christianity, according to tradition, was introduced to Egypt by the evangelist St Mark. During the first three centuries Egyptian

254
Statue of
Antinous from
Hadrian's villa
at Tivoli,
c.130 AD.
Marble;
h.241 cm,
94⅞ in.
Vatican
Museums,
Rome

255
Pyramidal
tomb of Caius
Cestius, Rome,
c. 12 BC

Christians were subjected to persecution, but the situation changed when Constantine became Roman emperor in 306 AD and himself adopted Christianity. In 395 AD Egypt became part of the Eastern Roman Empire centred on Constantinople (generally known as the Byzantine empire). It was now officially a Christian domain with its unique Coptic (Egyptian Christian) culture. Christians now purposefully distanced themselves from their 'pagan' predecessors. Ancient Egyptian monuments and works of art were often defaced or destroyed. But this was also a period of bitter theological disputes which eventually led to an almost complete isolation of the Egyptian Church from the rest of Christendom. Economically, the country began to stagnate and and social conditions deteriorated. The external political situation worsened and between 619 and 628 AD Egypt was temporarily occupied by the Persians. But forces were now gathering in the Arabian peninsula which would change the fate of Egypt permanently. Prophet Muhammad died in 632 AD and the new Islamic state began its expansion westward, into northern Africa, a few years later.

10

THÈBES. BYBÂN EL MOLOUK.

Pl. 91.

1.2 TABLEAUX DE LA SALLE DES HARPES DANS LE 5.ᵉ TOMBEAU DES ROIS A L'EST, 3.8 PEINTURES DES TOMBEAUX.

By 642 AD the Arab conquest of Egypt was complete, and Islamic art and architecture now flourished. While workmen reused stone from ancient monuments to build Islamic Cairo, the Islamic aesthetic took little from ancient Egypt. Arab writers and historians have left accounts of ancient monuments, but in the West the legacy of ancient Egypt was kept alive mainly through the continued popularity of Greek authors such as Herodotus and Diodorus Siculus, and their later successors, for example Horapollon, the leading Alexandrian Neoplatonic philosopher of the late fifth century AD. In Rome, the awareness of ancient Egyptian culture may have receded in the Middle Ages, but it never disappeared completely.

A new and vigorous phase of ancient Egyptian artistic influence unfolded during the Renaissance, which witnessed a general revival of interest in ancient philosophy, arts and literature. The theoretical basis for a renewed interest in ancient Egypt was provided by the Neoplatonic and Hermetic (so called after works whose authorship was ascribed to the Egyptian god Thoth, equated with Hermes by the Greeks) philosophical ideas. These had been debated in Alexandria and were now avidly studied because they were seen as providing links with Egypt's arcane wisdom. Horapollon's fanciful interpretation of hieroglyphic signs was very popular among Renaissance scholars and proved a serious obstacle on the path towards the correct deciphering of hieroglyphs. But more important in practical terms was the rediscovery of Egyptianizing, and also some genuinely Egyptian, works of art. In the fifteenth and sixteenth centuries, excavations in Rome and at other ancient sites, especially Hadrian's villa at Tivoli, brought to light a number of imperial works of art in the Egyptian manner. Several Popes supported these antiquarian activities, and the Vatican assembled a large collection of such

256
Plate 91 of
volume ii of
*Description
de l'Égypte*,
1809–26.
Scenes from
the tomb of
Ramses III in
the Valley of
the Kings,
Thebes

De
COEMITERIIS,
sive
ADYTIS AEGYPTIORUM
veterum.

C. Decker, in et fe.

pieces. Egyptian obelisks were re-erected or re-sited, including the Vatican obelisk in the Piazza di San Pietro in 1586. The knowledge of such monuments and works of art was reflected in the works of Renaissance architects and artists undertaking the decoration of new buildings. Egyptian influences were mostly transmitted at second-hand through Roman pieces; only a small number of genuine ancient Egyptian monuments, such as obelisks, played a part in this process.

In the seventeenth century, the Jesuit priest Athanasius Kircher was one of the first to study the Egyptian monuments of Rome seriously, publishing several influential volumes on this subject such as *Obeliscus Pamphilius* in 1650, *Sphinx Mystagoga* (257) in 1676 and other works. Antiquarians and travellers now began to bring pieces from Egypt to other parts of Europe, including England, but still more important were published engravings of Egyptian

257
**Athanasius
Kircher**,
*The Pyramids
of Memphis
and a Tomb:
a Baroque
Vision of
Egypt*,
frontispiece
to *Sphinx
Mystagoga*,
1676

antiquities and the Egyptianizing monuments of Rome. These contributed enormously to the spread of ancient Egyptian forms and motifs and served as inspiration for artists and architects. Outside Italy, the popularity of these Egyptianizing motifs was particularly strong in France, Germany and England, but there was also interest in Austria, Bohemia, Scandinavia and elsewhere. One result was the appearance of obelisks and small pyramids, including pyramidal tombs, in various settings; a miniature obelisk became a popular form of grave memorial, a function which it rarely had in ancient Egypt, although sphinxes were employed by architects in a way which was not dissimilar to their use in ancient Egypt.

In the eighteenth century Giovanni Battista Piranesi (1720–78) was the greatest and most original architect to use Egyptianizing elements in his designs (258). Egyptian monuments and architecture also provided background for paintings inspired by biblical stories set in Egypt. Most such works are conventional and a product of the artist's imagination rather than his knowledge of ancient Egypt, but some, for example *The Exposition of Moses* (259) by Nicolas Poussin (1594–1665), show genuine Egyptian

monuments which the artist had studied in Rome and which can still be identified today. The second-hand nature of his knowledge of Egypt is clear; there, obelisks were set up in temples, not in cities as in his painting. In interior design in the eighteenth century Egyptianizing motifs appeared on such diverse items as furniture, vases, tea services, clocks and desk writing sets. Most knowledge of Egyptian culture and arts continued to be transmitted through printed books. Once again, however, international politics were going to intervene in the history of the arts; a major step was about to be taken which

would bring first-hand knowledge of ancient Egypt to the forefront of public awareness. In 1798 Napoleon Bonaparte decided to invade Egypt.

The main military objective of Napoleon's campaign was to control trade routes with the East, especially India, and so to strike at British commercial interests. But his expedition was accompanied by scholars and artists, and strong emphasis was laid on scientific and artistic matters. The number of Egyptian

258
Giovanni
Battista
Piranesi,
Design for a
fireplace from
*Diverse
maniere di
adornare i
cammini*,
1769

259
Nicolas
Poussin,
*The Exposition
of Moses*,
1654.
Oil on canvas;
150 × 204 cm,
59⅛ × 80⅜ in.
Ashmolean
Museum,
Oxford

monuments that were studied and drawn with extraordinary attention to detail by some of the outstanding artists of the day was unprecedented. Yet when these artists attempted to copy reliefs on Egyptian temple and tomb walls, the results were not entirely satisfactory. The gap separating ancient Egyptian art from western art in the eighteenth century is more evident in these copies now than at the time. The same artists made excellent drawings of landscapes and general views of Egyptian pyramids, temples and tombs. They were less successful in copying Egyptian works because they did not understand the visual

language or the artistic conventions of its makers. The same difficulties can be seen in the work of copyists in Egypt in the 1820s. The pioneers of Egyptian epigraphy (the study of ancient inscriptions and representations), Henry Salt and John Gardner Wilkinson, both competent artists, at first made hesitant and clumsy copies. However, several years later, with the insight gained from some intensive study of ancient Egyptian art, both Salt and Wilkinson were able to produce superbly accurate and faithful copies.

Militarily, Napoleon's Egyptian campaign was a disaster but the publication of the scholarly and artistic results of the expedition in the huge *Description de l'Égypte* was a triumph (256). In spite of its faults, the work provided a massive record of actual Egyptian monuments and so was a first-hand, rather than transmitted, source of information. Its illustrations of sculptures and temple and tomb reliefs, and its detailed architectural drawings, gave further impetus to contemporary designers of porcelain (260), furniture (261), jewellery and textiles. Architects used Egyptian forms for official and solemn structures, such as cemetery gates, tombs and mausolea, railway stations and jails. Another direct consequence of the Napoleonic military adventure was the decipherment of the hieroglyphic script by Jean-François Champollion in 1822, which provided a solid base for the serious study of ancient Egyptian civilization and so marked the beginning of Egyptology.

260
Sèvres,
Egyptian
service sugar
bowl,
1812.
Porcelain;
h.32·4cm,
12³⁄₄in.
Wellington
Museum,
Apsley House,
London

261
Thomas Hope,
Armchair.
c.1802.
Ebonized and
gilt beech and
oak with
bronze and
gilt brass
mounts;
h.120cm,
47¹⁄₄in.
Powerhouse
Museum,
Sydney

The Hypaethral Temple at Philae called the Bed of Pharaoh

**262
David
Roberts**,
*The Kiosk at
Philae*, from
*Egypt and
Nubia*, II,
plate 22.
Lithograph
based on a
painting,
published
1846–9

In the first half of the nineteenth century, under Muhammad Ali, the Ottoman viceroy, Egypt was opened up to foreigners, who were now able to travel in the country more freely. Archaeological excavations and scholarly collecting of textual and visual material now began in earnest, and works of Egyptian art became available in museums around the world as well as in publications. Painters such as David Roberts (1796–1864) visited Egypt and were able to base their works on a first-hand experience of monuments (262). Roberts's canvases may have inspired some of the 'Egyptian' stage designs, which from this period onwards were created for theatre and opera. David Hockney's designs for the 1978 Glyndebourne production of Mozart's *The Magic Flute* (263) had an illustrious predecessor in Karl Friedrich Schinkel's 1815 set for the Berlin Opera (264). The French archaeologist and Egyptologist, Auguste Mariette, wrote the libretto and designed the costumes for the most Egyptian of all operas, Giuseppe Verdi's *Aida* (1871), originally planned to mark the opening of the Suez Canal in 1869, but not completed on time.

In the second half of the nineteenth century and the beginning of the twentieth, Egyptian architectural forms were adopted especially for buildings which deliberately suggested a link with arcane knowledge, such as masonic halls, or alluded to an illustrious past, such as war memorials. Crematoria exploited Egypt's sombre and funereal associations and zoos its geographical links with exotic animals. More oddly, Egyptian architecture also provided inspiration for mundane buildings such as factories.

A huge boost to the interest in ancient Egyptian art came with the discovery in 1922 of the tomb of King Tutankhamun. Its fantastic gold jewellery and exotic and luxurious tomb goods inspired everything from clothing to jazz-age punch bowls in a phenomenon that became known as Egyptomania. Art Deco, the exciting international style of the 1920s and 1930s, with its flowing curves and outlandish zigzag patterns, was especially suitable for Egyptianizing motifs, employed to connote luxury and leisure in the design of skyscrapers (265), cinemas, restaurants, hotels and

263
David Hockney, Set design for *The Magic Flute*, 1978

264
Karl Friedrich Schinkel, Set design for *The Magic Flute*, 1815

265
Elevator doors
in the Chrysler
Building,
New York,
1929

266
Gustav Klimt,
Expectation,
Cartoon for the
frieze in the
Palais Stoclet.
1905–9.
Tempera,
watercolour,
gold, silver,
bronze, crayon,
pencil on
paper;
193 × 115cm,
76 × 45¼ in.
Österreich-
isches
Museum für
angewandte
Kunst, Vienna

other buildings. Architects have continued to use Egyptian motifs throughout the twentieth century, although it is arguable to what extent pyramidal forms currently so popular, such as I M Pei's spectacular glass structure at the Louvre, should be regarded as inspired by Egypt and to what extent their architects simply share an admiration for strong, simple and elegant forms with their ancient Egyptian predecessors.

Painters and sculptors have been inspired by works in museum collections and visits to Egypt, as well as by the myth and 'spirit' of the ancient civilization. Paul Klee's (1879–1940) flat linear geometric painting, *Monuments at G*, was created after a visit to Giza. It was for many years in the collection of Mies van der Rohe, at one time director of the Bauhaus School. Many artists, such as Gustav

Klimt (1862–1918), used Egyptian art with freedom and spontaneity
(266), seeking the release of associations provided by ancient
motifs rather than fidelity to Egyptian conventions. The theme of
mythic rebirth, so common in Egyptian religion, was personally
inspiring to Klimt and he selected figures such as the goddess
Nephthys from the Osiris myth as subjects for a famous frieze in
the Palais Stoclet in Brussels. For František Kupka (1871–1957),
who later pioneered abstract painting, the overwhelming size
and enigmatically alien appearance of sphinxes provided a
metaphysical dimension which he sought in *Way of Silence II*
(267). Artists such as Amedeo Modigliani (1884–1920) studied
ancient sculptural forms. Modigliani's *The Head* (268) may have
been influenced by Egyptian sculpture. Henry Moore (1898–1986)

was familiar with Egyptian works in the British Museum and some of them can be directly linked to his own sculpture.

The story continues with more recent artists. Niki de Saint Phalle (b.1930) takes ancient Egyptian sculptural forms and exploits them with modern materials and lighting, capturing the smooth perfection of the ancient polished surfaces (269). Peter Randall-Page's stone sculptures would feel perfectly at home in an Egyptian temple because of their monumentality and allusions to infinity. The work of Igor Mitoraj (b.1944) shows the ravages

269
Niki de Saint Phalle,
Anubis,
1990.
Polyester, paint
and gold;
h.44cm,
17⅜in.
Private
collection

270
Andy Goldsworthy,
*Sandwork,
Sand
Sculpture,
Time Machine.*
As installed
at the British
Museum,
London, 1994

of time on even the most colossal and apparently unchangeable monuments (as if echoing Shelley's *Ozymandias*), and Stephen Cox seems to relish the exuberant texture and surface of Egyptian stone. The landscape artist Andy Goldsworthy (b.1956) has combined Egyptian monuments with modern sand sculptures in a wonderfully imaginative way. His *Sandwork* (270), 30 tons of sand installed in the middle of the Egyptian Sculpture Gallery in the British Museum in 1994, evoked ancient Egypt by its material, subject matter and location. The work provided a

powerful visual link between antiquity and the modern world. The abstract paintings of Dorothea Rockburne (b.1921) are inspired by the Egyptian use of simple geometric planes. Egyptian art, especially the brilliantly colourful decoration on cartonnage coffins, has provided ideas for some superb costume designs by Zandra Rhodes. The list is endless.

In the visual history of humanity, what chapter can compare with the extraordinary contribution of ancient Egypt? What other extinct culture arouses our imagination in such a powerful way? Through the prism of time this civilization appears as one of certainty, stability and profound wisdom, in direct contrast to the world in which we live today. It has become our strange and mystic 'other', a culture still partly understood on which we can impose our own exotic fantasies. Artists of the future will no doubt take something from ancient Egypt, continuing the link with the visual world explored in this book.

Glossary

Book of the Dead The name given by early Egyptologists to a collection of religious spells in common use from about 1500 BC, which were thought to be helpful to the deceased in the afterlife. The Book of the Dead was the successor of the **Pyramid Texts** and the **Coffin Texts**; some of the spells are directly derived from them, others are completely new. The selection of some two hundred spells, called the 'Book of Coming Forth by Day' by the Egyptians themselves, varies from one copy to another, and the texts are often accompanied by small illustrations (called 'vignettes' by Egyptologists). The Book of the Dead was mostly written on papyri but extracts from it also appear on tomb walls and various funerary items such as **sarcophagi**, coffins, **shabtis**, headrests and **scarabs**.

Canopic Jars Vessels in which the internal organs of the deceased were placed after being removed in the **mummification** process. The name ultimately derives from that of Kanopos, King Menelaos' pilot in the Trojan War, who was associated with the Egyptian Delta city of Canopus. A local version of the god **Osiris** who took the form of a human-headed jar was worshipped in the city. During the Late Period (after c.715 BC), canopic jars were made of alabaster or limestone and were distinguished by different lids. Their contents were identified with the four **Sons of Horus**: **Duamutef**, **Hapy**, **Imset** and **Kebehsenuf**. The canopic jars were placed in the burial chamber next to the coffin.

Cartonnage Material consisting mainly of linen or papyrus stiffened with plaster. It was used in the manufacture of anthropoid coffins and other funerary objects, especially from the Post-New Kingdom Period (after 1069 BC) onwards. In Egyptological terminology, the word 'cartonnage' is often used to mean an anthropoid coffin made of cartonnage.

Cartouche The name given by the scholars of Napoleon's Egyptian expedition to an ornamental, but also symbolic, frame used to surround the two most important names of Egyptian kings. The oval or round frame, which originally took the form of a rope enclosing the name, probably indicated that the king was placed under the protection of the sun god **Re**. The earliest cartouches date from about 2550 BC. After about 1500 BC, cartouches were also used to indicate the names of other members of the royal family and also some deities.

Causeway An ascending ramp or corridor, often roofed over, connecting the valley temple and the pyramid temple. The interior walls of the causeway were often decorated with painted relief.

Coffin Texts A collection of some one thousand religious spells inscribed on Middle Kingdom coffins (after 2040 BC) which were thought to be essential for the deceased's wellbeing. Some of the spells are connected with the earlier **Pyramid Texts** and many continue into the **Book of the Dead**.

Electrum An alloy of gold and silver.

Faience A material, usually with a glassy blue or green surface, manufactured by heating powdered quartz with ingredients such as natron (a naturally occurring compound of sodium carbonate and sodium bicarbonate). Faience was used for making various small objects (**shabtis**, **scarabs** and amulets), but also vessels, small statuettes, etc. Primitive faience is known from the Predynastic Period.

False Door A form of tomb **stela** (gravestone) especially popular during the Old Kingdom (2647–2124 BC). It developed from a stone-lined niche and eventually acquired the form of a dummy door, with several jambs and lintels, a round 'drum' (imitating a roll holding a curtain), and a rectangular panel above, usually with a scene showing the deceased seated at a table with offerings. All elements of the false door could be inscribed with the name and titles of the deceased. The false door was seen as connecting the world of the living with that of the dead.

Hieroglyphs The name derives from the Greek *hieros* ('sacred') and *gluphe* ('carving'). The signs of the Egyptian writing system always remained recognizable pictures of people, animals and objects (although Egyptian script was not true picture writing). There were several categories of hieroglyphs. Ideograms recorded words by depicting the people, animals, objects, etc. which the words described. Others stood for combinations of sounds and had nothing to do with the represented objects. Another type (determinatives) indicated to which category of meaning the word belonged. Hieroglyphs were used for monumental purposes and often display remarkable details indicated by carving or painting. Some eight hundred signs were commonly used but many more existed.

Hypostyle A hall in a tomb or temple, the roof of which is supported by pillars or columns.

Imi-duat Literally the book of 'That which is in the Underworld', one of the compilations of religious texts often found on the walls of New Kingdom royal tombs, but which also appears on papyri. The Imi-duat describes in detail various parts of the underworld and its inhabitants who are encountered by the sun god **Re** in his nightly journey.

Jubilee Festival This festival, called *heb-sed* in Egyptian (the 'festival of the tail', after an element of the king's ceremonial attire), was held in order to renew the king's physical powers and his entitlement to rule after a period of time, usually thirty years. In a sense, it was as if the ruler underwent a new coronation. The ceremonies included the king running between two sets of markers as a symbolic demarcation of royal territory, and visits to the shrines of various deities. The festival probably took place in the capital city. Representations relating to the jubilee festival were prominent in the funerary arrangements and conveyed the wish for an unlimited number of such occasions in the king's afterlife.

Ka The main element of each person (but also the gods and even some animals) was their *ka*, often translated as 'soul' or 'spirit'. The body was the *ka*'s physical manifestation and was essential for the person's existence because it provided the *ka* with individuality. This meant that the body had to be preserved if the person was to continue to exist after death. This idea gave rise to **mummification** (attempts to preserve the body by artificial means) and sculpture (providing the *ka* with a substitute body).

Lapis Lazuli A semiprecious blue stone used in the manufacture of jewellery. There may have been deposits of lapis lazuli in the Western (Libyan) Desert, but most was probably imported from as far away as Badakhshan (Afghanistan). **Faience** may have been an attempt to imitate the appearance of lapis lazuli.

Lotus The Nile white or blue water lily (*Nymphaea lotus* or *Nymphaea caerulaea*). The imagery of lotus flowers appearing above the surface of water as if from nowhere came to be associated with the concept of rebirth after death.

Mastaba The word is taken from modern Arabic in which it describes a low flat bench made of mud or mud-brick which is found outside houses in modern Egyptian villages. Egyptologists apply the word to the superstructures of tombs (and, less accurately, to such tombs) built mainly during the Early Dynastic Period (2972–2647 BC) and the Old Kingdom (2647–2124 BC). Mastabas were at first built of mud-brick, but later also of stone.

Mummification A process which aimed at the preservation of the body of the deceased person by artificial means. Attempts to ascribe the result to secret mummifying agents and arcane techniques are false; mummification was basically dehydration and desiccation achieved by means of the naturally occurring dehydrating substance natron (a mixture of sodium salts). Mummification involved the removal of most of the internal organs and sometimes also the brain, but not the heart.

Nomarch The name given to the administrators of Egyptian nomes (districts). These officials were appointed by the king but there was a tendency to turn the appointment into a hereditary office. In times of crisis nomarchs turned into local rulers who were largely independent of royal authority. The number of administrative districts varied: there may have been as many as twenty-two in Upper Egypt and twenty in Lower Egypt.

Palette A flat slab of stone used for the grinding of eye paint, which could take a variety of forms. Towards the end of the Predynastic Period (before 3000 BC) some of the palettes became highly decorative, lost their original, purely practical, function and were turned into votive objects (eg to be donated to a temple of a god). Egyptian scribes and artists used palettes of a different type that contained small cakes of paint (mainly black and red, but sometimes also other colours) and brushes (pens). These palettes were usually rectangular and made of wood, and may be compared to old-fashioned pencil cases; shells were also used for the same purpose. They were imitated in stone and deposited in tombs with other funerary goods.

Peristyle A court that is open to the sky but has roofed ambulatories (walkways) along its perimeter. The roof of these ambulatories rests on square pillars or columns.

Pylon A monumental gateway which forms the front façade of a temple or tomb.

Pyramid Texts A collection of over 750 religious spells, mostly connected with the king's afterlife, inscribed on the interior of royal pyramids from the reign of King Unas (2341–2311 BC) onwards. The last pyramid with such inscriptions dates from about 2130 BC, but the Pyramid Texts continued, in a limited way, to be used for the rest of Egyptian history on royal as well as non-royal monuments.

Raised Relief A method of relief carving in which the image is raised above the surrounding plane. The technique, therefore, involves the removal of the surrounding 'blank' surface. In Egyptological terminology, relief is low (bas-relief) when it projects only a few millimetres above the surface, or high (bold) when it projects more than that. A labour-saving technique removed only the material in the area immediately adjoining the representation and the cutting was then imperceptibly reduced to the original level. Raised relief was used primarily for representations that would be seen in diffused light, ie inside buildings; it was also invariably painted.

Reserve (or Portrait) Head A limestone sculpture which shows only the head of the deceased person, mostly dating from the century between about 2550 and 2450 BC. The form was unusual because

completeness was regarded as an essential element in Egyptian art, but it can be explained by the genesis of this type of sculpture and its specialized use. The reserve heads probably developed from the plaster masks which at first covered the face of the wrapped-up body in a rather primitive attempt at preservation. The reserve head was placed in the burial chamber next to the body of the deceased so the completeness was ensured by the body itself. These heads were made in royal workshops for tombs which were a gift from the king.

Sarcophagus A term (from the Greek *sarks*, 'flesh', and *phagos*, 'eating') that describes a stone container ('coffin') for the body of the deceased person, either rectangular or anthropoid. The sarcophagus consists of two parts, the case and the lid. Some Egyptologists use the term indiscriminately for large coffins, but in this book a distinction is made between sarcophagi made of stone and coffins made of wood, **cartonnage** or, exceptionally, precious metal.

Scarab The dung beetle (*Scarabaeus sacer*), *kheprer* in Egyptian, was thought to be connected with the sun god because its habit of rolling a ball of dung across the ground was reminiscent of the journey of the sun across the sky. Small amulets and seals in the form of the beetle became very popular from around 2000 BC.

Serdab The word means 'cellar' in Arabic and is used by Egyptologists to describe closed rooms, especially in tombs, which contained statues.

Serekh An Egyptian word describing the ornamental device used for the writing of the king's **Horus**-name. It shows the royal palace in the typically Egyptian composite view, as a combination of the front view (the niched façade) forming its lower part, and the view from above (the ground plan). The name is written in the blank space in the upper part. The hawk, which, like the king himself, is the manifestation of the god Horus, is usually perched on top of the *serekh*.

Shabti A small statuette, usually representing the deceased person as a mummiform figure holding agricultural implements (a hoe and a pick). These statuettes were at first called shawabtis or shabtis (perhaps from *shawab*, 'persea-tree', the wood from which some of these figures were made) and later ushebtis (from *usheb*, 'to answer', because they were expected to answer the call to work in the underworld). Shabtis were made of stone, wood, **faience** or even bronze, and were inscribed with one of the spells from the **Book of the Dead**.

Stela Usually a flat slab of stone, a gravestone. The word is also used more freely to describe gravestones which are more complex (*eg* **false doors**) and monuments which are not funerary (*eg* with commemorative inscriptions).

Sunk Relief A method of relief carving in which the image is cut below the surrounding plane. This technique, therefore, involves the removal of the surface filled by representations. Sunk relief relies on the contrast between light and shade and so is particularly suitable for brightly-lit exterior surfaces. Representations in sunk relief were usually further emphasized with paint. The effect of sunk relief can be reinforced by internal modelling, as if introducing **raised relief** within the sunk relief. The term sunk relief must not be confused with low relief (bas-relief).

Sun Temple It seems that six kings of the 5th Dynasty (Userkaf, Sahure, Neferirkare, Raneferef, Neuserre and Menkauhor) built temples dedicated to their special relationship with the sun god between 2454 and 2369 BC. These were primarily funerary monuments and were situated in the royal necropolis. Only two have so far been located, those of Userkaf at Abusir and Neuserre at Abu Ghurab, although the names of another four are known.

Talatāt A term borrowed from Islamic architecture that describes a building block of a particular size (from the Arabic word *talāta*, 'three', *ie* three handspans long). *Talatāt* were particularly used in the temples built under Akhenaten at Karnak (in sandstone) and at el-Amarna (in limestone).

Triad A group of three, used to describe three deities (male, female and junior: *eg* **Amun**, **Mut** and **Khons**, or **Ptah**, **Sakhmet** and **Nefertum**) or three statues (usually a family group: husband, wife and child).

Vizier A word borrowed from Arabic to describe a chief official of the Egyptian state who had supreme executive control over all aspects of administration. The vizier was directly responsible to the king.

Deities and Personifications

Amun or Amun-Re The chief god of Thebes (ancient Egyptian Weset, the modern city of Luxor) who, after c.2000 BC, became the main Egyptian deity. His most important temple was at Karnak, but he had temples and shrines in other parts of Egypt, *eg* Memphis, Tanis and the Siwa Oasis. Amun was also the god worshipped by the Kushite pharaohs (25th Dynasty) in their native city of Napata in Sudan. His name (sometimes rendered as Amen in compounds) was incorporated into many royal names, such as Amenemhet ('Amun is at the Front'), Amenhotep ('Amun is Satisfied') or Tutankhamun ('The Living Image of Amun'), and also appears in many private names, *eg* Tutankhamun's queen Ankhesenamun ('She Lives for Amun'). Iconography: a man wearing a headdress consisting of two tall plumes, sometimes in ithyphallic form (with an erect penis). Amun's zoomorphic manifestations were the ram or goose.

Anubis The necropolis god, worshipped all over Egypt, who was universally associated with burial and **mummification**. Iconography: the jackal, usually recumbent, or a jackal-headed man.

Apis Bull The bull associated with the god **Ptah** of Memphis and described as his 'herald'. A bull with special markings was always kept in the temple of Ptah at Memphis. When it died, the animal, which was then known as **Osiris**-Apis, was buried at Saqqara in huge underground galleries (collectively called the Serapeum). These served as the communal burial place of the animals and were first created during the reign of Ramses II (1279–1213 BC). The practice continued until the Roman Period. Iconography: the bull, or a bull-headed man.

Apophis A large snake, the sun god's main enemy, who had to be combatted and defeated during the god's nightly sojourn in the underworld.

Aten The Aten was the radiant disc of the sun which became the main focus of worship during the reign of Akhenaten (1353–1337 BC). The name of the Aten was incorporated into the name of the kings Akhenaten and Tutankhaten (the early version of the name of Tutankhamun). The earliest temples of the Aten were built in the eastern part of Karnak at Thebes and then at Akhetaten (el-Amarna) in Middle Egypt. There were Aten temples at several other sites, including Heliopolis (the northeastern suburb of Cairo) and Memphis, to the east of the old temple of **Ptah**. Iconography: a sun-disc with human arms and hands which extend the symbols of life (*ankh*) to those living under it. There were no anthropomorphic representations of the Aten.

Atum The creator god of Heliopolis, usually combined with the sun god, *eg* as **Re-Harakhty**-Atum. Atum was believed to have existed in the primeval waters before the earth appeared and to have created the first deities of the Heliopolitan Ennead by masturbating. He was particularly linked to the afternoon sun. Iconography: a man wearing the double crown.

Autib A rather obscure personification of joy, shown as a woman.

Bastet The local goddess of the city of Bubastis (modern Tell Basta, near Zagazig in the northeastern Delta), often linked with the bellicose goddess **Sakhmet** whose friendly and homely aspect she was thought to have been. Bastet became especially popular in the Post-New Kingdom Period, after c.950 BC, when pharaohs of the 22nd Dynasty originated from her native city. Cats, Bastet's zoomorphic manifestations, were kept in large temple catteries in various parts of Egypt during the Late and Ptolemaic Periods. Iconography: the cat (or lioness), or a cat-headed woman (or lion-headed, Egyptian iconography does not always allow a clear distinction).

Bes A demi-god who was linked to family happiness, pregnancy and childbirth. Appears on various items of daily life, such as furniture, vases and mirrors. Iconography: a dwarf with a feathered crown, lion mane and long tail.

Duamutef One of the four so-called **Sons of Horus** identified with the internal organs removed during **mummification**, especially the stomach (the lid of the canopic jar holding it was jackal-headed). Linked to the goddess **Neith** who was thought to protect the contents of the jar. Iconography: mummiform figure, often jackal-headed.

Hapy One of the four so-called **Sons of Horus** identified with the internal organs removed during **mummification**, especially the lungs (the lid of the canopic jar holding them was baboon-headed). Linked to the goddess **Nephthys** who was thought to protect the contents of the jar. Iconography: mummiform figure, often baboon-headed.

Harakhty or Re-Harakhty The most common form of the sun god, literally 'The God Horus belonging to the Horizon', especially closely linked with Heliopolis and its creator god **Atum**. Iconography: the hawk or a hawk-headed man wearing a sun-disc on his head.

Hathor The goddess of the Theban necropolis, especially Deir el-Bahri, but also a tree or sky goddess. Worshipped under slightly different forms all over Egypt, eg at Memphis, Heliopolis and Dendara, and also in Sinai (Serabit el-Khadim) and Nubia (Abu Simbel). Hathor was, as an embodiment of female qualities, the patroness of music and dancing. Iconography: a woman, often with the hieroglyphs employed for the writing of her name on her head, or with cow horns and a sun-disc. Also shown as a cow or as a sistrum, a musical instrument associated with her.

Heh A personification of eternity. Iconography: usually a kneeling man holding two curved wands (hieroglyphs used for the writing of 'years').

Horus A god worshipped at various places, especially at Hierakonpolis (Kom el-Ahmar) in Upper Egypt and at several Delta sites, and the earliest state god – the king was regarded as his manifestation and one of the royal names was the Horus-name. There was a large temple of Horus built at Edfu in the Ptolemaic period. Horus was a member of the Heliopolitan Ennead (nine deities regarded as a group, reflecting an attempt to systematize and formalize the relationship between them). In Egyptian mythology he was the son of **Osiris** and **Isis**, often shown as a child, but also the avenger and heir of his murdered father. When paired with the god **Seth**, Horus represented Lower Egypt. Iconography: the hawk, or a hawk-headed man, usually wearing the double crown, sometimes also shown as a child with a finger to his mouth, often seated on the lap of his mother.

Imhotep A chief official of King Djoser (2628–2609 BC) who is credited with the design of the Step Pyramid at Saqqara, the first monumental stone structure in the world. Posthumously deified, he was the patron of scribes and physicians, particularly during the Late and Ptolemaic Periods. Regarded as the son of the god **Ptah** and the woman Khreduankh. Iconography: a seated scribe.

Imset One of the four so-called **Sons of Horus** identified with the internal organs removed during **mummification**, especially the liver (the lid of the canopic jar holding it was human-headed). Linked to the goddess **Isis** who was thought to protect the contents of the jar. Iconography: human-headed mummiform figure.

Isis The goddess who, in Egyptian mythology, was the companion of the god **Osiris**, the mother of **Horus** and the sister of **Nephthys**. Because of her connections with Osiris, she was worshipped at many places, especially Philae in the Aswan region, Koptos in Upper Egypt and Behbeit el-Higara in the central Delta. A member of the Heliopolitan Ennead. One of the guardian deities associated with **mummification**, she is linked to **Imset**, one of the **Sons of Horus**. The cult of Isis spread outside Egypt into many parts of the Roman Empire. Iconography: a woman, usually with the hieroglyphic sign representing a seat (part of the hieroglyphic writing of her name) or with cow's horns and a sun-disc on her head, but also as a tree goddess. Often shown nursing her young son, Horus.

Kebehsenuf One of the four so-called **Sons of Horus** identified with the internal organs removed during **mummification**, especially the intestines (the lid of the canopic jar holding them was hawk-headed). Linked to the goddess **Selket** who was thought to protect the contents of the jar. Iconography: a mummiform figure, often hawk-headed.

Khentiamentiu Literally 'The Foremost of the Westerners' (ie the dead), the ancient god of the Abydos necropolis in Upper Egypt, soon merged with the god **Osiris** as Osiris-Khentiamentiu. Iconography: the jackal.

Khons The junior member of the Theban triad (with **Amun** and **Mut**). A large temple of Khons was built at Karnak. Iconography: a young man with a sidelock of hair.

Maet The goddess personifying truth and order. Iconography: a woman with an ostrich feather (this was a hieroglyphic sign used to write her name) in her hair.

Min The ithyphallic god of Koptos in Upper Egypt. A colossal statue of Min from Koptos is the earliest large statue representing a deity known from Egypt. Iconography: an ithyphallic man holding his penis with one hand, and a raised arm holding a flagellum.

Montu The traditional god of the Theban region, especially of the city of Hermonthis (modern Armant) where he was connected with the sacred Buchis bull. A war god. A large precinct dedicated to Montu formed the northern part of the complex of temples at Karnak. Iconography: a hawk-headed man with a sun-disc and two tall plumes on his head.

Mut A member of the Theban triad, the female companion of **Amun**. A large precinct dedicated to Mut formed the southern part of the complex of temples at Karnak. Iconography: a woman wearing the white crown or the double crown; also the vulture (the hieroglyph used to write her name), the lioness or the cat.

Nefertum The junior member of the Memphite triad (together with **Ptah** and **Sakhmet**). Iconography: a young man with a **lotus** flower on his head, often with two tall plumes.

Neith The local goddess of the city of Sais (Sa el-Hagar) in the Delta, but also popular at Memphis and other places. Neith was the goddess of war and hunting. She was one of the guardian deities associated with **mummification**, linked to **Duamutef**, one of the **Sons of Horus**. Iconography: a woman, often wearing the red crown or with a shield and crossed arrows (the hieroglyphic writing of her name) on her head.

Nekhbet The local goddess of Nekheb (modern el-Kab in Upper Egypt), regarded as the Upper Egyptian deity *par excellence*. Iconography: a vulture or a woman, sometimes vulture-headed.

Nephthys The goddess who, in Egyptian mythology, was the companion of the god **Seth** and the sister of **Isis**. A member of the Heliopolitan Ennead. One of the guardian deities associated with **mummification**, linked to **Hapy**, one of the **Sons of Horus**. Iconography: a woman, sometimes with the two hieroglyphs representing her name appearing on her head.

Nut The sky goddess, the female companion of the earth god Geb and a member of the Heliopolitan Ennead. Often shown on ceilings and on the inside of coffin lids. Iconography: a woman whose body spans the horizons.

Osiris Originally perhaps a local deity of Busiris in the central Delta, Osiris became the most popular of all the Egyptian deities as the 'ruler of the West' (*ie* the kingdom of the dead), linked to resurrection and continued existence after death. A member of the Heliopolitan Ennead. In Egyptian mythology, Osiris was murdered by his brother **Seth** but was resurrected thanks to the efforts of his female companion **Isis** and her sister **Nephthys**. He was the father of the god **Horus**. His mythical grave was thought to have been at Abydos, a cemetery that was particularly closely associated with him and where he was combined with the necropolis god **Khentiamentiu**. When Osiris' name precedes the name of a king, person, or even a sacred animal, it gives it the meaning 'deceased'. Iconography: mummiform, often with a green face, wearing the white crown, sometimes with plumes, horns or a small sun-disc, and holding a sceptre and a flagellum.

Ptah The chief god of the Memphite **triad** (together with **Sakhmet** and **Nefertum**) and one of the main Egyptian deities worshipped at a number of sites, and also in Nubia. A creator god and the patron of craftsmen, Ptah was also closely linked to the **Apis bull**. Iconography: a man wearing a closely fitting skullcap and holding a triple sceptre.

Re The sun god (the word *re* means 'sun' in Egyptian) and one of the main Egyptian deities. His cult focused on Heliopolis, where, usually as **Re-Harakhty**, he was combined with the creator god **Atum**, *eg* as Re-Harakhty-Atum. The king was described as 'the son of Re' and the name of the god was incorporated into many royal names, *eg* Ramses ('The God Re has Given Birth to Him'). Because of his universal character, he was often combined with other deities, *eg* as **Amun**-Re, **Sobek**-Re, etc. Re was believed to take a nightly journey through the underworld, accompanied by the king. Iconography: a hawk-headed man with a sun-disc on his head.

Re-Harakhty see **Harakhty**

Rennutet The cobra goddess especially worshipped in the Faiyum (her temple was built at Medinet Madi). Iconography: the cobra, or cobra-headed woman.

Ruty The name given to the lion form of the sun god **Re**. The Great Sphinx at Giza may depict King Khephren (2518–2493 BC) as a manifestation of this god. Ruty was originally a pair of deities especially associated with Tell el-Yahudiya in the southern Delta. Iconography: the lion or a lion-headed man.

Sakhmet A member of the Memphite **triad**, the female companion of **Ptah**. Linked to **Bastet** as the bellicose aspect of the goddess. Iconography: a lion-headed woman or a lioness.

Selket One of the guardian deities associated with **mummification**, linked to **Kebehsenuf**, one of the four **Sons of Horus**. Iconography: a woman with a scorpion on her head.

Serapis A deity artificially created during the Ptolemaic Period. His name is based on that of **Osiris**-Apis (Osorapis), 'the deceased **Apis bull**'. Iconography: always shown as a man.

Seth In Egyptian mythology the brother and murderer of **Osiris**, but also the local deity of Tanis in the Eastern Delta, Ombos in Upper Egypt and several other sites. The god of inclement weather and war, and a member of the Heliopolitan Ennead. His female companion was **Nephthys**. When paired with **Horus**, Seth represented Upper Egypt. Iconography: an unidentifiable species of animal (perhaps a wild donkey) or a man with the head of this animal.

Sobek The local god of the Faiyum and several places in Upper Egypt, including Esna and Kom Ombo. Iconography: a crocodile or a crocodile-headed man.

Sokar The ancient god of the northern part of the Memphite necropolis, usually combined with the chief Memphite god **Ptah** and **Osiris** as Ptah-Sokar-Osiris. Iconography: the hawk.

Sons of Horus see **Duamutef, Hapy, Imset** and **Kebehsenuf**

Thoth The local god of Hermopolis Magna (Ashmunein) in Middle Egypt and Tell el-Baqliya in the northern Delta, but worshipped all over Egypt because of his association with writing, wisdom, mathematics and medicine. Iconography: the ibis or the baboon or an ibis-headed man, often with a crescent moon and shown as a scribe.

Wadjit The local deity of Buto (Tell el-Farun) in the eastern Delta, regarded as the Lower Egyptian deity *par excellence*. Iconography: the cobra or a cobra-headed woman.

Wepwawet Literally the 'Opener of the Ways', probably the god of the Abydos region in Upper Egypt, linked to the king. Iconography: the wolf, usually shown as an image of the wolf on a standard.

Dynasties and Kings

All dates before the seventh century BC should be regarded as approximate. The margin of error varies from some one hundred years for the First Dynasty to about fifteen years for the Post-New Kingdom Period (the Third Intermediate Period).

Predynastic Period: 5500–2972 BC

Dynasty 0 (3100–2972 BC):
Includes Narmer, perhaps the same
 as 'Scorpion' (3000–2972 BC)

The Early Dynastic Period: 2972–2647 BC

1st Dynasty (2972–2793 BC):
Aha (2972–2939 BC)
Djer (2939–2892 BC)
Wadji (also Djet; 2892–2879 BC)
Dewen (also Den; 2879–2832 BC)
Adjib (2832–2826 BC)
Semerkhet (2826–2818 BC)
Qaa (2818–2793 BC)

2nd Dynasty (2793–2647 BC):
Hetepsekhemui (2793–2765 BC)
Raneb (2765–2750 BC)
Ninutjer (2750–2707 BC)
Weneg (2707–2700 BC)
Send (2700–2690 BC)
Sneferka (2690–2682 BC)
Neferkasokar (2682–2674 BC)
Sekhemib-perenmaet Peribsen
 (approximately contemporary with the
 preceding three kings; 2700–2674 BC)
Khasekhem/Khasekhemui (2674–2647 BC)

The Old Kingdom: 2647–2124 BC

3rd Dynasty (2647–2573 BC):
Nebka (2647–2628 BC)
Netjerikhet Djoser (2628–2609 BC)
Sekhemkhet (2609–2603 BC)
Khaba (2603–2597 BC)
Qahedjet Huni (2597–2573 BC)

4th Dynasty (2573–2454 BC):
Snofru (2573–2549 BC)
Khufu (also Kheops; 2549–2526 BC)
Radjedef (also Djedefre; 2526–2518 BC)
Khephren (also Khafre/Rakhaef; 2518–2493 BC)
Khnemka or Wehemka (2493–2488 BC)
Menkaure (also Mycerinus; 2488–2460 BC)
Shepseskaf (2460–2456 BC)
Thamphthis (2456–2454 BC)

5th Dynasty (2454–2311 BC):
Userkaf (2454–2447 BC)
Sahure (2447–2435 BC)
Neferirkare (2435–2425 BC)
Shepseskare (2425–2418 BC)
Raneferef (also Neferefre; 2418–2408 BC)
Neuserre (2408–2377 BC)
Menkauhor (2377–2369 BC)
Djedkare Izezi (2369–2341 BC)
Unas (also Wenis; 2341–2311 BC)

6th Dynasty (2311–2140 BC):
Teti (2311–2281 BC)
Pepy I (2280–2243 BC)
Merenre I (2242–2237 BC)
Pepy II (2236–2143 BC)
Merenre II (2142–2141 BC)
Neitiqert, Queen (also Nitocris; 2141–2140 BC)

7th and 8th Dynasties (2140–2124 BC):
A number of lesser kings

**The Heracleopolitan Kingdom (or the
First Intermediate Period): 2123–2040 BC
(contemporary with the First Theban
Kingdom)**

9th and 10th Dynasties:
Includes Meryibre Akhtoy and Merykare
(2065–2045 BC)

**The First Theban Kingdom (or the First
Intermediate Period): 2123–2040 BC
(contemporary with the Heracleopolitan
Kingdom)**

11th Dynasty (first part):
Mentuhotep I and Inyotef I (2124–2107 BC)
 (dates for both kings)
Inyotef II (2107–2058 BC)
Inyotef III (2058–2050 BC)
Nebhepetre Mentuhotep II
 (before reunification; 2050–2040 BC)

The Middle Kingdom: 2040–1648 BC

11th Dynasty (second part):
Nebhepetre Mentuhotep II (after reunification;
 2040–1999 BC)
Sankhkare Mentuhotep III (1999–1987 BC)
Nebtawyre Mentuhotep IV (1987–1980 BC)

*12th Dynasty (1980–1801 BC)
(overlaps due to coregencies):*
Amenemhet I (1980–1951 BC)
Senwosret I (1960–1916 BC)
Amenemhet II (1918–1884 BC)
Senwosret II (1886–1878 BC)
Senwosret III (1878–1859 BC)
Amenemhet III (1859–1814 BC)
Amenemhet IV (1814–1805 BC)
Sobekkare Sobeknofru, Queen (1805–1801 BC)

13th Dynasty (1801–1648 BC):
Many kings, including Neferhotep I
(1738–1727 BC), Sihathor (1727 BC),
Sobekhotep IV (1727–1720 BC), Sobekhotep V
(1720–1716 BC), Iaib (1716–1706 BC) and
Merneferre Ay (1706–1683 BC)

The Hyksos Kingdom (or the Second Intermediate Period): 1648–1540 BC (contemporary with the Second Theban Kingdom)

14th Dynasty:
Many kings, at least some non-Egyptian

15th (Hyksos) Dynasty:
Salitis
Bnon
Apakhnan
Apophis
Iannas
Assis

16th (Lesser Hyksos) Dynasty

The Second Theban Kingdom (or the Second Intermediate Period): 1648–1540 BC (contemporary with the Hyksos Kingdom)

17th Dynasty:
Includes Senakhtenre Teo I, Seqenenre Teo II and Kamose

The New Kingdom: 1540–1069 BC

18th Dynasty (1540–1295 BC):
Ahmose (1540–1525 BC; accession 1550 BC)
Amenhotep I (1525–1504 BC)
Thutmose I (1504–1492 BC)
Thutmose II (1492–1479 BC)
Hatshepsut, Queen (1479–1457 BC)
Thutmose III (1479–1425 BC)
Amenhotep II (1427–1401 BC)
Thutmose IV (1401–1391 BC)
Amenhotep III (1391–1353 BC)
Amenhotep IV/Akhenaten (1353–1337 BC)
Smenkhkare (1338–1336 BC)
Tutankhaten/Tutankhamun (1336–1327 BC)
Ay (1327–1323 BC)
Haremhab (1323–1295 BC)

19th Dynasty (1295–1186 BC):
Ramses I (1295–1294 BC)
Sety I (1294–1279 BC)
Ramses II (1279–1213 BC)
Merneptah (1213–1203 BC)
Amenmesse (1203–1200 BC)
Sety II (1200–1194 BC)
Siptah (1194–1188 BC)
Twosre, Queen (1188–1186 BC)

20th Dynasty (1186–1069 BC):
Setnakht (1186–1184 BC)
Ramses III (1184–1153 BC)
Ramses IV (1153–1147 BC)
Ramses V (1147–1143 BC)
Ramses VI (1143–1136 BC)
Ramses VII (1136–1129 BC)
Ramses VIII (1129–1126 BC)
Ramses IX (1126–1108 BC)
Ramses X (1108–1099 BC)
Ramses XI (1099–1069 BC)

The Post-New Kingdom Period (or the Third Intermediate Period): 1069–715 BC

21st Dynasty (1069–945 BC):
Smendes (1069–1043 BC)
Amenemnisu (1043–1039 BC)

Psusennes I (1039–991 BC)
Amenemope (993–984 BC)
Osochor (984–978 BC)
Siamun (978–959 BC)
Psusennes II (959–945 BC)

22nd Dynasty (945–730 BC):
The Lower Egyptian group:
Shoshenq I (also Sesonchis; 945–924 BC)
Osorkon I (924–889 BC)
Shoshenq II (also Sesonchis; 890 BC)
Takelot I (889–874 BC)
Osorkon II (874–850 BC)
Shoshenq III (also Sesonchis; 825–773 BC)
Pimay (773–767 BC)
Shoshenq V (also Sesonchis; 767–730 BC)

The Upper Egyptian group:
Harsiese (870–860 BC)
Takelot II (850–825 BC)
Pedubaste I (818–793 BC)
Iuput I (804–803 BC)
Shoshenq IV (also Sesonchis; 793–787 BC)
Osorkon III (787–759 BC)
Takelot III (764–757 BC)
Rudamun (757–754 BC)

23rd Dynasty (754–715 BC):
Pedubaste II (754–730 BC)
Iuput II (754–720 BC)
Osorkon IV (730–715 BC)

24th Dynasty (727–715 BC):
Tefnakht I (727–720 BC)
Bekenrenef (720–715 BC)

The Late Period: 715–332 BC

25th Dynasty (partly only in Nubia) (c.715–656 BC):
Kashta (c.760–747 BC)
Piye (also Piankhy; 747–716 BC)
Sabacon (also Shabako; 716–702 BC)
Shebitku (702–690 BC)
Taharqa (690–664 BC)
Tantamani (664–656 BC)

26th Dynasty (664–525 BC):
Psammetichus I (also Psametek; 664–610 BC)
Necho II (610–595 BC)
Psammetichus II (also Psametek; 595–589 BC)
Apries (589–570 BC)
Amasis (570–526 BC)
Psammetichus III (also Psametek; 526–525 BC)

27th (Persian) Dynasty (525–404 BC):
Cambyses (525–522 BC)
Darius I (521–486 BC)
Xerxes I (485–465 BC)
Artaxerxes (464–424 BC)
Darius II (423–405 BC)

28th Dynasty (404–399 BC):
Amyrtaios (404–399 BC)

29th Dynasty (399–380 BC):
Nepherites I (399–393 BC)
Psammuthis (393 BC)
Hakor (also Achoris; 393–380 BC)
Nepherites II (380 BC)

30th Dynasty (380–343 BC):
Nectanebo I (380–362 BC)
Teos (362–360 BC)
Nectanebo II (360–342 BC)

31st (Persian) Dynasty (342–332 BC):
Artaxerxes III (342–338 BC)
Arses (337–336 BC)
Darius III (335–332 BC)

The Macedonian Period (332–305 BC):
Alexander III the Great (332–323 BC)
Philip III Arrhidaeus (323–317 BC)
Alexander IV (317–310/309 BC)

The Ptolemaic Dynasty (304–30 BC):
Ptolemy I Soter (304–282 BC)
Ptolemy II Philadelphus (285–246 BC)
Ptolemy III Euergetes I (246–222 BC)
Ptolemy IV Philopator (222–205 BC)
Ptolemy V Epiphanes (204–180 BC)
Ptolemy VI Philometor (180–145 BC)
Ptolemy VII Neos Philopator (145 BC)
Ptolemy VIII Euergetes II Physcon (145–116 BC)
Ptolemy IX Soter II Lathyros
 (between 115 and 80 BC)
Ptolemy X Alexander I
 (between 110 and 88 BC)
Ptolemy XI Alexander II (80 BC)
Ptolemy XII Neos Dionysos Auletes
 (between 80 and 51 BC)
Ptolemy XIII Dionysos (51–47 BC)
Ptolemy XIV Philopator (47–44 BC)
Cleopatra VII Thea Philopator (51–30 BC)

Egypt as a Roman province (30 BC–395 AD):
Includes Augustus (30 BC–14 AD),
Tiberius (14–37 AD), Nero (54–68 AD),
Trajan (98–117 AD) and Hadrian (117–138 AD)

Byzantine Egypt: 395–642 AD

Islamic Egypt:
639–642 AD Arabs conquer Egypt

Author's note on chronology:
I have used a fairly conservative
chronological system (neither 'short' nor
'long' in Egyptological terminology) which
is based, though not in all the details, on
the following specialized studies:

For the Early Dynastic Period, on Jürgen von
Beckerath's *Chronologie des pharaonischen
Ägypten* (Mainz, 1997), adjusted by ten years.

For the Old Kingdom, on Jaromir Malek
and Werner Forman, *In the Shadow of the
Pyramids. Egypt during the Old Kingdom*
(London, 1986), with the corrected dates for
the beginning of the 9th and 11th (and the
end of the 8th) dynasties.

For the Middle Kingdom, on Richard A
Parker's calculation of the Sothic astronomical
date of 1872 BC for the 7th year of Senwosret III
(*The Calendars of Ancient Egypt*, Chicago,
1950), but the regnal years of the 12th Dynasty
pharaohs have been recalculated according
to Detlef Franke in *Orientalia 57* (1988).

For the Hyksos and the Second Theban
Kingdoms (the Second Intermediate Period),
the New Kingdom, and the Post-New
Kingdom Period (the Third Intermediate
Period), on Kenneth Anderson Kitchen's
*The Third Intermediate Period in Egypt
(1100–650 BC)* (2nd edn, Warminster, 1986),
his articles in Paul Åström's *High, Middle
or Low?*, parts 1 and 3 (Gothenburg, 1987
and 1989), and on Jürgen von Beckerath's
Chronologie des pharaonischen Ägypten,
op. cit.

Key Dates

Numbers in square brackets refer to illustrations
Note: The dates for the Ancient Near East follow, with some exceptions, those in Michael Roaf's
Cultural Atlas of Mesopotamia and the Ancient Near East (New York and Oxford, 1990)

	Egypt and Nubia	Ancient Near East	Greece and Rome
		8500–7000 Aceramic Neolithic (Jericho) period	
8000–5500 BC	Mesolithic period		
6500–3200	(Nubia) Sudan Neolithic (Early Khartoum, Shaheinab, El-Kedada)	**6500–6000** Hassuna and Samarra cultures	
		6000–5400 Halaf culture	
		5900–4300 Ubaid period	
5500–4000	Merimda, Faiyum and Badari Neolithic cultures		
		4300–3100 Uruk period	
4000–2972	Nagada culture	**4000–3000** Susa I and II periods (Iran)	
4000–2800 or later	Lower Nubian A-Group culture		
3200	'MacGregor Man' [24]		
3150	Min colossus [27]		
3100	Painted Tomb, Hierakonpolis [25]	**3100–2900** Djemdet Nasr period	
3000	Narmer Palette [30–1], Two Dogs Palette [32–3], Battlefield Palette [34], Scorpion Macehead [35]	**3000–2500** Proto-Elamite (Iran) culture	**3000–2000** Early Minoan civilization
		2900–2334 Sumerian Early Dynastic period	
2650	Statue of Khasekhem [38]		
2610	Step Pyramid of Djoser [43], Hesyre's stelae [64]		
		2600–2400 Royal cemetery of Ur	
2570	Maidum geese frieze [65], Statues of Rahotep and Nofret [75]		
2560	'Bent Pyramid' of Snofru [46]		
2550–2450	Reserve heads [77]		
2530	Great Pyramid of Khufu [8], Tomb of Queen Hetepheres [82–4]		
2500	Pyramid and statues of Khephren [5, 8, 48, 54], Great Sphinx at Giza [49–50]	**2500–1100** Elamite culture (Iran)	
2460	Pyramid and statues of Menkaure [8, 55–6]		
2454–2369	Sun temples [63]		

	Egypt and Nubia	Ancient Near East	Greece and Rome
2440	Pyramid and causeway of Sahure [52, 59–61]		
2400–1540	(Nubia) Kerma culture and state		
2400	Tomb and statue of Ty [3, 72]		
		2334–2154 Akkadian (Agade) period (2334–2279 Sargon, 2254–2218 Naram-sin)	
2315	Earliest Pyramid Texts		
2250–1540	(Nubia) C-Group culture	2250 Destruction of Ebla	
		2112–2004 Third Dynasty of Ur (2112–2095 Ur-nammu, 2094–2047 Shulgi)	
		2100 First ziggurats built	
		c.2100 Gudea, ruler of Lagash	
2040	Nebhepetre Mentuhotep II unites Egypt		
		2004 Occupation of Ur by Elamites	
2000	Funerary temple of Nebhepetre Mentuhotep II at Deir el-Bahri [91–2]		2000–1400 Minoan (Cretan) palace civilization
c.1960	Fortress at Buhen [96]		
		1894–1595 First Dynasty of Babylon	
1890–1820	Dahshur jewellery [116–17]		
1880	Tomb of Khnumhotep II, Beni Hasan [111–12]		
1820	Sphinxes of Amenemhet III [85, 104]		
		1757 Destruction of Mari	
		1700–1520 Hittite Old Kingdom	
		1600 Hittites sack Ebla	
		1595 Hittites sack Babylon	
1550	Accession of Ahmose	1550–1320 Hurrian kingdom of Mitanni	1550 Theran volcanic eruption
1540	Ahmose defeats Hyksos		
1460	Funerary temple of Hatshepsut at Deir el-Bahri [133–6]		
1430	Imi-duat scenes in tomb of Thutmose III [139]		
		1415–1155 Kassite dynasty in Babylon	
1410	Tomb of Sennufer [140]		
			1400 Destruction of Knossos
1375	Tomb of Mena [2]		
		1363–1076 Middle Assyrian empire	
1360	'Memnon Colossi' [132]		

Egyptian Art

	Egypt and Nubia	Ancient Near East	Greece and Rome
1350	Temples of the Aten and colossi of Akhenaten at Karnak [155, 157–8]	1350–1200 Hittite empire	
1348	Akhenaten moves to el-Amarna		
1340	Bust of Nefertiti [161–2]		
1330	Tomb of Haremhab at Saqqara [168–70]		
1327	Tomb of Tutankhamun [171–84]		
1274	Battle of Qadesh [188]		
1259	Peace treaty with Hittites		
1250	Abu Simbel temples [185, 190–1], Hypostyle hall at Karnak [186], Extension of Luxor temple by Ramses II [188–9]		1250 Trojan War
			1200 Destruction of Mycenae
1160	Medinet Habu temple [192–5]		
1039–773	Royal tombs at Tanis [212–16]		
		971–931 Solomon	
		931 Israel and Judah	
		911–612 Late Assyrian empire (883–859 Ashurnasirpal II, 858–824 Shalmaneser III, 744–727 Tiglath-pileser III, 721–705 Sargon II, 704–681 Sennacherib, 680–669 Esarhaddon, 668–627 Ashurbanipal)	
850–295	(Nubia) Kushite kingdom (Napatan period)		
			814 Foundation of Carthage
			776 First Olympic games
			753 Foundation of Rome
710	Head of Sabacon [221]		700 Homer
670	Head of Taharqa [222]		
650	Statues and tomb of Montuemhet [226–7, 231]		
		647 Susa destroyed by Assyrians	
		625–539 Neo-Babylonian (Chaldean) dynasty	
		612 Nineveh sacked by Medes and Babylonians	

Egypt and Nubia	Ancient Near East	Greece and Rome
	550–330 Achaemenid (Persian) empire (**559–530** Cyrus the Great, **529–522** Cambyses, **521–486** Darius I, **485–465** Xerxes I)	
	539 Persians take Babylon	
525 Cambyses conquers Egypt		
		512 Persians invade Thrace
		509 Roman republic established
		490 Battle of Marathon
		480 Battles of Thermopylae and Salamis
		469–399 Socrates
		430 Peloponnesian War
		384–322 Aristotle
		336–323 Alexander the Great of Macedon
331 Alexandria founded		**330** Alexander launches campaign against the Persians
323 Death of Alexander the Great at Babylon		
	300–150 Seleucid period	
295 BC–350 AD (Nubia) Meroitic Kingdom		
237–57 Edfu temple [240, 247, 249]		**264–241** First Punic War
		218–202 Second Punic War
		218 Hannibal's invasion of Italy
196 Rosetta Stone [1]		**149–146** Third Punic War
		146 Carthage razed
50 Brooklyn 'Black Head' [242], Berlin 'Green Head' [243]		
		44 Julius Caesar murdered
		31 Defeat of Mark Antony and Cleopatra at Actium
30 BC–395 AD Roman Province		**31 BC–14 AD** Octavian/Augustus
		c.12 BC Tomb of Caius Cestius [255]
	66–70 AD First Jewish revolt	**79** Eruption of Vesuvius
		130 Statue of Antinous [254]
	132–135 Second Jewish revolt	
395–642 Byzantine Egypt		
639–642 Arabs, led by Amr ibn al-As, conquer Egypt		

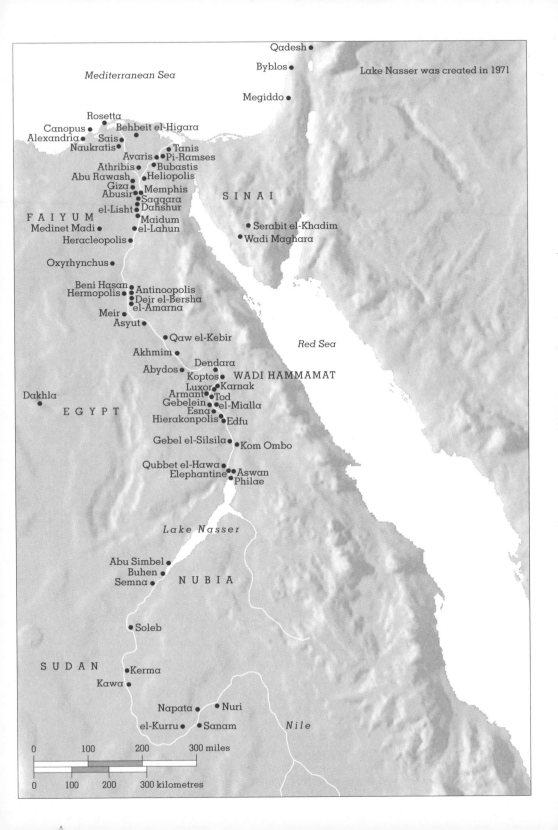

Qadesh •

Byblos •

Megiddo •

Lake Nasser was created in 1971

Mediterranean Sea

Rosetta •
Canopus • Behbeit el-Higara •
Alexandria • Sais •
Naukratis •
Athribis • Avaris • Tanis •
Abu Rawash • Bubastis •
Giza • Heliopolis •
Abusir • Memphis •
el-Lisht • Saqqara •
Dahshur •
Maidum •
Medinet Madi • el-Lahun •
Heracleopolis •

F A I Y U M

S I N A I

• Serabit el-Khadim
• Wadi Maghara

Oxyrhynchus •

Beni Hasan • Antinoopolis •
Hermopolis • Deir el-Bersha •
el-Amarna •
Meir •
Asyut •

• Qaw el-Kebir

Red Sea

Akhmim •
Dendara •
Abydos • Koptos • WADI HAMMAMAT
Luxor • Karnak •
Armant • Tod •
Gebelein • el-Mialla •
Esna •
Hierakonpolis • Edfu •

Dakhla •

E G Y P T

Gebel el-Silsila • • Kom Ombo

Qubbet el-Hawa •
Elephantine • Aswan •
Philae •

Lake Nasser

Abu Simbel •
Buhen •
Semna • N U B I A

• Soleb

S U D A N

Kerma •
Kawa •

Napata • • Nuri
el-Kurru • • Sanam *Nile*

0 100 200 300 miles

0 100 200 300 kilometres

Further Reading

Excavation reports and publications of primary sources are listed, in topographical order, in Bertha Porter, Rosalind L B Moss and Ethel W Burney (now edited by Jaromir Malek), *Topographical Bibliography of Ancient Egyptian Hieroglyphic Texts, Reliefs and Paintings*, i–viii (Parts 1 and 2), i2–iii2 (Oxford, 1927–99).

General

Cyril Aldred, *Egyptian Art in the Days of the Pharaohs, 3100–320 BC* (London, 1980)

Jan Assmann and Günter Burkard (eds), *5000 Jahre Ägypten. Genese und Permanenz pharaonischer Kunst* (Nussloch, 1983)

Christiane Desroches-Noblecourt and Pierre du Bourguet, *L'Art égyptien* (Paris, 1962)

Marianne Eaton-Krauss and Erhart Graefe (eds), *Studien zur ägyptischen Kunstgeschichte* (Hildesheim, 1990)

Gaballa Ali Gaballa, *Narrative in Egyptian Art* (Mainz, 1976)

Henriette Antonia Groenewegen-Frankfort, *Arrest and Movement. An Essay on Space and Time in the Representational Art of the Ancient Near East* (London, 1951, repr. New York, 1978)

Erik Iversen (with Yoshiaki Shibata), *Canon and Proportions in Egyptian Art* (2nd revised edn, Warminster, 1975)

Thomas Garnet Henry James and W Vivian Davies, *Egyptian Sculpture* (London, 1983)

Jean Leclant (ed.), *Les Pharaons. i, Le temps des Pyramides. De la Préhistoire aux Hyksos (1560 av. J-C). ii. L'Empire des Conquérants. L'Egypte au Nouvel Empire (1560–1070). iii. L'Egypte du crépuscule. De Tanis à Méroé. 1070 av. J-C–IVe siècle apr. J-C* (Paris, 1978–80)

J E Livet et al., *Private Theban Tombs. Mastabas of Saqqara* (Paris, 1993)

Kazimierz Michalowski (revised by Jean-Pierre Corteggiani and Alessandro Roccati), *L'Art de l'Égypte* (Paris, 1994)

Hans-Wolfgang Müller, *Ägyptische Kunst* (Frankfurt am Main, 1970)

Gay Robins, *The Art of Ancient Egypt* (London, 1997)

—, *Egyptian Painting and Relief* (Princes Risborough, 1986)

—, *Proportion and Style in Ancient Egyptian Art* (London, 1994)

Heinrich Schäfer, ed. by John Baines, *Principles of Egyptian Art* (Oxford, 1986)

W Stevenson Smith (revised and updated by William Kelly Simpson), *The Art and Architecture of Ancient Egypt* (3rd edn, New Haven and London, 1998)

Jane Turner (ed.), *The Dictionary of Art* (London, 1996)

Claude Vandersleyen (ed.), *Das alte Ägypten* (Berlin, 1975)

Dietrich Wildung, *Die Kunst des alten Ägypten* (Freiburg im Breisgau, 1988)

Richard H Wilkinson, *Symbol and Magic in Egyptian Art* (London, 1994)

Walther Wolf, *Die Kunst Aegyptens. Gestalt und Geschichte* (Stuttgart, 1957)

Museum Handbooks and Exhibition Catalogues

Daniela Ferrari and Patrizia Piacentini (eds), *Il Senso dell'arte nell'Antico Egitto. Bologna, Museo Civico Archeologico* (Milan, 1990)

Karl-Heinz Priese, *Ägyptisches Museum. Staatliche Museen zu Berlin* (Mainz, 1991)

Mohamed Saleh and Hourig Sourouzian, *The Egyptian Museum, Cairo. Official Catalogue* (Mainz, 1987)

Wilfried Seipel, *Gott, Mensch, Pharao. Viertausend Jahre Menschenbild in der Skulptur des Alten Ägypten* (Vienna, 1992)

Donald Spanel, *Through Ancient Eyes. Egyptian Portraiture* (exh. cat., Birmingham Museum of Art, Alabama, 1988)

Edward Lee Bockman Terrace and Henry George Fischer, *Treasures of Egyptian Art from the Cairo Museum; A Centennial Exhibition* (exh. cat., Museum of Fine Arts, Boston, etc., 1970)

Eleni Vassilika, *Egyptian Art (Fitzwilliam Museum Handbooks)* (Cambridge, 1995)

Christiane Ziegler, *The Louvre. Egyptian Antiquities* (Paris, 1990)

Chapter 1

John Baines and Jaromir Malek, *Atlas of Ancient Egypt* (Oxford, 1980)

Barry J Kemp, *Ancient Egypt. Anatomy of a Civilization* (London, 1989)

Chapter 2

Whitney Davies, *The Canonical Tradition in Ancient Egyptian Art* (Cambridge, 1989)

—, *Masking the Blow. The Scene of Representation in Late Prehistoric Egyptian Art* (Berkeley, 1992)

Chapter 3

Nicolas Grimal (ed.), *Les Critères de datation stylistiques à l'Ancien Empire* (Cairo, 1998)

Yvonne Harpur, *Decoration in Egyptian Tombs of the Old Kingdom: Studies in Orientation and Scene Content* (London, 1987)

Kunst des Alten Reiches. Symposium im Deutschen Archäologischen Institute Kairo am 29. und 30. Oktober 1991 (Mainz, 1995)

W Stevenson Smith, *A History of Egyptian Sculpture and Painting in the Old Kingdom* (Oxford, 1949)

Roland Tefnin, *Art et magie au temps des pyramides. L'énigme des têtes dites 'de remplacement'* (Brussels, 1997)

Christiane Ziegler, *Les Statues égyptiennes de l'Ancien Empire* (Paris, 1997)

Chapter 4

Janine Bourriau and Stephen Quirke, *Pharaohs and Mortals. Egyptian Art in the Middle Kingdom* (Cambridge, 1988)

Élisabeth Delange, *Catalogue des statues égyptiennes du Moyen Empire, 2060–1560 avant J-C* (Paris, 1987)

Hans Gerhard Evers, *Staat aus dem Stein. Denkmäler, Geschichte und Bedeutung der ägyptischen Plastik während des Mittleren Reichs*, 2 vols (Munich, 1929)

Biri Fay, *The Louvre Sphinx and Royal Sculpture from the Reign of Amenemhat II* (Mainz, 1996)

Edward Lee Bockman Terrace, *Egyptian Paintings of the Middle Kingdom* (London, 1968)

Dietrich Wildung, *Sesostris und Amenemhet. Ägypten im Mittleren Reich* (Munich, 1984)

Chapter 5

Arielle P Kozloff, Betsy M Bryan and Lawrence Michael Berman, *Egypt's Dazzling Sun: Amenhotep III and his World* (exh. cat., Cleveland Museum of Art, 1992)

Karol Myśliwiec, *Le Portrait royal dans le bas-relief du Nouvel Empire* (Warsaw, 1976)

Roland Tefnin, *La Statuaire d'Hatshepsout. Portrait royal et politique sous la 18e Dynastie* (Brussels, 1979)

Chapter 6

Cyril Aldred, *Akhenaten and Nefertiti* (exh. cat., Brooklyn Institute of Arts and Sciences, New York, 1973)

Iorwerth Eiddon Stephen Edwards, *Tutankhamun: His Tomb and its Treasures* (New York, 1976)

Maya Müller, *Die Kunst Amenophis' III und Echnatons* (Basel, 1988)

Nicholas Reeves, *The Complete Tutankhamun: The King, the Tomb, the Royal Treasure* (London, 1990)

Chapter 7

Emma Brunner-Traut, *Egyptian Artists' Sketches. Figured Ostraca from the Gayer-Anderson Collection in the Fitzwilliam Museum, Cambridge* (Istanbul, 1979)

Richard A Fazzini, *Egypt. Dynasty XXII–XXV* (Leiden and New York, 1988)

Matthieu Heerma van Voss, *Ägypten, die 21. Dynastie* (Leiden, 1982)

Karol Myśliwiec, *Royal Portraiture of the Dynasties XXI–XXX* (Mainz, 1988)

Hourig Sourouzian, *Les Monuments du roi Merenptah* (Mainz, 1989)

Tanis. L'or des pharaons (exh. cat., Galeries Nationales d'Exposition du Grand Palais, Paris and Centre de la Vieille Charité, Marseille, 1987)

Chapter 8

Bernard V Bothmer, Herman De Meulenaere and Hans-Wolfgang Müller, *Egyptian Sculpture of the Late Period, 700 BC to AD 100* (Brooklyn, NY, 1960)

Jack A Josephson, *Egyptian Royal Sculpture of the Late Period 400–246 BC* (Mainz, 1997)

Edna R Russmann, *The Representation of the King in the XXVth Dynasty* (Brussels, Brooklyn and New York, 1974)

Chapter 9

Morris Leonard Bierbrier (ed.), *Portraits and Masks. Burial Customs in Roman Egypt* (London, 1997)

Lorelei H Corcoran, *Portrait Mummies from Roman Egypt (I–IVth Centuries AD). With a Catalog of Portrait Mummies in Egyptian Museums* (Chicago, 1995)

Euphrosyne Doxiadis, *The Mysterious Fayum Portraits. Faces from Ancient Egypt* (London, 1995)

Richard A Fazzini and Robert Steven Bianchi, *Cleopatra's Egypt: Age of the Ptolemies* (exh. cat., Brooklyn Museum of Art, New York, 1988)

Günter Grimm, *Kunst der Ptolemäer- und Römerzeit im Ägyptischen Museum Kairo* (Mainz, 1975)

Helmut Kyrieleis, *Bildnisse der Ptolemäer* (Berlin, 1975)

Chapter 10

Patrick Conner (ed.), *The Inspiration of Egypt. Its Influence on British Artists, Travellers and Designers, 1700–1900* (exh. cat., Brighton Museum and Art Gallery and City Art Gallery, Manchester, 1983)

James Steven Curl, *Egyptomania. The Egyptian Revival: A Recurring Theme in the History of Taste* (Manchester and New York, 1994)

Heinz Herzer, Sylvia Schoske, Rolf Wedewer and Dietrich Wildung, *Ägyptische und Moderne Skulptur. Aufbruch und Dauer* (exh. cat., Museum Morsbroich, Städtisches Museum Leverkusen, 1986)

Jean-Marcel Humbert, Michael Pantazzi and Christiane Ziegler, *Egyptomania: L'Égypte dans l'art occidental 1730–1930* (exh. cat., Musée du Louvre, Paris and National Gallery of Canada, Ottawa, 1994)

James Putnam and W Vivian Davies, *Time Machine. Ancient Egypt and Contemporary Art* (exh. cat., British Museum and Institute of International Visual Arts, London, 1994)

Three-dimensional Sculpture

Edna R Russmann and David Finn, *Egyptian Sculpture: Cairo and Luxor* (Austin, 1989 and London, 1990)

Regine Schulz, *Die Entwicklung und Bedeutung des kuboiden Statuentypus*, 2 vols (Hildesheim, 1992)

Matthias Seidel, *Die königlichen Statuengruppen, i* (Hildesheim, 1996)

Painting

Marcelle Baud, *Le Caractère du dessin en Égypte ancienne* (Paris, 1978)

Werner Forman and Hannelore Kischkewitz, *Die altägyptische Zeichnung* (Hanau, 1971)

Arpag Mekhitarian, *Egyptian Painting* (Geneva, 1954, trans. London, 1978)

William H Peck, *Drawings from Ancient Egypt* (London, 1978)

Roland Tefnin (ed.), *La Peinture égyptienne ancienne. Un monde de signes à preserver. Actes du colloque international de Bruxelles, avril 1994* (Brussels, 1997)

Architecture

Dieter Arnold, *Lexikon der ägyptischen Baukunst* (Zurich, 1994)

—, *Die Tempel Ägyptens. Götterwohnungen, Kultstätten, Baudenkmäler* (Zurich, 1992)

Iorwerth Eiddon Stephen Edwards, *The Pyramids of Egypt* (London, 1993)

Rainer Stadelmann, *Die ägyptischen Pyramiden. Vom Ziegelbau zum Weltwunder* (Darmstadt, 1985)

Minor Arts

Cyril Aldred, *Jewels of the Pharaohs* (London, 1971)

Carol Andrews, *Amulets of Ancient Egypt* (London, 1994)

—, *Ancient Egyptian Jewellery* (London, 1990)

Janine Bourriau, *Umm el-Ga'ab. Pottery from the Nile Valley before the Arab Conquest* (Cambridge, 1981)

Egypt's Golden Age. The Art of Living in the New Kingdom, 1558–1085 BC (exh. cat., Museum of Fine Arts, Boston, 1982)

Geoffrey Killen, *Egyptian Woodworking and Furniture* (Princes Risborough, 1994)

Alix Wilkinson, *Ancient Egyptian Jewellery* (London, 1971)

Index

Numbers in **bold** refer to illustrations

Acknowledgements

I am grateful to Dr Jane Jakeman for reading
several drafts of this text and making sure
that my feet stayed firmly on the ground.
A number of Egyptologists responded to
my Internet enquiry about ancient Egypt
and modern art, and I have benefited from
their advice. And many thanks to Pat Barylski,
Cleia Smith and Giulia Hetherington for their
professionalism and expertise.

J M

For J J with love, as ever. And to Lord
Ambrose, with admiration and respect.

Photographic Credits

Ägyptisches Museum, Berlin: photo Margarete Busing 219, 234, 243; AKG London: 194–5, 267, photo Erich Lessing 142; Ancient Egypt Picture Library, Knutsford: 5; Ashmolean Museum, Oxford: 18, 19, 24, 27, 32–3, 35, 38, 166, 225, 259, 262, photo Werner Forman 15, 16; Axiom Photographic Agency, London: photo James Morris frontispiece, 68–9, 157, 224; courtesy Manfred Bietak, Institute of Egyptology, University of Vienna, reconstruction copyright M Bietak, N Marinatos and C Palyvou: 149; Bildarchiv Preussischer Kulturbesitz, Berlin: 264, photo Margarete Busing 156, 160–3, photo Jürgen Liepe 52, 244; Boltin Picture Library, New York: 181; British Museum, London: 1, 10, 14, 21, 34, 118–9, 121–2, 141, 147, 150, 167, 199, 203, 207–8, 211, 233, 235, 252; Brooklyn Museum of Art, New York: 26, 58, 76, 107, 164, 202, 237, 242, Charles Edwin Wilbour Fund 209–10, 231, 253, Museum Collections Fund, photo Justin Kerr 12; Calouste Gulbenkian Museum, Lisbon: 105, 148, 204, 229–30; Cambridge University Library: 256; Peter Clayton, Hemel Hempstead: 96, 99; Giovanni Dagli Orti, Paris: 2, 3, 41, 85, 94, 116, 126, 136, 139–40, 145–6, 155, 175, 187–9, 191, 205, 226; courtesy W V Davies, Department of Egyptian Antiquities, British Museum, London: 46, 223; Field Museum of Natural History, Chicago: photo Ron Testa 129; Editions Gallimard, Paris: 6, 13, 22, 67, 179, 198, 251; courtesy of the Getty Conservation Institute, Los Angeles: © 1992 the J Paul Getty Trust 200; courtesy Andy Goldsworthy, photo Julian Calder: 270; Griffith Institute, Ashmolean Museum, Oxford: 11, 49, 172–3, 248; Guy Gravett Picture Index, Hurstpierpoint: 263; Graham Harrison, Thame: 143, 186; Image Service, Geodia snc, Verona: photo Alberto Siliotti 30–1, 60–1, 109–10, 124; Israel Museum, Jerusalem: 108; J Allan Cash Photolibrary, London: 255; Randy Juster, San Mateo, CA: 265; Kunsthistorisches Museum, Vienna: 70–1; Jürgen Liepe Photo Archive, Berlin: 4, 20, 40, 45, 54, 75, 80, 98, 104, 117, 128, 152, 165, 174, 176, 197, 227, 239; Lotos Film, Kaufbeuren: photo Eberhard Thiem 39, 44, 63, 84, 86, 91–2, 114, 134–5, 193, 212–6, 221; MacQuitty Collection, London: 250; Jaromir Malek, Griffith Institute, Ashmolean Museum, Oxford: 17; Metropolitan Museum of Art, New York: purchase, Edward S Harkness Gift (1926) 9, 102, 217, Rogers Fund and Contribution from Edward S Harkness (1929) 137, Theodore M Davis Collection, bequest of Theodore M Davis (1915) 125; Mountain High Maps © 1995 Digital Wisdom Inc: p.437; Musées Royaux d'Art et d'Histoire, Brussels: 245; Museo Civico Archeologico, Bologna: 169–70; Museum d'Histoire Naturelle, Lyon: 23; courtesy Museum of Fine Arts, Boston: Harvard University–Museum of Fine Arts

Expedition 55, 78, 113, William E Nickerson Fund 151; MAK, Vienna: 266; Niki de Saint Phalle Archives, Paris: photo L Condominas 269; Petrie Museum of Egyptian Archaeology, University College, London: 28–9; Powerhouse Museum, Sydney: 261; RMN, Paris: 220, 232, 238, photo Chuzeville 37, 57, 87, 153–4, photo Laser 206, photo Hervé Lewandowski 53, 73, 115, 127, 159, 218, 236; Robert Harding Picture Library, London: 178, photo R Ashworth 138; Roemer und Pelizaeus Museum, Hildesheim: 71; John G Ross, Cortona: 36; Scala, Bagno a Ripoli, Florence: 7, 56, 64–6, 72, 79, 81, 88, 93, 95, 100–1, 103, 106, 120, 144, 158, 177, 180, 182–3, 196, 201, 222, 240, 254; Prof. Dr Abdel Ghaffar Shedid, Munich: 111–2; Soprintendenza al Museo Delle Antichita Egizie, Turin: 246; Spectrum Colour Library, London: 50–1, 123, 131, 185, 190, 247, 249, photo Carolyn Clarke 43, photo D & J Heaton 132–3, 184; Stichting Rijksmuseum van Oudheden, Leiden: 168; Staatliche Sammlung Ägyptischer Kunst, Munich: 42; Tate Gallery, London: 268; diagrams by Roger Taylor: 47, 90, 91, 97, 130, 192; Tony Stone Images, London: 48, photo Stephen Studd 8; University of Pennsylvania Museum of Archaeology and Anthropology, Philadelphia: 89, 228; by courtesy of the Board of Trustees of the Victoria and Albert Museum, London: 260; Werner Forman Archive, London: 59, 62, 74, 82–3, 241

Acknowledgements

Phaidon Press Limited
Regent's Wharf
All Saints Street
London N1 9PA

First published 1999
© 1999 Phaidon Press Limited

ISBN 0 7148 3627 3

A CIP catalogue record for this book is
available from the British Library.

Text typeset in Memphis

Printed in Singapore

Cover illustration Funerary mask
of Psusennes I from his tomb at Tanis,
1039–991 BC (see p.347)